The Eye Expanded

The Eye Expanded

Life and the Arts in Greco-Roman Antiquity

EDITED BY

Frances B. Titchener and
Richard F. Moorton, Jr.

UNIVERSITY OF CALIFORNIA PRESS

BERKELEY LOS ANGELES LONDON

University of California Press
Berkeley and Los Angeles, California

University of California Press, Ltd.
London, England

Copyright © 1999 by the Regents of the University of California

Library of Congress Cataloging-in-Publication Data

The eye expanded : life and the arts in Greco-Roman antiquity / edited
by Francis B. Titchener and Richard F. Moorton
 p. cm.
Includes bibliographical references and index.
ISBN 0–520–21029–8 (alk. paper)
 1. Greece—Civilization. 2. Rome—Civilization. 3. Civilization, Western—Classical
influences. I. Titchener, Frances B., 1954– . II. Moorton Jr., Richard F.
DE59.E93 1999
938—dc21 98-41403
 CIP

Printed in the United States of America

08 07 06 05 04 03 02 01 00
9 8 7 6 5 4 3 2

The paper used in this publication meets the minimum requirements of
ANSI / NISO Z39.48-1992 (R 1997) (*Permanence of Paper*). ©

Chapter 13, "Augustan Classicism: The Greco-Roman Synthesis" by Karl Galinsky, is
reprinted by permission from *Augustan Culture: An Interpretive Introduction* by Karl Galinsky
(Princeton, N.J.: Princeton University Press, 1996).

This book is respectfully dedicated by all who helped to create it to Peter Morris Green, Charles R. Dougherty, Jr., Centennial Professor Emeritus of Classics at The University of Texas at Austin.

His long and brilliant career as scholar, teacher, translator, writer of fiction, essayist, editor, poet, and critic of text, theater, television, and film is one of the cultural wonders of the age.

CONTENTS

ILLUSTRATIONS

TABLES

ACKNOWLEDGMENTS

The editors would like to thank Professor Frank Frost, Utah State University, and Connecticut College for generous subventions of this project. We are also grateful to the Department of History at Utah State University and the Department of Classics at Connecticut College for supporting this book in various ways. Special thanks is due to two secretaries, Carolyn Doyle at Utah State University and Diane Monte at Connecticut College, for their untiring work and skill in assembling and processing the manuscripts. We also owe a continuing debt of gratitude to our unfailingly supportive spouses. Last but by no means least, we thank the University of California Press and its senior humanities editor, Mary Lamprech, for their goodwill in accepting this manuscript, and Kate Toll, Cindy Fulton, and Peter Dreyer for their patient and skillful help in preparing it for publication.

Introduction

Richard F. Moorton, Jr.

Classicists are rightfully fascinated with the fruitful symbiosis of the Greco-Roman arts and the world in which they flourished. Works like *Homer and Mycenae* by Martin P. Nilsson, *The Political Art of Greek Tragedy* by Christian Meiei, *Catullus and his World* by T. P. Wiseman, and *The Power of Images in the Age of Augustus* by Paul Zanker document the conviction of the modern scholar that in antiquity the world and the arts formed one another in profound and multifarious ways. This conviction has its roots in antiquity. Plato and Aristotle both wrote that the arts are mimetic creations of the human mind. Both also believed that the tragic art, for example, had the power to influence human society. In this they were representative of a widespread consensus in ancient culture. Herodotus asserted that Homer and Hesiod had given the Greeks their gods, in that the authority of their art had established a quasi-official version of the divinities and their doings. Athenian artists sought to order civic consciousness by the architecture, cult statues, and friezes of the Parthenon and other public buildings. In both his patronage of Vergil's *Aeneid* and his commissioning of the Ara Pacis Augustae, Augustus strove to control public perceptions of the relationship between national mythology and his own political accomplishments. Ancient culture, then, was both the parent and the product of its arts. Cultural and political impulses informed the fine arts, and these in their turn shaped—and often were intended to shape—the living world from which they sprang.

The task that this book undertakes is not only to find examples of this mutual influence of the arts and the world of antiquity—for this has been done many times—but also to survey this dynamic interaction from the time of archaic Greece right down to our own times in a series of studies focusing on the interplay of life and the arts in Greece, Hellenistic times, the

Roman world, and the modern age, which owes so much to Greco-Roman antiquity. We therefore seek to document in a single book ranging throughout antiquity and into modernity the interaction between human life and the literary and plastic arts that has served to make art more lively and life more artful. So far as we know, this aspiration is rare.

The first three essays in this book explore the theme of mimesis in the Greek world, beginning from the point at which history emerges from mythology in ancient Greece, bearing the traces of its birth. In "The 'Ominous' Birth of Peisistratos," the inaugural chapter in the volume, Frank J. Frost argues that the story in the first book of Herodotus telling of the omen of the miraculously boiling cauldron by which Hippokrates, the father of Peisistratos, was warned not to have a son was originally contrived by the Peisistratids themselves—and Frost shows how Hippokrates could personally have faked the *miraculum*—in imitation of the oracle by which Aegeus was warned not to have intercourse until he had returned from Delphi to Athens. Thus, Hippokrates made of the faked omen a prodigious announcement of the future greatness of his son, modeled on the oracle of Aegeus. In this interpretation, the mythology of Attica, as much an art form as any other, inspires dynastic connivers in the real world, who then themselves become part of the legends of Attica as enshrined by the mythologos Herodotus. In his study "Antigone Nodding, Unbowed," Alan Boegehold continues the exploration of the connection between life and art in Greece by looking to life in modern Greece to illuminate a generally misunderstood point in a great ancient text. Arguing from the body language of modern Greeks, Boegehold shows that when Sophocles' Antigone nods toward the ground in response to Creon's interrogation, she is proudly affirming her part in Polyneikes' burial ritual, not abjectly denying it. The power of the gestures and deeds of Greek life to animate drama is then explored in the world of Aristophanic comedy by Richard F. Moorton, Jr. In his essay "Dionysus or Polemos? The Double Message of Aristophanes' *Acharnians*," Moorton endeavors to show that Aristophanes' play pictures the Archidamian War as detrimental to Athens's economy, and for that reason urges the making of peace with Sparta through the rescinding of the Megarian Decree, unless the Spartans set conditions detrimental to the Athenian *arche*. On this reading, the play is not a disengaged comic fantasy but a comic thought experiment inspired by Aristophanes' understanding of the best economic interests of Athens in 425 B.C. and intended by the playwright to influence his fellow citizens on whether, and how far, to prosecute the war with Sparta. If this is correct, the *Acharnians* is also a civic act.

The next essay continues the exploration of the relationship between the civic ethos and Greek literature. Alan Samuel expands the analysis of the influence of economic and civic realities on the arts (and vice versa) with a more philosophical analysis of the socioeconomic system of ancient Greece

and the ways in which it influenced literary and philosophical discourse in antiquity. In the fourth essay, "Athenian Democracy and the Idea of Stability," he investigates the ways in which key pieces of Athenian literature reveal that Athenian democracy was led into some of its most characteristic behaviors, including imperialism and the political suppression of women, by its cultural preference for stability and fixed limits, rather than by anything comparable to the modern ideal of progress, especially in the form of economic growth. For Samuel, the egalitarian and inclusive tendencies of Athenian society created a need for increased resources that could not be filled by economic development because of the Greek reverence for stability and limit. In consequence, Athens widened the sphere of prosperity for its citizens through the exploitation of women, slaves, and the cities of the empire, an exploitation that has left its traces in tragedy, comedy, history, and philosophy. Therefore both Moorton and Samuel see the political and economic convictions of the Greeks giving form to some of their most memorable literary art during the classical age of the Hellenes.

In the second section of this book, seven essays treat the theme of the arts and reality in the Hellenistic world. The first three essays deal with the impact on art of the life and legacy of Alexander of Macedon, the commanding figure whose brief but legendary career gave birth to the Hellenistic Age. In the first essay, Philip O. Spann focuses his paper on Alexander. In "Alexander at the Beas: Fox in a Lion's Skin," Spann argues that the episode in Arrian and other writers in which Alexander's officers and men refused to continue on in the famous confrontation with the conqueror at the Beas is based on a real episode, in which Alexander, realizing that the end of the world was not over the next hill, maneuvered his army into calling a halt to his potentially endless war of conquest, so that he himself might not be compelled to do so, to the great detriment of his legend. Spann's Alexander is at pains to shape his story for the chronicle of posterity in a way most flattering to his stupendous ambitions. Spann contemplating Alexander sees, as does Frost contemplating Hippokrates, a historical personage reaching through the manipulation of his image across the years to influence for the better the historical and artistic portraits commemorating him for the ages.

There is reason to believe that not all subsequent artists uncritically accepted Alexander's self-glorification. In his study "A Note on the 'Alexander Mosaic,'" Ernst Badian argues that contrary to the views of almost all scholars, in the Alexander Mosaic, Alexander is represented in disarray, and Darius is represented not in flight but in eager attack. Badian believes that this is because the original was commissioned by Cassander, who hated Alexander and thus had him portrayed at a point in the battle of Gaugamela when Darius's splendidly prepared forces went on the offensive. Badian concludes, with Heinrich Fuhrmann and others, that the brilliant work

was probably executed by Philoxenus of Eretria, picturing in his mind's eye a highlight in the battle—Darius's vigorous onset—that Alexander might have preferred to suppress.

Alexander's conquests indisputably led to a cultural revolution in the ancient world. Greek culture was carried east by a series of soldiers and dynasts and, by the very act of being imposed on a multitude of peoples, lost its own provincialism. The barbarians did not always acquiesce in Greek rule, and in the perennial cycle of empire, they sometimes overthrew the Greek overclass and the culture it had established to celebrate its dominion. But change here sometimes came as evolution rather than sudden rupture. In "Mimesis in Metal: The Fate of Greek Culture on Bactrian Coins," Frank L. Holt refutes Sir William Tarn's contention that an absolute cultural divide separated the artists who produced the last Greek coins in Bactria and those who fashioned the earliest "barbarian imitations" by showing that the decline of accurate Greek on Bactrian coins began before and gained momentum during the reign of the last Greek king, Heliocles I, thus reflecting gradually changing cultural conditions rather than an absolute break caused by the barbarian invasions. Holt finds in this metal mimesis of gradual cultural change confirmation that "art indeed imitates life."

For the scholars of Hellenistic antiquity, it was an era of extraordinary cosmopolitanism, during which Greek culture served as a kind of lingua franca uniting a multicultural ecumene of rich diversity. The next four essays in this section focus on the impact of both cultural diversity and the new social structures of Hellenistic culture on the literary art of the period as well as the influence of Hellenistic arts on their polycentric world. The first two of these studies consider Judaism in the Hellenistic period. In "Cleitarchus in Jerusalem: A Note on the *Book of Judith*," Stanley M. Burstein contends that the story of Judith's killing of Holophernes is ultimately derived from an episode in Cleitarchus's *Life of Alexander* detailing the killing of the Sogdian noble Spitamenes by his wife for the benefit of Alexander the Great. Thus Burstein makes the point that in the Hellenistic age, Greek culture influenced even the construction of Jewish sacred texts. The uneasy but fruitful relationship between Jewish and Greek culture during Hellenistic times is also the subject of Erich S. Gruen's essay "The Hellenistic Images of Joseph." Gruen shows how Hellenistic Jews such as Philo and Artapanus used the story of Joseph in Genesis to reflect on the admirable qualities of the Jews that enabled them to survive and flourish in the foreign world of Hellenistic culture. Joseph's story was that of a Jew in an alien land, ideally suited to symbolize the predicament of Jewry during the Diaspora. The complex nature of Joseph's character, containing darker elements of cunning and manipulation alongside the shining traits of righteousness and skill, was emblematic of the complications faced by Jews outside of Palestine endeavoring to live under foreign domination. In Gruen's view, the Jews

used the narrative of Joseph as a model and an inspiration for their own struggle to endure and maintain their identity in a strange and sometimes hostile empire. Influenced by their experiences in Hellenistic Eurasia, Jewish writers like Philo and Artapanus retold the Joseph story to offer to Hellenistic Jewry cultural messages such as the eulogy of Jewish intelligence abroad, admonitions about the dangers of hubris for a Jew amid aliens, and simple romantic escapism. In the history of the Joseph story in Hellenistic Jewry, as Gruen traces it, life and art complexly intertwine.

Joseph was a foreigner in Egypt. In "Egyptians and Greeks," Diana Delia reflects on the supreme irony that under Hellenistic and Roman rule, the Egyptians had in a sense become strangers in their own land, but she contends that (like the Jews) they had kept their cultural integrity through sheer strength of character. The focus of her discussion is a passage in Strabo 17.1.12 in which—in the common manuscript reading—the author quotes Polybius to the effect that the Egyptians in the Alexandria of his day were "political." This many scholars find surprising in a Greek author, but Delia argues that *Aiguption . . . politikon* should not be emended to *Aiguption . . . apolitikon*. Instead, we should accept Polybius's evident meaning in the passage under discussion that by the second century B.C., the Greeks of Alexandria had become apolitical, while the Egyptians were characterized by community involvement. Delia supports this contention with a wealth of other ancient evidence for the political corruption of the Greeks and the public-spiritedness of the Egyptians in Hellenistic Alexandria. The text of Strabo as received shows once again that art imitates life.

The second section concludes with an analysis of an important and characteristic effect in the *Geist* of the Hellenistic age on the literary tradition. In "Autobiography and the Hellenistic Age," Frances B. Titchener argues that the disintegration of the communal spirit of the traditional polis in the Hellenistic age encouraged the development of biographic and particularly autobiographical works focusing on the person rather than the society. The peoples of the Hellenistic period had been gradually deprived of civic structures in which they could find their identities. Democracy, for example, was a thing of the past, and dynastic rule, often by an overclass dominated by a foreign culture, was everywhere. In such a world, people abandoned the grand civic identifications and imperial ambitions of the past and became absorbed instead in the ordinary affairs of their mundane existence. Hellenistic autobiography was the voice of this more down-to-earth view of life and its possibilities.

The third section of this book views the interaction of reality and the arts in the Roman world. The role of Rome in the ancient world is surveyed in essays exploring the implications of the literary and archeological evidence of the economic nature of the Greco-Roman city, the role of the Hellenistic spirit in Augustan classicism, and the paradigmatic power of narratives of

women in the first book of Livy. Each chapter in this section is, in its own way, revolutionary, taking vigorous issue with dominant schools of interpretation of the question at hand. The first essay sets Rome in the context of the ancient world by asking whether the agricultural territories of the ancient city as depicted in our sources were capable of producing enough to create a surplus for the farmers in question. In "The Classical City Reconsidered," Donald Engels maintains that we should trust literary evidence in Greco-Roman sources such as Aristophanes, Plato, Aristotle, and Varro that indicates—in contradiction to the tenets of the influential primitivist and consumer city models for the interpretation of the relationship between the ancient farmer and the city—that the ancient farmer produced a significant surplus enabling him to participate in the city economy both as a supplier of agricultural goods and as a consumer of urban products. Thus Engels provides a picture of the ancient city supplementary to that of Alan Samuel earlier in this volume. Samuel emphasizes the cultural and economic forces that elevated stability and the observation of limits to the status of ideals in the ancient world. Without necessarily denying this view, Engels is clearly more optimistic about the ability of a major part of the ancient economy, the agricultural sector, to produce wealth. It would appear that Engels's conclusions provide less ground than Samuel's view for the idea that socioeconomic exploitation was essential to the accomplishments of ancient civilization.

The next essay also sets Rome in the context of Hellenistic culture. The widespread idea that Augustan art and architecture are a repudiation of Hellenistic models in favor of an emulation of the Greek classical period is rejected by Karl Galinsky in "Augustan Classicism: The Greco-Roman Synthesis." Instead, Galinsky argues, the Augustans combined Roman elements with motifs drawn from archaic, classical, and Hellenistic Greek sources to create the masterful synthesis that we call Augustan classicism. Galinsky is at pains to criticize a view of Augustan art and literature developed in neoclassical Europe that saw its accomplishment as preconceived and static. Rather, he insists that Augustan artistry was experimental and evolutionary, although it became, paradoxically, an "evolution that was lasting." The point here made is that made elsewhere by the political theorist Michael Oakeshott. Contrary to the view that moderns take of tradition (and, we may add, traditional art), it is not a rigid and unchanging thing but fluid and dynamic, maintaining continuity with the past in the very act of transforming it.[1] For Galinsky, Augustan classicism had a compelling reason for assimilating rather than repudiating Hellenistic culture: like the Hellenistic World, Augustan art and literature aspired to the universal and were thus well served by a transforming identification with their imperial predecessor.

The final essay in this section examines Roman historical literature on its own terms. Elizabeth Vandiver explores the place of Roman values in

Roman historiography in "The Founding Mothers of Livy's Rome: The Sabine Women and Lucretia." Rejecting the commonplace view among modern scholars that the Sabine women and Lucretia should be seen predominantly as abstractions of broad concepts or important primarily for their effects on men, Vandiver argues that both in the episode of the "rape" of the Sabine women and in the story of Lucretia, Livy has crafted female characters who function as active, positive moral agents serving as exempla for Romans, particularly Roman women. In Vandiver's reading, Livy takes the women of the Roman world seriously, and strives to rework the material of the foundation myths of Rome so as to create positive models for Roman women that emphasize their capacity to be creative and active copartners in the origination and sustenance of a virtuous society. For Livy, literary mimesis is a constructive and moral act intended to engender, through the paradigmatic use of the mythological tradition in a literary work, corresponding mimeses in the world of real human beings striving to live their lives in accord with socially positive principles.

In the final section of this book, two essays examine the impact of the art and culture of ancient civilization on an era that Greece and Rome did much to shape, the modern world. This section deals intensively with the creative mimetic uses of the past. The first essay views antiquity as a virtual text read by modern individuals shaping personal identities. The second essay also sees antiquity as a kind of text or model, read this time not by individuals in search of themselves but by contending groups seeking to appropriate ancient Macedonia for rival nationalistic visions.

In "Modern Pagans in a Classical Landscape: Norman Douglas and D. H. Lawrence in Italy," Robert Eisner explores the role of ancient civilization in Italy in shaping the art and sensibilities of two very disparate modern authors. Eisner contrasts Lawrence's romantic, almost mystical vision of the Italian, particularly the Etruscan, past with Norman Douglas's sustained meditation on the Greek influence in the peninsula, especially Magna Graecia in the south. Both men found in their experiences of antiquity in Italy important factors for the elaboration of their sexual and spiritual identities, but what they chose to idealize in the past was very different. Lawrence celebrated the life force and exuberant heterosexuality he thought he detected in the relics of Etruscan culture, particularly the sculpture and wall paintings. Douglas much preferred the intellectualization of homosexuality in ancient Greece and, by extension, Greek Italy, which he found congenial to his own erotic nature. For both men, Italy was a classical refuge from a Protestant England that was inhospitable to their deepest impulses. Both men found themselves in a selective reading of the text of the past as it was preserved in Etruscan Italy and Magna Graecia to the south.

In the final essay, "Macedonia Redux," Eugene M. Borza shows how both modern Greek and (Slavic) Macedonian nationalists have read ancient

culture in their own images in an attempt to assimilate the region of ancient Macedonia into their very different nationalistic visions of what the past was and what the present should be. The Greeks are attempting to restore lost glory by identifying with an ancient Macedonia that they see as Greek and as linked to modern Greece by a continuous Hellenic cultural and ethnic tradition. The Macedonians, lacking historical identity as a nation, and in desperate need of one in the wake of the collapse of Yugoslavia (where their distinct identity was affirmed by Tito), seek to find ethnic legitimacy through identification with an allegedly Slavic Macedonia of antiquity. The contest is symbolized by the rival uses to which the two parties have put the ancient Macedonian symbol of the sixteen-pointed sunburst. The Macedonians put it on their national flag and a postage stamp, while the Greek government stamped the same sunburst on a new 100 drachma coin and declared the emblem a symbol of the Greek state. As Borza ruefully points out, the problem is a characteristically Balkan one, in which people prefer "a past bent out of shape rather than a reasonable and peaceful vision of the future."

The essays presented to Peter Green in this volume show in profusion that the mimesis of life by the arts and of the arts by life began in early antiquity and continues to the present day. Classical culture held at its heart a dynamic interplay between the life of human beings and the aesthetic objects they created to incarnate their aspirations, terrors, and joys. For better or worse, that interplay between humanity and the classical imagination flourishes today in the lives of persons and the conflicts of national groups. Classical antiquity is in our own time a living force, and it articulates itself, now as always, in the dialectic of mimesis.

NOTES

1. See the title essay in Michael Oakeshott, *Rationalism in Politics and Other Essays* (New York, 1962).

The "Ominous" Birth of Peisistratos

Frank J. Frost

The sixth century in the Aegean is not quite yet history. Many of the personages and events narrated by Herodotos can claim a legitimate place in the historical record, although it may take a bit of jiggling to make them fit. An equal number, however, wear the soft focus of epic and legend: they give the impression of taking place in midair, somewhere between sleep and waking—although a marvelous midair it is, from Arion and his dolphin to Hippokleides dancing on his hands.

This atmosphere of what is often no more than inspired storytelling makes it difficult to assess something as down to earth and effective as the career of Peisistratos. The very first event in the life of the tyrant—his birth—demonstrates something of this ambiguity.

It was well known in fifth-century Athens that Peisistratos was descended from and named after the son of Nestor and companion of Telemachos in the *Odyssey* (3.400, etc.). Herodotos knew that the descendants of Nestor had come to Athens in the time of Melanthos and his son Kodros (5.65), and the tradition about a Pylian origin of the Neleid colonists of Ionia can be traced back as far as Mimnermos, in the late seventh century.[1] It is probable therefore that some version of the standard tradition about the Medontid line of Athenian kings, descended from Kodros, had been propagated by the family of the first Athenian we know by the name of Peisistratos, archon in 669/8.[2] We may thus believe in the existence of a fairly standard family history of the Athenian Neleids, passed on from generation to generation. At the end of the seventh century sometime, even though Hippokrates, the prospective father of Peisistratos, was *idiotes,* that is, a private person, he and everyone else would

have known that his family had distinguished antecedents. This is an important consideration when one interprets the following story.

> A great marvel befell Hippokrates, who was a person of private station, while he was observing the Olympian games. For while he was sacrificing, the cauldrons had been set up and were full of meat and water when without fire they boiled and foamed over. Chilon the Lakedaimonian happened to be present and seeing the marvel he advised Hippokrates first, not to take a childbearing wife into his house. Second, if he should happen to have one, he should send the woman off. And if he should happen to have a son he should disown him.[3]

But Hippokrates did not take Chilon's advice and soon afterward Peisistratos was born.

Since Herodotos is our only source for this story,[4] much depends on where he heard it and what he intended it to accomplish in his history. The difficulties are obvious. The episode of Peisistratos's birth was inserted as a minor bit of background in the larger *logos* (1.56–70), which described what Kroisos found out about the most powerful of the Greeks, after the Delphic oracle had instructed him to make them his friends. The Athenians, he found, were subjected (κατεχόμενον) by Peisistratos, having been until then split by faction (διεσπασμένον). This, at least, is how I interpret the sequence of tenses.[5] Herodotos's story now required the description of the Athenian factions and Peisistratos's final mastery of Attica after two failed attempts. But Herodotos could have begun immediately with the nature of the three factions and Peisistratos's ruse to get himself a bodyguard. For some reason the historian thought he should tell the story of the omen (*teras*) as a prologue. Why did he do so? He related the tale of the boiling cauldrons in leisurely fashion. But immediately following, he was in such a hurry to get through the background of the three factions that he crammed all this information into one long complicated relative clause. Modern historians will consider this narrative unbalanced. There are eight Teubner lines devoted to the *teras*—four for the *staseis*. Our modern historians, it will be admitted, care very little for portents, while their interest in the three factions can be measured by the enormous literature of interpretation that has been produced, beginning with Aristotle.[6] This should remind us that Herodotos was often a storyteller first and the sort of historian we should like him to be only as an afterthought.

Ordinarily in the *History,* oracle, dream, or omen all mean the same thing: some god has intervened in mortal affairs with what can be construed as an instruction, a warning, or perhaps merely a simple announcement.[7] At first glance we assume that the cauldrons boiling over was a warning that Hippokrates should not have a son. Warnings of this type are frequent in the folk literature of the world[8] and usually take the form: X is warned that

if Y is born something bad will happen to him (X). X then takes various steps to prevent Y from being born or surviving, but of course all is in vain; Y survives, grows to manhood and X is overtaken by his fate.

The problem in the case of Hippokrates is that he ignored the *teras* and the interpretation of Chilon, Peisistratos was born, but no evil fate befell Hippokrates. Obviously X must be someone else. On the surface, there are two obvious possibilities.

Because the interpreter was the Spartan, Chilon, one could argue that Peisistratos's birth boded ill for the Spartans. But this is not borne out by later relations between the Peisistratids and the Spartans, which according to Herodotos, were friendly until the Delphic oracle, corrupted by the Alkmeonids, ordered the Spartans to set the Athenians free (5.63). Chilon is also a later addition to this story as he will not fit chronologically. He was made ephor at Sparta during the archonship of Euthydemos at Athens, around 555; he could not then have been born much before 600, like Peisistratos himself. His name may have been attracted to this story by Herodotos's day because of his reputation for initiating an anti-tyrant policy at Sparta.[9] Thus the storyteller who put Chilon into the story may have believed that X was the Spartans. But Herodotos did not; he accepted the detail of Chilon, perhaps as a famous name to spice up his narrative (cf. 7.235) but not the anti-tyrannical implications.

One might think it more likely that X was meant to be the Athenians. The account of Herodotos leaves no doubt that he preferred democracy to tyranny and he portrays the last years of Hippias's regime as harsh and oppressive. Moreover, the story of Kroisos's inquiry is often interpreted to mean that he chose the Spartans as his allies, not only because they were the most powerful Greeks (1.69), but because the Athenians were disunited by the Peisistratid tyranny. The moral of the story therefore would be that Hippokrates was warned not to have a son; he ignored the warning, however, and the Athenians had to endure the Peisistratid tyranny. Even if unspoken, this interpretation would have been uppermost in the minds of an Athenian audience hearing the story in the decades following the fall of the Peisistratids. But because it would not in reality have been apparent to the Athenians that the tyranny was oppressive until, say, after 520 or so, the story of Chilon's warning would have had little meaning until then. If this is the interpretation that Herodotos, recounting his *historie* in Athens with the democracy in full flower, wished to have understood, why did he not say so?[10] As we have seen, his narrative is so condensed here that the birth of Peisistratos and his creation of a third stasis are all part of one sentence. But in the following account, when Herodotos has the opportunity to make his point that the birth of Peisistratos was evil for Athens, he seems to have lost track of the message. Peisistratos preserved the status quo, obeyed the laws,

and ruled καλῶς τε καὶ εὖ (1.59 fin.), a judgment with which Thucydides and Aristotle agreed.[11] And at the conclusion of 1.64, that is, at the time Kroisos was inquiring about the most powerful Greeks, Herodotos tells us that the Athenians, far from being *diespasmenoi,* were firmly under the control of Peisistratos.

If this "ominous" story, whenever it took the form in which Herodotos found it, was meant to cast the Athenians as the potential victims of Hippokrates' son, there is an obvious parallel to be considered in the *History:* the divine warning to the Corinthians. The Bakchiad rulers of Corinth were warned by Delphi that an "eagle" would give birth to a "lion." Investigating further, they found that one Eetion had married Labda, and that they were expecting a child. When the child was born, the men sent to kill it were at first filled with pity and later were unable to find it because Labda had hidden the child in a chest (*kypselos*). Thus the boy Kypselos survived, made himself despot of Corinth, and became a byword for the excesses of a tyrant. Moreover, whatever vicious deeds he had left undone, his son Periander completed (5.92). In this form, the story is a perfect example of X being warned not to let Y live. The Bakchiads had full warning, they had the chance to eliminate Y, but as the historian said, "it was necessary that evils for Corinth should spring from the seed of Eetion."[12] In reporting the Corinthian tradition, Herodotos repeatedly emphasizes the vicious and oppressive rule of the Kypselids, in contrast to his silence about the impact of Peisistratos.

But we can find another parallel, with yet another lion symbol, perhaps closer to the example of Hippokrates and Peisistratos. Herodotos reports that Agariste, the wife of Xanthippos, had a dream that she had given birth to a lion, and a few days later Perikles was born (6.131). In this case, the dream was not a warning but merely an announcement, a prediction that a son with the attributes of a lion—strength, courage, and so on—would be born. We should assume that the source of Agariste's dream was the Alkmeonid family; once Perikles began to make his mark, the story would have been recalled, or improved, or even invented, to make it clear that Perikles was a man of destiny.[13]

It is in the light of this tale that we should consider yet one more origin for the story of Peisistratos's ominous birth. Like the vision of the lion before Perikles' birth, the omen that appeared to Hippokrates at Olympia may originally have been regarded, not as a warning, but as a divine announcement that great things could be expected from him or his progeny. The story has some similarity with that of Perdikkas, the founder of the Makedonian royal house, and his daily ration of bread, which rose twice as much as the other loaves.[14] In both cases, one can see a divine sign involving food that was meant to signal great good fortune for the person receiving it. Thus, the original source for the omen of the boiling cauldron may actually have been Hippokrates himself.

Unless one believes that pots can in fact boil over without fire, one must assume a degree of falsification. The possibilities are endless, beginning with a moderately innocent alibi for a clumsy cooking mistake by Hippokrates' servant ("but I didn't know the fire had caught!") that suggested itself as a divine sign—to complete invention of the whole tale. Whoever interpreted the omen in the original form of the story we shall never know; as we have seen, Chilon could not have been inserted into the story until he had become famous, sometime in the mid sixth century.

Inspiration for the concoction of the omen is not hard to imagine. If Hippokrates had been at Olympia in, say, 605 or so, he would already have been aware of the meteoric rise of Kypselos of Corinth and the oracles that had predicted his birth. That Kypselos had been a cruel ruler to the Corinthians would, to contemporaries, have been of little import compared to his great good fortune in ruling for thirty years and then dying peacefully in old age.[15] By 630 or so, a daughter of the Kypselid family had come to Athens, married the Philaid Agamestor, and produced a son named Kypselos after his famous ancestor.[16] By that time, Hippokrates and everyone else in Athens would have known that, as well as coming from a family foretold by an oracle, the younger Kypselos was already being spoken of as a promising young man—to be elected archon, in fact, in 597/6.[17] In the continuing competition for honor and esteem at Athens, the family of Peisistratos would not have been the only aristocrats to try to find something miraculous about their own sons. This is all conjectural, but the later fame of the Peisistratids for their mastery of oracular literature adds to the probability that they had already been trying their hands at this game for some time.

In considering this story under the heading *Warnings Not Heeded,* I am reminded of another parallel: what might possibly be the most famous Delphic oracle involving Athens that was expressly disregarded.

By the mid fifth century, Athenians were familiar with the legend that their ancient king Aigeus, although married,[18] had been childless and had gone to Delphi to seek advice. The earliest direct evidence for the tale is an Attic RF vase by the Kodros painter showing Aigeus consulting Themis, but the tradition must go back well before the Persian Wars.[19] At Delphi, Aigeus received the famous response cited by many writers, the first extant being Euripides, *Medea* 679, 681:

> Loose not the jutting foot of the wineskin
> Before returning once more to the ancestral hearth.[20]

Aigeus did not understand the response (not the swiftest of the Achaians he) and made a detour to Troizen to seek advice from the wise Pittheus. And there at Troizen, of course, Pittheus heard the response and for whatever motive tricked Aigeus into "loosening the foot of his wineskin" with his daughter Aithra.[21] Theseus was thus born at Troizen and had to grow up

there, be informed by his mother of his real father, and make his famous trip to Athens before he could become a "naturalized" Athenian.

Martin Nilsson once observed that Theseus seems originally to have been a hero not of Athens but of east Attica; he adds that the parentage of Theseus and his birth in Troizen present difficult problems.[22] This is true. One finds it difficult to explain why an Attic hero had to be born across the Saronic gulf in Troizen. But the antiquity of this episode is well established and can be documented earlier than many of the other embellishments of the greater Theseus legend. Theseus's mother Aithra is identified in the *Iliad* (3.144) as one of Helen's servants. Therefore Homer obviously knew how she had gotten to Troy: Theseus had kidnapped the young Helen, concealed her at Aphidna in the care of Aithra; subsequently Helen's brothers, the Dioskouroi, rescued her, captured Aithra at the same time, and made her Helen's handmaiden.[23] The story was known to both literature and art quite soon after Homer's own day (c. 750). The *Iliupersis* mentioned Aithra's rescue after the sack of Troy by Theseus's sons and the same account was known to Alkman at about the same time, namely, the early seventh century,[24] as well as to the painter of a proto-Corinthian aryballos in the Louvre.[25] Theseus's birth at Troizen to Pittheus's daughter Aithra must therefore have been an established legend in the earlier seventh century. No early testimony explains *why* Aigeus made a detour to Troizen but it is quite probable that this detail involving the Delphic oracle was already part of the greater legend; it was at this time that Apollo's priests at Delphi had begun their energetic promotion of the oracle as a necessary precondition for any venture.

In summary, I propose that by the early seventh century, it was generally known in the Greek world that Pandion's son Aigeus had gone to Troizen to have explained an oracle that instructed him not to have sex before he reached his ancestral hearth. But while in Troizen, still not understanding the allegorical terms of the oracle, he had sex with Aithra and later Theseus was born. One can then claim that well before Hippokrates went to Olympia in about 605, Athenians knew that one of their heroes had only been born because a Delphic oracle had been explicitly circumvented.

In the earlier seventh century, Theseus may still have been a rather obscure Attic hero, as Nilsson said. But by the early sixth century, testimonia for the hero and his deeds had begun to accumulate. Peisistratos and his family after him were notoriously eager to associate themselves with the primary figures of popular worship. The best example is the pageant Peisistratos and Megakles devised, using the maiden dressed up as Athena, to glorify his return to power after his first exile.[26] But the Peisistratids seem also to have made every effort to associate themselves with the earlier legends of Theseus.[27] It is in this light that we may connect the oracle to Aigeus and

the omen occurring to Hippokrates. In both cases, a supposed divine injunction advised against the birth of a son:

1. Aigeus was told not to have sexual relations before he returned to the ancestral hearth. Fortunately for the Athenians, the oracle was circumvented, and Theseus was born.
2. Hippokrates saw an omen interpreted to mean that he should not have a son. But he ignored the advice and (luckily for the Athenians, the Peisistratids would say) Peisistratos was born.

One would have to be remarkably ingenuous to reject completely the possibility that the second story was inspired by the first. And to reinforce the inspiration, there was already the example of Kypselos in recent memory: the oracle had warned against his birth—and look how fortunate his family was.

Normally, one would resist the temptation to speculate about the exact occasion when the omen of Peisistratos's birth was first revealed to the Athenian people. But in the spirit of adventurous speculation that has always been such a delightful side of Peter Green's scholarship, I shall venture a few guesses. Chronologically, the first opportunity would have actually been at the scene of the omen at Olympia. As I proposed earlier, the boiling cauldron could have been the exaggeration of a simple cooking mistake by a clumsy servant. But Hippokrates might even have planned the omen from the very beginning and retained a miracle worker (*thaumatopoios*) to make his cauldron boil over through some sleight of hand (anyone who doubts the existence of miracle workers must believe in one of two improbable theories: that miracles actually took place; or that they were all completely invented by storytellers *post eventum*). We all agree that the Greeks, and particularly the archaic Greeks, believed in the usefulness of oracles, dreams, and portents. The Peisistratids were to become masters of oracular prophecy. Anyone could produce a helpful dream, although they were hard to document. Can we doubt that sooner or later someone decided to help along an omen?[28]

And if Hippokrates at Olympia had in fact neglected to manufacture an omen, this was a deficiency that the young Peisistratos would willingly have corrected as soon as he perceived the utility of an ominous birth. Consider the next two events in his life for which we have testimony: he won a crushing victory over the Megarians at Nisaia by use of a clever stratagem,[29] and he tricked the Athenians into allowing him a bodyguard by inflicting wounds upon himself and his mules. Confident that his contemporaries believed his birth had been heralded by a divine sign, Peisistratos had a great advantage over Oidipous: he knew who he was and made the most of it.

NOTES

1. Mimnermos fr. 9 West; Strabo 14.1.4.

2. Dion. Hal. *AR* 3.1.3; Paus. 2.24.7; and see Cadoux's comments in *JHS* 68 (1948): 90.

3. Ἱπποκράτεϊ γὰρ ἐόντι ἰδιώτῃ καὶ θεωρέοντι τὰ Ὀλύμπια τέρας ἐγένετο μέγα. θύσαντος γάρ αὐτοῦ τά ἱρά οἱ λέβητες ἐπεστεῶτες καὶ κρεῶν τε ἐόντες ἔμπλεοι καὶ ὕδατος ἄνευ πυρὸς ἔζεσαν καὶ ὑπερέβαλον. Χίλων δὲ ὁ Λακεδαιμόνιος παρατυχῶν καὶ θεησάμενος τὸ τέρας συνεβούλευε Ἱπποκράτεϊ πρῶτα μὲν γυναῖκα μὴ ἄγεσθαι τεκνοποιὸν ἐς τὰ οἰκία. εἰ δὲ τυγχάνει ἔχων, δεύτερα τὴν γυναῖκα ἐκπέμπειν, καὶ εἴ τις οἱ τυγχάνει ἐὼν παῖς, τοῦτον ἀπείπασθαι. The text is Rosén's Teubner ed.

4. Diog. Laert. 1.68 and two late lexicographers cite Herodotos by name for various parts of this passage.

5. Others will make both participles the indirect object of "by Peisistratos," e.g., "The Attic ethnos was held in subjection and divided into factions by Peisistratos" (Godley, in the Loeb ed.; so also Legrand, in the Budé). But cf. Selincourt (Penguin): "Athens had been split by faction and was now under the dictatorship of Peisistratos"; so also K.-E. Petzold, *RFIC* 118 (1990): 153. As R. McNeal says, the juxtaposition of participles is harsh and has invited emendation, *Herodotus, Book I* (Lanham, Md., 1986) 132 f. See also n. 10 below.

6. *AP* 13.4–5; see the exhaustive analysis by M. Stahl, *Aristokraten und Tyrannen im archaischen Athen* (Stuttgart, 1987), 56–104; representative studies are E. Kluwe, *Klio* 54 (1972): 101–24; R. J. Hopper, *ABSA* 56 (1961): 189–219.

7. For other *terata*, see 6.98, 7.57, 8.37, 8.137.

8. Examples were collected by G. Binder, *Die Aussetzung des Königskindes* (Meisenheim am Glan, 1964), who did not include Peisistratos, evidently because he did not fit the pattern.

9. Chilon's dates: Sosikrates in Diog. Laert. 1.68; 556/5 or 555/4 in *Mar. Par.* A 41; Eusebius variously reports Ol. 56.4–55.3 = 558/7–553/2. His anti-tyrant policy: *P. Rylands* 18, *FGrHist* 105 F 1; other details in Plut. *DHM* 859 CD.

10. B. Lavelle, *The Sorrow and the Pity* (Hist. Einzelschriften 80, 1993), 90–92, believes the whole story to have been an Athenian invention after the downfall of the tyranny to explain the divine purpose of the omen and therefore the inevitability of Peisistratos's tyranny, thus excusing their inaction. This is a convincing reconstruction; I differ only in believing the origin of the story to have been much older; if Solon's charges of Athenian stupidity and cowardice were authentic (frs. 9–11 West; Plut. *Sol.* 30), the Athenians would certainly have been looking for an excuse).

11. Thuc. 6.54.5; *AP* 16. Despite these assessments, R. Crahay, *La littérature oraculaire chez Hérodote* (Paris, 1956), 252 f. offers the standard interpretation that the omen predicted an *enfant fatal* for the people of Athens.

12. ἔδει δὲ ἐκ τοῦ Ἠετίωνος γόνου Κορίνθῳ κακὰ ἀναβλαστεῖν. Binder, *Aussetzung*, 150f.; Lavelle, *Sorrow and the Pity* (cit. n. 10 above), 90.

13. P. Frisch, *Die Träume bei Herodot* (Meisenheim am Glan, 1968), 42–46; P. Stadter, *Commentary on Plutarch's Pericles* (Chapel Hill, N.C., 1989), ad *Per.* 3.3; C. Fornara points out that Herodotos left the meaning of the dream to the inter-

pretation of his audience, *Herodotus* (Oxford, 1971), 53 f.; perhaps the historian intended this ambiguity with Hippokrates' *teras* as well.

14. Hdt. 8.137; this was seen as a close parallel to Hippokrates' cauldrons by W. Aly, *Volksmärcher, Sage, und Novelle bei Herodot und seinen Zeitgenossen* (Göttingen, 1969, orig. 1921), 41.

15. Hdt. 5.92 ζ; it would have been at almost exactly that time that Solon, in one of his poems, claimed that most people would be delighted to become a tyrant, fr. 33.5–7 West (Plut. *Solon* 14.9).

16. Agamestor (Pherekydes in Marc. *vit. Thuc.* 3, *FGrHist* 3 F 2) is not explicitly named as father of Kypselos but on the basis of Hdt. 6.128.2 and the archon date of 597/6 (ML no. 6), this is the usual assumption; see Davies, *APF* 8429 II, V.

17. ML no. 6, a 2; the fundamental discussion was by D. Bradeen in his original publication of the stone, *Hesp.* 32 (1963): 187–208.

18. Euripides, *Medea* 673; his first wives were Melite and Chalkiope, schol. ad loc.; cf. Athen. 556F, Apollod. 3.15.6, who report slightly different names.

19. Beazley, *ARFVP²* 1269 No. 5; the scene is portrayed on the cover of the paperback ed. of J. Fontenrose, *The Delphic Oracle* (Berkeley and Los Angeles, 1981). The connection between Aigeus and Troizen is implied by the refuge provided during the Salamis campaign, Hdt. 8.41, and the Nikagoras decree, Plut. *Them.* 10.5; Frost, *Plutarch's Themistocles* ad loc. I shall not press the restoration of "Pittheus" in the Themistokles decree to make my point.

20. ἀσκοῦ με τὸν προὔχοντα μὴ λῦσαι πόδα . . . πρὶν ἂν πατρῷαν αὖθις ἑστίαν μόλω. A "corrected" version in Delphic hexameters had emerged by the time of Plut. *Thes.* 3.5 and Apollod. 3.207, but there is no real change in meaning.

21. Plut. *Thes.* 3.5; Diod. 4.59.1 is the earliest literary mention of the liaison at Troizen, but fifth-century knowledge of the event is implicit in the plots of the *Medea* and the *Hippolytos*. Theseus is shown finding Aigeus's gifts under the stone, sometimes with Aithra present, on fifth-century RF vases: F. Brommer, *Theseus* (Darmstadt, 1982), 1–2, pls. 18, 44.

22. M. Nilsson, *Cults, Myths, Oracles, and Politics in Ancient Greece* (Lund, 1951), 52 f.

23. Fully recounted by Plut. *Thes.* 31–34. The Homeric scholia to *Il.* 3.144 expel Aithra on chronological grounds, believing she could not still be alive; but Homer cannot be expected to have read Eratosthenes and other Hellenistic chronographers (*Mar. Par.* A 20, 24, e.g., dated the fall of Troy 50 years after Theseus's "synoikismos" of Attica). G. S. Kirk, *The Iliad: A Commentary* I (Cambridge, 1985), ad loc. believes 3.144 to be an Athenian interpolation, but see the next two notes.

24. *Iliupersis* fr. 21 *PMG;* Paus. 10.25.7; schol. A Hom. *Il.* 3.242; cf. schol. Eur. *Troades* 31.

25. Ruth Edwards, in Anne Ward, ed. *The Quest for Theseus* (New York, 1970), 30 f., pls. 33, 34.

26. Hdt. 1.60; *AP* 14.4; W. R. Connor, *JHS* 107 (1987): 40–50.

27. Nilsson, *Cults, Myths,* 55–59; Connor, *Quest for Theseus,* 143–50; H. A. Shapiro, *Art and Cult under the Tyrants in Athens* (Mainz am Rhein, 1989), 148–49.

28. In the spirit of inquiry, I performed the following experiment. I filled a six-quart stew pot with cold water, pieces of beef, and beef bones. I then slipped in

a ten-pound iron sledgehammer head, about the size and shape of a big chunk of meat, which had been lying in glowing coals for an hour. After three seconds the pot began to bubble. A few seconds later, it boiled violently and within ten seconds, it foamed over quite satisfactorily, the albumen from the raw meat making a nice froth. The pot continued to simmer for another ten seconds. Even Chilon would have been impressed.

29. Aineias Tacticus 4.8–12.

Antigone Nodding, Unbowed

Alan L. Boegehold

Actors who played in ancient Greek comedies and tragedies wore masks and costumes that were sometimes long and bulky, and so they could not use winks, smiles, grimaces, and all the other resources of facial expression to say or to reinforce what they wanted. Nonverbal communication was a necessity, and its vocabulary had to be expansive. For those of the audience who sat high in the cavea, a long way from the action, postures and gesticulations had to be large, not delicate and slight. For readers today, the pervasive use of nonverbal communication should be an element of interpretive efforts. When you envision what actors might have been doing with their heads, hands, and torsoes, you find sometimes that seeming puzzles of syntax or motivation are not really puzzles at all. Or at least you may find new possibilities of interpretation. An introduction to ancient postures and gestures can be found in the compendious study of Carl Sittl, *Die Gebärden der Griechen und Römer,* still an important source of examples.[1] A more recent and more tightly focused study is that of Gerhard Neumann, *Gesten und Gebärden in der griechischen Kunst.*[2]

Modern editors and commentators do sometimes note passages in ancient epic, oratory, drama, and dialogue where posture or gesture could have conveyed added meaning, but they are not systematic in their application of such observations. Also, many scholars have more or less completely denied themselves the benefits of these observations. As a consequence, there is a wide world of discoveries to be made in Greek literature, especially that concerning performance. It would be agreeable, when one character speaks of another moving in a certain way, to be able to picture the act. But words are not enough: they do not give the start, speed, direction, duration, and finish of a particular body movement. Scholiasts, principally to Aristophanes, intuit body language on the stage, and they can be explicit.[3]

Pictures on red-figured vases, especially genre scenes, provide tantalizing hints, but again, as is the case with words, they provide only a glimpse.[4] A possible and not yet fully tested line of inquiry is to apply the body language of modern Greeks as heuristic device. Since some of their signifying gestures are the same as those used in antiquity, it is only prudent to ask what use can be made of them.

One such gesture is the combination of head movements that signify Yes and No today, as they did in Homer's time. An illustrative line early on in Sophocles' *Antigone* may show how this source of information can be useful. It is especially appropriate in an essay honoring Peter Green, whose vision of Hellenism is whole, to use the present to illuminate the past.

In Sophocles' *Antigone* at line 384, a very relieved guard brings Antigone before Kreon. He has caught the malefactor, the previously unknown rebel who defied Kreon's edict, and so he is himself exonerated. Antigone stands by as the guard explains to Kreon exactly what happened. When the guard stops talking, Kreon turns in anger and surprise to Antigone. What does he say? σὲ δή, σὲ τὴν νεύουσαν ἐς πέδον κάρα, φής, ἢ καταρνῆι μὴ δεδρακέναι; (line 441). Translators differ among themselves as to single words and phrases here, but the overall sense of their interpretations leads a reader to suppose that Antigone is downcast, frightened, or ashamed of what she has done. Richard Jebb translates: "Thou—thou whose face is bent to earth—dost thou avow, or disavow, this deed?" and then interprets in a note: "Antigone has her eyes bent on the ground: she is neither afraid nor sullen, but feels that Creon and she can never come to terms."[5] Paul Mazon: "Et toi, toi qui restes là, tête basse, avoues-tu ou nies-tu le fait?"[6] E. F. Watling: "You, what do you say—you, hiding your head there?"[7] Elizabeth Wykoff implies a languid Antigone, one faint perhaps with apprehension: "You there, whose head is drooping to the ground, do you say you did, or do you deny you did it?"[8] Peter Arnott sees Antigone as grieving: "You there whose face is bent to the ground."[9]

A paradoxical aspect of such translations is that they present an Antigone whose demeanor (even if only for the moment) is markedly different from that which characterizes her elsewhere in the play. From the very beginning, Antigone as she declares herself to Ismene (lines 1–99) is righteously angry: she could be described as "fierce" and "outraged," but not shamefaced, guilty, or pathetic. For instance, when Ismene urges her to keep her deed hidden and promises not to tell, Antigone says no, announce it to all the world (lines 85–86). Why ever then should she stand with her eyes fixed on the ground,[10] or worse, hiding her head, a way of showing sorrow or shame?[11] Furthermore, when Antigone answers Kreon's question, she says: "I say I did it, and I do not deny it." This is not a frightened, guilty, or shamefaced response. It is that of a bereaved sister, who does not regret what she has done. Consider her very next words, when Kreon asks her if she actually

knew of the edict. She says, "Yes, of course, it was perfectly clear." Again, her forthright answer is consistent with the character and temper of Antigone as she appears in the opening lines of the play.

Sophocles' Greek returns the same unrepentant Antigone, once the implications of a literal translation are faced. Kreon says: "You there, you nodding your head toward the ground, are you saying Yes? Or do you deny that you did it?" That is, the Greek verb νεύω, "nod," tells of motion, and in its present, continuative aspect implies repeated noddings. Translations that have Antigone merely turn her face to the ground render νεύω inert.

The Greek verb ἀνανεύω means to move the head up and back, a gesture of the head that says No. The Greek verb κατανεύω to nod down, means to affirm, to say Yes. From Kreon's words, it is clear that Antigone is nodding down, toward the ground: she is confirming the guard's account: the guard is saying that she is the culprit. Kreon cannot believe his eyes. Here is a blood relation, who very much appears to be a lawfully apprehended lawbreaker. But how can that be? Still, she stands there and says with her posture and gesture. Yes, she did it. Kreon accordingly must ask Antigone to say aloud that she has done it, so that there cannot be any possibility of misunderstanding. This is to make her confession public and official. But then he offers her an escape. She could plead ignorance. But she does not. She asserts once again the passion of her belief. Indeed at line 483, Kreon complains that she exults in her deed and is laughing at having done it (τούτοις ἐπαυχεῖν καὶ δεδρακυῖαν γελᾶν).

In Aristophanes, *Acharnians* at line 115, Dikaiopolis sees that the supposed visitors from Persia are actually Greeks: he has asked them questions which they have answered with uniquely Greek gestures, namely head back to signify No, head forward and down to signify Yes. Ἑλληνικόν γ' ἐπένευσαν ἄνδρες οὑτοιί κοὐκ ἔσθ' ὅπως οὐκ εἰσὶν ἐνθένδ' αὐτόθεν. "These men nodded Greek. No way they're not from here." LSJ[9] cite comparable gestures in Homer, Plato and later authors under the headings νεύω, ἀνανεύω, διανεύω, ἐπινεύω, κατανεύω, and to this day, the same motions of head, neck, and eyebrows remain endemic.[12] A Greek may tilt the head back a little to say No, even when saying οὐχί aloud, or even almost imperceptibly (to a foreigner) lift the eyebrows. A spoken or unspoken Yes can be signed or reinforced with a nod forward and down that goes slightly to one side.

Why have editors and translators not used these widely accessible data as an aid in interpreting Kreon's question at *Antigone*, line 441? It may be that they have been influenced by a similarity to the phraseology of lines 269–70. There, the unhappy guard, in explaining how he was allotted to bring bad news to Kreon, tells of the fellow guard who caused the whole company to nod their heads toward the ground in fear (ὃς πάντας ἐς πέδον κάρα νεῦσαι φόβωι προύτρεψεν). LSJ[9] s.v. νεύω cite Sophocles, *Antigone*, line 270, where νεύω shows fear, adding a reference to line 441 as comparable.

But in their notation, which runs "cf. Sophocles, *Antigone* 441," the abbreviation "cf." should be understood to say "compare and contrast," because if νεύω is to convey a sense of fear, a word for "fear" (like the φόβωι at line 270) is indispensable. A later usage may likewise be instructive: Chairemon of Alexandria (*FGrHist* 618 F2) in describing an Ethiopian sign language has the sign for grief "a man holding his chin and nodding toward the ground" (ἀντὶ λύπης τῆι χειρὶ τὸ γέννειον κρατοῦντα καὶ πρὸς γῆν νεύοντα). Here it is the hand holding the chin that defines exactly how "nodding toward the ground" is to be taken.[13] Again, compare Homer, *Odyssey* 18.237, where the hope is that the suitors will incline their faces toward the ground after they have been overpowered (δεδμημένοι).

Aristophanes, *Wasps*, line 1110 presents a use of νεύω that is suggestive if not so clear: the old heliasts (i.e., chorus of wasps) describe themselves as nodding toward the ground, barely moving, like larvae in their cells" (νεύοντες εἰς τὴν γῆν μόλις ὥσπερ οἱ σκώλακες ἐν τοῖς κυττάροις κινούμενοι). What can this simile be supposed to mean? Larvae do move in their cells, and a beekeeper informs me that they do indeed appear to nod. But what is the relevance of that for old heliasts? Sokrates evokes the "dozing dikast" as if that might be a kind of standard description (νυστάζοντος δικαστοῦ, Plato, *Rep.* 405c5–6), and a universally recognizable signal of drowsiness is nodding. But perhaps Aristophanes has seen aging dikasts nod steadily in affirmation, giving an appearance of listening closely to the arguments.[14]

To return to line 441 of the *Antigone*, once the sense of Antigone's nodding is clear, she can be seen standing before Kreon, not cowering, not fearful, not ashamed, but brave and sure of her place in an ordered universe.[15] The actor who plays Antigone, masked and robed, will have nodded—we can imagine—slowly, majestically, unmistakably while the guard spoke. Kreon in asking what this nodding means directs the audience's attention to Antigone. They turn their eyes from him to her, prepared to see and understand the statement she is making with her head, a solemn and unflinching affirmation.

NOTES

1. Carl Sittl, *Die Gebärden der Griechen und Römer* (Leipzig, 1890).

2. Gerhard Neumann, *Gesten und Gebärden in der griechischen Kunst* (Berlin, 1965).

3. For example, Σ Aristophanes, *Birds* 442: δεικνὺς τὸν πρωκτόν.

4. Neumann, *Gesten und Gebärden*, passim.

5. Richard Jebb, *Sophocles: The Plays and Fragments, Part III* (Cambridge, 1900), 87, 89.

6. *Antigone*, trans. Paul Mazon, in *Sophocle*, vol. 1, ed. Alphonse Dain (Paris, 1955), 88.

7. E. F. Watling, *Sophocles: The Theban Plays* (New York, 1947), 138.

8. *Antigone*, trans. Elizabeth Wykoff, in *The Complete Greek Tragedies: Sophocles*, vol. 1, ed. D. Grene and R. Lattimore (Chicago, 1954), 173.

9. Peter Arnott, *Public Performance in the Greek Theatre* (London and New York, 1989, 1991), 63.

10. Frances Muecke, "Turning Away and Looking Down: Some Gestures in the *Aeneid*," *BICS* 31 (1984): 105–11, cites and discusses passages in Latin and in Greek where someone is indubitably looking down at the ground. None of these employs a form or compound of νεύω.

11. Sorrow: Homer, *Od.* 8.92, κατὰ κρᾶτα καλυψάμενος γοάασκεν. Shame: G. Ferrari, "Figures of Speech: The Picture of Aidos," *Metis* 5 (1990): 185–200.

12. At LSJ⁹ s.v διανεύω; see also Plato, *Republic* 441c4.

13. I owe this reference to Charles Fornara.

14. In his commentary on the *Wasps*, D. MacDowell sees the heliasts as bent over somehow toward the ground (Aristophanes, *Wasps* [Oxford, 1971], 275, ad 1110). Hesiod in *Works and Days* 473 has corn nodding in its fullness (ἁβροσύνηι) toward the ground. LSJ⁹ s.v. νεύω cites Homer, *Iliad* 13.133 where the bunched-up warriors are described variously by modern commentators as looking steadfastly ahead, or peering around shields.

15. A Lucanian nestoris from the early fourth century (BM F175; Lily B. Ghali-Kahil, *Les enlèvements et le retour d'Hélène dans les textes et les documents figurés* [Paris, 1955], vol. 2, pl. 27) shows a scene painted by the Creusa painter in which two guards bring Antigone before Kreon, just the scene apparently of Sophocles, *Antigone* 441. Antigone inclines her head forward: she is nodding, saying Yes. If she were showing shame or guilt or confusion, she would be covering her face with her himation. This should be clear enough, but a convention of the times was for a painter to represent honorable women as looking downward. And so the illustration is ambivalent.

Dionysus or Polemos?

The Double Message of Aristophanes' Acharnians

Richard F. Moorton, Jr.

In the second parabasis of the *Acharnians,* the choregus bans Polemos the war god from his parties, since the god is an unruly guest who quarrels during the singing of the Harmodius hymn and sets fire to the vine-props and pours the wine out of the vines. Later, Dicaeopolis, the champion of peace, is invited by the priest of Dionysus to come to a symposium to feast and sing the Harmodius hymn. In this thematic opposition, Dionysus stands for the joys of peace and Polemos for the rigors of war. Dicaeopolis chooses Dionysus, and over the centuries most readers have assumed that this was the thematic point of the play. The writer of the first hypothesis to Aristophanes' *Peace* believed that the *Acharnians* was a play in which Aristophanes earnestly advocated the seeking of peace with Sparta. This position is shared by most modern critics, editors, and translators of the play, including W. Rennie, W. J. M. Starkie, R. T. Elliott, G. Murray, Douglass Parker, G. E. M. de Ste. Croix, A. Sommerstein, Lowell Edmunds, and D. M. MacDowell.[1] But there have been dissenting views. K. J. Dover, Cedric Whitman, and A. M. Bowie see Dicaeopolis, the comic protagonist, as so blatantly selfish that no one should take seriously the idea that the play harbors any earnest message about peace.[2] Furthermore, W. G. Forrest pointed out that the apparently hawkish message of the parabasis calls into question the alleged peace theme of the play, a point subsequently elaborated by Helene Foley.[3] In the following paper, I attempt to resolve this interpretative opposition by considering the historical context of the play, the case for taking the text of the play as an argument for peace on the terms of lifting the Megarian Decree, and the case for taking the parabasis of the play as an argument for continuing the war if need be to preserve the Athenian *arche,* and finally by asking if the two themes of Dionysus and Polemos are as contradictory as they appear at first inspection to be.

The first question to be asked is whether in the light of the historical context a genuine argument in the *Acharnians* for peace makes any sense at all.[4] A. W. Gomme was a determined opponent of the view that Aristophanes makes definite political recommendations, but he paints a picture of an Athens in 425 in which a recommendation would have a certain situational logic:

> The *Acharnians* was produced early in 425, written therefore in 426—after five and more years of war, marked by the disastrous pestilence, but not by any serious military check for Athens. On the other hand there had been a series of pinpricks in the annual invasions of the country by the Peloponnesians. Just in fact what would keep alive an intense and fiery patriotism in the majority, and make for a conviction that an early peace was necessary in a few. That is the atmosphere which Aristophanes depicts. It is a "probable" picture of Athens at the time.[5]

W. G. Forrest paints a darker picture of the Athenian situation, one so dark that it would in his view have been outright treason for Aristophanes to have recommended peace:

> [The Second World War] was for us, as the Archidamian War was for Athens, a total war; it was also, in its earlier years, as was the Archidamian War until 425, an almost totally unsuccessful war. The long and costly siege of Potidaea, the revolt of Mytilene, the disaster in Aetolia; all this at a distance while the Athenians watched the destruction of their farms and felt the horror of the plague.[6]

Forrest certainly exaggerates the absence of success on the Athenian side of the war. The plague had been a terrible blow, but it was clear by 426 that Athens had survived its worst ravages as a formidable fighting power. The Athenian fleet reigned supreme throughout the Eastern Mediterranean. Athens had enjoyed considerable success in Sicily, including the seizure of Messina in 426 (although it was retaken by the enemy a few months after the production of the *Acharnians*), a major strategic development. The Mytilenean revolt had been put down, with the wholehearted support of some of the allies, including the Methymneans on Lesbos. And Demosthenes and a group of peltasts had in concert with allies inflicted a stunning defeat on the Laconians in Ambracia. Athens's military position in 426–5 was serious but not grave, and it was certainly not desperate. That is to say, the situation was serious enough to permit thoughtful people to wonder about the wisdom of the war without being desperate enough to require suppression of such doubts in the interest of solidarity in the face of disaster.[7]

The following analysis, however, does not assume that many Athenians were contemplating peace in 425 B.C. Donald Kagan rejects the assumptions of Beloch, Busolt, and West that the political balance of power at Athens was at this time swinging to the moderates and peace. For Kagan, the Athenians

continued to elect both radicals and moderates to office with a view towards keeping the war in motion: "As the campaigning season of 425 approached the Athenians continued to seek opportunities, as their means permitted, to damage the enemy and change the course of the war."[8] The fact is that the *Acharnians* presents us with a picture of an Athenian populace set on war, a position I argue the poet invites the audience to reconsider.

There are several reasons for this invitation, but an important basis for the *Acharnians'* call to peace is an economic argument.[9] The Megarian Decree that Dicaeopolis calls upon the Athenians to rescind was an economic measure. It was, to be sure, instituted for reasons of empire, but the *arche* itself existed to augment Athenian glory and prosperity.[10] The market that Dicaeopolis opens after his separate peace with the Spartans and their allies is certainly designed to make an economic point to bolster the argument for peace. War is expensive, and peace is enriching. Xenophon puts the case plainly in *Ways and Means,* written after the Peloponnesian War:

> Again, is any one persuaded that, looking solely to riches and money-making, the state may find war more profitable than peace? If so, I cannot conceive a better method to decide that question than to allow the mind to revert to the past history of the state and to note well the sequence of events. He will discover that in times long gone by during a period of peace vast wealth was stored up in the acropolis, the whole of which was lavishly expended during a subsequent period of war. He will perceive, if he examines closely, that even at the present time we are suffering from its ill effects. Countless sources of revenues have failed, or if they have still flowed in, been lavishly expended on a multiplicity of things. Whereas, now that peace is established by sea, our revenues have expanded and the citizens of Athens have it in their power to turn these to account as they like best.[11]

It was certainly apparent by 425 B.C. that the war was a very expensive proposition for Athens. The yearly Peloponnesian invasions had resulted in burned crops, farms, and villages and ruined vineyards and olive trees. Trade had been disrupted. But above all, the expense of conducting naval warfare and sieges on a large scale was particularly ruinous. Athens began the war with a reserve of 6,000 talents. The early confidence that financial resources would prove more than sufficient was dispelled by the long and expensive siege of Potidaea, which cost at least 2,000 talents. Tribute assessments steadily increased, and in 428 (the year of the revolt of Mytilene) the first of a series of special exactions on the rich, the *eisphorai,* was inaugurated. In 425, the tribute assessment reached more than 1,460 talents. But for all of the increased taxation, the treasury year on year ran in the red throughout the war.[12]

To be sure, different classes had different class interests in the war. Landholders tended to be flexible in dealing with potential opponents, espe-

cially land powers who might ravage their fields, while the lower classes were more hawkish, since they had less to lose. As Pseudo-Xenophon put it:

> If the Athenians ruled the sea as islanders, they were able to do harm, if they wanted to do so, without being injured themselves, as long as they ruled the sea, thus without having their own country devastated and without having to be assailed by the enemies. Now, however, the farmers and the rich people among the Athenians must rather shrink before the enemies, while the people, who know very well that these will neither burn nor ravage anything of theirs, live without concern and without shrinking before the enemy.[13]

In fact, Dicaeopolis makes his address to the angry Acharnians as a landholder speaking to other landholders. Because of their losses in the annual invasions, they are certainly not indulgent of the Spartans, but Dicaeopolis serves (among many other things) as the voice of class interest, reminding them that in the long run, they have more to gain from peace than from war. The lower classes, who were employed as rowers in the fleet, were more likely to look favorably on war, since for Athens this inevitably involved extensive naval deployments in triremes, which the propertied classes were required to outfit. As Aristophanes puts it in the *Ecclesiazusae:*

> Ships must be launched; the poor men all approve,
> The wealthy men and farmers disapprove.[14]

But as Russell Meiggs points out, all Athenians had an interest in the tribute made possible by the naval empire, since "[t]he tribute from the empire directly or indirectly affected the living conditions of most Athenian citizens."[15] In the *Acharnians,* the interests of the naval empire are voiced in the parabasis. The fact that the play gives a sympathetic and affirmative reckoning of the interests of both affluent and more proletarian Athenians may be an important reason why the *Acharnians* both disarmed partisan criticism and won a brilliant victory at the Lenaean festival.

In analyzing the thematic import of the *Acharnians,* critics have paid a great deal of attention to the details of the play. That will not change here. But it is important also to notice certain larger principles implicit in the development of the comedy, some of which have not been sufficiently noticed by its commentators. If we look at political comedy as an attempt at persuasion, or at least an invitation to think about the taking of real decisions in political life, we would do well to look beyond the comic absurdities to underlying appeals to principles that might actually move the body politic to take action in practical deliberations in the assembly. There are such principles latent in the argument of the *Acharnians* for peace, to which I now turn.

We may begin with the name of the protagonist. "Dicaeopolis" is an actual Athenian name of a common type ending in *-polis,* "city." The name has been variously interpreted, but its most likely meaning is "Just City."[16]

The protagonist's name unites the concepts of justice and the city, and it is very unlikely that Aristophanes does not mean to use that fact in this play in some highly significant way. My thesis here is that Dicaeopolis represents not just a comic character but a thought experiment giving Aristophanes' comic version of how the just city would deal with Athens's present impasse. As S. Douglas Olson puts it, "the name Dicaeopolis in *Acharnians* is a comment on the lack of δικαιοσύνη in the old Athens and an intimation of the intended character of the hero's new city."[17]

K. J. Dover would disagree. He argues that Dicaeopolis is an incarnation of hedonistic selfishness, not civic-mindedness:

> It cannot be too strongly emphasized that Dikaiopolis does not concern himself even with the interests of his own city, let alone those of the Greek world; in this respect he is strikingly different from Trygaios in *Peace*. He wants his own comfort and pleasure, and escapes by magical means from his obligations as a citizen subject to the rule of the sovereign assembly and its elected officers.[18]

But this argument does not come to terms with the implications of Dicaeopolis's name, a failure it shares with most of the scholarly cases made for understanding Dicaeopolis as nothing more than a self-centered hedonist. Dicaeopolis never ceases to be a (highly amusing) comic character, but his name suggests that he is also the vehicle for a conceptual exercise, comic to be sure but at least potentially serious in some of its implications, since the relationship between justice and the polis was one of the cardinal concerns of Greek political life and thought. However we explain the function of the chief character's name in this play, we cannot disregard it in attempting to understand the way(s) the comedy means. It is well known that most of the names of Aristophanes' comic heroes are highly significant to the themes of their plays: one thinks of Demos or "Mr. People" in the *Knights;* Philocleon, "Love Cleon," in the *Wasps;* and Lysistrata, the "Disbander of the army," and Praxagora, "She who does business in public," in the *Ecclesiazusae.* Dicaeopolis's name suggests that he has something to do with justice and the city, whether that something is an affirmation or a purposeful travesty, and it is part of the interpreter's task to determine what this relationship might be.[19]

A. M. Bowie has tellingly connected Dicaeopolis's name with the opposition between Just and Unjust Cities in Hesiod:

> *Acharnians* displays affinities with the opposition between the Just and Unjust Cities found in Hesiod's *Works and Days.* . . . If the contrasted worlds of *Acharnians* are less strictly sundered than those of Hesiod, the play works with the same ideas. As in Hesiod's Unjust City, Athens before Dicaeopolis' treaty is a city in which violence is regular, just treatment hard to come by, visitors like the Megarian starving, sexuality disordered and political management in the hands of two classes opposed to mature citizens presumed to be the natural masters—the young and the foreign. In Dicaeopolis' private world, there is

peace and plenty; visitors are, if not exactly given "straight judgments," at least welcomed and to some extent fed, family life is untroubled and sexuality appears more "normal."[20]

Bowie believes that this powerfully developed theme of the Just City of peace in the *Acharnians* is deconstructed by a myriad of details encoded in the social, mythical, and ritual syntax of the play that undermine the admirability of Dicaeopolis and his peace, thus setting up a conflict of thematic tendencies that raises the consciousness of the spectators on the issues of war and peace without presuming to do anything so forthright as giving them advice on the subject.[21] This thesis is crucial to the present inquiry and is examined in some detail in the pages below.

The play opens with Dicaeopolis waiting for the ecclesia to convene so that he can make his case for peace. A great deal has been made of Dicaeopolis's selfishness by critics like Dover who wish to argue that the play contains no political counsel, but MacDowell is surely right to point out that Dicaeopolis first resorts to constitutional means to attain his end.[22] The first person who attempts to speak is "Amphitheus," "Godschild," descended from Demeter and Triptolemus, patrons of agriculture, which has been so devastated by the war.[23] The gods have entrusted him with the making of peace between Sparta and Athens but the prytaneis will give him no travel money and the herald refuses to allow him to speak. Of course, this is a comedy, but the symbolization of this episode is still a potent one in a culture that believed in and worshiped a pantheon of gods: the gods will peace. The strategic location of the episode biases the thematic vector of the play in the direction of peace, a very good reason to believe that the play may possibly contain a serious recommendation that the Athenians make efforts to end the war. At this point and hereafter, we know that in refusing to hear the pleas of Dicaeopolis for peace the Athenian assembly is, in the comic hypothesis, knowingly rejecting the will of the gods.

The rejection of the herald of peace is followed by the assembly's hospitable reception of two embassies that stand for war. The first is a group of Athenian ambassadors escorting an alleged emissary of the great king, Pseudartabas. The ambassadors are satirized as money-grubbing timeservers. They claim that the emissary is promising Persian gold to prosecute the Archidamian War, but when pressed by Dicaeopolis, Pseudartabas in garbled Greek denies that the Athenians will get any gold at all. The Athenians were certainly negotiating with the Persians at the time for support in the war, and the comedy mocks their expectations of material help from that quarter, mockery that history shows was basically well warranted. Eventually, Dicaeopolis unmasks the "eunuch" Pseudartabas as the homosexual sex fiend Cleisthenes. This constitutes a reductio ad absurdum of the idea of Athens prosecuting the war with the help of foreign aid. Pseudartabas is

unmasked as an Athenian sex addict, that is, the hope of Persian aid is only an Athenian delusion—wishful thinking indeed!—masquerading as reality.

At this point Dicaeopolis turns to Amphitheus, who has crept back into the assembly, and gives him the travel money that the city has denied him so that Amphitheus can make a special peace for Dicaeopolis and his family alone. One of the reasons that Forrest and Foley reject the idea that the *Acharnians* is a serious plea for peace is that they refuse to believe that Aristophanes is advocating treason.[24] I would point out that Dicaeopolis should not be taken quite so seriously, nor in quite so literal a fashion. Dicaeopolis's name indicates that he is in one of his dramatic dimensions the incarnation of the just city, and, in fact, at this point in the play, he begins to act as a micropolis, conducting his own foreign policy and establishing his own economic regulations, just like a polis. In fact, this is the essence of the comic thesis. The *Acharnians*, although a rollicking comedy, is also a reflection on the principles of policy, as the rest of the play makes abundantly clear.

Dicaeopolis has already exposed the vanity of Athenian hopes for foreign aid from Persia in the war, a refutation very well grounded in historical reality, since Athens got little help from the Persians throughout the war (Alcibiades' offer to deliver Persian aid was, of course, a will-o'-the-wisp). Now he mocks the Athenian hopes in a foreign alliance when Theorus leads in the Thracian embassy from Sitalces. Historically, this connection also failed, although it was as much due to the Athenian failure to properly cultivate the alliance as to anything else. But more potent in the comic argument is the fact that both the Persians and the Odomantians whom the Athenians seek as allies are barbarians in a war against Greeks. The configuration of both alliance and antagonism is unnatural in the eyes of Greek chauvinism. The point is one that Aristophanes was to make more explicitly in the *Lysistrata* of 411 B.C.

Disgusted by the gullibility of the people and the chicanery of the leadership, Dicaeopolis calls the ecclesia to a halt by declaring that he has discerned an unfavorable omen, a raindrop. This reiterates a thematic point already made: the gods are against deliberations opting for war instead of peace. In perfect continuity with this theme, the god Amphitheus—pursued by warmongering Acharnians—now enters with three treaty samples. Dicaeopolis, of course, chooses the most generous treaty, a thirty years' treaty, not so incidentally the length of the peace treaty that the Spartans and Athenians repudiated at beginning the Archidamian War.

As Dicaeopolis is celebrating his own Dionysia—that is, a religious celebration of peace—he is confronted and accused by the chorus of Acharnians, who charge him with being a traitor because he has made a separate peace with the enemy. It is highly significant that Aristophanes should construct the agon of the play as a debate over the appropriateness of making peace between a protagonist whose name means "Just City" and a chorus

that represents the deme that was by far the largest in the polity of Athens and at the same time most embittered against the Spartans and most keen on continuing the war.[25] As so often in this play, the symbolic structure of events encodes a highly significant political dynamic. Moreover, the incursion is religiously significant, since Dicaeopolis is celebrating the rites of the god who is the play's primary symbol of peace, represented as the will of the gods. These rites have been profaned by the hawkish Acharnians, who are in violation of the will of the gods in their adamant insistence on war.

A. M. Bowie finds a deep significance in the fact that Dicaeopolis was celebrating the Anthesteria:

> This was not a *polis* festival, but was celebrated by individual demes under their demarch. . . . The celebration of this local festival thus marks the start of Dicaeopolis' independence of the city and his separation from his fellow-citizens. The celebration of this Dionysia by one family is highly anomalous, given that it was a public rite expressing the ideology and unity of the deme as a whole. For one family to arrogate the whole festival to itself (as opposed, say, to always supplying the main officials) was a denial of the nature of the festival and an act excluding all others from the rites. Dicaeopolis in effect moves back not just to his deme, but to a deme that has now become his own private kingdom; the Chorus are not invited in and there is no sign of his fellow demesmen. He is a kind of demarch, but one with sovereign powers somewhat wider than that office normally enjoyed.[26]

Bowie is right to see the celebration of this festival as marking the separation of Dicaeopolis from Athens, but in my view he does not go far enough. Dicaeopolis celebrates the Dionysiac festival of his deme because Cholleidae is to the micropolis he has founded what Attica is to Athens. His deme is the territory of his new polity, but since his fellow demesmen have not accepted peace as he has, they have no part in the new order. Thus only Dicaeopolis and his family are represented as celebrating the Anthesteria.

Bowie goes on to remark that "[t]he Anthesteria was a festival of ambiguities, in that it combined the celebration of the opening of the jars of new wine with the presence of ghostly figures in the city; it involved the competitive drinking of good quantities of wine with commemoration of the survival of the flood." Bowie evidently sees the darker elements in this picture as undercutting the positive picture of Dicaeopolis's peace, but they seem to me to support it. The Greek world of this play *is* full of ghosts, the ghosts of the war dead, but Dicaeopolis drinks the wine of peace to exorcise them and to commemorate the survival of the "flood" of misfortune the war has brought. To state these themes baldly might be offensive, but to adumbrate them through the ritual codes of the Anthesteria is the height of artfulness in Aristophanes' paean to peace.

Faced with the angry Acharnian profaners of his Dionysia, Dicaeopolis is prepared to defend his policy at peril of his life. The Acharnians are

reluctant even to hear out the apologia of one who has done so hateful a thing, but Dicaeopolis compels them by taking hostage a bucket of coals, a precious thing to the charcoal-gathering Acharnians. From this point on, the play begins to mimic the Telephus myth, in which the Mysian king Telephus, wounded by Achilles in defending his country and told by an oracle that only the one who has wounded him can cure him, goes to the Greek camp at Aulis in disguise as a beggar, offends the Greeks by speaking in defense of the Trojans, and to protect his life seizes the infant Orestes so that he might have a hearing. To make the parallel unmistakable, Dicaeopolis goes to the house of Euripides to borrow the rags of Telephus from the tragedian's play on the theme. Thus fortified by the seriousness of tragedy, Dicaeopolis prepares to make his defense before the angry Acharnians.[27]

Dicaeopolis here speaks as a citizen to citizens. The Acharnians are incapable of conceiving of Dicaeopolis as a symbolic micropolis, and besides, Aristophanes wishes to use his protagonist to make some pertinent points to his own fellow citizens in the audience. This is why Dicaeopolis makes extraordinary claims about the importance of what he has to say, even if it is said in a comedy:

> Bear me no grudge, spectators, if, a beggar,
> I dare to speak before the Athenian people
> About the city in a comic play.
> For what is true even comedy can tell.
> And I shall utter startling things but true.
>
> (497–501)

These lines claim as plainly as possible that what follows has a serious point, in spite of its being presented in a comedy, and I believe that Forrest is too cavalier in insisting that the sequel is nothing more than a joke for the war weary.

The breaking of the dramatic illusion by the reference to comedy and the following reminder of the prosecution of the poet by Cleon for the *Babylonians* of the previous year make it clear that Aristophanes identifies himself with his protagonist at this moment and arguably throughout the play.[28] The claims for the underlying seriousness of the comic message and the identification of the character with its creator mean that the burden of proof is upon those who deny that Aristophanes is making a kind of enthymemic argument for peace that on one level at least is intended to be real food for thought.

Dicaeopolis makes a point of observing that the play is being presented at the Lenaea, not at the City Dionysia, as was the *Babylonians* of the previous year, at a time of year when foreigners were present and Cleon was consequently able to prosecute the poet for his slandering of the officials of Athens before foreigners.[29] The point is a serious one—Aristophanes means to avoid

another prosecution by stating his comic case in a forum of citizens. In this insistence that no scandal is being given to foreigners, that the speaker as a citizen has a right to raise difficult issues with fellow citizens, and in the subsequent placing of blame for the beginnings of the conflict on just a few Athenians, not the city, Dicaeopolis/Aristophanes shows a kind of prophylactic punctiliousness, even anxiety, which is not entirely a laughing matter:

> Nor now can Cleon slander me because,
> With strangers present, I defame the State.
> 'Tis the Lenaea, and we're all alone;
> No strangers yet have come; nor from the states
> Have yet arrived the tribute and allies.
> We're quite alone, clean-winnowed; for I count
> Our alien residents the civic bran.
> The Lacedaemonians I detest entirely;
> And may Poseidon, Lord of Taenarum,
> Shake all their houses down about their ears;
> For I, like you, have had my vines cut down.
> But after all—for none but friends are here—
> Why the Laconians do we blame for this?
> For men of ours, *I do not say the State,*
> *Remember this, I do not say the State,*
> But worthless fellows of a worthless stamp,
> Ill-coined, ill-minted, spurious little chaps,
> kept on denouncing Megara's little coats.[30]
>
> (502–19; emphasis added)

The *captatio benevolentiae* of the initial snarl at Sparta notwithstanding, Dicaeopolis begins by adopting a daring strategy—he defends the Spartans. Now some might say that he does so only for the sake of the Telephus parody,[31] but it is just as plausible that the Telephus parody has been undertaken to sugarcoat a strategy of making the Athenians think over their reasons for the war in the most amusing and hence disarming way possible. Perhaps a more comprehensive way to view the matter is that the apologia for Sparta and the Telephus parody exist for the sake of one another. Aristophanes in this view of his art is simultaneously comic poet and intellectual provocateur, inciting thought with laughter and laughter with thought.

For Gilbert Murray, it was this extraordinary defense of the Spartans that marks this scene, and this play, as an indubitable plea for peace.[32] Forrest was highly skeptical:

> It is indeed an astonishing scene if the normal interpretation is correct, a fantastic scene, perhaps too fantastic to be true. Were the Greeks so tolerant? And, even if they were, were they also so fair-minded that an audience of average people would not only allow a poet to defend their enemies but would go on to give that poet the first prize for his defense?[33]

If we can show that the audience may have had reason to understand the argument of the play as being based on an appeal to Athenian best interests, then we can well imagine that audience of average people doing just what Forrest describes—even if they disagreed with the political analysis—so long as they felt that the poet had crafted his patriotically intended art surpassingly well.

Dicaepolis traces the beginnings of the war to the activities of sycophants denouncing illegal Megarian imports. To this irritation to the Megarians was added the insult of the theft of a prostitute named Simaetha by some drunk Athenian rakes. Angry, the Megarians stole away two whores of Aspasia's. Infuriated, Pericles retaliated with the Megarian Decree, which led to the war. This has been seen by some as a parody of the beginning of Herodotus's histories, where the reciprocal thefts of women by Greeks and Asians led to the Trojan war,[34] although Charles Fornara has cast doubt on this explanation.[35] Douglas MacDowell, on the other hand, sees in Aristophanes' comic recounting real historical causes of the war, such as Megarian smuggling into Attica and Megarian reception of runaway slaves.[36] This is entirely possible and if true adds force to the notion that there is lurking in the comedy here a serious argument, but there are also other ways to see this beginning as a serious attempt at persuasion by Aristophanes.

For one thing, the Aristophanic parody reminds the audience that in the Athenian deliberations leading up to war, many Athenians questioned whether the Megarian Decree was worth fighting for. By trivializing, or at least satirizing, their inception, Aristophanes raises the issue once again. Moreover, by tracing Pericles' motivation to the influence of Aspasia over the leading Athenian statesman, the comic poet plays a potent card in a sexist society that viewed with real invidiousness the supposed role that the Milesian courtesan had in the policymaking of the Athenian politician almost single-handedly responsible for the war. Moreover, by reminding the Athenians that Pericles was the prime mover of the war, Aristophanes offers him as a kind of scapegoat for the sorrows that the war caused. It's Pericles' fault, he argues, not yours. This factor would make it all the more easy to repudiate the policy, since Pericles was now dead and unable to defend the policy he had instituted. Making a scapegoat of a dead man has a kind of delicious economy that is a powerful instrument of persuasion. And best of all, a dead man can't talk back.

Dicaeopolis must also deal with the anger of the Acharnians against the Spartans for going to war over the Megarians' complaints. He does so by pointing out that if one of the Spartans had stolen a puppy belonging to Seriphus, an Athenian ally, the city would have launched a war fleet of three hundred warships in an uproar. This is a comic way of putting a perfectly serious point. Like Athens, Sparta is a great power, with the responsibilities of a great power. These include the obligation to protect the interests of its

dependents. The Spartans were doing no more than what the Athenians would have done in their place, and as a great power dealing with a great power, the Athenians of all people ought to understand why Sparta acted as it did in such a circumstance. Once again comic discourse conceals a point of considerable cogency.

One half of the chorus is persuaded by Dicaeopolis's case. The other half calls in Lamachus to oppose Dicaeopolis. The symbolism of the names of the debaters is important. Lamachus's name means "Hyperwar" or "Hyper-warrior." So "Hyperwar" debates "Just City" on the justice of a war that the gods wish to end. We may indeed view all of this as a joke, but it is a potent symbolic matrix whose prima facie significance is that the war should be brought to an end. The burden of proof is once more on those who insist that this is not the meaning of the play.

Dicaeopolis gets the better of the comic side of the contest. Lamachus is the butt of all the jokes. The generalissimo's strident militarism is mocked by Dicaeopolis's comic revulsion, carried to the point of physical nausea. When Lamachus attempts to pull rank, contrasting his office of general with the rags of the lowly beggar that he takes Dicaeopolis to be, Dicaeopolis reveals himself as an Athenian citizen who has served honorably in the war, as opposed to Lamachus, a mere mercenary:

An honest townsman, not an office-seekrian,
Since war began, an active-service-seekrian,
But you're, since war began, a full-pay-seekrian.

(595–97)

Lamachus's profiteering is contrasted with the rank and file in the chorus who have served without extraordinary pay. This appeals to the primordial democratic invidiousness against any citizen who violates the basic axiom of equality by rising above his fellows in status or prosperity. But it also draws an important distinction between those who make war for the good of the polis, like Dicaeopolis before he submits to *dike* and the will of the gods, and those who are war lovers for personal gain, like Lamachus and—as Aristophanes is far too diplomatic to say explicitly—the rowers in the fleet. The distinction between personal and public good is an important one for the play. Dicaeopolis seems to betray the public good by making a separate peace, but in fact he incorporates symbolically the most advantageous policy for Athens if it will only become a "just city," and thus is paradoxically revealed as the patriot he claims to be. Lamachus, in supporting the war, seems to be a patriot, but Dicaeopolis reveals him as a self-seeker who supports a flawed policy for personal gain.[37]

Helene Foley observes that when Dicaeopolis/Aristophanes strips off the rags of Telephus, he abandons the role of Telephus. For Foley, the Telephus motif is central to her understanding of how Dicaeopolis/Aristophanes

defends peace with the enemy in a way that is meant to be neither convincing nor ultimately triumphant with the audience. Aristophanes uses the rags of Telephus to dupe the Acharnians, but he confidentially assures the audience that they are too clear-sighted to be taken in.[38] This is an interesting point, but not a decisive one. As war-lovers, the Acharnians are as much butts of comic fun in a peace play as Lamachus the warmonger, but Aristophanes/Dicaeopolis's sly winks to the audience need mean no more than a warning not to be taken in by a cheap costume like those stupid Acharnians, who were also taken in by the theatrical arguments of Pericles to stay the course in an unwise war.

Foley asserts that just as Telephus was revealed by events to be a true Greek, who won glory by leading the Greeks against the Trojans, whom he had previously defended, so is Dicaeopolis/Aristophanes revealed here as a true Athenian, who will be commended in the parabasis as a counselor to lead the Athenians to victory against the Spartans defended by the poet/protagonist in his paratragic rhesis.[39] This is an intriguing understanding of the play, but there are difficulties with it that prove ultimately to be insuperable. For one thing, as Foley herself observes, the case for peace in the play is both strong and seductive.[40] For another, the peace argument can be understood to encode not just Dicaeopolis's personal desires but Aristophanes' understanding of Athenian interests, a possibility Foley neglects. For a third, hostility to Sparta and her allies represents war, not against an alien Asiatic power, but against fellow Hellenes, a striking contradiction to the point of the Telephus myth: Hellenic solidarity against Asia. Finally, as Foley herself observes, by play's end the role of Telephus has been assumed by Lamachus in a way that, as we shall see, supports the theme of peace, not war.

After Dicaeopolis strips off the rags of Telephus, Lamachus responds to his adversary's insults with the declaration that he will make continual war against the Lacedaemonians, while Dicaeopolis announces that he will trade with all of the Peloponnesians, but not with Lamachus, nor, it is implied, any who think like him. This "economic policy" of Dicaeopolis is a kind of inverted Megarian Decree, in which Athens, the instigator of the decree, replaces Megara as the excluded party in the new world of economic peace that Dicaeopolis is creating. The second half of the play is taken up with exploring the implications of this new economic order of peace. Since the Peloponnesian War grew out of an act of economic warfare, the Megarian Decree, it is quite appropriate that the "Peace of Dicaeopolis" should begin with an act of economic rapprochement, his declaration of open markets to all but those who insist on continuing the waste of war. Thus the "market scenes" are an important part of Aristophanes' argument for peace and require careful consideration.

In ll. 719 ff. Dicaeopolis sets down the boundary stones that mark out his

new market outside his house. The conditions of the new market under-score that it is the inverse of the Athenian economic order:

> These are the boundaries of my market-place;
> And here may all the Peloponnesian folk,
> Megarians and Boeotians, freely trade
> Selling to me, but Lamachus may not.
>
> (719–22)

To certify this new order, he sets up a pillar with the terms of his treaty with the Laconians in his marketplace.[41] He thereby mimics not an individual but a state, and must therefore be understood as being not a citizen but a symbolic micropolis, the "Just City" signified by his name. Even the details of this scene stress this symbolic shift from man to city. For example, Dicaeopolis declares in ll. 723–24 that he is establishing three thongs as market wardens (*agoranomous*). When Aristotle comes to discuss those offices most essential to the polis, he begins with the official in charge of the marketplace, whose duties are to supervise contracts and maintain good order (*Politics* 6.8, 1321b4). Thus, even in his jokes, Aristophanes confirms that Dicaeopolis is a kind of comic polis incarnate.

There now enters a Megarian, with his two daughters, come to trade. The Megarian salutes the Athenian market in terms of great warmth:

> Guid day, Athenian market, Megara's luve!
> By Frien'ly Zeus, I've miss't ye like my mither.
>
> (729–30)

There is a certain illogic in this greeting, for in the fantasy of the comedy, Dicaeopolis's micropolitan market is no longer exactly Athenian soil. But the philo-Athenian message, which cannot all be attributed to the hunger of the Megarian, is meant to ingratiate the Megarian to the Athenian audi-ence and to make conceivable the idea of a rapprochement between Megara and Athens.

Some have seen this Megarian and the wretched deal he has come to strike with Dicaeopolis—the exchange of his two daughters, and his wife and mother if need be, for a bunch of garlic and a quart of salt—as an attempt to incite pity in the Athenians for the plight of the Megarians.[42] The Megarian and his daughters are certainly piteous. But they are also an object of comedy, and their wretched state is used to raise a laugh with the Athenians.[43] The fact is that the lowly state to which the Megarians have been reduced is part of the economy of Aristophanes' argument. The war of Athens against Megara has been horrifyingly successful, in this represen-tation. The Megarians are starving. By representing Athenian potency to the audience, Aristophanes appeals to their strength and the security it inspires: you are strong, the argument says—you can afford to relent

precisely because of your power. There is an additional appeal to Athenian greed. When the Athenians do conduct business instead of war with the Megarians in the future, look at what tremendous deals we shall be able to make, dealing as we do from a position of strength.[44]

As Dicaeopolis and the Megarian are concluding their business, a sycophant rushes in to denounce the goods. The irruption is highly symbolic, since in Dicaeopolis's comic aetiology of the war, it all began in the restraint of trade imposed by sycophants: as the Megarian puts it, "here it comes again, / the vera primal source of a' our wae" (820–21). Dicaeopolis runs the informer off, asserting thereby a policy of free trade highly germane to the economy of peace he espouses.

In the next scene a Boeotian comes in to trade, accompanied by a slave, a band of pipers, and a baggage train of all sorts of goods. This scene is not often noticed by those trying to assess the political message of the *Acharnians,* but that seems to me to be a serious oversight. The message of the Megarian's scene, the weakness of the enemy, is here utterly reversed. Megara was a sea power and thus reduced to the point of starvation by the Athenian naval blockade. In Boeotia we see the other side of the coin: the Boeotians are a land power and relatively unaffected by the Athenians' naval superiority. Hence the Boeotian is rich in the produce of the land, pennyroyal, marjoram, rush mats, lamp wicks, ducks, jackdaws, francolins, coots, wrens, dabchicks, geese, hares, foxes, moles, hedgehogs, cats, badgers, martens, otters, and Copaic eels.

Dicaeopolis's extravagant outburst of nostalgia and appetite when the eels are mentioned reminds the Athenians of the other side of the coin of the war. They may deny the Megarians the fruits of commerce, but they themselves suffer economically by being cut off from virtually all domestic, mainland Greek markets. The self-sufficiency of the Boeotians is underscored when Dicaeopolis attempts to trade fish or pottery for the Copaic eels. The Boeotian refuses the trade on the basis that the Boeotians have plenty of fish and pottery. What they don't have at home, it eventuates, is a sycophant, and when the same one who harassed the Megarian now attempts to ruin Dicaeopolis's commerce by denouncing the "illegal" goods, Dicaeopolis offers the parasite in trade. The Boeotian is happy to take this novelty home, and the furiously protesting sycophant is wrapped up in straw like a piece of crockery and taken off by the Boeotian when he returns home. The export of the sycophant from Dicaeopolis's micropolis and Attica is symbolic of the "exorcism" of the primordial evil from which the war began.

Everything about the Megarian betokens scarcity and weakness. But everything about the Boeotian betokens strength and prosperity. The Megarian comes only with his two daughters to trade, but the Boeotian comes with a slave and musicians and a whole market of goods. His mood is hearty and upbeat, and everything about him reminds us that the land power Boeotia

is next door and as dangerous to the Athenians as ever. In the real world the Boeotians were continually raiding Attic territory, a fact brought home to the audience when the Boeotians steal the oxen of the farmer Dercetes later in the play. The comic message is that the Boeotians make bad enemies, but good friends, and it is much wiser to do business with them than to make war on them and suffer the same. Both the scene with the Megarian and the scene with the Boeotian remind the Athenians that the war has severely damaged trade, a serious matter to a maritime nation like Athens. The two scenes give different pictures of the enemy, but Aristophanes uses both pictures to argue for peace. The scene with the Megarian says to the Athenians, "You are strong, and as such you can afford to make peace." The scene with the Boeotians tells them, "The enemy is strong as well, and you would be well advised to make peace." There is also a comic point in the terrible deal the Boeotian makes with Dicaeopolis: the Boeotians are real dummies—the sooner we can begin trading with them, the sooner we can skin them in the transaction.[45]

But the economic argument as advanced by this scene goes even further. It says that war destroys wealth through the constraint of trade and the depletion of wealth caused by expending on armaments money and energy that might go into making more wealth. In peace, through trade, foreigners' wealth becomes your wealth. In war, through predation, your own wealth is ruined.

After the Boeotian deal is concluded, Dicaeopolis is approached by three parties seeking to partake in his peace, Lamachus, Dercetes, and the Groomsman. Lamachus offers a drachma for thrushes for the Pitcher Feast and three drachmas for a Copaic eel. Dicaeopolis scornfully rejects the offer of the Athenian general and sends him word to eat salt fish instead. That is, the leader who chooses war must give up the bounty of peace, in this case, fresh imported animals, and accept the fare of war, old fish preserved with salt.

At this moment the chorus salutes Dicaeopolis as the wise man of peace who was clever enough to reject war and profit from the decision, and it denounces Polemos in the hymn referred to in the beginning of this paper, a transparent rejection of Lamachus the warrior, who is virtually identified with Polemos. Immediately, there follows a stanza in praise of Dicaeopolis and Diallage, "Reconciliation," the patron goddess of this play, just as Dionysus, the deity of the life force, is the tutelary god mentioned with praise again and again. When Dicaeopolis sees Diallage, he prays that Eros might bring them together in marriage, a symbol of the rejuvenation of the old by the blessings of peace.

Dicaeopolis then turns to the roasting of the thrushes he has bought from Boeotia, while the chorus look on enviously. At this point, he is interrupted by another petitioner, Dercetes, who has wept his eyes out over the two oxen that the Boeotians stole away at Phyle on the border between

Attica and Boeotia. Dercetes asks for his eyes to be anointed with peace so that he can see again. This scene is pregnant with meaning. It shows the other side of the peaceful and fruitful relationship with Boeotia that Dicaeopolis enjoys. Because Dercetes has not made peace with the enemy, he must suffer their depredations rather than the access of wealth that comes from peaceful trade with them. It is highly significant that he has gone blind weeping over the losses of war, since his name means "the perceiver" or "the sighted one."[46] Grief over the war has blinded him to reality. It is also significant that he has lost two oxen, which suggests that, just as Lamachus the *strategos* represents the war leadership, Dercetes represents the two hundred medimnoi yoke men, or *zeugetai,* part of the rank and file of the Athenian democracy who have been blinded by war and yet will not do what it takes to end it, that is, vote for peace in the assembly. Dicaeopolis has been faulted for denying the fruits of peace to his fellow citizens, but the point is that he will not, and cannot, make peace for them. They must do it themselves. Moreover, having taken the trouble and risk to make peace in the face of hostility or indifference from his own, he is in a position very like Henny Penny of the children's story, who, having baked corn bread without the help of others, in spite of imploring their assistance, is determined that others will go without a share when it is eaten. In Lamachus and Dercetes, Aristophanes symbolizes the Athenian citizenry who cannot expect to enjoy peace unless they make it.

It is highly significant that Dicaeopolis makes an exception of the bridegroom, who next seeks a ladle of peace so that he can stay and make love to his bride instead of going off to war. In spite of the fact that the groom has generously sent Dicaeopolis a slice of meat from the wedding feast, Dicaeopolis first says no, and on the same principle—the groom bears a part of the responsibility for the war and must make peace before he can have peace. But the farmer's heart is softened when he hears a request from the bride that the groom's phallus stay home for her delectation. Dicaeopolis then confides that he will send a share of peace to her alone, because as a woman *she is not responsible for the war.* This makes it clear that the motivation of Dicaeopolis in this scene is not selfishness but justice. Those responsible for maintaining the war must endure the consequences, while those who do not belong to the war party can enjoy the benefits of peace. Dicaeopolis sends the bride a dram of peace, probably symbolized by a bit of wine, the ecstasy of Dionysus the life god, and instructs the bride to anoint the groom's penis with peace while the city officials are making up the war roster. The symbolism is transparently clear: peace is the balm of life and gives pleasure and fruitfulness.

There is a special point to this part of the play that would not have been lost on the Athenians, although Aristophanes does not overplay his meaning for obvious reasons. The Athenians had lost men in the fighting, but

they had lost far more of their population in the plague that had devastated the city. By some accounts, the Athenians had lost a third of their fighting force,[47] and extrapolated to the city as a whole, the plague had been a disaster for the polis. There was a real need to disperse the rural population being housed in Athens back to the rural districts to eliminate the overcrowding that breeds disease and to replenish the population through the rites of Dionysus and Eros. The *Acharnians* in arguing for peace is making an argument for renewing the life of the city itself. We can be particularly sure that the point of Dicaeopolis's bounty is repopulation, because the petitioners are an Athenian bridegroom and bride, and Athenians understood full well that the predominant purpose of marriage at Athens was not sexual pleasure but the engendering of Athenian citizens.

Immediately after Dicaeopolis sends a dram of peace off to the bride, two messengers rush in. The first summons Lamachus to war, since the enemy is raiding Attica, the hostile counterpoint to the invasion of peace from the Megarian and Boeotian that Dicaeopolis has welcomed into his market. Just as Lamachus is now summoned to face the results of his policy, so is Dicaeopolis, for the second messenger enjoins Dicaeopolis to attend a feast being hosted by the Priest of Dionysus. Lamachus fills his kit with rations, while Dicaeopolis fills his lunchbox with dainties. Point by point, the military equipment of Lamachus is paralleled with implements of pleasure by Dicaeopolis. The point of this comic teaching is that the two men are getting their just deserts, in each case the antipode of what their rival reaps.

This "before" snapshot of peace and war is, after a brief choral interlude,[48] answered by an "after" portrait of Lamachus and Dicaeopolis returning from battle and carousing respectively. Lamachus has been wounded and is brought in by two soldiers. Dicaeopolis is wracked not with pain but with pleasure—he is drunk and supported by two dancing-girls. Lamachus is dizzy, for a stone has hit his head. Dicaeopolis is dizzy too, for the wine has gone to *his* head. Lamachus asks to be carried out to the house of Pittalus, the city physician. Dicaeopolis asks to be borne to the judges, where he will claim victory for his comedy and peace.

It is Helene Foley who points out that by play's end, Lamachus has assumed the role of Telephus abandoned by Dicaeopolis when he stripped off the Euripidean rags:

> The pompous Lamachus, however, whose self-presentation evokes the ethos of epic and tragedy, now suffers the consequences of his chosen style. In an absurd military encounter, Lamachus is lamed like so many Euripidean heroes. The similarity to the fate of Telephus, whom Dionysus punished by shackling him with a vine shoot as he fled from Achilles, is pointed, although the messenger speech describing Lamachus' fall borrows additional tragic pathos by echoing Euripides' dying Hippolytus. Like Telephus, Lamachus is headed not for a tragic demise but a (here unheroic) cure. Telephus was

wounded in the thigh by Achilles; Lamachus, pretending that he was pierced by an enemy spear (1192), receives a less dignified ankle wound.[49]

It is possible to extend this excellent analysis in very interesting ways. It is important to notice exactly *how* Lamachus is wounded. He is pierced by a vine stake, that is, he is wounded by Dionysus, the god of peace, for slighting his worship in favor of Polemos. When wounded, Telephus first sought out conventional physicians, who proved ineffective. He then consulted an oracle, who told him that ὁ τρώσας ἰάσεται: "he who wounded you will cure you."[50] That is, Telephus had to be cured by Achilles; on a symbolic level, Telephus had to be cured by war. But Lamachus has a very different symbolic valence in this play. He has been wounded by Dionysus. He is now seeking out a conventional cure from the public physician, Pittalus, but Pittalus, the physician of war-crazy Athens, will no more be able to cure the symbolic wound of Lamachus the war-lover than he will have proved able to cure the blindness of Dercetes, whom Dicaeopolis sent to Pittalus earlier in the play. Lamachus is Telephus before the oracle, seeking false physicians. In the words of the oracle to Telephus, "he who wounded you will cure you." Lamachus must be healed by Dionysus. "Hyperwar" must submit himself to the god of the life force and peace before he can be cured of the wound the angry god has inflicted upon him.

This is Aristophanes' case for peace. In terms of policy, it recommends a revocation of the Megarian Decree in exchange for the end of the war and the signing of another thirty years' peace treaty to replace the one broken by the outset of the Peloponnesian war. The making of peace is supported by the consideration that there was blame on both sides for the outbreak of the war, that the provocations Athens faced were insufficient for the response of war, that Sparta did what it had to do in going to war, that Pericles had been unduly influenced by private motives, that is, Aspasia's influence, in framing an injudicious policy, that the continuation of the war costs more than it is worth in human and economic terms, and that Athens needs peace to regain its full strength, particularly restored trade, a recovered countryside, and a replenished population. On both superficial and deep levels, the comic art of the play supports this argument for peace.

This is not to say that there are not comic extravagances in the play. Dicaeopolis's victory is depicted as a carnival of concupiscence, but this is a Dionysiac comedy, not a speech by Pericles. Its very carnality functions to strengthen the intellectual case for peace with the power of instinctual drives. Dicaeopolis could be seen as a treacherous citizen were he not a symbolic stalking-horse for Aristophanes' agenda for Athenian policy and were this comedy not a joke—however thought-provoking—between citizens, far from the eyes and ears of strangers. To the natural impulse of everyone in the audience to chuck the damned war and wallow in the pleasures of peace

is added the thought that it might even be the statesmanlike thing to do. The great majority of scholars from antiquity to the present day have assumed that this play is a play for peace. In my view, they are correct.

But that conclusion cannot be accepted without further analysis. Forrest and Foley are quite right to point out that the parabasis of the play, with its jaunty pro-war message, seems to contradict the peace message of the play's plot. The parabasis is by far the strongest argument for Aristophanes' support for the Archidamian War. In its lines the chorus lauds the poet as the key to victory in a transcript of an alleged conversation between a Spartan embassy and the great king of Persia:

> And truly the fame of his prowess, by this,
> has been bruited the universe through,
> When the Sovereign of Persia, desiring to test
> what the end of our warfare will be,
> Inquired of the Spartan ambassadors, first,
> Which nation is queen of the sea,
> And next, which the wonderful Poet has got,
> as its stern and unsparing adviser;
> For those who are lashed by his satire, he said,
> must surely be better and wiser,
> And they'll in the war be the stronger by far,
> enjoying his counsel and skill.
> And therefore the Spartans approach you to-day
> with proffers of Peace and Goodwill,
> Just asking indeed that Aegina ye cede;
> and naught do they care for the isle,
> But you of the Poet who serves you so well
> they fain would despoil and beguile.
> But be *you* on your guard nor surrender the bard;
> for his Art shall be righteous and true.
> Rare blessings and great will he work for the State,
> rare happiness shower upon you;
> Not fawning, or bribing, or striving to cheat
> with an empty unprincipled jest;
> Not seeking your favour to curry or nurse,
> but teaching the things that are best.
>
> (646–58)

This is a fascinating passage whose implications have not been plumbed by commentators. It is certainly impossible to square this passage with the idea that the *Acharnians* is an unconditional call for peace. It affirms the cornerstone of Athenian strategy in the Archidamian War, the naval supremacy of Athens, and seems to call for continued war against the Peloponnesian alliance.

But it is important to notice the structure of the tale. The alleged

conversation takes place at the court of the great king. We know that the Spartans had sent a number of deputations to Persia in the previous years,[51] a diplomatic interest in the Persians certainly shared by the Athenians, as the comic exposure of the Athenian delegation to the great king by Dicaeopolis earlier in the play implies. Both sides sought any possible advantage, but the earlier passage represents the Athenians as seeking gold. Gold has many uses, but none is more important in the present war than maintaining a fleet, the cardinal principle of Athenian strategy. It is hard to believe that the Spartans do not also seek money to strengthen their fleet. The very fact that the great king and the Spartans are represented as talking about naval supremacy in the war is a not entirely amusing reminder to the Athenians that the Persians had the means to alter the balance of power at sea, and in fact the Spartans ultimately ended the war by a victory over the Athenian fleet aided by Persian gold.[52] Naval supremacy is by far a more substantive Athenian advantage than the possession of Aristophanes, in the real world, at least.

Because the Athenians have these two decisive advantages, the chorus goes on, they should not give back Aegina, which the Spartans demand as a condition of peace, since to do so would be to surrender one of their great assets, Aristophanes. This has commonly been taken by commentators through the ages to mean that Aristophanes (or Callistratus) had property on Aegina, perhaps as a cleruch. Sommerstein finds no evidence to support this speculation,[53] but what is important is that the parabasis connects the poet—whether the audience understood him to be Aristophanes or Callistratus—with Aegina. It is worth recalling here something about the history of Aegina. Athens's relations with Aegina serve as a kind of index to her ascendancy as a great power.

When Athens faced Spartan enmity for the institution of the Cleisthenic democracy in 506 B.C., the Aeginetans joined in an alliance with Boeotia and Sparta against the city of Athena. Aegina plundered Phalerum and the Attic coast with her fleet. Athens treated with Persia for an alliance but broke off negotiations when the Persians demanded the restoration of Hippias as a precondition for help. Operating as an independent democracy in the decades that followed, Athens found itself again at war with Aegina in the first Peloponnesian War. The Athenians invaded Aegina and invested the capital in 458, and Sparta and its allies proved unable to force the Athenians to lift the siege. In 457, Athens reduced Aegina and forced the Aeginetans to join the Athenian alliance and become tributaries of Athens. At the end of the war in the winter of 446–445, the Thirty Years' Treaty did not relieve Aegina of its tributary status, but Athens gave the Aeginetans a guarantee of autonomy. When the Lacedaemonians and their allies considered renewing the war against Athens in a council in 432, the Aeginetans sent deputies who secretly complained about the Athenian violations of their autonomy. After war broke out, the Aeginetans were deported from

their own land and the island was settled by Athenian cleruchs. Sparta settled the exiled Aeginetans in the Peloponnesus. To the bitter disappointment of many of Sparta's allies, Aegina was left in Athenian hands under the terms of the peace of Nicias. Not until the Spartans destroyed the Athenian fleet at Aegospotomi in 405 was Aegina returned to its dispossessed people.

For good reason the Athenians considered the possession of Aegina to be vital to their naval supremacy and their hegemony over the *arche*. That is why the island was not set free until the Athenians had no choice in the matter. By imploring the Athenians not to give back the island, even to get peace, lest they lose Aristophanes, the poet was affirming his support of the naval empire of Athens, both because it was essential to Athenian naval preeminence and perhaps because he had a stake in the spoils. If war was the price that had to be paid to keep Aegina, then let there be war.[54]

How can this affirmation of the empire and the war waged to keep it be squared with the call for peace in the text of the play? In my view, critics would be wise not to insist on using either message to trump the other. In fact, the two positions are not incompatible. Taken together, the plot and the parabasis can be understood as arguing for either Dionysus, peace, or Polemos, war, depending upon the circumstances. If the Spartans will be satisfied with the repeal of the Megarian Decree, a measure whose savage impact on Megara had already made an important point about Athenian power and that could be reinstituted with ease whenever necessary, then let there be peace. Any damned fool (but not Lamachus!) knows enough to prefer peace to war, when the terms are not dishonorable. But if the Spartans, motivated by the fear of Athenian power to which Thucydides attributed their entry into the war, should really hold out for the liberation of Aegina, that would be tantamount to demanding the abdication of the Athenian *arche*, entirely too high a price for a patriot like Aristophanes to accept. Tiny Megara is not worth a war. Strategic Aegina is. The implication of the *Acharnians* is that the Athenians should chose the pleasures of peace or the rigors of war as their best interests dictate. On the grounds of this rollicking but practicable comic counsel, Aristophanes commends himself to the Athenians as a precious resource because he is the poet who does not flatter them but recommends to them the things that are best.

We may ask how such a double strategy might have been implemented. In 430 B.C., the Athenians, exasperated with the ravages of the plague and their failure to take Potidaea or inflict significant damage during their raids on the Peloponnesus, sent ambassadors to Sparta to ask for peace.[55] But the Athenians were dealing from weakness, and the Spartans did not offer acceptable terms. In fact, it is to these negotiations that Donald Kagan dates the Spartan offer of peace in return for Aegina to which Aristophanes refers in the parabasis of the *Acharnians*.[56] Aristophanes might have hoped for a renewal of peace negotiations with the Athenians in a stronger position

than before. They had weathered the plague and inflicted significant reversals on the Spartans in Ambracia and Sicily. Moreover, Thucydides tells us that when the war began, the Peloponnesians did not expect the Athenians to hold out for more than one, or two, or three years at the most.[57] By holding out for six, the Athenians will have significantly dampened Peloponnesian hopes for victory. The Spartans had proved themselves uninspired leaders, missing more than one chance to damage the Athenians seriously. By offering to rescind the Megarian Decree the Athenians would have offered the Spartans the removal of what the Spartans had said was the chief reason for the war. They would also have appealed to the Megarians, who were suffering terribly under the blockade. Moreover, Megara in 425 was governed by a democracy, which might have responded favorably to a peace appeal from Athens.[58] But under no circumstances would Aegina be surrendered. By keeping the island, the Athenians would come out of the war in one critical respect stronger strategically than when they entered it. By acquiescing in their possession of Aegina, the Spartans would be de facto recognizing the permanence of the Athenian *arche,* one of Pericles' original goals in steering Athens into the war. The Spartans would thereby be weakened in their own alliance and thus less able to threaten Athens in the postwar period. It is interesting to notice how these terms compare with the treaty actually concluded in the peace of Nicias. There, the Spartans, eager to get back Pylos and the captive Spartiates, accepted a treaty that did not even mention the Megarian Decree and left Athens in possession of Aegina. The policy that I think Aristophanes is suggesting in the *Acharnians* is more moderate, but the Athenians and Spartans were on a more even footing in 425 than in 421. The comic counselor did not persuade his fellow citizens to offer peace, but his advice was honestly if hilariously offered, and he took away the acclamation of his polis and the first prize in the Lenaean contest.

In conclusion, the *Acharnians* can be viewed as an attempt by a citizen poet to prepare the minds of his fellow citizens for the negotiated end to a costly and indecisive war in which a total victory seems too difficult and risky to attain. This is, arguably, a civic act. It recognizes that in any peace on terms, there must be give and take. Aristophanes is prepared in principle to give, particularly to rescind the act that for the Spartans was the major cause of the war, the Megarian Decree. But Aristophanes is part of an undoubtedly widespread Athenian consensus in being unwilling to trade the *arche* for peace. If the Spartans set conditions tantamount to the end of the Athenian empire as the cost of peace, then the price is too high, and peace can wait.

NOTES

It is a privilege and a pleasure to dedicate this essay to Peter Green, an extraordinary mentor.

1. W. Rennie, *The Acharnians of Aristophanes* (London, 1909); W. J. M. Starkie, *The Acharnians of Aristophanes* (London, 1909); Richard T. Elliott, *The Acharnians of Aristophanes* (Oxford, 1914); Gilbert Murray, *Aristophanes: A Study* (Oxford, 1933); Douglass Parker, trans., *The Acharnians* (Ann Arbor, Mich., 1961); G. E. M. de Ste Croix, *The Origins of the Peloponnesian War* (Ithaca, N.Y., 1972), 363–67; Alan H. Sommerstein, *The Comedies of Aristophanes*: vol. 1, *The Acharnians* (Warminster, Wilts., Eng., 1980); Lowell Edmunds, "Aristophanes' *Acharnians*," *YCS* 26 (1980): 1–41; D. M. MacDowell, "The Nature of Aristophanes' *AKHARNIANS*," *G&R*, n.s., 30 (1983): 143–62.

2. K. J. Dover, *Aristophanic Comedy* (Berkeley and Los Angeles, 1972), 87; Cedric Whitman, *Aristophanes and the Comic Hero* (Cambridge, Mass., 1964), 78–80; A. M. Bowie, "The Parabasis in Aristophanes: Prolegomena, *Acharnians*," *CQ*, n.s., 32 (1982): 27–40.

3. W. G. Forrest, "Aristophanes' *Acharnians*," *Phoenix* 17 (1963): 1–12; Helene Foley, "Tragedy and Politics in Aristophanes' *Acharnians*," *JHS* 108 (1988): 33–47.

4. Dover (*Aristophanic Comedy*, 84–85) stresses the fact that war was a normal part of Greek life. But he admits that on the whole, the Greeks considered peace more enjoyable than war. Furthermore, on the terms of the evidence that he presents, we can argue that the corollary of the fact that the Greeks frequently went to war is that they frequently made peace.

5. A. W. Gomme, "Aristophanes and Politics," 85, in *More Essays in Greek History and Literature* (Oxford, 1962).

6. W. G. Forrest, "Aristophanes' *Acharnians*," 2.

7. For Forrest, the point of the *Acharnians* is pure escapism. To make his case, he compares the play with Compton Mackenzie's *Whiskey Galore*, in which the island people of Great and Little Toddy find a private supply of whiskey and abandon military watchfulness in favor of inebriation, to the exasperation of that neo-Lamachus, Captain Waggett. For either MacKenzie or Aristophanes to have written such works for any reason other than escapist levity to relieve the horrors of war must have been treason, in Forrest's view ("Aristophanes' *Acharnians*," 4–6). I would answer that if Aristophanes commends peace through a protagonist who can be understood as an encrypted comic symbol of Athens's pursuing its own best interests, then Forrest's case falls to the ground.

8. Donald Kagan, *The Archidamian War* (Ithaca, N.Y., 1974), 218 and n. 1.

9. For an important study of Dicaeopolis's separate peace as prompted by economic motives, see S. Douglas Olson, "Dicaeopolis' Motivations in Aristophanes' *Acharnians*," *JHS* 111 (1991): 200–203.

10. I do not say that these were the *only* reasons for the *arche*. An aboriginal reason for the founding of the League of Delos was to keep the Persians in check, and I for one do not believe that this objective had faded from the minds of Athenian statesmen during the Archidamian War. But I am not convinced that Pericles supported the Megarian Decree even to the point of war just to keep the Persians out of the Aegean.

11. *Ways and Means* 5.10–12, tr. H. G. Dakyns, in *The Works of Xenophon*, vol. 2 (London and New York, 1892), 347–48.

12. For a detailed picture of the finances of the war with close attention to sources, see Russell Meiggs, *The Athenian Empire* (Oxford, 1972), 306–39.

13. Pseudo-Xenophon, 2.14, tr. Neils Heislund and Hartvig Frisch, in Hartvig Frisch, ed., *The Constitution of the Athenians* (New York, 1976), 27.

14. *Ecclesiazusae* 197–98. Unless otherwise noted, all translations from Aristophanes in this chapter are from the classic rendering of Benjamin Bickley Rogers.

15. Meiggs, *Athenian Empire,* 260.

16. On the meaning of the name "Dicaeopolis," see Lowell Edmunds, "Aristophanes' *Acharnians,*" *YCS 26* (1980): 1 n. 2. Edmunds rightly argues that the name cannot mean "Just *Citizen.*" Edmunds explains the meaning of Dicaeopolis as meaning "he of the just city," but he calls the character "Just City" in his article, and I think that his instinct is correct. The meaning of *polis* is "city-state." In view of personal names like Nicopolis and Eupolis, scholars have translated *-polis* as "he of the —city," but the primary meaning of *polis* is a Greek polity, and in this play I think we have strong reason to believe that the aboriginal significance of the stem comes to the fore. On the general subject of names in Aristophanes, see S. Douglas Olson, "Names and Naming in Aristophanic Comedy," *CQ,* n.s., 42 (1992): 304–19.

17. Olson, "Names and Naming in Aristophanic Comedy," 307.

18. Dover, *Aristophanic Comedy,* 87.

19. In "Nature of Aristophanes' *AKHARNIANS,*" D. MacDowell has less confidence in the significance of Dicaeopolis's name. As he turns to the analysis of the play, he remarks: "The play begins with the appearance of the chief character on his own. His name, Dikaiopolis, is not given to the audience until much later (line 406). So nothing in the earlier scenes can possibly depend for its interpretation on the meaning of the name, and at this stage we need not consider what the name means, or take any notice of it" (144–45). I can only say that this represents a rather parsimonious interpretive position. Every part of a performance illuminates every other, and when the audience learn in the scene at Euripides' house that the protagonist's name is "Dicaeopolis," they are clearly being invited to amplify and alter their understanding of what has gone before.

It is worth noting that there is nothing unusual in the disclosure of the protagonist's name hundreds of lines into the text of the *Acharnians.* In "Names and Naming in Aristophanic Comedy," Olson points out that "[o]n average . . . heroes and heroines in the extant comedies are anonymous for about 383 lines" (307). He also points out that protagonists often first reveal their names when approaching a residence (308), as Dicaeopolis does when he visits the house of Euripides.

20. A. M. Bowie, *Aristophanes: Myth, Ritual and Comedy* (Cambridge, 1993), 19. See also 24 with n. 29.

21. Ibid., 27–44. Bowie's study is rich and stimulating, but in my view, it overestimates the negative elements in Aristophanes' picture of Dicaeopolis.

22. MacDowell, "Nature of Aristophanes' *AKHARNIANS,*" 147–48.

23. On the historicity of the name "Amphitheus" and the doubtful utility of elaborate interpretations based on this fact, see Sommerstein, *Acharnians,* 160, ad 45. The translation "Godschild" is from Sommerstein's translation.

24. Forrest, "Aristophanes' *Acharnians,*" 5; H. Foley, "Tragedy and Politics in Aristophanes' *Acharnians,*" 38.

25. Technically, Dicaeopolis's apology scene is not an agon, but it serves an analogous function in the *Acharnians.* For the enmity of the Acharnians against the Spartans, see esp. Thuc. 2.21–22.

26. Bowie, *Aristophanes: Myth, Ritual and Comedy,* 35–36.

27. For an interesting view of how Aristophanes seeks to appropriate the moral prestige of tragedy for comedy through his use of Euripidean motifs, see Foley, "Tragedy and Politics in Aristophanes' *Acharnians,*" passim.

28. It is worth bringing up the old problem of whether the audience would have understood this identification between Dicaeopolis and the poet as one with Aristophanes or with Callistratus, the official producer or "didaskalos" for both the *Babylonians* and the *Acharnians,* a position often but not always undertaken by the author of the script. My own view is that the audience understood that Aristophanes, not Callistratus, had written both plays, but if they took the poet of the *Acharnians* to be Callistratus, the case for the *Acharnians* as a peace play is still intact, mutatis mutandis. For a recent overview of the question with a bibliography of earlier work, see D. MacDowell, "Aristophanes and Kallistratos," *CQ,* n.s., 32 (1982): 21–26; see also Foley, "Tragedy and Politics in Aristophanes' *Acharnians,*" 33 n. 4, and Niall W. Slater, "Aristophanes' Apprenticeship Again," *GRBS* 30 (1989): 67–82.

E. L. Bowie has argued that Dicaeopolis is to be identified with Eupolis ("Who is Dicaeopolis?" *JHS* 108 [1988]: 183–85.) This interpretation has been persuasively refuted by L. P. E. Parker in "Eupolis or Dicaeopolis?" *JHS* 111 (1991): 203–8.

29. On the historicity of Cleon's prosecution of Aristophanes, see J. E. Atkinson, "Curbing the Comedians: Cleon versus Aristophanes and Syracosius' Decree," *CQ,* n.s., 42 (1992): 56–64.

30. Foley argues ("Tragedy and Politics in Aristophanes' *Acharnians,*" 33) that in making a separate peace with Sparta and in defending the enemy in his speech before the chorus, Dicaeopolis "commits 'crimes' equivalent to those for which Aristophanes was indicted" in the prosecution for his "slander" of the Boule and Demos in the *Babylonians* of the previous year. This leads her to make the somewhat peculiar argument that in the *Acharnians,* Aristophanes defends his own patriotism by advocating treason, which is repudiated by the logic of the Telephus myth. It seems more natural to me to conclude that in the figure of Dicaeopolis, Aristophanes is attempting to frame in a comic way an alternative policy to that practiced by the polis, one based on Aristophanes' view of Athens' best interests. The fact that the Athenians are convened at the Lenaea, when no strangers are present, means that the poet is at liberty to frame his criticism of current policy and his comic picture of dissent from that policy with a certain audacity that would be inappropriate if he were "airing dirty linen in public" at the Dionysia.

31. In fact, Forrest says just this in "Aristophanes' *Acharnians,*" 7. For a very useful review of the Telephus myth and its use in the *Telephus* of Euripides and Aristophanes' *Acharnians,* see Foley, "Tragedy and Politics in Aristophanes' *Acharnians,*" passim. My most important reservations about her conclusions for Aristophanes are stated in the text of this chapter.

32. Murray, *Aristophanes,* 32.

33. Forrest, "Aristophanes' *Acharnians,*" 6–7.

34. E.g., ibid., 8. Forrest thinks that the element of literary parody of Herodotus and Euripides is the raison d'être of the whole peace argument of Dicaeopolis. But it is impossible to demonstrate without reference to other considerations whether the peace theme exists for the parody or the parody for the peace theme, and I have suggested on the basis of such additional considerations, especially the idea that the

plea for peace can be understood as based on Athenian economic interest, that the theme and the parody exist for one another.

35. Charles Fornara, "Evidence for the Date of Herodotus' Publication," *JHS* 91 (1971): 25–34.

36. MacDowell, "Nature of Aristophanes' *AKHARNIANS*," 151–54.

37. Lamachus in this play is more a symbol than an object of vicious personal satire. He is chosen for the role because of his name and the fact that as a man of moderate means he found the stipend of the *strategos* more compelling than did his wealthier colleagues.

38. Foley, "Tragedy and Politics in Aristophanes' *Acharnians*," 38–41.

39. Ibid., 37.

40. Ibid., 37, 46.

41. A. M. Bowie observes that Dicaeopolis is setting up his market to parallel the Athenian agora, a polis center, and setting up stelae marking the peace treaties as poleis do, but he does not seem to draw the connection that in so doing, Dicaeopolis is, *ex nomine et hypothesi,* acting as a polis, not an individual. Thus when Bowie observes that "it was sufficiently intolerable for an individual to make a separate peace for Plato to recommend the death-penalty for it," we must reply that Dicaeopolis is functioning as a polity not a person and new rules apply, since poleis are sovereign and act as their interests dictate (*Aristophanes: Myth, Ritual, and Comedy,* 32).

42. E.g., Murray, *Aristophanes,* 36.

43. In *Aristophanes: Myth, Ritual, and Comedy* (33), Bowie is understandably aghast at the sale of his own daughters by a father, but the sale is arguably a kindness, since at Athens the daughters will be fed, as opposed to starving with their father in Megara (cf. *Acharnians* 734–35: the girls choose being sold rather than starvation). Similarly, Bowie sees dark hints in the fact that the girls are described by their father as Mystery pigs, since the Mystae sacrificed these pigs to purify themselves, but it is perfectly clear from the Megarian father's assertion that these "pigs" are for sacrifice to Aphrodite alone of all the gods (*Acharnians* 792, 794) that the blood shed at their "sacrifice" is the blood of defloration, not ritual slaughter. I recognize that this is quite brutal enough for modern moral convictions, but for a Greek audience, and even for us, the shadows in the reference to the "Mystery pigs" are not as dark as Bowie paints them.

44. This is my answer to Forrest, who cannot understand how Aristophanes' Schadenfreude vis-à-vis the Megarians can function in a play appealing for peace ("Aristophanes' *Acharnians*," 6).

45. Olson argues in "Dicaeopolis' Motivations in Aristophanes' *Acharnians*" that Dicaeopolis conducts his market with barter rather than money because Aristophanes wishes to glorify the barter economy of the country rather than the money-based exchange of the city. For me, the Aristophanic point is more likely to be the comic illustration of the terrible bargaining positions of the Megarians and the Boeotians (the Megarians being hard-pressed and the Boeotians thick-headed), thereby giving the poet's argument for peace an added comic force. With trading partners like this, the Athenians can replenish their war losses in no time.

46. Sommerstein points out (*Acharnians,* 206, ad 1028) that Dercetes of the deme of Phyle appears to have been a real person. Cf. *IG* ii² 75.7 and 1698.6. I would

maintain that like Lamachus and Amphitheus, Dercetes appears as a character in this drama because of the thematic significance of his name, although his real-life identity may have given his appearance an additional import now unrecoverable (cf. Lamachus).

47. For an overview of the sources and their interpretations, see Barry Strauss, *Athens after the Peloponnesian War* (Ithaca, N.Y., 1987), 75–77.

48. In this choral passage, the chorus hopes that Orestes the highwayman will brain the cheap choregus who did not provide them with a supper for the Lenaea; A. M. Bowie speculates that since in the mythology of the Anthesteria, on the day of the Choes (which Dicaeopolis is celebrating), the epic hero Orestes came to King Demophon to be purified for killing his mother, we are being invited to connect the myth with the play in some way (*Aristophanes: Myth, Ritual and Tragedy*, 36–38). Bowie does this by comparing Demophon's treatment of Orestes with Dicaeopolis's treatment of Lamachus. It is hard to see why we should take the step of paralleling Lamachus with Orestes. Why must we go beyond what Aristophanes gives us, a comic comparison between Orestes killing his adulterous mother and a highwayman braining a stingy choregus? Both should be purified, because the ones they did in had it coming! In a topical comedy, this is grounds enough for the allusion.

49. Foley, "Tragedy and Politics in Aristophanes' *Acharnians*," 39.

50. Cf. Eustathius, *Commentary on Homer's Iliad*, ad *Il.* 1.60.

51. For the Spartan embassies, see Thuc. 4.50.2–3.

52. It is worth remembering that Alcibiades won a temporary reconciliation with Athens by promising to swing the great king's support to the Athenian side, as Thucydides tells us in 8.53 ff. But it is also useful to remember that Alcibiades had counseled Tissaphernes to wear out the two sides against one another (Thuc. 8.46), a strategy obviously in the best interest of the Persians, as Aristophanes' picture of the great king playing on the greed of the Athenians and the fears of the Spartans implies.

53. Sommerstein, *Acharnians*, 189 ad 654.

54. Thomas Hubbard (*The Mask of Comedy: Aristophanes and the Intertextual Parabasis* [Ithaca, N.Y., 1991], 52) puts it well: "Critical of the city's policies in the war, the poet nonetheless shows here that he is not a pacifist who advocates peace at any price; nor does his critique of the city's policies indicate any disloyalty to Athens. He views his role not as revolutionary, but as didactic."

55. Thuc. 2.59.2, 2.65.2. See also Diod. 12.45.5.

56. Kagan, *The Archidamian War*, 82–83.

57. Thuc. 7.28.3.

58. The Megarian rank and file may well have hated the Athenians, who after all had caused their polis immense suffering. But there is reason to believe that the democratic leadership at Megara may have had some sympathy with the Athenian democracy. Not long after the production of the *Acharnians*, in 424 B.C., the Megarian democrats attempted to hand Megara over to the Athenians, an attempt foiled by Brasidas. See Thuc. 4.66–74.

Athenian Democracy and the Idea of Stability

Alan Samuel

Peter Green is a student of antiquity very much concerned with social and political problems of our own day, and I have, therefore, chosen the influence of ideas over politics as the theme of this essay. The ideas I examine here are not, however, the openly stated maxims of philosophers, politicians, and historians, but the tacit assumptions that influence more explicit statements. Underlying assumptions about the nature of people and their societies have fundamental effects on the political decisions people make, and the clarification of those assumptions and the delineations of their effects, in antiquity and in the present, can, I believe, help us in formulating our own political and social decisions.

When I first came to Toronto just after the middle of the 1960s, the city was overflowing with optimism. There were, on the horizon, not only the celebrations of the centennial year for all of Canada, but in Toronto, great struggles for control over development, focused on the architectural and artistic heritage of the city, with a successful battle to preserve the Old City Hall and a fight to prevent the use of an apartment building just constructed in one of the few green areas of the city. Both fights were won by the protesting populace: Old City Hall still stands, and the apartment house, which never was occupied, stood empty for years until it was finally torn down. Art, in a way, was directing life.

It was in this atmosphere that I found myself involved in city politics, concerned with issues of urban renewal, and, eventually, straight electoral politics aiming at reform of the Toronto city council, which was then, and is now, "the regulatory agency for the development industry," as the political writer James Lorimer once put it. In those days, the early 1970s now, one of the slogans of reformers was "Small is beautiful," and the arguments of the Club of Rome had been carried forward to the elaboration of a no-growth

doctrine—a doctrine applied as much to macroeconomics as to the issues of urban development. The report of the Club of Rome, a document purporting to have the authority of "Science," began to mold opinions and then events.

My thoughts about antiquity were not untouched by all this, naturally, and it was, I think, the mid 1970s when I delivered a lecture at Toronto's University College arguing that our understanding of Greek economics and Greek economic thought was skewed by our own growth-oriented economic aims: Greeks, unlike us, aimed at a stable economy, not a growing one, and when that is understood, a lot of political writing can be comprehended as dealing with means to achieve that objective economically as well as politically. Naturally, I saw that Greek goal of stability as a good thing, possibly a historical precedent for what we should be trying to achieve in our own system. I proceeded to write a book on the subject, aiming, perhaps, at being a theoretician for the urban nondevelopment movement. But by the time I finished my book, I had felt the rude shocks the world experienced in the late 1970s and early 1980s. There was the economic disruption generated by the jump in world oil prices, which came in part as a response to the Club of Rome's notions of limits on growth and resources—a classic case of life following art, if the Club of Rome's report can be called art. Then the serious setback of the recession of the early 1980s cut heavily into the prosperity of Western nations. So, by the time the book appeared, I was feeling some doubts about the virtues of the no-growth ethic, and by the end of the 1980s, I had reversed my views completely. The disparagement of growth, it now seemed to me, was the ideology of the prosperous, the "I got mine" people of Sanibel Island, Florida, who, ensconced in their new condominiums, opposed all proposals for new building. "No growth," I now thought, condemned the majority of humanity, from the poor of Toronto's downtown to the rural farmers of the third world, to a permanent state of poverty as an underclass.

If history can be called an art form used to comment on the present, as I have referred to it from time to time, my own views of the present and my interpretations of the past show how life and art interact. From an acute sensitivity to the problems—ecological, economic, political, and social—generated by the devotion to growth, I shifted to an awareness of the difficulties confronted by a society that not only achieves stability but has no options but stability. The frame of mind that made Greek thinkers and politicians so dedicated to social and economic stability precluded them from developing structures that could generate growth. So, even when "more" was needed, it could not be achieved by a genuine economic growth—that is, the production of more goods or wealth on the same base. People did not seek growth and did not create institutions or technology that would generate growth.

What are the implications of this for society? Looking at Greek history from, let us say, 500 to 300, we can see both effects of the no-growth situation and the impact that situation had on other aspects of society. In looking at Athenian history, which we know best, there are at least three areas in which the implications of stable-state thinking can be traced clearly: the development of the Athenian empire in the fifth century, the use of slaves in fifth-century Athens, and the treatment of women at that time.

Before I proceed to review these three, however, there is one other aspect of Athenian society that must be mentioned in order to complete the picture: that is, Athenian democracy. We are all aware of the Athenian system of running public affairs in a manner allowing for a relatively great role to the ordinary citizen without status or wealth, and we have read, from ancient as well as modern writers, deploring remarks about the tendency of Athenian politicians to pander to the political and economic demands of the lower classes. I do not intend to explore this attitude in depth, but I present it to make clear some of the dominant characteristics of Athenian society in terms of its democratic institutions. As a democracy, Athens went relatively far along the road traveled by many Greek cities, placing more power in the hands of a larger body of citizens than did many Greek cities, even other democracies.

However, granting power to the citizens, in one way or another and to greater or lesser extent, was the norm in Greek society. For whatever reason or reasons—and I do not yet comprehend them—the normal Greek manner of running public affairs was based on the assumption that the members of the society, the citizens, male and adult, were entitled to a role in decision-making and were also entitled to share in the benefits achieved by the group as a whole. The institutional ways of expressing this assumption could vary widely, taking in Athenian democracy, the equality of Spartan males dedicated to military superiority, and even including the Macedonian monarchy, in which the king ruled safely only so long as he satisfied the ambitions of the military aristocracy.

In the Athenian version of this relationship between society as a whole and its members who deserved their shares, by the last quarter of the fifth century, the poorest citizens had long demonstrated their value to society, not only serving in the fleet and infantry but carrying on many civil functions in the assembly, administration, juries, and religious festivals. Of course, this was not just a matter of demonstration and appreciation, and the increased role of the poorer citizens marched together with increasing demands by those citizens for more share in the public wealth. And they got it, as pay in the military, for jury service and for fulfilling other public offices, and also by sharing in increased economic activity, particularly building, that characterized Athens in mid-century. We can continue our discussion then, in awareness of Athenian democracy as a particular form of

Greek citizen participation that called for, and produced, increasing allocation of benefits, or economic share, to the widest and poorest class of citizens. The question lurking behind this, of course, is, where did the increased benefits come from?

The most obvious source, of course, is the empire. The annual assessment of men and ships, usually paid in coin and levied at the outset of the alliance in 478, had a value of 460 talents, an enormous sum worth an equivalent of billions of dollars in wage value over the fifty-year period down to 431, by which time it had risen to 600 talents per year. The reserve fund kept on the acropolis had reached the sum of 9,700 talents at its highest point, and even after the payments for the cost of public buildings and the war against the city of Potidaea, the reserve fund, not counting religious treasure and uncoined precious metal, stood in 431 at 6,000 talents, a sum I estimate would pay for work that three to five billion dollars would pay for in the United States or Canada today. So, when Athens paid the workmen on the acropolis, or paid the 29,000 or more soldiers when it used them, or equipped a 100-ship fleet, as it did at the outbreak of war, it did not need to call upon the resources of its rich men or cut back on expenditures for the festivals such as those of Dionysus, or the Panathenaic celebrations, or curtail payment for jury service or reduce any of the customary payments to citizens. Indeed, it took nearly thirty years of war, and a succession of disasters, compounded by Persian financing of the other side, to deplete Athenian resources to the point of exhaustion and defeat. Furthermore, the confidence engendered by the revenues allowed the Athenians, in the midst of this war, to vote the notorious—or impressive—*diobelia,* a 2-obols-a-day payment to those of the Athenian citizens who were needy. That the money came at the expense of the allies, who had, initially at least, agreed to a mutual defense fund to be used against Persia, was of no concern to Athens, so far as we can tell from the rhetoric reported by Thucydides. In fact, that historian is at pains to tell his story and create his speeches to present an impression of Athenian politicians and policies constrained only by the politics of power, with no room in their calculations for abstract justice.

The empire, then, was a major source of increased revenue at a time when expenditures were rising. The rise, it should be stressed, was not just a matter of the costs of the war against Sparta. The 3,700 talents of difference between the highest level of reserve and the state of the fund in 431 was spent, in addition to the war at Potidaea, on the building of the Propylaea and other public buildings. In addition, considering the some 10,000 talents in reserve, there must have been expended 15,000 over the 50-year period before 431, since about 25,000 talents had been collected. We are talking here, of a sum, 15,000 talents, that would buy services that ten to fifteen billion dollars would buy in the United States or Canada today. This money had bought the services of Athenian ships and sailors over those fifty

years, putting money into Athenian hands, but it had also bought the construction of the long walls down to the ports and the walls around the ports themselves, plus paid the wages of the 16,000 citizens and resident aliens who garrisoned those fortifications even in times of peace. Athens was, from 460 on, extremely prosperous, spending money on all sorts of civic and cultural and political purposes, and much of the money came from the empire or was at least freed up by the revenues of empire.

Another Athenian resource was that of slavery. Here, of course, the Athenians were not alone: most Greek cities had domestic and industrial slaves, in numbers enough to raise the vexing and frequently visited question, "How much did Greek society depend on slavery?" I do not intend to deal with that question in those terms, but rather I want to show how useful slavery was to the Athenians as their need for labor grew in the last half of the fifth century. If that can be made clearer, then the role of slavery in the nongrowth economies of the Greek world generally can be better understood.

The relative value of slaves is one of the issues. Some published studies suggest that purchased slaves were not cheap. Furthermore, a slave valued for some skill, talent, or potential might bring a high price. A home-born slave represented some investment, but it was a gradual one, and slave children could be useful and help earn their keep after a few years. We have quite a number of references to slaves "born in the household," but no evidence for slave-farming.

The existence of organized markets are an indication of the demand for slaves, and information for the fifth century suggests a very large number of slaves in the traffic. The remnants of the Persian army and fleet would have provided some at the beginning of the century, and later, Athenian actions against Persian territories produced a good many more. Slave-making occurred a number of times during the Pentakontaetia, at Eion in the mid 470s, at Skyrus, Chaeroneia, and elsewhere. The Peloponnesian War brought enslavements of whole populations, and the Athenians lost at least 7,000 soldiers to slavery at the end of the Sicilian expedition. Even with the typical small-scale use of slaves for agricultural service and commercial production, there was enough activity in the Greek world to absorb a significant number of the slaves brought in to the markets by war, and the indications from Thucydides' text are that Athens accounted for a good number of them.

Without the availability of these slaves, the Athenian system could not have expanded so well when wartime demand called for it. With no concept of increasing productivity, or growth in production on the same base, only increased numbers allowed greater manufacturing or commercial activity. The large numbers of slaves in Athens were a factor in the city's ability to dominate others. Entirely apart from their utility to private activity or agriculture, slaves at Athens were an important resource for the society as a whole and helped to create and expand the empire.

The relation of slavery to the structure of society should not be evaluated in isolation from the roles of women and children, and here we turn also to the problem of production in agriculture. The Athenian use of slaves in urban production represents a much smaller fraction of labor enterprise than the work devoted to farming. Even Athens, the most urbanized of Greek cities, surely left at least 80 percent of its population on the land. The density of slaves spread around the territory of Attica and owned by the 80 percent of Athenian citizens in the rural areas is much lower than the concentration in the urban center, showing that proportionately, there was much less use of slaves for agricultural production. No doubt the small farmers were living in the manner that Hesiod advises, using women as an important part of the productive force.

The work of women was an important resource, and came free, or even might come with a dowry. It has been noted that the condition of women in late-fifth-century B.C. Athens was worse than at any other time or place in the ancient world. The common view of the miserable state of women has recently been challenged, looking at the status of priestesses and others and considering the presentation of women in the plays of Aeschylus, Sophocles, and Euripides. But these impressive, even frightening, women are dramatic representations, and their reverse side is a sense of the hidden hostility and rage that sensitive men could imagine in women. Life truly influences art here, as the males' unconscious appreciation of the potential of women calls forth both dramatic image and political control. Athenian drama responds to the realities of life with representations of women that exculpate any perceived injustice. If fifth-century Athenian women could be seen today as worst off among all women in Greece in antiquity, their potential for harm could set Athenian consciences at ease. Lysistrata might be a comic portrayal of what women could do if allowed, but Jason's diatribe against Medea was an expression of the common view of women.

It is difficult not to set the negative image of women, in the words of Hippolytus or the reputation of Xanthippe, against the severe social restrictions on women of the better classes in Athens in the fifth century. It is also difficult not to comprehend the increased Athenian dependence on women, both for physical and managerial work, as the war progressed and men were away or dead. With increased dependence came increased control, especially of the women of rank and wealth, who might present just the kind of threat politically and economically that Lysistrata made sexually. The situation of Athenian women, and the social measures to control them, can be understood in terms of the manpower needs of an Athens unable to create growth, and strained in wartime to carry on activities at an increased level without the potential of additional resources. The increased use of the resource provided by Athenian women is an obvious response to the problem.

The characteristics of empire, slavery, and exploitation of women in the democracy of fifth-century Athens are understandable in terms of the goals of the society. These goals were, among others, stability and a sharing of the goods of the polis. As the citizens at the bottom of the economic ladder demanded more and more of the practical goods, the aristocratic leadership, unwilling to give up its own privileges and constrained by a system that did not allow for growth, could only look outside Athens for the increased resources needed. Thus the empire. The empire, in turn, called for greater human resources from a stable society, and to supply those resources, Athenians turned, probably without thinking about the issue in depth, to slaves and their women. But some were aware of what they were doing, and Euripides, at least, tapped the latent anxiety about women with the terrible heroines of so many plays.

The characteristics of society represented by empire, slavery, and the strongly repressive treatment of women relate to the basic ideals and goals of society, goals that can be seen, or at least interpreted, through other forms of expression than political. Traditionally, fifth-century B.C. Greek sculpture has been credited with a "timeless" quality, a realism that abstracts the particular in favor of the general. Another way of looking at the sculpture would be to credit it with a kind of stability of representation, and art, in this sense, can be seen as expressing the ideal of stability sought in political and economic life. To pursue the metaphor, we might observe that, as Greeks never really achieved the stability they sought politically, so the idealism of fifth-century sculpture yielded to the styles of the fourth and subsequent centuries. The orderly nightmare of war in the fifth century— orderly in the sense that enemies remained so for a reasonable period of time, gave way to the fourth-century confusion of Xenophon's epilogue, and the increasing complexity of life not only made achievement of the goal of stability more difficult, but the goal itself had an increasingly deleterious effect. As more and more people, and more and more powerful people, sought greater shares in the unchanging assets of the peninsula, the state of polis society itself was undermined. Only the huge treasure that Alexander's conquest brought to the Greek world allowed the continuation of the patterns of urban life. And eventually even that ran out.

Until recently, all modern commentators have believed that economic thought was nearly nonexistent in ancient Greece, and this view has been based on the modern assumption that the goal of economics and economic thought is growth. In the absence of that kind of thinking and planning, Greeks seemed to have little idea of economics, and it was only when we were able to see the goal of stability as the object of ancient economic thought that we have been able to perceive what might be called economic thought.

In human history, growth of a real sort has been achieved relatively rarely. Although the Western democracies have been able to produce

increasing material well-being for increasing parts of the population, the nineteenth-century empires were as much or more responsible than the Industrial Revolution for the wealth that made this possible. One of the most notable periods of real growth came after World War II, and this genuine growth in the late 1940s and 1950s encouraged many to believe that the pie would continue to enlarge, and that real growth rather than expansion of the base would provide a wider distribution of the goods of society. The notion of "The Limits of Growth" nipped that optimism in the bud. The problems of the past decade or two now begin to bear some resemblance to those of the growth-limited Athenian democracy of the fifth century B.C., and we can recognize among ourselves some of the characteristics of Athenians of that period.

Leaders of our own society are often as contemptuous of the "lesser classes" as were those of Athens. When "The Old Oligarch" remarks, for example, that the masses are interested primarily in holding the public offices that bring them pay and benefit their pockets, he reveals the same hostility to the "mob" evinced by Thucydides and other ancient writers, an attitude shared by the gentlemen who occupied chairs of classics in the nineteenth century, as well as the middle-class successes of today. Much of the view we have of Athenian democracy is through the eyes and via the pens of aristocrats whose view of events was colored by the dwindling influence their class had over the process of decision-making in Athens. Pericles was, in the opinion of Thucydides, a great leader, and the historian's account of the Peloponnesian War is in part a demonstration of how badly the democracy went astray when no longer under the influence of the "best man," a best man who was, it goes almost without saying, a member of the greatest family at Athens. The leader who followed, Cleon, is often denigrated as a tanner, and although he can be shown to have been of the propertied classes, we would not call him an aristocrat, nor do we consider aristocrats others who followed him, men like Hyperbolus and Cleophon. Even the aristocrat Nicias came from a lesser family. However, that many or any of these men took on public roles merely for the pay available fits neither their own personal histories nor explains the policies they advocated.

The implications of Thucydides' history include demurrers about the aggressiveness of Athenian policy. The most aggressive were, however, as aristocratic as any, beginning with Aristeides' leadership in establishing Athenian naval hegemony, and continuing on through the century with leaders like Pericles and Alcibiades. To Aristotle, the changes that took place in Athens in the sixth and fifth centuries all contributed to the evolution of the civic organism to the fulfillment of its form, the democracy in place in his own time. Aristotle and aristocratic analysts like Plato saw the growth of naval power and support for naval activity as a contributor and a concomitant of increasing democracy, and naval leaders and supporters

were, accordingly, suspect in their motives. But the naval policy was part and parcel of the economic and philosophical complex based on stability, and as Athenians moved more and more toward political egalitarianism in the operation of the democracy, the necessity to find resources led to a policy that called for naval power.

It would be a mistake, however, to set precise causal relationships here: I do not assert that the desire of members of the Athenian polity to gain more, economically, from the society led to the establishment of a navy and thus the empire. The relationships were more subtle, and are illustrated by the fact that the diobelia came not at the beginning of the growth of Athenian power, as a cause generating the need for obtaining more resources, but rather well after the Athenians had broadened the limits of their resources considerably, so that the allocation of some small portions of those resources was a disposition of what they already had, just as the proposal, not accepted at the time, to distribute the increased resources from silver would have been an allocation of what was there, not what was to be grasped.

Still, the general motion of the society toward increased sharing of increased amounts produced a willingness, and eventually, a desire, to expand the base from which the Athenians drew their resources. It was this attitude that elicited Thucydides' version of the Corinthian description of Athenians as restless and never satisfied. One *ought* to be satisfied, the "Corinthians" thought, and certainly, if one were to join Plato and Aristotle in the pursuit of stability, any democracy that led to the desire for increase was excessive.

In many ways, the perceptions of society found in the comments on democracy by philosophers like Plato and Aristotle, or implied by the historical account of Thucydides, produced a sense that a major difficulty lay precisely in the lack of limit on the political process. We see accusations that the Athenian demos was unfettered by law, that the demos could do whatever it wished. The artful presentations of the "ordinary" members of the demos by Aristophanes show us people without a sense of parameters controlling public decisions. Thucydides shows us a populace urged by its "demagogic" leaders to exercise its will without regard to limit. Lysistrata leads a democracy before which even the most sacred limits on women's activity have fallen. In the comic poet's inventions, in the historian's imagined speeches, and in the philosopher's fictionalized debates, we move from the reality of Athenian life to art's interpretation, while at the same time interpretation, artistic or otherwise, lends authority to a certain set of attitudes about politics. Limit becomes a sacred principle, not only to the ancient writers but to their modern interpreters, and we see the principle at work mightily in Herodotus before we even analyze the writers who demur about the merits of the Athenian system.

It is the case, I suggest, that the sense of limit and the pursuit of stability were the greatest impediments to the success of the Athenian democratic polis. The sense of limit was, in fact, the corollary of the search for stability, for it was only by limit, on the extent of territory or population, for example, as urged by Plato and Aristotle, that stability could be achieved. Political and social thinkers thus sought, in pursuit of stability, to impose a limit on one aspect of political life that seemed, in Athens at least, to be unlimited: the participation of members of the group in the direction of group activity, and the desire by members of the group to obtain greater shares in the wealth of the group. In Athens, we see the working out of these contradictions more clearly than we do in other cities. But Greek societies in general shared many of the same attitudes we can delineate clearly at Athens, and the problems and failures elsewhere had common roots with those at Athens.

We can recognize the failures and successes of Hellenism particularly clearly from the vantage point of the experiences of the modern world in the past two decades. From a myth of growth, expansionism, optimism, generosity, and sharing, we have moved to one closer to that of the Greeks, stability and limit in potential, but that myth has created a very different set of attitudes and expectations. Precisely because we are only too aware of the lack of limit on the numbers of those of us who are members of the group, and because we have a sense that our numbers are the planetary numbers, the search for stability and the sense of limits have generated the pessimism, selfishness, and meanness that increasingly characterizes the societies considered the offspring of Athenian democracy.

If, however, we can recall the damage that the pursuit of stability and limit imposed on Athenian society, we may rethink our modern devotion to them and seek to find practical methods of growth, rather than practical ways to impose limits. If we are aware of the extent to which prevailing social myths dictate the decisions and development of societies, and above all, if we remember that basic political attitudes rest, ultimately, only on the prevailing *mythoi* of the characteristics of human beings, society, and the natural world, we may reject those myths that lead us away from the exploitation of a potential in which we have the capacity to believe.

FIVE

Alexander at the Beas

Fox in a Lion's Skin

Philip O. Spann

In the summer of 326, after his victory over Porus at the Jhelum (Hydaspes), Alexander continued eastward across the central rivers of the Punjab to the western bank of the Beas (Hyphasis)[1] Here, as a result of what is generally termed a mutiny in his army, he was presumably forced to fix an eastern boundary to his conquests and to turn back to the west.

What Alexander hoped to achieve beyond the Beas is a matter of some controversy. Scholars are fairly divided on the nature of his ambitions in India. One extreme represents him as driven to the ends of the earth by his famous "longing";[2] the other reduces him to a kind of greengrocer tidying up the eastern shelves of his store to enhance trade.[3] There is, however, virtual consensus[4] that he did in fact wish to cross the river, either in ignorance of the geographical obstacles ahead,[5] or aware of them but determined to cross anyway.[6] All agree that he was dissuaded by his army or at least by the reluctant "bearing of his generals."[7]

This chapter attempts to clarify the episode at the Beas and suggests that once appraised of what lay ahead in India, Alexander did not genuinely wish to proceed, that he in fact encouraged what history might record as a "mutiny" in his army in order to preserve his public image and indeed his own mythopoeic vision of himself.

Events at the Beas can best be understood by relating Alexander's geography to his political aims and to his waxing divine pretensions. Whatever his ultimate plans for world conquest in the west, in the east, after his victory over Porus, he was bent on extending his power to the limits of the earth as bounded by the Ocean. This fact is explicit in Plutarch, Curtius, and Diodorus and implicit in Arrian's explanation of the march to the Beas. Alexander, he says, had advanced to the Beas, "to subdue the Indians beyond as well. For he thought there could be no end of the war as long as

any enemy was left."[8] This intention to mop up Indian resistance was feasible only as long as Alexander believed that no great distance remained between his army and the Ocean. And this he did indeed believe up to the time he reached the Beas.

Alexander and his staff got their basic geography of this area from Hecataeus, Herodotus, and most recently from Aristotle, all of whom believed that not far beyond the headwaters of the Indus lay the outer, eastern ocean.[9] From Aristotle they probably had the idea, expressed in the *Meteorologica,* that "when you have crossed the mountain range called Paropamissus [Hindu Kush] the outer ocean is already in sight."[10] And already, no later than the early summer of 327, when recrossing the Hindu Kush to begin his invasion of India, Alexander must have discovered that this statement was incorrect.[11] But he still had reason from Aristotle to believe that the eastern ocean lay just beyond the Punjab.[12]

After his victory over Porus, he had, therefore, advanced eastward with the reasonable intention of securing what remained of the world in that direction. As he moved from one river to the next, the efforts of his reconnaissance teams kept turning up more and more accurate intelligence as to what ahead lay of him and in a sense below him. At the Chenab (Acesines), on the basis of beans and crocodiles, he had concocted the theory that the Indus river was the source of the Nile. But he was soon corrected by the inhabitants: the Chenab flowed into the Indus, which flowed into the sea.[13]

Now if Alexander could obtain accurate information concerning the destination of the Indus, some 500 miles away, by the time he reached the Beas, he must have received fairly accurate information about what lay beyond that river. From Porus and Taxiles and other Indian princes, he had probably heard, well before he reached the Beas, of the tremendous distance to anything like an eastern ocean.[14] But this contradicted a geographical proposition considered axiomatic by Alexander and his staff. He therefore continued his march eastward, waiting for his accumulating geographical intelligence to clarify the matter. I suggest that at the Beas, he became convinced that the Greek theory was wrong. At this point, he was probably not far from what is now the city of Gurdaspur.[15] Due east and probably visible on a clear day lay the formidable barrier of the Western Himalayas. Fifty miles SSE was the last great river of the Punjab, the Sutlej (Hesidrus). From there, following the southeasterly slant of the mountains to the westernmost tributary of the Ganges, the Jumna, lay some 200 miles of the Indian desert, and following the Jumna into the Ganges and the Ganges into the ocean would be a journey of well over 1,000 miles.[16] Just how precisely he understood the totality of his original misconception one cannot know, but we cannot doubt that at this point Alexander possessed sufficient information to reveal to him the utter impracticality of his continued quest for the eastern end of Asia and the ocean he thought he would find there.

What, then, does this mean in terms of the mutiny?

Tarn, of course, believes that Alexander still thought the Ocean was not distant, and although he rejects Arrian's speeches at the Beas, he accepts the idea of a mutiny.[17] But the mutiny makes no sense if Alexander thought the ocean was near. Are we to believe that Alexander would have permitted his soldiers or his senior officers to deny him his goal if he truly believed that it lay just beyond the next river? More important, would his soldiers have refused to continue if they had believed, if it had been the prevailing opinion among Alexander and his staff, that the ocean was within a few days' march? Alexander's army were eager as he to set eyes on what would surely mark the end of their toils in the east and the beginning of their journey, for some by ship, homeward. If he had thought the ocean was near, he would have convinced his troops of the fact, and they would have gone with him.[18]

But the fact is, no one in Alexander's camp believed the ocean was at hand, not Alexander, not his staff, not his troops. Andreotti and Droysen accept this fact and its implications and recognize that Alexander could not have intended, given his new knowledge, to continue with his former plan. They therefore assume that his intention in crossing the Beas was not to march to the sea but merely to establish a buffer zone to guard the eastern boundary of his empire. The expedition was to be merely a "first reconnaissance," a "*Kavalkade*." As for the mutiny, Andreotti contends that there was no mutiny; merely the "reluctant bearing of Alexander's generals."[19]

This interpretation, while correct in regard to the mutiny, entails a rather cavalier rejection of our sources, unanimous regarding Alexander's stated intentions, and, moreover, it makes no sense even of the reluctance of his officers to proceed, much less of a mutiny. If Alexander's aims beyond the Beas were as limited as Andreotti and Droysen contend, why was there opposition in any form? Why does not one of our sources portray Alexander as trying to convince his troops to cross the river on the grounds that he intended no more than a reconnaissance patrol? And why, if he intended no more than a raid across the river, would his army and his officers have been reluctant to go?

The answer is that such an operation was not his stated intention. In every source account of events at the Beas, Alexander makes mention of the numerous and formidable tribes still to be conquered in the east, and of his intention of conquering them. Nor can it be reasonably doubted that he knew of the Ganges at this point.[20] It is evident that he knew that he had many miles and tribes and battles to go to get to the eastern ocean. Moreover, he expressed his intention of going there, and virtually every author who has addressed this subject, however obliquely, in the past sixty years has accepted the sincerity of Alexander's stated intention of crossing the Beas.[21] But this reconstruction requires another assumption that seems wholly impossible:

namely, that Alexander would disregard the physical and mental state of his troops at the outset of a major campaign. Every source describes them as ill-equipped, fatigued, and disheartened.[22] If he did indeed wish to embark on a major campaign beyond the Beas, was this the time to insist on it? From Curtius and Diodorus, we learn that reinforcements and supplies were near at hand.[23] Would it not have been wiser, if Alexander really meant to continue, to wait for these reinforcements to catch up with him? By then his Macedonian troops might have recovered their vigor and morale, especially as they witnessed an end to the rainy season.[24] Alexander had in the past shown no little ability to sense and manipulate the emotional temper of his troops.[25] Why now this sudden insistence on a campaign for which he knew they were physically and mentally unprepared?

At the Beas, Alexander had finally realized that nature had presented an obstacle that not even he could expect to conquer and still hope to hold together his recently conquered empire to the west. He had, after the battle with Porus, every intention of marching to the eastern sea; thus the buildup of troops, thus the reinforcements on the way. But at the Beas, he must have realized that further campaigning would be perilous at best, and perhaps disastrous in the end.[26] What if, as he advanced farther east, the ocean were discovered to be even more remote than indicated by his current intelligence, the tribes more warlike, the weather worse?

The combination of what he knew and what he did not know must, at this point, have made it clear to Alexander that the time had come, quite simply, to set an eastern boundary to his empire. But this he could not do without suffering a tremendous loss of face.

As far back as his interview with Pharasmenes in the winter of 329/28, he had made public his goal of conquering all of Asia by subduing India.[27] And since he had left the Jhelum, he had no doubt been using the proximity of that goal as a stick and carrot device to lure his troops on: "just one more river," as it were. His determination here was fired not just by a desire to reduce all resistance in the east, to conquer the last of the cities and tribes of Asia in the interests of tidy administration; but to conquer geography, to make the eastern border of his empire coterminous with that of the world. It was not an original notion, but it was suitably Olympian. In a speech Herodotus had put into the mouth of Xerxes, the great king expressed his intention, by conquering the Greeks and passing through all of Europe, to "show to all a Persian empire that has the same limit as Zeus's sky. For the sun will look down upon no country that has a border with ours, but I shall make them all *one* country."[28] Whether Xerxes ever entertained or uttered such a thought matters not here. Herodotus's tale and the idea it contained had been around for a hundred years by the time Alexander began to realize that such *world* conquest was perhaps within his reach. No one, not Cyrus or Darius, and certainly not Xerxes, had achieved it. Alexander might be

the first. He must therefore look elsewhere, upward and indeed closer to home for models and rivals. His mimesis would not look to men but to the gods. As Peter Green has noted: "Dionysus had passed through the country [India] with his Bacchic rout, carrying out a program of conquest and civilization (he was supposed, *inter alia,* to have brought India the vine). Fifteen generations later, according to tradition, came Alexander's ancestor Heracles, who through his daughter sired a long line of Indian Kings. Alexander was determined to outshine them both; perhaps even to win acceptance—here if anywhere—as a god himself."[29]

Alexander had not blushed at Nysa and Aornus to compete with these kindred sons of Zeus, and he may have been especially keen on the tradition that Heracles had established his Pillars at the limits of the world in the west, on the shores of the western ocean.[30] Alexander was perhaps driven now to do the same in the east. At the Beas, he had already conquered the Persian empire. The eastern ocean would be his greatest conquest to date. And although his mimetic ambitions in this direction would not be achieved, they proved historically infectious. He established a model of geographical, indeed oceanic, aspiration that would spawn similar *imitatio,* or indeed *aemulatio,* in a host of Romans, from Pompey and Caesar to Augustus and subsequent Roman emperors.[31]

Thus Alexander's dream, his pretensions, and their consequences, as he paused on the western bank of the Beas hearing reports that there lay before him and his exhausted, weather-beaten, and depleted army a world as formidable in arms and extent as the one he had just conquered. But could someone who was pleased to be styled a son of Zeus, and a rival of Heracles and Dionysus,[32] suddenly decide, in view of mere difficulties ahead, to forsake a goal in which he had publicly invested so much of his *gloire?* He could not, but neither did he intend to risk his empire, his army and his life by forging ahead into uncertainties of the Indian interior.

Wilcken recognizes the difficulty of accepting Alexander's stated wish to continue, given all its absurd impracticality, but concludes that we must accept it at face value "otherwise a characteristic [personality] trait will be lacking."[33] Wilcken is, of course, thinking of the "pothos," the "longing," of the adventurous young king who had invaded Asia some eight years earlier with little to lose and the world to gain, driven by that longing to seek the unknown and do the undoable (or at the very least to cobble together enough booty to pay his army).[34] There was indeed this quality in Alexander, but one may rightly wonder if it could still override his common sense by the time he reached the Beas.[35] We must remember here that Alexander's hitherto unbounded successes had by now given him much to lose and more to live up to, and all of this had revealed or evoked a negative side to his personality. By 326, Alexander's achievements and crimes had rendered him suspicious, arrogant, and despotic; tolerant of flattery, intolerant of

remonstrance and fiercely aware that everything he did was history-making, epic, in the classical sense of the word.[36] The Alexander we find at the Beas has perhaps less in common with his first role model, Achilles, than he does with Louis XIV. His previous behavior toward Parmenio, Philotas, Cleitus, and Callisthenes shows that he could be brutal, treacherous, and, above all, ruthlessly deceptive when crossed.[37] If he had set out to conquer what remained of the world in the east, conquer he must or find a reason for turning back that did not impugn his Olympian self-image.

He could not, of course, concoct a judicial murder of the ever-receding horizons to the east. So there could be but one solution: the army did it.

But not through a mutiny. There was no mutiny, as has long been recognized by some.[38] Alexander gave no order to move out and no order was refused. Indeed, it is probable that Alexander could not have induced either his officers or his men to disobey a direct order, no matter what he had asked them to do at this point.[39] But there was a middle course. Knowing full well that his troops were weary and disheartened, Alexander put it about that he intended to march on. When this produced the expected grumblings in the ranks, he did not address the troops (they might have said yes); rather, he called together his top officers (who would write or inform history), as if calling a press conference.[40] Although some have rightly doubted the authenticity of Arrian's account of the speeches exchanged here,[41] the exhaustive source studies of Holt and Hammond indicate that Arrian's version is based on the authority of Ptolemy, who was present at the Beas and would have had no reason either to distort or to look too deeply into what he saw and heard there.[42] If Arrian-Ptolemy has produced even a rough outline of the course of events and the operative words exchanged, Alexander's behavior becomes transparent and his agenda obvious.

Crowing to the last that he "set no limit to exertions for a man of noble spirit, save that the exertions themselves should lead to deeds of prowess," he expressed his desire to advance.[43] He even made a plausible pretense of trying to persuade those present to follow by saying, in Arrian's version of the speech, that the eastern ocean was not distant.[44] Now this may seem to contradict what has been said above about Alexander's waxing geographical enlightenment, but his assertion that the ocean was not distant was simply a clever lie. Alexander knew it was not so, and, more important, he knew that his officers knew that it was not so. He ran no risk of convincing them. Indeed, he contradicted himself in the next paragraph of his speech when he told them that there were still many tribes and peoples to be conquered before they reached the ocean.[45] Magnanimously, however, he gave the commanders the opportunity to express their obvious misgivings.[46]

At first the offer was greeted with profound silence. His officers were confused. Was he seriously asking them to disagree with him or was this a

ruse to weed out the fainthearted and disloyal?[47] Arrian is emphatic on the length and resonance of the silence that followed Alexander's invitation to his officers to debate. The fact that he had to ask them repeatedly to disagree suggests how terrifying he had become to all those around him. It also suggests how desperate he was to find a way out of his predicament. In the end, only Coenus had the courage or perspicacity to accept the invitation, and he made an eloquent appeal to Alexander to call a halt to his conquests and lead them back to hearth and home. He could come back another day with another army.[48]

This, of course, was precisely what Alexander realized that he had to do. He simply did not want to be responsible for proposing it. Proof of his true feelings is perhaps to be found in the fact that he had invited anyone to speak against his wishes in the first place, and in the fact that it was Coenus who finally did. Alexander was, after all, king, commander-in-chief, and a de facto autocrat, not an Athenian politician. He did not have to debate anyone to make his will prevail. Moreover, he had been manipulating his army now for some eight years. If he wanted them to react for or against something, he simply installed in their midst a man or a claque of several who spoke "spontaneously," as it were, in favor of what Alexander wanted done. Coenus had served in this capacity before. Several years earlier, when Philotas had been brought before the army for trial and his miserable and manacled condition was arousing pity in the soldiers, Coenus had jumped up "spontaneously," as it were, and had begun to attack him in the most violent language.[49] Already part of Alexander's inner circle, Coenus subsequently had advanced rapidly in command, and by the time Alexander had reached the Beas, Coenus was the senior person present in age and rank.[50]

After Coenus's speech, Alexander dismissed the group, only to call them together the next day threatening to go on with volunteers. This was an excellent idea if Alexander really meant to coerce the unwilling, but he made no effort to enroll volunteers; rather, he stalked off to his tent, entered on a two-day sulk and would not speak to anyone (an act surely perceived as a somewhat histrionic encore to his behavior after he killed his friend Cleitus). On the third day, however, he arose from his tent and offered sacrifice with a view to crossing the river. Of course, the omens were ominous. With this he gave up publicly to the wild gratitude of the soldiers, who, says Arrian, "drew near the royal tent and invoked blessings on Alexander, since he had submitted to defeat at their hands alone."[51]

And this was precisely the point that Alexander wished to convey to posterity. The failure to conquer all of Asia, to reach the eastern Ocean was indeed a defeat, but the army was responsible for it. His speech at the Beas, indeed his behavior as a whole, was a disingenuous fiction designed to flatter his self-image while inflaming the misgivings of his officers by appeals to arguments that he knew that they knew were false.[52]

Nor was this the first time he had used disingenuous heroic language to disguise sound military judgment. Just before the battle of Gaugamela, when Parmenio suggested a night attack, Alexander replied, "since others were listening, that it was dishonorable to steal the victory." Arrian goes on to opine that this bluff grandiloquence covered careful calculation. Alexander simply considered the night attack a very risky operation.[53]

The complicity of Coenus in the Beas affair cannot, of course, be proven. Given his long standing as part of Alexander's inner circle, he may have divined the king's wishes without prompting. There is certainly no evidence that he incurred the usually murderous wrath of Alexander by making the case for sane strategy at the Beas.[54] If the thesis of this chapter is correct, Coenus had done exactly what Alexander wished, and there is no suggestion in Arrian that his death of disease shortly after the return from the Beas was in any way suspicious. Alexander gave him a splendid funeral, such as was possible under the circumstances, and inflicted on his loyal companion no more than a posthumous wisecrack, if that. We need not assume that Coenus was murdered.[55]

To conclude the production at the Beas, Alexander ordered the construction of altars of grand dimensions as "thank-offerings to the gods," and as memorials to his labors, to equal or rival, presumably, the Pillars of Heracles in the west.[56] He had perhaps intended to set these up on the eastern edge of the world, on the shores of the eastern ocean, where they would have been genuine trophies, emblems of his victory over geography. Erected at the Beas, they were meant to disguise geography's victory over him. Like the staged confrontation with his top officers, which historians have too often described as a mutiny, it was all a perfect piece of public relations bunkum.

NOTES

1. On the date, see Peter Green, *Alexander of Macedon* (Berkeley and Los Angeles, 1991), 406 f. and xxxvi (the month was perhaps July); A. B. Bosworth, *Conquest and Empire: The Reign of Alexander the Great* (Cambridge, 1988), 131; and N. G. L. Hammond, *Alexander the Great: King, Commander and Statesman*, 2d ed. rev. (Bristol, 1989), 314. My thanks to Ms. Ann Till for her valuable assistance in the preparation of this chapter.

2. U. Wilcken, *Alexander the Great* (New York, 1967), 174, 186.

3. B. Breloer, *Alexanders Bund mit Porus* (Leipzig, 1941), 1 ff., 29 ff., 56 ff, and esp. 115 ff. R. Andreotti, "Die Weltmonarchie Alexanders des Grossen in Überlieferung und geschictlicher Wirklichkeit, " *Saeculum* 8 (1957): 140–45, and J. G. Droysen, *Geschichte des Hellenismus*, vol. 1, 3d ed. (Basel, 1952), 356 f., also stress his limited aims beyond the Beas.

4. H. Endres, *Geographischer Horizont und Politick bei Alexander d. Gr. in den Jahren 330/323: Ein Beitrag zur Würdigung Alexanders* (Würzburg, 1924), 12–15, states, as

this chapter argues, that at the Beas, Alexander simply changed his mind about advancing farther east, and used the "Versagen des Heers" as the "aussere Anlass zur Ruckehr." The "tiefere Grund" was his evolving geographical orientation. Endres notes Alexander's dissimulation in the affair at the Beas, but he does not connect it with the "mutiny."

5. W. W. Tarn, *Alexander the Great*, vol. 1 (Boston, 1962) (hereafter Tarn I), 99.

6. To mention only some of the more recent and/or scholarly discussions: J. M. O'Brien, *Alexander the Great: The Invisible Enemy* (London, 1991), 162–70; Green, *Alexander of Macedon*, 406–11; E. M. Anson, "The Evolution of the Macedonian Army Assembly," *Historia* 40 (1991): 233; Hammond, *Alexander . . . : King, Commander and Statesman*, 218–20; Bosworth, *Conquest and Empire*, 132 f.; D. Engels, *Alexander the Great and the Logistics of the Macedonian Army* (Berkeley and Los Angeles, 1978), 107; R. L. Fox, *Alexander the Great* (London, 1974), 368–70; Botsford and Robinson's *Hellenic History*, 5th ed., rev. D. Kagan (London, 1969), 341; R. D. Milns, *Alexander the Great* (New York, 1969), 220–23; J. Snyder, *Alexander the Great* (New York, 1966), 158–61; A. K. Narain, "Alexander and India," *Greece and Rome* 12.2 (1965): 159; P. A. Brunt, "The Aims of Alexander," *Greece and Rome* 12.2 (1965): 212; F. Schachermeyr, "Alexander und die Ganges-Länder," *Innsbrucker Beiträge zur Kulturgeschichte* 3 (1955): 123–35. C. A. Robinson, Jr., *Alexander the Great* (New York, 1947), 190–96.

7. Andreotti, "Weltmonarchie," 145, one of several authors who have recognized, rightly, that there was in no real sense a mutiny. See n. 38 below.

8. Arrian 5.24.8 (Loeb ed., vol. 2, trans., notes, and appendices by P. A. Brunt [Cambridge, Mass. 1983]; hereafter Brunt, Arrian II). See also Plut. *Alex.* 62–3; Q.C. 9.2.11; Diod. 17.89.4–5; Strabo 15.1.32.

9. See W. Reese, *Die Griechischen Nachrichten über Indien bis zum Feldzuge Alexanders des Grossen* (Leipzig, 1914), who makes it clear (p. 99) that "Keine Spur . . . zeigen die Schriften des Aristoeles von den neuen ergebnissen des indischen Alexanderfeldzuges."

10. I.13 (350a) (Loeb 2d ed., trans. and notes by H. D. P. Lee [Cambridge, Mass., 1962]). The *Meteorologica* seems to belong to Aristotle's "second Athenian period" (= 335–323 B.C., G. E. L. Owen, *OCD* [Oxford, 1972], 114–16) during almost all of which time Alexander was in Asia. Still, Aristotle's ideas about the geography of the continent were certainly available, either in print (not necessarily the book we possess) or by word of mouth, to Alexander and his learned advisers. W. W. Tarn, *Alexander the Great*, vol. 2 (Cambridge, 1948) (hereafter Tarn II), 6, thinks he got his geography, along with his politics and ethics, "from Aristotle himself." See also O'Brien, *Alexander*, 149.

11. On Alexander's geographical confusion in this area (based probably on Aristotle's ideas), see Wilcken, *Alexander*, 153, 174, 175. See also Green, *Alexander of Macedon*, 379 and xxxvi, on the date.

12. The picture of the world described by *Meteorologica* II.5 (362b) indicated that beyond India and the head waters of the Indus (as beyond the Pillars of Heracles) lay the outer ocean. See the map and discussion in Loeb, *Meterologica* (1962), 102–3.

13. Arrian 6.1.1–5.

14. Diod. 17.93.2 and Q.C. 9.2.2–9 indicate that he asked Phegeus and Porus about conditions to the east only at the Beas. Even if we discount Phegeus as a legend (so Tarn II, 280 f.), if Porus was with Alexander at the Beas (as he surely was,

Arrian 5.24, 4), he had surely been consulted earlier as Alexander proceeded eastward. See also Strabo 2.1.6 and Andreotti, "Weltmonarchie," 143.

15. So H. G. Rawlinson, *India: A Short History,* (London, 1960), 60, and Tarn I, 98.

16. See Green, *Alexander of Macedon,* 408, and Engels, 109, on the actual geography beyond the Beas. "No logistical difficulties would have been encountered in the region ahead," Engels thinks.

17. Tarn II, 275 n. 5, 287 ff., and I, 98 ff. See also G. Radet, *Alexandre le Grand* (Paris, 1931), 300.

18. J. F. C. Fuller, *The Generalship of Alexander the Great* (New Brunswick, N.J., 1960), 131.

19. Andreotti, "Weltmonarchie," 141 and 145; "die von der Misstimmung der Soldaten unterstutze Haltung seiner Generale." Droysen, *Geschichte,* 357. Schachermeyer, "Alexander und die Ganges-Länder," 123 ff., and F. Hampl, "Alexander der Grosse und die Beurteilung geschichtlicher Personlichkeiten in der modernen Histiographie," *La Nouvelle Clio* 6 (1954): 106, both argue (contra Andreotti and Droysen) that Alexander's building of a fleet on the Jhelum is not inconsistent with his knowledge of the Ganges soon after the battle with Porus and with his intention to march to the eastern sea. It might be added that the order to build the fleet on the Jhelum, whatever he knew of the eastern regions at that time, made sense: the timber was available, the fleet would be useful no matter what he found or did in the east.

20. E.g., Schachermeyer, "Alexander und die Ganges-Länder," 135, Hammond, *Alexander . . . : King, Commander and Statesman,* 218, and Bosworth, *Conquest and Empire,* 133. See J. R. Hamilton, *Plutarch, Alexander: A Commentary* (Oxford, 1969), 170–72, for sources, discussion and his own assessment: "It is more likely than not that he had heard of the Ganges."

21. See nn. 2, 3, 5, and 6 above. Endres, *Geographischer Horizont,* is the exception.

22. See Green, *Alexander of Macedon,* 406 f., for sources (n. 114) and a vivid description of the mental and physical state of the army at this point.

23. Diod. 17.95.4; Q.C. 9.3.21.

24. I.e., late in September (Bosworth, *Conquest and Empire,* 131), plenty of time for rest, recuperation and the reequipping of the army.

25. See A. R. Burn, "The Generalship of Alexander," *Greece and Rome* 12.2 (1965): 140; Fuller, *Generalship of Alexander,* 301–5.

26. "By the time he reached the Beas he must have practically shot his bolt; even without the mutiny he could have gone little farther; the mutiny was really a blessing in disguise," Tarn II, 169, notes.

27. Arrian 4.15.6

28. *Herodotus: The History,* trans. D. Greene (Chicago, 1988), 7.8g.1–2. The same idea, similarly expressed appears in Arrian's version of the speech Alexander delivered to his reluctant officers at the Beas (5.26.2): "The boundaries of our Empire here are becoming those which God set for the whole continent." Cf. Q.C. 9.2.26.

29. Green, *Alexander of Macedon,* 380.

30. On Nysa and Aornus and the divine connections, see the full discussion of O'Brien, *Alexander,* 148–54. The Pillars (*stelai*) of Heracles are mentioned several times by Herodotus (2.33; 4.8,42, 152, 181, 185, 196; 8.132) and discussed in

connection with Alexander, Heracles, and Dionysus by Strabo 3.5.5–7. See also Rhys Carpenter, *Beyond the Pillars of Heracles* (New York, 1966), 156.

31. Peter Green, "Caesar and Alexander: *Aemulatio, Imitatio,* and *Comparatio,*" *AJAH* 3.1 (1978): 1–26, shows that Pompey was made somewhat ridiculous by his Alexander *imitatio* (pp. 4–6) and that Caesar was too much Caesar to indulge in it. The comparison was largely imposed on him by subsequent rhetorical fashion. On Augustus's oceanic *aemulatio,* see his *Res gestae* 26, milestones on the Via Augusta in Baetica reading AD OCEANUM (e.g., *CIL* II, 4701), and E. S. Gruen "Augustus and the Ideology of War and Peace," in *The Age of Augustus,* ed. R. Winkes (Providence, R.I., 1985), 68–72. In the same volume, on later emperors, see R. Moynihan, "Geographical Mythology and Roman Imperial Ideology," 147 ff., esp. 156: "Again and again the Romans sought to follow Alexander to the ends of the earth—Corbulo (under Nero), Trajan, Julian." But cf. A. B. Bosworth, *From Arrian to Alexander* (Oxford, 1988), 131, who doubts that "the ocean featured prominently in his [Alexander's] thinking as a boundary of world empire."

32. It should not be assumed (as does Tarn I, 78; see also Tarn II, 373) that Alexander cynically encouraged these divine associations merely to manipulate the credulous herd. See Brunt, "Aims of Alexander," 208–11: "a man so devout would hardly have aspired to divinity unless he had felt that he had a religious justification" (211). See also Green, *Alexander of Macedon,* 452 f., and E. Badian, *Studies in Greek and Roman History* (Oxford, 1964), 202: "He had always liked and encouraged the story that he was the son of the god Ammon."

33. Wilcken, *Alexander,* 186.

34. On Alexander's aims when he invaded Asia, cf. Brunt, "Aims of Alexander," 208, and E. Badian, "The Administration of the Empire," *Greece and Rome* 12.2 (1965): 166. See Arrian 2.26.3 (Gaza); 4.21.3 (Rock of Chorienes); 6.6.3 (Malli); 6.24.3 (march to Pura) and V. Ehrenberg, *Alexander and the Greeks* (Oxford, 1938), 52–56, on Alexander's daring and "longing." Green, *Alexander of Macedon,* 153–56, notes the king's financial straits at the outset of the invasion of Asia.

35. See Arrian 1.18 (at Miletus); 2.17 (at Tyre); 3.9.1 and 4 and 3.10.3–4 (Gaugamela) for examples of Alexander's caution and restraint. See also Green's discussion of the battle at Granicus (*Alexander of Macedon,* 174 f.) where in the end Alexander's Homeric instincts yielded to Parmenio's wiser counsel.

36. Green, *Alexander of Macedon,* 443, marks a "change for the worse" in Alexander after the Gedrosian disaster but rightly notes that "from the beginning his ambition had been insatiable and murderous when thwarted."

37. See Badian, *Studies,* 194–200, for a discussion, and id., "The Eunuch Bagoas," *CQ* 8 (1958): 153–57, for a debunking of the idea that the "Peripatetic portrait" put a negative slant on Alexander's behavior in the death of these men.

38. E.g., Endres, *Geographischer Horizont*; Andreotti, "Weltmonarchie"; W. L. Adams, "Macedonian Kingship and the Right of Petition," *Ancient Macedonia* 4 (1986): 49–50; F. L. Holt "The Hyphasis 'Mutiny': A Source Study," *The Ancient World* 5 (1982): 47–49; Hammond, *Alexander . . . : King, Commander and Statesman,* 220; and O'Brien, *Alexander,* 164 ff.

39. Whatever their discomforts, neither officers nor men were prepared to invite the chaos their disobedience would provoke. Witness their behavior and state of

mind some months later when they thought Alexander dead at the hands of the Malli (Arrian 6.12–13).

40. Arrian 5.25. See Brunt's note (Arrian II, 81) and N. G. L. Hammond, *Three Historians of Alexander the Great* (Cambridge, 1983), 63, on Diodorus's and Curtius's ("almost certainly unhistorical"—Hammond) statement that the entire army was addressed.

41. E.g., Tarn II, 287, asserting that Coenus was not even present (but see Brunt, Arrian II, 531), and A. B. Bosworth, *From Arrian to Alexander* (Oxford, 1988), 123–34, esp. 133. Certainly, some of the geographical details in Alexander's speech may be "unashamedly borrowed from Eratosthenes" (130).

42. Holt, " Hyphasis 'Mutiny,' " 33–59; N. L. G. Hammond, *Sources of Alexander the Great: An Analysis of Plutarch's Life and Arrian's Anabasis Alexandrou* (Cambridge, 1988), 253–60. See also Brunt, Arrian II, 531 f. On Ptolemy as "court historian," see Bosworth, *Conquest and Empire*, 297. Ptolemy would neither have been party to the deception nor have been likely to report it if he had perceived it.

43. Arrian 5.26, 1–3. Bosworth (*From Arrian,* 128) rejects the authenticity of these lines on the grounds that Alexander's theme here is "grossly inappropriate" and Alexander himself "insensitive" in speaking thus to men "soaked, exhausted and weary with the endless pursuit of glory." Such language makes sense, however, if Alexander was not trying to persuade them at all.

44. Arrian 5.26.1. A laughable lie.

45. Arrian 5.26.3. The unpalatable truth. If the speech were pure invention, why the inconsistency?

46. Arrian 5.27.1: After an initial silence in which no one "dared oppose the King" or "was yet willing to agree."

47. Plut. *Alex.* 57.3, notes that at the outset of the Indian campaign (early summer 327) Alexander "was already feared by his men for his relentless severity in punishing any dereliction of duty." After the weddings at Susa, admittedly two years after the Beas incident, they so distrusted the king that they would not accept his offer to pay their debts. See Arrian 7.5. 1–3 and Green, *Alexander of Macedon,* 448 f., for a discussion. They had traditional right of petition (Adams, "Macedonian Kingship and the Right of Petition," 43–42).

48. Arrian 5.27.2–9.

49. Q.C. 6.9.30–31. See O'Brien, *Alexander,* 117–28 for a discussion. Bosworth, *Conquest and Empire,* 102, calls the trial "carefully stage-managed." Badian. *Studies,* 194–97, emphasizes Alexander's guile and Coenus's treachery (he was married to Philotas's sister).

50. His speech in Arrian (5.27.3) mentions his age and superior rank. On his career and standing, see *RE* XI 1, 1055.

51. Arrian 5.28 and 5.29.1 for the quotation. The sacrifice has variously been called the "official" reason for turning back (Badian, "Harpalus," 20 n. 23) and a "face-saving" device (Green, *Alexander of Macedon,* 410). Alexander was generally scrupulous in religious matters, but he would not have wanted history to record that he had been turned back from his goal by anything as patently malleable as omens. (See A. D. Nock, "Religious Attitudes of the Ancient Greeks," *Proceedings of the American Philosophical Society* 85 (1942): 475: "As a rule, you sacrificed victims until you

got favorable omens; unless you desired otherwise.") The "official" reason—that is, the reason Alexander wanted history to record—was the one he publicly elicited (and later professed to believe at Opis [Arrian 7.10.7]), namely, the reluctance of his officers, little men that they were, to continue. History has more than done its job in the matter. The jocular tone of the line quoted in the text meant that both Alexander and his men remained undefeated, an idea certainly attractive to Ptolemy.

52. Further proof of Alexander's wiles at the Beas may be found in the report (Diod. 17.94.3–4) that he authorized a local looting spree at the Beas to make the troops amenable to his appeal for further advance. But Plutarch (*Alex.* 57.1; see also Hamilton, *Plutarch, Alexander,* 157) says that at the outset of the Indian campaign, Alexander *burned* all the wagons loaded with loot, "since he saw that his army was by this time cumbered with much booty and hard to move." Why reload the army with loot if he really meant to march on?

53. Arrian 3.10.2–4.

54. Arrian 5.38.1 does indicate that Alexander was "irritated at Coenus's freedom of language." Naturally, it was his part in the play. E. Badian, "Harpalus" *JHS* 81 (1961): 20–23, and *Studies,* 199 f., describes Coenus as "the spokesman for the mutinous soldiers" (199) at the Beas and so hints at foul play in his death. Likewise, Bosworth, *Conquest and Empire,* 133 f., and O'Brien, *Alexander,* 171.

55. Arrian 6.2.1, reporting his death, still describes him as "one of the most trusty of the Companions of Alexander," and both he and Q.C. 9.3.20 note that he died of disease. Curtius says that Alexander mourned (*ingemuit*) his passing but remarked: "propter paucos dies longam orationem eum exorsum, tamquam solus Macedoniam visurus esset." Badian, "Harpalus," 20, n. 24, calls this a "vindictive comment," while noting Berve's assertion that it bears the mark of "Unwahrheit." Aside from being inaccurate and confusing (why *solus?* Coenus spoke for the whole army), it is lame as either invective or humor. It is also unnecessary to assume that the terrible hardships of Alexander's march back to the west were *inflicted* on the army as punishment for their behavior at the Beas (so e.g., Green, *Alexander of Macedon,* 411). I hope to elaborate this point elsewhere.

56. Arrian 5.29.1–2. See Hammond, *Alexander . . . : King, Commander and Statesman,* 219 f., and Hamilton, *Plutarch, Alexander,* 174 f., for other source references to even more exotic constructions at or near the Beas. See also Green, *Alexander of Macedon,* 411. A version of this chapter was submitted to Peter Green in a seminar he gave on Alexander at The University of Texas in 1971. Although disagreeing with its thesis, he cited it in the 1974 edition of his *Alexander of Macedon,* 555, n. 109, kindly claiming to have derived from it "much useful information." I would like to say here how grateful I am to Professor Green for the "much useful information" and inspiration I have derived from him over the past twenty-five years.

A Note on the "Alexander Mosaic"

Ernst Badian

Eyes have they, and see not.
PSALM 115

It takes a great deal of temerity for a mere historian to rush in and speak where (to adapt Sir Ronald Syme's words on another matter) so many of the pachyderms of *Kunstgeschichte* have trodden and trumpeted. But the Mosaic has fascinated me ever since I first saw it in Naples, over forty years ago, and much more so since the splendid publication by Bernard Andreae[1] gave the world some idea of what the colors must originally have looked like and how much they contribute to the effect.[2] In a lecture I gave at the Boston Museum of Fine Arts on November 4, 1981, I included a discussion of the Mosaic, not rehashing all that had been said, but concentrating on some points that had never, to my knowledge, been raised in the treatments I had seen and that have a major bearing on its interpretation. My remarks seem to have been fairly widely disseminated and led to some correspondence, and they were at later times repeated and expanded in lectures on various occasions at Harvard. Of course, much has been written on the Mosaic since, most notably by Carl Nylander, whose careful observation and knowledge of Achaemenid matters have transformed important aspects of the way we look at it.[3] The editors' request for an essay in honor of a scholar whose contribution to the history of Alexander III of Macedon is second to none, and who has demonstrated his interest in the art surrounding that king, has finally persuaded me to publish some of my views in this volume, for his consideration and perhaps amusement.

I

That it is called the "Alexander Mosaic" appears to be largely due to an accident of its discovery and history.[4] Discovered in October 1831, in the House of the Faun, which at the time was called the "House of Goethe" in honor

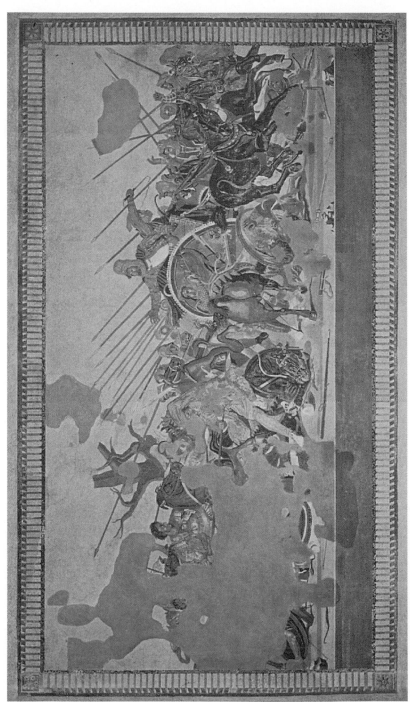

Figure 6.1 Alexander meets Darius: the "Alexander Mosaic." Permission for reproduction granted by the Museo archeologico nazionale di Napoli and Bernard Andreae.

Figure 6.2. Alexander meets Darius: Amphora by the Darius Painter. Permission for reproduction granted by the Museo archeologico nazionale di Napoli.

of the poet's visit there in 1787, it became known just when German Romanticism had transformed the classical world in its image, largely through the agency of Goethe's genius. A rather inaccurate drawing by Wilhelm Zahn reached Goethe in March 1832, not long before his death, with a letter in which Zahn at once identified Alexander and Darius III. Goethe's reply expresses his joy at seeing this depiction of Alexander as "Überwinder," with Darius personally being carried away in flight before him. And he at once appreciated (better than many of his successors) the horror shown by Darius at the death of the Persian who had sacrificed himself for his King. He also at once recognized the work as a "Wunder der Kunst."

As Andreae has pointed out (32 ff.), Goethe's interpretation was both subtle and penetrating, considering the circumstances. But it was his basic point, that Alexander is here shown as the conqueror, that mainly impressed itself on practically all future interpretations and was no doubt responsible for the name by which the Mosaic is generally known. To the German tradition fashioned by Johann Gustav Droysen in history and by Goethe in cultural matters, it seemed inconceivable that Alexander could not be depicted as the all-conquering hero. Yet a mere glance at the picture shows the truly dominating position of Darius in his chariot as the artistic focal point on the right, as the tree is on the left, and above all the visual obscurity of Alexander himself—as was in due course partly recognized by some art historians (e.g., Ludwig Curtius). The Mosaic should in fact have been more appropriately called the Darius Mosaic.

But the facts have had little effect on the general interpretation, even down to the present. Heinrich Fuhrmann, in what is still much the fullest and in many ways the best treatment of the Mosaic,[5] sees in the portrayal of Darius only "Sorge um das eigene Ich" (p. 143) and describes him as "Schreckerstarrt, mit angstvollen Augen, . . . die Rechte waffenlos ausstreckend und damit auf jeden Widerstand verzichtend"; whereas Alexander "blickt . . . fest und unbeirrt auf sein Ziel" [Darius]. Not only is this far from Goethe's sensibility, but the untrained onlooker, ignorant both of art history and of the historical background, would surely find it impossible to understand how a trained eye could see in this picture what the expert here describes.

Nor has the composition, much admired by critics, always been better understood. Thus Ludwig Curtius[6] says of Alexander: "Er ist nur Vordrängen, nur Richtung [*sic*], nur Tun. Die Perser, das ist nur Erleiden." Georg Lippold, writing in the *Real-Encyclopädie*,[7] finds classical standards of composition satisfied, "obwohl die größere Masse auf der Perserseite ist": the left side has "das Gegengewicht der Vorwärtsbewegung." (We cannot help wondering how he knows this, since practically the whole of the left side is lost.) More recently, Tonio Hölscher,[8] no mean art historian, opined: "Von Alexander geht die Bewegung aus." (The reader is invited to look at the

actual picture!) One could continue the dreary catalogue, but let us conclude with an extravaganza by a recent writer, as well informed on the Mosaic as any of the great men cited. Burkhard Fehr, in an idiosyncratic interpretation of the original as having been painted in Egypt, finds in it from the Greek point of view a depiction of the barbarian King as cowardly and cruel, while from the Egyptian point of view he sees Alexander as the true Pharaoh and Darius mocked as the foreign enemy.[9]

II

Some general reflections seem indicated before we start. A realistic action painting like the original of the Mosaic is the painter's equivalent of a snapshot—except, of course, that within given limits it may vary reality according to the artist's choice. They are alike in that the painter chooses to "click the shutter" at a certain point in the action and, like the photographer (though with greater freedom of action, especially since he is depicting a past event), he selects the moment at which he does so. The photographer must in the heat of action choose a moment that illustrates what he regards as the significant message; the painter, correspondingly, also chooses his moment, but is free to reconstruct it and is not forced to seize it as it occurs. It is helpful to bear this in mind when we look at the Mosaic.[10]

It would have been easy, and tempting, to show a godlike Alexander eagerly riding toward and thrusting his lance at a King whose back was turned in flight: the King's terrified face (as Fuhrmann saw it), full of fear for his own safety, could be shown as he turned his head. Fortunately, this is not merely a theoretical construction. This is largely how the scene is depicted on an Apulian amphora from Ruvo, by the "Darius Painter" (Naples Museum no. 3220), which some art historians have actually thought similar to the Mosaic. (It is also worth commenting on the limp right arm held out by Darius in the painting and on the look of resignation on his face, as contrasted with the face tight with horror and the arm purposefully stretched out toward the enemy in the Mosaic.) What our artist has chosen to show is vastly different: as different as it could be, given the fact that he had to keep within the constraint of the historical situation well known to his public.

Since practically the whole of the Macedonian half of the picture is lost, we cannot tell how that was shown. But it is reasonably clear that, at the imaginary moment when the painter chose to click his shutter, the actual movement was from right to left—not from left to right, with Macedonians pursuing the fleeing Persians. Darius himself leans forward, as do two of the Persians seen in front of him; in fact *no* Persian except for the charioteer clearly leans away from the enemy. The one Macedonian we can see does not seem to be leaning toward the enemy, and his helmet points toward the

left. As for Alexander himself, the "camera" has caught him at a time when (for whatever reason) his horse is rearing, so that he too leans slightly away from the enemy. No one, of course, could show Alexander as retreating, since the painting was intended to be essentially true to the historical event. But it is interesting that Bucephalus, at any rate, could be shown as *apparently* unwilling to attack and rearing away from the enemy, thus imparting to Alexander's body the paradoxically contrary inclination that the artist was clearly aiming at.[11] The momentum is strikingly enhanced by the tree. Its trunk could easily have been represented as pointing in the direction of Alexander's attack, or at least as standing straight upright. In fact, it shares the inclination from the Persian to the Macedonian side and, dominating the whole picture as the viewer first looks at it, impresses it on him before he even has time to note the details. The tree is in a way the conductor of the whole ballet that is acted out underneath it. It embodies and directs the tour de force of the artist's conception.

The effect is vastly increased by the lances in the background on the right. Where we can see the bearers, they are Persians, and all but three on the far right point toward the Macedonian enemy. Among them, visibly carried by a Persian (as his costume shows), is one that displays (for us) the remains of a banner, most of it erased by damage. It is not inclined quite as much as the actual lances, but it still clearly points in the right direction. This posed a problem for the traditional interpretation. Fuhrmann (p. 142) had long ago correctly identified the banner as the royal standard: that had to be explained away. The lances were correctly seen to be *sarissae* characteristic of Macedonian armament. This was developed into the interpretation of their bearers being Macedonians (contrary to what our eyes tell us where we can distinguish them): they had surrounded the Persians and were closing in to annihilate them. But what could be done about the royal standard? With increasing unanimity Andreas Rumpf's "proof" that it was in fact a Macedonian signal for attack has been followed—never mind the fact that it would be singularly out of place for such a signal and that it is slanted in the wrong direction.[12]

It was one of Nylander's great merits to expel this whole phantom and restore the true interpretation. Consulting old drawings that showed the Mosaic before some deterioration had set in, he found that the symbol on the banner was a bird and that, in view of what we know of Achaemenid symbols, the banner must be a royal standard and presumably Darius's own. It follows that the lances are indeed carried by Persians, even though they are Macedonian-style *sarissae;* and this led Nylander (for the first time, as far as I know) to a reasoned identification of the battle intended. It must be Gaugamela. According to Diodorus (17.53.1), the only source that gives details of Darius's arming of his forces between Issus and Gaugamela,[13] he "had made [his army's] swords and lances much longer than the ones they

had had before, since it was thought that it was because of these weapons that Alexander had had a great advantage in the battle in Cilicia [i.e., at Issus]."[14] Gaugamela (at the time called Arbela, its vulgate designation) had been the original identification of the battle when the Mosaic was discovered.[15] It was accepted by Fuhrmann (p. 44), who fitted it to Callisthenes' account of the battle as reported by Plutarch. A further detail may point toward this identification. Andreae (p. 20) noted the shadows that appear on the right in some places: they show the fact that the sun was behind Alexander. He regarded this as a detail that confirmed the artist's overall accuracy. We may add that it also seems to confirm Gaugamela as the identification. On the plain of Issus, extending roughly north to south, the sun could not have been behind Alexander except briefly in the middle of a winter's day—much too early for the decisive moment in the battle. We do not know the orientation of the battlefield at Gaugamela, but since the possibility is not excluded, we must take it that this was the battle the artist intended.[16] This detail further strengthens Nylander's decisive proof.[17]

As we have seen, it has at times been observed that it is Darius who dominates the action. He is raised above all others on his chariot, where he stands up to increase the effect and leans forward toward the enemy, who is leaning away from him. His right arm is stretched out toward that enemy whom he now realizes he will never actually reach. The expression of horror on his face, as he contemplates the self-sacrifice of his faithful nobles, has almost invariably been seen. (We have noted the strange exception of Fuhrmann.) As for the portrayal of Alexander, it was noted by Fuhrmann that this is not the standard later heroic or divine portrait, but a portrait of a warrior (pp. 131 ff.). Fuhrmann drew attention to the "Backenbärtchen" that must be true to life, since they were later affected by some of Alexander's imitators. Andreae calls the portrait truest to life of all we have (p. 40) and comments, i.a., on the heavy chin, the arrogant lips and the knitted eyebrows, which, with his large (and, we may add, ruthless and fanatical) eyes make the face "schreckenerregend." (The portrait can be well studied in Andreae's enlargement on p. 41, just as Darius's can be on p. 43.) Ludwig Curtius (op. cit. n. 3, p. 329) calls it "das einzige authentische *und durch seine Häßlichkeit garantierte* [Porträt Alexanders; my emphasis]." Andreae (25) practically echoes these words. It must be added that, in life as we know it, ugliness does not guarantee the full authenticity of a portrait: it is as likely to be a caricature. But that, of course, was beyond the imagination of those who regarded the "Alexander Mosaic" as glorifying Alexander.

It must further be noted that this Alexander not only, as we have seen, seems to be unable to control his recalcitrant horse, which imparts to him the appearance of leaning away from his enemy, but he is bareheaded. This has been taken to be a heroic attribute—but then we notice, even in our fragmentary representation, that his helmet is lying on the ground. He is,

to put it bluntly, a man who has lost his hat.[18] The representation as a whole may justly be called not merely not heroic, but deliberately unheroic, even though (in Andreae's word) terrifying.

We have already noted the importance of the tree. If it is Darius who dominates the action, it is the tree that dominates the whole composition. We must now note how it serves as a link among the principal actors, with one exception, probably due to the loss of much of the Mosaic.

Its left branch is roughly parallel to Darius's outstretched right arm: it is impossible to say whether the approximation is due to the mosaicist or to the original artist, who may have wanted to create an impression of a parallel without too obvious insistence. But we note the twig at the top of the branch, corresponding to Darius's thumb. The branch is more precisely parallel to the slope of Bucephalus's head, even to mirroring the little lump on the horse's head. The two strands of the horse's mane falling over his forehead correspond inversely to two twiglets to be seen above the lance. On the right side of the tree, the little branch is parallel to the right arm of the charioteer, with a twig at its end recalling the angle of the charioteer's whip. The main (vertical) branch on the right parallels Darius's left arm, though pointing in the opposite direction. But there is nothing except perhaps the inclination, which we have noted, to link what we have of Alexander with the tree. We can only assume that this is due to our having so little of Alexander's body preserved. In view of the careful links established by the artist, it would be astonishing if Alexander had not been drawn into the scheme. It is not unreasonable to suggest that, if we had his right leg, it would show some parallelism to one of the features of the tree, and so probably to one of the other main actors. Of course, this can never be proved. But it is surely an obvious, indeed (I would say) a necessary hypothesis, in view of the artist's care in linking the main actors through the tree.

The most astonishing fact about the tree is that it is a striking piece of deliberate fiction. Everyone knew that, in order to deploy his cavalry and scythed chariots to best effect, Darius had "flattened the ground" on the whole battlefield (Arr. 3.8.7; elaborated Curt. 4.9.10). The artist introduced the tree, as the key to his whole composition. No doubt it was also intended as a many-faceted symbol. At the simplest level, it may be taken to symbolize the destruction and denudation caused by Alexander's war. But it must surely above all be a memento mori. In the words of "Nabarzanes" in Curtius's delightful Roman *controuersia* that precedes the death of Darius III: *ultimum omnium mors est* (Curt. 5.9.7). Or, in the words ascribed to a modern economist: "In the long run we are all dead." This trivial truism certainly acquired some exposure in Hellenistic times. It is here raised from banality to the level of great art by the role assigned to the fictitious tree. After all, much great art has (if I may say so) been rooted in universal truisms. The

tree, dwarfing Alexander "the Great," essentially stands for the vanity of human, and especially of heroic, effort. Andreae has commented on the splendid portraiture we find in the Mosaic: of Alexander, of Darius, even of Bucephalus ("a portrait of a horse"). We may add, a portrait of a dead tree.

I was fortunate to be able to discuss this with Professor Anthony Snodgrass when he visited Harvard. He later wrote to me that he knows of nothing precisely parallel in earlier Greek art. As far as specifically Macedonian art is concerned, the matter is more complicated. We shall return to it after considering the identity of the artist.

III

The only Alexander battle reliably assigned to an artist in antiquity is that painted by Philoxenus of Eretria for Cassander: *cuius tabula, nullis postferenda, Cassandro regi picta, continuit Alexandri proelium cum Dario* (Pliny, *NH* 35.110). An obscure manuscript here reads *rege*, which would transform Cassander into a mere chronological point of reference and move the *terminus ante quem non* down to when he began to call himself king, some time after 311. Fortunately, I have not seen any serious attention paid by textual critics to that variant. We may take it that Cassander commissioned the painting—and not necessarily after he became king, for such titles are freely used merely to pinpoint identity, without intended chronological implications. An ascription of such a painting to an Egyptian Helen by Ptolemy "Chennus" ("the Quail") was disbelieved, along with much other stuff reported by that purveyor of fiction, by Adolf Michaelis (cited by Fuhrmann) over a century ago and was completely demolished by Fuhrmann, who supported the ascription to Philoxenus with elaborate arguments. (He pointed to connections between Philoxenus's teacher Nicomachus and Cassander's father, Antipater, attested to in ancient sources.) Pliny's high praise for his painting would certainly fit what most modern critics have said about the Mosaic.[19]

Yet Fuhrmann's powerful arguments have recently tended to be rejected, usually by far from convincing reasoning.

Thus Andreae, while expanding Pliny's judgment that "Die Komposition zählt zu den großartigsten, die je von einem Künstler entworfen wurden" (p. 19), rejects Philoxenus, because Pliny reports that he did his painting quickly, whereas the original of the Mosaic cannot have been the work of a "Schnellmaler." (He is more inclined to accept its assignation to Apelles— absurd, because it could not fail to be mentioned in the numerous sources on his works—because Apelles was the greatest of Greek painters!) But relative speed of execution—Philoxenus is said to have worked even faster than Nicomachus—is not necessarily a mark of lack of quality, any more

than length of time employed in the composition of a work of art, music, or literature is any guarantee of it. Both Bach and Mozart could be called "Schnellkomponisten."[20]

Moreover, we cannot be sure that there are no signs of "Flüchtigkeit" in the painting. Some infelicities usually ascribed to the mosaicist may be due to the painter. Ludwig Curtius (op. cit. n. 3, p. 332) thought that only the central figures are rendered with real care, and that away from them the rendering becomes "flüchtig und ungenau."

Nor did Andreae notice that one of his own best comments, that Alexander's face is "schreckenerregend," fits in precisely with what Plutarch reports about Cassander's reaction to Alexander (*Alex.* 74) after Alexander had treated him inhumanly,

> Cassander's spirit was so deeply penetrated and imbued with a dreadful fear of Alexander that many years afterwards, when he was now king of Macedon and master of Greece, . . . the sight of an image of Alexander struck him suddenly with a shuddering and trembling from which he could scarcely recover, so that he became dizzy at the sight.

This is also the answer to others, who have denied that Cassander, with his hatred of Alexander and Alexander's family, could have chosen to commission a painting of one of Alexander's victories to adorn his palace. We must consider how it was depicted.

Cassander was acquainted with Peripatetic philosophers. The painting he commissioned was, as we have seen, a "philosophical" one. Alexander is shown with his features distorted to the ruthless ugliness that Cassander remembered; the battle is paradoxically depicted at a moment when his enemy, although ultimately defeated, dominates the action; and the tree behind him symbolizes the vanity of his heroic striving and the destruction that was the sole result of it. I see no reason why Cassander should not have ordered a painting such as this, as part of his vengeance against Alexander. It is only the German romantic admiration for Alexander, which comes across in so many of the comments on the Mosaic, that will see a problem in this. A further reflection ought at least to be set out for consideration. When Cassander commissioned, and his artist executed, a painting showing Persian nobles sacrificing themselves for their King, and the King's compassionate horror at their sacrifice, one wonders whether, at least in Cassander's mind, there was an implied comparison with Alexander: the Alexander who had rewarded some of those who most loyally fought for him (Parmenio and Philotas), who had saved his life in battle (Clitus), and even those who had unhesitatingly carried out his repulsive orders (the murderers of Parmenio), with death. Cassander well knew that that fate was probably in store for his father Antipater, who had loyally governed Greece for Alexander and saved it for him at the time of Agis's war: for Antipater

had been superseded by Craterus and recalled to the court; with the fate of others swept up in the great purge after Alexander's return from India before his eyes, he refused to obey and instead sent two sons to Alexander as hostages—one of them Cassander himself, whose treatment at Alexander's hands both imbued him with that indelible fear and hatred and clearly showed the fate in store for Antipater if he obeyed the summons. He was in fact saved by Alexander's death, and so (perhaps) was Cassander himself.[21] Perhaps this at least in part accounts for the introduction of that striking *Motiv,* which was not part of the general tradition on the battle or even an obvious theme to dwell on.

It is clear that the artist must at least have worked from a very detailed description of Darius, whose depiction seems as realistic as that of Alexander (if more sympathetic). Indeed, since the Persian tradition, inherited from Mesopotamia, did not go in for realistic portraiture, Darius III is the only Achaemenid King whose features we actually know: like Alexander, he must here be shown "true to nature," as far as his basic features are concerned. It is in fact very likely that the artist must himself have seen Darius, whether in life or after the King's death. That he knew Persian traditions on depicting the King is clear. As we know from Persepolis and Naqsh-i Rustam, the King had to be shown taller than anyone in his company. This, of course, could not be done in a Greek painting. But this artist has skillfully transferred that traditional rendering into the Greek medium by the way he arranged for Darius to tower from his chariot above the other figures. He must have been to one of the Persian capitals—at least Susa, if not Persepolis itself—where he could pick up that information. The evidence compels the conclusion that he was either on Alexander's expedition, at least as far as the Persian heartlands, or that he traveled there a little later and got his information on Darius's appearance at second hand.

Nylander some time ago suggested that the painting was commissioned by someone who aimed at reconciling Greeks, Macedonians, and Persians.[22] He seems by implication to point to Seleucus, although he does not name him. If so, it would be easy enough to imagine the artist in Seleucus's company, visiting the old Achaemenid capitals and receiving from Seleucus and some who had served with him an account of the features of Darius III that might enable him to devise his portrait. Like everything that Nylander has written about the Mosaic, or indeed about Achaemenid matters, this will have to be very seriously considered. But I must disagree with him on one or two points, which admittedly are not vital to his interpretation; yet their abandonment would weaken it and allow for an alternative. First, as will be clear, I do not at all agree that this painting "glorified Alexander" (his p. 694); nor (as he will know) do I accept his statement that Alexander's ideas included "brotherhood among nations, unity between East and West" (p. 693): this is the Alexander of Tarn's historical fiction, not (as far as I know)

based on anything in real life or the principal sources.[23] As for Seleucus, we simply do not know how he regarded or treated Persians; although we do know that, for good political reasons, he did not divorce Apame, and that he was popular in Babylonia, so he may have treated them well. On the other hand, since he, like the rest of the Diadochi, in part derived his legitimacy from Alexander, I cannot conceive of his conspiring in having Alexander characterized as he is in this painting.

To return to Philoxenus, whom Fuhrmann so plausibly confirmed as the best candidate. Did he accompany Alexander? Unfortunately, we cannot tell. We can only say, *Nihil obstat*. Alexander's moving court included painters, as well as poets and philosophers, who are occasionally attested. Apelles certainly accompanied the expedition, at least for some time. And Alexander's widely reported unwillingness to let anyone other than Apelles paint him shows that there were other willing candidates about. They are not named, simply because they never succeeded in painting Alexander, and because the special favor shown to Apelles made it inevitable that his officers who wanted to be immortalized would also let only Apelles paint them.[24] Of the poets and philosophers too, only those are actually named who came into close contact with Alexander (e.g., Agis and Anaxarchus). Those artists who knew their own worth—and if Philoxenus was there, we may take it that he was among them—would not like Alexander any better because of their exclusion. They might be prepared to work for Cassander.

For all these reasons, which admittedly cannot be called decisive, but which seem to me better than those advanced for any other ascription, I would prefer to restore the credit for this outstanding painting, *nullis post-ferenda* (as all its interpreters admit), to Philoxenus of Eretria.

IV

Let us now return to the puzzle of the tree.[25] In Hellenistic times, dead trees became mere items of artistic furniture, as indeed they are on Macedonian tombs, most of which are Hellenistic in date. Their first appearance in Macedonia is in the famous frieze of the "royal hunt" on tomb no. 2 at Vergina, identified by Manolis Andronikos as the tomb of Philip II.[26] In addition to some living vegetation, the scene shows two dead trees in the center, framing a wreathed youthful figure aiming at a lion. Andronikos identified the young man as Alexander, with Philip an older, bearded man (not much of whose face survives) over to the right, also aiming at a lion. He at once compared the dead trees to the tree in the Alexander Mosaic, pointing out various similarities (some of them not easy to see, in part perhaps because of the poor state of preservation of the frieze). He points out, quite rightly, that the artistic standard of the frieze can in no way be compared to that of the Mosaic. From this he concludes that the frieze may be

the work of the same artist as the original of the Mosaic, only "not less than fifteen or twenty years" earlier. He inclines to accept Philoxenus of Eretria as the artist in both cases.

There is an obvious *petitio principii* in the argument. If the two works are not by the same artist (and nothing actually proves that they are), then the fact that the frieze is not as outstanding a work of art as the Mosaic is irrelevant to their respective dates, even on the assumption that one was influenced by the other. As is well known, many scholars believe that tomb no. 2 is that of Philip III (Arrhidaeus), and the question may be regarded as still open.[27]

Now it was suggested to me by Professor Olga Palagia that the dead trees are descended from Persian funeral monuments in Asia Minor of the fifth and fourth centuries. The best-known of these, frequently reproduced, comes from a site near Dascylium and shows a hunt including a (perfectly straight) dead tree.[28] If, as is likely, these *paradeisoi* scenes were indeed the inspiration of the royal hunt at Vergina, it is likely that that painting was executed after Alexander's invasion of Asia Minor, most probably indeed after the return of his soldiers in 323. Professor Palagia is among those who believe that it adorns the tomb of Philip III and that the tomb was constructed under Cassander. This of course brings the frieze into close proximity to the original of the Mosaic: there is no easily imaginable way of telling which precedes the other. If we accept the similarities noted by Andronikos, it would seem that one was the model for the other. But some of the similarities are less striking on close inspection. Thus the two straight dead trees of the frieze, although also used as artistic devices (to frame the main figure in the frieze), show no close resemblance to the dominant tree, with its tone-setting leftward slant, in the Mosaic. It is probably easier to posit that both these works were independently inspired by Persian tomb art seen in Asia Minor.

If the frieze indeed postdates the return of Alexander's soldiers and was executed under Cassander for Philip III, this has an obvious bearing on the identity of the figure framed by the trees. On general principle, that figure ought to be the inhabitant of the tomb: no one else would reasonably be given such a central position. Indeed, this is a basic flaw of Andronikos's identification of the tomb: there is no good reason why, in a tomb erected for Philip II, Philip should be depicted in an out-of-the-way position, with Alexander holding the center of the stage. If we assume that it is indeed the tomb of Philip III, the objection vanishes: there is no argument against the central figure being an idealized Arrhidaeus—with his father Philip shown in a corner, much-needed authentication of his claim to rule, for which his descent from Philip was the sole qualification. The wreath can also now be explained: we hear incidentally that, on Alexander's expedition, Arrhidaeus, not known to have held any military or administrative post, had in

fact been a priest (Curt. 10.7.2; according to Curtius, this was urged in his favor when he was put forward as a candidate for the throne).[29] In view of what we have seen about Cassander's attitude to Alexander's memory, it would of course be quite unimaginable that Cassander could have made Alexander the central figure in a frieze on a tomb whose occupant was in any case not Alexander himself.

The identity of the occupant of the tomb and that of the central figure on its frieze will no doubt continue to be debated. It is here only of marginal concern, but needed a mention. As far as the original of the Mosaic is concerned, the introduction of the deliberately fictitious dead tree as a symbol and as the artistic center of the whole composition was quite probably suggested by Persian hunting scenes in *paradeisoi* depicted in Asia Minor. (I have seen no reference to such trees in earlier *battle* scenes.) This only makes the originality of the artist's genius shine forth all the more brightly.

NOTES

1. I refer to Andreae's final publication, *Das Alexandermosaik aus Pompeji* (Recklinghausen, 1977), with a foldout of the Mosaic and enlargements of various details, in much better colors than the visitor to Naples would ever see in the Museum. I am grateful to the editors of this volume who, right from the start, agreed to having a color reproduction of the Mosaic included with my essay, which indeed would not make much sense without it, and to Professor Andreae for allowing the use of his reproduction in this volume. It will be obvious that I unfortunately could not use the extended new treatment of the Mosaic by Ada Cohen, *The Alexander Mosaic: Stories of Victory and Defeat* (Cambridge and New York, 1997).

2. I have only recently seen Andrew Stewart's *Faces of Power: Alexander's Image and Hellenistic Politics* (Berkeley and Los Angeles, 1993), where the Mosaic is discussed in detail (esp. pp. 130–50), unfortunately with a rather poor reproduction. I am glad to see that on some points of detail he has independently reached readings similar to mine, and if there are far more points on which we differ, that is largely because of the difference between a general historian and an art historian. I shall not, on the whole, comment on the differences in detail, since I have found his book very instructive, in part because of the very fact that it is methodologically so remote from the works of historians.

3. I assume throughout that the general execution of the Mosaic was, in its undamaged state, of a very high level, as Andreae's reproductions make clear, and that we are entitled to attribute what we see to the original artist. In this, I am happy to follow Nylander's judgment in *Opuscula Romana* 14 (1983): 19 n. 4. The excellence of the composition has always been recognized. See, e.g., Ludwig Curtius, *Die Wandmalerei Pompejis* (Leipzig, 1929), 329: "Dem, der sich die Mühe nicht verdrießen läßt, sie immer aufs neue zu studieren, eröffnet sich die grandioseste Komposition eines Gemäldes, die es überhaupt gibt." (Echoed by Andreae, *Alexandermosaik*, 19.) And see further n. 6 below.

4. See the treatment in Andreae, *Alexandermosaik*, 29 ff.

5. Heinrich Fuhrmann, *Philoxenos von Eretria: Archäologische Untersuchungen über zwei Alexandermosaike* (Göttingen, 1931). I again unhesitatingly share Nylander's admiration for this work (expressed loc. cit., n. 3 above).

6. Op. cit. n. 3 above, 335. Yet he not only comments on the excellence of the composition, but in that respect compares the artist to "dem Geschlechte der Raffael, Michelangelo und Rubens"!

7. *RE* s.v. Philoxenos 29, col. 202.

8. Tonio Hölscher, *Griechische Historienbilder des 5. and 4. Jahrhunderts v. Chr.* (Würzburg, 1973), 127.

9. Burkhard Fehr, in *Bathron: Beiträge zur Architektur und verwandten Künsten für Heinrich Drerup*, ed. Hermann Büsing and Friedrich Hiller (Saarbrücken, 1988), 121–34, at pp. 125, 128. The cruelty is said to be shown by the charioteer whipping his horses to run fast over the bodies of Persians in the way. However, he is not depicted as actually whipping them; and would one push the accelerator to the floor when going round a sharp bend? The most reasonable suggestion made is that he is signaling with his whip held high for Persians to get out of the way.

10. Andreae, *Alexandermosaik*, 19, seems to get close to realizing this, but he is too caught up in the traditional Alexandrolatry to pursue it or make much of it. He even manages to find (33) that "in der rechten Bildhälfte die Kompositionslinien sich nach rechts neigen" (with the sole exception of Darius, and no mention of the *sarissae* in the background). He was presumably looking from the top down.

11. Needless to say, this too can be explained away, with sufficient imagination. Andreae (cf. preceding note) finds proof, in the piece of the rear leg of Alexander's horse that survives (16), "wie das Pferd . . . zum Sprung ansetzte, aber von Alexander durchpariert wird." The picture of that hoof is not shown among the many excellent enlargements. This painting, incidentally, was one of the first works of art showing a rider in battle on a rearing horse. That soon became fashionable. But in later examples (chiefly sculpture) the rider sits vertically on his horse (as in the Dexileos memorial in Athens) or actually leans forward (as in one scene of L. Aemilius Paullus's relief at Delphi).

12. Thus Andreae: "Above everything there rises the Greek sign of victory, the red standard giving the signal for attack" (Andreae, *Alexandermosaik*, 69, my translation). This, of course, is the only way of saving the implausible interpretation of the lances in the background as showing Macedonian soldiers.

13. Arrian is not interested in the Persian armament, and Curtius's real interest is limited to the exotic scythed chariots (4.9.4), details of which were bound to fascinate his readers.

14. As I put it in a contribution to a memorial essay for David M. Lewis (forthcoming): "No army in the field was ever better prepared for a single battle than Darius' at Gaugamela." Unfortunately, its commander was not at the same level of excellence.

15. See Andreae, *Alexandermosaik*, 31.

16. Andreae strangely comments on Alexander's choosing to attack with the sun behind him, "so wie jeder geschickte Feldherr der Antike." (One could surely extend this to more recent times.) He overlooks two facts. First, that Alexander could not choose the direction of his attack, either at Issus or at Gaugamela. At Issus, Darius's army was uncomfortably fitted into a narrow plain and Alexander, coming up from

the south, could only move northward. At Gaugamela, Darius was waiting for him, encamped on a large plain; Alexander had led his forces to a ridge overlooking that plain and the attack would have to be launched from there, no matter where the sun was that morning. Second, and above all, that if Alexander, at Gaugamela, was fortunate enough to be able to attack with the sun behind him, he could not expect the sun to stand still (as in the Bible at Jericho) for the whole day that the battle would take. The only battle where Alexander had that choice was the battle of the Granicus. There he could choose between attacking across the river in the afternoon, with his army somewhat tired from the march but with the sun shining straight into the enemy's eyes, and waiting until next morning, with his men rested but having to face the sun as they crossed the river. Alexander wisely opted for the former. That battle could be expected to be a short one, as indeed it turned out.

17. That is not to say that the wrong identification has not been arbitrarily revived: thus F. Salviat in the *Acta of the 12th International Congress of Classical Archaeology*, vol. 2 (1988), 193–97. Stewart, *Faces of Power* (cit. n. 2 above), 134, argues for Issus, but I do not find his rather subjective arguments persuasive. He apparently did not know Nylander's article. The game will no doubt continue, as scholars seek "originality."

18. Andreae probably knew, though he does not mention, the portrait of Alexander holding the thunderbolt that forms the reverse of the "Porus decadrachms" (or, as Martin J. Price preferred, largely for the sake of his theories, "5-shekel pieces"). Since that time, more of these coins have turned up. That portrait is presumably related to (if not based on) the famous painting by Apelles at Ephesus (see, e.g., Pliny, *NH* 35.92; Plut. *Alex.* 4—which helps to show that what distinguished the painting simply cannot appear on a coin). Both must have been done after Alexander's return from India, the first time when divine (as distinct from heroic) pretensions are attested in him. But the coin portrait is much too small to give any detailed impression, and it can in any case hardly be expected to be realistic. The identification of the fallen helmet in the Mosaic, visibly adorned with a horn characteristic of the royal Macedonian helmet, as Alexander's has of course been denied by some who see him depicted as the all-conquering hero. See, e.g., Tonio Hölscher (op. cit. n. 8 above, 129 f.), who claims that the helmet is not Alexander's (he does not say whose it can be): Alexander is shown heroically bareheaded. (A disquisition on kings and emperors later portrayed bareheaded is added, without reference to the fact that they must have imitated portrayal of Alexander.) Andreae, to his great credit, takes it for granted that the fallen helmet is Alexander's.

19. "Chennus" was not revived even by Fehr (cit. n. 9 above with text), who argued that the painting was produced in Egypt. Unfortunately, Stewart, *Faces of Power* (cit. n. 2 above), lists that notice without any warning as serious ancient documentation. Art historians not familiar with source criticism, and with this discussion in particular, may well take it seriously. It is perhaps worth pointing out that Chennus's statement comes from his book 4, on women called Helen. It lists, i.a., a Helen, daughter of Musaeus, from whom Homer took his plot, and a Helen who fought a duel with Achilles and almost killed him. That "Helen's" painting of the Alexander battle is said to have stood in the enclosure of Vespasian's Temple of Peace raises the intriguing possibility that Philoxenus's painting, like so many great Greek works of art, ended up in Rome—whether specially shipped across for the Temple of Peace

or (rather more likely) taken from some other public place in Rome, where an earlier Roman art thief had displayed it.

20. Stewart, *Faces of Power* (cit. n. 2 above), 147 f., has advanced a different explanation of the term used by Pliny, which would not refer to speed of execution. I do not know enough about the terminology of ancient art criticism to discuss this, but as it comes from a distinguished art historian, it will have to be seriously considered. However, the context in Pliny undoubtedly suggests actual speed of execution: note his reference to "Laia" (if that is the correct reading)—"no hand was faster [*uelocior*] than hers." I have compared the floating anecdote of the painter who, when his sitter complained of the high price charged for a few hours' work, replied that it was based on a lifetime of experience.

21. On this see my treatment in "Harpalus," *JHS* 81 (1961): 16–43, at pp. 16 ff.

22. Carl Nylander, "Il milite ignoto," in *La regione sotterrata dal Vesuvio*, ed. Alfonso de Franciscis (Naples, 1982), 689–95.

23. See my essay "Alexander the Great and the Unity of Mankind," *Historia* 7 (1958): 425–44, the conclusions of which seem to have been generally accepted.

24. For Alexander's insistence on letting only Apelles paint him, widely reported, see, e.g., Pliny, *NH* 7.125. (Pyrgoteles and Lysippus were the only artists allowed to portray him in sculpture.) Complete documentation on Apelles in H. Berve, *Das Alexanderreich auf prosopographischer Grundlage* (Munich, 1926), vol. 2, no. 99. Berve thinks Lysippus accompanied Alexander as far as the Granicus, but as far as I recall, does not list any other artist as accompanying the expedition. No others are named in our sources.

25. What follows owes much to a fine lecture by Professor Olga Palagia at a colloquium on Alexander organized by Dr. Elizabeth Baynham and Professor A. B. Bosworth at the University of Newcastle, NSW, in July 1997. Professor Palagia also provided some references to earlier literature. She should of course not be taken as agreeing with any of my interpretations. (I know that she disagrees with some.)

26. See Manolis Andronikos's splendid publication *Vergina: The Royal Tombs and the Ancient City* (Athens, 1984), 116 ff. The "royal hunt" has been much discussed, particularly with reference to Persian and possible earlier Macedonian influences. See, e.g., the articles by Bruno Tripodi and Pierre Briant in *Dialogues d'Histoire Ancienne* 17 = *Annales litteraires de l'Université de Besançon* 450 (1991): 143–209 and 231–43 respectively. Briant is (cautiously) inclined to believe that there were hunts in imitation of *paradeisoi* in Argead Macedonia. He even suggests (234 n. 40) that the Nympheum at Mieza, where Aristotle is said to have taught Alexander, was part of a Macedonian *paradeisos*! But he finally admits that there is little evidence.

27. Basic for this view, A. M. Prestianni-Giallombardo and B. Tripodi, *ASNP*, Cl. di lettere, ser. 3, 10 (1980): 889–1001. Both these scholars have since contributed much to the support of the view by art-historical analysis. Tripodi (cit. n. 26, 209) now dates the tomb "soon after Alexander the Great." It will be clear that this is the view I accept, even though my suggested identifications of the two principal figures in the hunt scene differ from his (and in part from Andronikos's).

28. I have not actually come across other examples of such trees, but take Professor Palagia's word for their existence. They are no doubt well known to specialists. For the one referred to here, see J. K. Anderson, *Hunting in the Ancient World* (Berkeley and Los Angeles, 1985), 71 f. (illustration on p. 72), with references to

previous publications. He thinks it possible that the tree in the relief "suggests mortality." Tripodi (cit. n. 26 above), on the lookout for detailed parallels with the Vergina hunt in earlier art, does not mention this relief or indeed refer to the dead trees in the Vergina frieze except in passing.

29. Even though she thinks the tomb is Philip III's and agrees that the central figure in a tomb painting ought normally to be the occupant of the tomb, Professor Palagia still accepts Andronikos's identification of the central figure as Alexander.

Mimesis in Metal

The Fate of Greek Culture on Bactrian Coins

Frank L. Holt

It was at Athens, on July 30, 1992, as I sat musing amid the relics of the National Museum, inspired by a blundered Bactrian coin and Peter Green's proverbial barking dog, that I conceived the first thoughts of this modest investigation.[1] I was in the inner sanctum of the numismatic department, working my way slowly through the Vasileou Collection, when a worn specimen of King Heliocles I came to hand.[2] This drachm (3.90 g) belongs to an issue struck sometime in the third quarter of the second century B.C. by a king otherwise unattested in ancient sources.[3] The ruler's portrait appears on the obverse, where he wears the diadem and a military cloak, all within a "bead and reel" border. The reverse shows Zeus standing to front, draped, holding a scepter in his left hand and a thunderbolt in his right. Nothing about the types seemed out of place; this was Greek art in a Greek museum.

But when I routinely checked the inscription on this coin, a habit that must be enforced after many years of reading the same familiar words on thousands of specimens, a measure of the relic's Greekness suddenly fell away. It should have read ΒΑΣΙΛΕΩΣ ΗΛΙΟΚΛΕΟΥΣ ΔΙΚΑΙΟΥ, but this coin's engraver had garbled the Greek into progressive nonsense: ΒΛΣΙΛΕΩΣ ΗΛΙ•ΚΛΕΣ ΔΚΙV. Was this a later "barbarian imitation" of a Bactrian coin, the work of a people obviously unskilled in the language? If not, could this be an early sign of cultural change among the Bactrian Greeks themselves? Were the royal mints of Heliocles becoming somehow less Greek, their faltering Hellenism betrayed by botched inscriptions of this sort?

As I jotted these questions into my journal, I recalled Peter Green's own deep thoughts on the decline and fall of the Bactrian Greeks. Only recently, he had written of Hellenistic Bactria as an "extraordinary example of Greek enclave culture" until "finally absorbed by something larger than itself."[4]

Long fascinated by the fate of eastern Hellenism, he has pondered the hold of Greece over Central Asia, and even tested that grip by means of mosaic art—the degeneration of which he likened to the increased inaccuracies and abstractions found on Celtic imitations of royal Macedonian coins in Europe.[5] Some aspect of that larger historical problem had created the coin I held in my hand. The challenge was clearly to quantify and clarify the numismatic evidence—to formulate and then test a hypothesis about the fate of Greek culture in Bactria. If art indeed imitates life, then *mimesis* in metal should preserve for us some important evidence.

HYPOTHESIS

Heliocles I was apparently the last Greek king to rule in the Oxus Valley; afterward, the entire region was occupied by nomadic invaders.[6] These "barbarians" settled in and imitated the coinage of the last of the Greek monarchs, a copying that finally evolved into mere stylized impressions like those on the Celtic coins of Europe. These imitations of Heliocles' coins bear, of course, progressively blundered versions of the original Greek inscription (e.g., BACIΛEΛC HΛIIΛEVC DIIDIV).[7] In some cases, this jumble of Greek-like letters resulted from unschooled die-engravers copying, not the original Greek coin, but the mistakes passed on to them by previous workers. Error then compounded error with no real hope—and no real need—of correcting the original "text." This process makes perfect sense in the aftermath of Greek rule in the East and should come as no surprise for any of the frontiers of Hellenism.

Still unclear in Bactria, however, is the connection between the artists who produced the last Greek coins and those who engraved the dies of the earliest "barbarian imitations." For some scholars, most notably Sir William Tarn, the cultural line between their worlds was absolute. He argued that when Bactria fell to the "barbarians," those Greeks who worked in the mints were all "known to have been exterminated" because "the Greek coinage of Bactria remained fine to the end, and then the great Bactrian artists vanished from the world."[8] But what of the few coins in major collections, like the Vasileou drachm in Athens, that seem to be lifetime issues of a Greek king—coins that would appear Greek enough were it not for mistaken inscriptions? Either "Greek" art (if not language) could be reproduced by non-Greeks or Bactrian coinage did not remain so perfectly Greek to the end. Since Heliocles I ruled after the first onslaught of nomadic invaders around 145 B.C. (which saw the destruction of the Greek city at Ai Khanoum), but before the final blow of around 130 B.C., we may wonder if his coinage provides an index of cultural change in this crucial period. Judging by inscriptional error, rather than more subjective criteria such as

artistic quality, do we find the "Greekness" of his Bactrian coins consistent with—or markedly different from—earlier periods?

My work in many museums, plus a long search through the records of numismatic auctions worldwide, suggested a working hypothesis: while there are minor inscriptional errors throughout the period of Greek coin production in Bactria, most involving no more than errant letter forms, the coinage of Heliocles I betrays a measurable increase in wide-ranging error (multiple errant letter forms and missing or intrusive letters). If validated, then we must pursue the matter in order to explain why this should be the case. As the cause(s) for such mistakes, we might consider a change in the condition or means of production, or a change in the competence of the die engravers to manage the Greek. The latter explanation would suggest that Greek workers were losing their facility with their native language or that mint workers were becoming increasingly non-Greek after the first wave of "barbarian" invasions. Both possibilities would discredit Tarn's interpretation and clarify the process by which Hellenistic Bactria actually gave way to "something larger than itself."

EVIDENCE

To test the general hypothesis (a meaningful increase in the incidence of Greek error on the lifetime issues of Heliocles I), we must find a large representative sample of coins to analyze. To avoid "contamination" of the evidence for lifetime issues, we must avoid modern forgeries and ancient "barbarian imitations."[9] Since our hypothesis is based upon museum and market coins, we must seek a different source of material to test. This is particularly important since the museum and market coins have generally passed through an aesthetic filter that favors unflawed specimens over those with blunders of any kind. Thus, the holdings of most museums and auction houses will not reflect the actual ancient ratio of flawed/unflawed coins.[10] For the Bactrian reigns down to the fall of Ai Khanoum (Diodotus I through Eucratides I), we may naturally use the hoard evidence recovered from this excavated site, plus the secure Bukhara hoard of 1983.[11] To extend our sample through the reign of Heliocles himself, we need to examine the large Kunduz hoard of 1946.[12] Independent of other sources, this sample provides our best information for the Greek coins circulating in the Oxus Valley down to around 130 B.C. or later.[13] If we cautiously exclude from this sample the two (of 221) Heliocles types that *might* be the earliest examples of "barbarian imitations" in the Kunduz hoard, we are left with the database of Bactrian royal silver coins shown in table 1.

In this sample are a number of die-linked specimens, coins struck from the same obverse or reverse die. Our investigation requires that we adjust

TABLE 1 Database of Bactrian Coins

King	Ai Khanoum	Bukhara	Kunduz*	Total
Diodotus I and II	22	5	5	32
Euthydemus I	108	43	12	163
Demetrius I	11	0	8	19
Euthydemus II	4	0	5	9
Agathocles	14	2	3	19
Antimachus I	4	0	14	18
Demetrius II	0	0	50	50
Apollodotus I	1	0	0	1
Eucratides I	9	0	147	156
Eucratides II	1	0	130	131
Plato	0	0	12	12
Heliocles I	0	0	219	219
TOTAL	174	50	605	829

*TQ (*Trésor Qunduz*) nos. 582 and 583, both with multiple anomalies in the inscriptions, are excluded with an abundance of caution as possible "barbarian" imitations: see Osmund Bopearachchi, *Monnaies gréco-bactriennes et indo-grecques: Catalogue raisonné* (Paris, 1991), p. 75. This hoard also contained seventeen coins of later Indo-Greek kings whose issues lies outside the scope of this brief investigation: Lysias (4), Theophilus (1), Antialcidas (3), Amyntas (5), Archebios (2), Philoxenus (1), and Hermaios (1). None has inscriptional errors.

for this fact by counting only the number of different inscribed dies in the sample. In other words, we are tracking the relative number of flawed and flawless dies made by engravers, not how many coins made from a given die happen to show up in our sample. A given inscribed die, with or without mistakes, must only be counted once. With this caveat in mind, our sample yields the basic information shown in table 2.

The sample of dies for some reigns is still too small for reliable comparisons. Can we be certain that Agathocles maintained a flawless mint production, or that Antimachus I could manage only 85 percent accuracy? If grouped roughly by period, we find an error rate down to ca. 200 B.C. of 6 percent of 191 dies; from 200–160 B.C., about 6 percent of 110 dies; from ca. 160–145, about 5 percent of 145 dies; from ca. 145–140, about 3 percent of 128 dies; and finally, for the reign of Heliocles, from ca. 145–130, about 19 percent of 180 dies. This seems to validate our general hypothesis. Too, if we safely consider only those reigns for which our sample provides a minimum of 100 inscribed dies, we have: Euthydemus I (7 percent errors), Eucratides I (5 percent errors), Eucratides II (3 percent errors), and Heliocles I (19 percent errors). The incidence of error seems quite significant for the coinage of Heliocles I, marking a nearly fourfold jump from that of his father, Eucratides I. One surprise is the very low rate of error for

TABLE 2 Incidence of Error on Inscribed Dies

King	Inscribed Dies	Error Dies	% Flawed
Diodotus I and II	31	0	0
Euthydemus I	160	11	7
Demetrius I	18	0	0
Euthydemus II	9	0	0
Agathocles	18	0	0
Antimachus I	20	3	15
Demetrius II	44	4	9
Apollodotus I	1	0	0
Eucratides I	145	7	5
Eucratides II	118	4	3
Plato	10	0	0
Heliocles I	180	34	19
TOTAL	754	63	8

Eucratides II, whose coinage seems to have been minted slightly before and after the fall of Ai Khanoum.[14] The more than sixfold increase of Greek error from Eucratides II to Heliocles (perhaps brothers with partially overlapping reigns) suggests a rapid deterioration as the full effects of the first "barbarian" invasion were felt in the Oxus Valley.

To understand what this evidence means, we must consider more closely the nature of these errors. In most cases, the flawed dies have only errant letter forms. We may classify these as follows: (a) V for Υ; (b) Λ for A; (c) b for B; (d) O for Θ; (e) : for I; and (f) I for P. These are plainly "one-stroke" errors, where the engraver omits, or does not clarify a single stroke in the formation of a Greek letter. Most of the flawed dies identified in our sample exhibit a single variety of one-stroke error. For example, 100 percent of the error dies for Euthydemus I and Antimachus I are mistakes of this sort (i.e., an error of the type a–f, but never two types of error on the same die). By contrast, only 71 percent of the error dies of Eucratides I are of the simple variety, and for the flawed dies of Heliocles I "simple" errors account for only 38 percent of the total. Eucratides II has 75 percent error dies due to errant letter forms, but in each case there are multiple error types (combinations of varieties a, b, and f).

These observations suggest that the early mints of Bactria generally produced error-free dies, and that most lapses were due to an engraver's sloppy work on just one given letter. If hurried, careless, or ignorant, an engraver might fail to cut crossbars on alphas, crossbars on thetas, bases on deltas, stems on upsilons, curls on rhos, curls on betas, or to connect the dots for iota. These oversights often produce an actual (if erroneous) Greek letter,

not a nonsense mark that stands out. Therefore, such inscriptions look respectable enough when scanned quickly since the eye tends to "see" the expected letter form, especially when it is surrounded by accurate ones as in ΒΑΣΙΛΕΩΣ or ΕΥΟΥΔΗΜΟΥ. Such is the limited character of early Bactrian die flaws in our sample of coins.

With Eucratides I, this sort of error continues, but there are also more complex engraving mistakes involving more noticeable flaws: combinations of error types a–f, missing letters, or intrusive letters. Of his error dies, 29 percent are complex mistakes, representing an overall rate for complex error of 1 percent.[15] For Eucratides II, all error dies are complex, representing an overall rate of 3 percent complex error.[16] This jumps dramatically with Heliocles I, whose dies exhibit a 12 percent overall incidence of complex error (of his flawed dies, 38 percent have simple errors and 62 percent have complex).[17] Clearly, we find not just a sharp rise in the *rate* of flawed dies, but a notable change in the *magnitude* of the errors themselves. Although this evolution may have begun just before the invasions which destroyed Ai Khanoum, it was afterward in the reign of Heliocles I that the "Greekness" of Bactrian coins began to decline noticeably. Furthermore, we cannot attribute this process to "barbarian imitation," but rather to the output of the royal mints of the Greeks themselves. Our original hypothesis again seems validated by the sample at hand.

INTERPRETATION

To explain these observed changes in the manufacture of coinage in Bactria, we might assume that after about 145 B.C., the working conditions and/or the workers' competence had deteriorated in the royal mints. The loss of eastern Bactria, along with its mint city at Ai Khanoum, may have obliged Heliocles to establish some new mint operations with new personnel.[18] The need for money to deal with the military emergency may also have compelled these workers to pound out coinage at urgent and error-prone speeds.

Only a long-term study of all mint-marks, engraving styles, and metrology could clarify the precise conditions under which our sample was struck. But some important matters are straightforward enough. The way that coins were manufactured remained the same and thus played no role in the increased rate of error. As before, the engraver had the task of cutting a "negative" die in order to stamp out a "positive" coin. For Greek lettering, this process was never as daunting as it might first appear. Our Bactrian engraver did not chisel out complex inscriptions, but rather a few words over and over again. In fact, the total Greek vocabulary on Bactrian dies from Diodotus I to Heliocles I amounts only to 24 words over a period of some 120 years.[19] Since most Greek letters are symmetrical on a vertical

axis, they are "mirror-neutral" and may be engraved without fear of reversing them by mistake. Therefore it is possible to make such a mistake with only seven of the Greek letters (Σ, E, B, N, P, Γ, K) that spell out the die vocabulary of Bactria, and altogether these letters make up only 27 percent of the engravers' work over many generations. For a die cutter at work in the mints of Heliocles I, only three words had to be mastered, a mere twenty-five letters, of which seventeen were engraved the same forwards or backwards. Overall, this may explain why *none* of the 754 engraved dies in our total sample has a mistake of this sort.[20] The need to work backwards does not account for the errors on royal Bactrian coins.

Were these mint workers mere copyists, cutting meaningless patterns while oblivious to the language? Or did they actually think in Greek as they prepared these die inscriptions? The ordination of coin legends throughout the period in question suggests that die engravers worked the same way, so that no change in production techniques can account for the increase in error. Furthermore, it seems that these workers consistently began each word at its beginning, "spelling" it out as they cut letters backward from right to left.[21] Thus, we generally find that uneven alignments for parallel inscriptions will fall at the end of those words, as do crowded and undersized letters.[22] It does appear from this evidence that our engravers were cognizant of what they were *supposed* to be writing in Greek.

During the reign of Heliocles I, engravers working this same way were nevertheless making substantially more, and more complex, errors. They began rather suddenly to spell out such blunders as ΒΑΙΛΛΕΩΣ, ΒΑΣΙΛΕΕΩ, ΒΑΣΙΛΕΣ, and ΙΛΣΙΛΕΩΣ, and this for a word struck on nearly every coin ever minted in Bactria.[23] They botched their king's name by engraving ΗΛΙΟΙΙΚΛΕΟΥΣ and ΗΛΙΟΚΛΕΥΣ. Even after such errors were made by the engravers, these dies were obviously used to make coins that passed by whatever quality controls the mint employed. What Greek would not notice mistakes of this magnitude? Either in an emergency the manufacturers and market users did not care, or the makers were considerably deficient in their ability to spell out three simple Greek words. Both imply drastic conditions, but the latter would entail a serious cultural shift of profound significance for the fate of eastern Hellenism.

Complex, multiple engraving errors first began to appear in our sample on the eve of the fall of Ai Khanoum. Was the mint operation becoming "less Greek" than it had been previously? Archaeologists have found in the bureaucracy of the palace treasury at that very time some officials with local, non-Greek names, including Aryandes, Xatrannos, Oxybazos, and Oxyboakes.[24] The royal mint at Ai Khanoum has been associated with this same bureaucracy.[25] We know, too, that some economic matters were managed in Aramaic rather than Greek, and that bilingualism was on the rise all across Central Asia and northwest India.[26] It is therefore evident that some

functionaries in the Bactrian mints were indeed drawn from a non-Greek, bilingual population just prior to the first "barbarian" invasion that toppled Ai Khanoum. It is possible that a small number of die engravers had been non-Greek since the reign of Euthydemus I, on whose coins the rise of *simple* errors has been noted at the rate of 7 percent. Though not nearly as complicated as the mistakes on later dies, the Euthydemid errors resemble precisely the errant letter forms (i.e., types a, d, etc.) found on early Sogdian imitations.[27] Even these simple errant forms, then, are of the type made by local engravers whose native language was not Greek. Under Eucratides I, and perhaps the early reign of Eucratides II, these simple mistakes continued alongside the rise of a 1–3 percent incidence of complex die errors. This may reflect a growing number of workers with poor Greek skills.

When Ai Khanoum fell, the tide of serious error accelerated to 12 percent in the mints of Heliocles. With the military and economic problems associated with protecting the remaining enclave of Greek rule in the Oxus Valley, Heliocles may have been compelled to draw much more heavily upon non-Greeks for the operation of his mints. Errors were made and overlooked at an unprecedented rate. Though they still tried to work out the three-word text in Greek, some of these engravers brought about a measurable decline in the vitality of eastern Hellenism. We can only guess at the troubles they faced, but they seem to have been linguistic rather than mechanical or technical. The complex misspellings of the name Heliocles involve vowels, never consonants. Perhaps non-Greeks found it especially difficult to manage these sounds. For example, there are three common variants in the Kharoshthi spelling of the name Heliocles (on the bilingual coins of Heliocles II): He-li-ya-kre-ya-sa, He-li-ya-kre-a-sa, and He-li-ya-kre-sa-sa.[28] The differences may reflect regional interpretations of the "foreign" Greek, especially in terms of vowels and case endings. Also troubling might be various confusions between Greek and non-Greek letter forms. As one example, an engraver familiar with Greek and Kharoshthi would find Λ to be *lambda* in one language, and *ya* in the other. Spelling the name "Heliocles" in either script would use this letter form, but in different places for entirely different sounds. Further study might show whether our engravers were sometimes thrown off by such letters. Also of value would be a broad comparison of rates of error for the Greek and non-Greek scripts on bilingual coins. For the moment, we may suggest that non-Greek engravers would be prone to make the kind of errors we find on Heliocles' coins.

With the eventual collapse of Heliocles' kingdom around 130 B.C., the entire region was finally "absorbed by something larger than itself." The migrating Yueh-Chi were fully established in Bactria-Sogdiana (Ta-Hia of the Chinese sources) by 126 B.C., laying the foundations for the rise of the great Kushana state. Minting operations passed into the hands of men less and less familiar with Hellenic art and language, converting the coinage

into imitations that merely caricatured the original Greek types and texts as did the Celtic coins of Europe.

Perhaps now we can learn how, and how soon, that process of cultural change actually began. Statistically, the decline of accurate Greek on Bactrian coins originated *before* and accelerated *during* the reign of the last Greek king, Heliocles I. Powerful cultural forces were at work that we may glimpse in the workshops of the royal mints, forces of diversity and displacement that did not wait upon the final blow of the "barbarian" invasions to loosen the grip of Hellenism. Numismatics imitated life at a remarkable moment in Hellenistic history, preserving in metal the extraordinary story of Bactria's decline and fall.

NOTES

This research project has been supported by a Faculty Development Summer Grant from the University of Houston's College of Humanities, Fine Arts, and Communications.

1. I refer, of course, to Peter Green's "The Dog That Barked in the Night: Revisionist Thoughts on the Diffusion of Hellenism," originally published in M. Fancy and I. Cohen, eds., *The Crake Lectures, 1984* (Sackville, New Brunswick, 1986), 1–26, and later incorporated under a similar title into his magisterial *Alexander to Actium* (Berkeley and Los Angeles, 1990), 312–35.

2. On this collection of coins, see Mando Oeconomides, "ΣΥΛΛΟΓΗ I. ΒΑΣΙΛΕΙΟΥ," *AD* 28 (1973): 71–97. The Heliocles drachm is coin number 60; it was usually displayed in the Exhibition Hall, Case XII, of the National Museum before the move to the old Schliemann House. I gratefully acknowledge the expert assistance of the museum's numismatic staff.

3. Although his coins were known as early as 1788, Heliocles was not identified as one of the kings of Bactria until 1799. Thus far, no reference to him exists outside the numismatic record. For this evidence in general, consult the standard works: A. N. Lahiri, *Corpus of Indo-Greek Coins* (Calcutta, 1965); Michael Mitchiner, *Indo-Greek and Indo-Scythian Coinage*, 9 vols. (London, 1975); and Osmund Bopearachchi, *Monnaies gréco-bactriennes et indo-grecques: Catalogue raisonné* (Paris, 1991). The provisional dates for the reign of Heliocles I are 145–130 B.C.

4. Green, *Alexander to Actium*, 330.

5. Ibid., 333–34, where Green stresses the cultural malaise of an enclave that merely copies without benefit of fresh talent. The die engravers of Bactria, whose early work has won universal praise from numismatists and art historians, may have succumbed to a similar fate. In some cases, scholars have used the "progressive degradation of the Greek lettering and design" to establish the chronological order of late Indo-Greek reigns: see, e.g., R. B. Whitehead, *Catalogue of Coins in the Panjab Museum, Lahore*, vol. 1 (1914; reprint, Chicago, 1969), 6.

6. Coin-finds reliably fix the reign of Heliocles I *after* the fall of Ai Khanoum, where none of his coins (so abundant in the Kunduz hoard) has been recovered:

Paul Bernard, *Fouilles d'Ai Khanoum IV* (Paris, 1985), 70 and 103 (TF51 is a later intrusion). On the "barbarian" invaders, see also Strabo 11.8.2 and Justin 41.6. The first substantial invasion occurred at the close of the reign of Eucratides I (apparently the father of Heliocles I), toppling Ai Khanoum and shrinking the domain of the Bactrian Greek enclave. At the close of Heliocles' rule, a second thrust swept aside this last remnant of Greek independence.

7. For some examples of these imitations, see M. Mitchiner (above, n. 3), vol. 4, types 501–6.

8. Tarn, *The Greeks in Bactria and India*, 3d ed. (Chicago, 1985), 301.

9. While modern die-struck forgeries are obviously unwanted in our sample, such fakes can serve a separate purpose—they often show us the kinds of mistakes made by engravers who do not understand the Greek. In one case, we can look over the shoulder of a struggling forger as he copies ΑΛΕΞΑΝΔΡΟΥ with a vague semblance of the proper letters: ΛΛΣΣΛΝ1ΙΟΥ; see F. Holt, "The So-Called 'Pedigree Coins' of the Bactrian Greeks," 69–91, in W. Heckel and R. Sullivan, eds., *Ancient Coins of the Graeco-Roman World: The Nickle Numismatic Papers* (Waterloo, Ontario, 1984), esp. p. 74.

10. The less perfect the coin, the less likely it is to be prominently marketed or preserved in a museum. Those who study only preselected material get a biased view; therefore, much that has been written about Bactrian numismatics emphasizes its purely Greek artistic merits and little else. "Nowhere in the world was the vitality of Hellenism more vividly exhibited than in Bactria," where the beautifully engraved royal coins possessed "a spiritual quality," C. A. Robinson, Jr., once wrote, for example; see his "The Greeks in the Far East," *CJ* 44 (1949): 407. The specimens of a decidedly non-Greek "spirituality" have mostly dropped from public view.

11. The Ai Khanoum hoard material has been conveniently collected and republished in book form: Olivier Guillaume, ed., *Graeco-Bactrian and Indian Coins from Afghanistan* (Delhi, 1991). Not included in this translation is the hoard material already published in English: F. Holt, "The Euthydemid Coinage of Bactria: Further Hoard Evidence from Ai Khanoum," *RN* 23 (1981): 7–44. The Bukhara hoard has been variously published, most accessibly in E. V. Rtveladze, "La circulation monétaire au nord de l'Oxus à l'époque gréco-bactrienne," *RN* 26 (1984): 61–76.

12. Although the Kunduz hoard is summarized in Guillaume's compilation (cit. n. 11 above), scholars will need to consult the principal publication, R. Curiel and G. Fussman, *Le trésor monétaire de Qunduz* (Paris, 1965).

13. Since there is no comparable excavation material for this area after ca. 145 B.C., it has been thought wiser to limit the sample to hoard rather than stray finds. In any case, such finds are overwhelmingly bronze and notoriously difficult to read due to size and corrosion. Thus, we are left with hoarded silver coins as the fairest sample through the reign of Heliocles I. Not among the hoards analyzed here are those buried far beyond Bactria and/or inadequately documented, such as the Oxus treasure, the Susa hoard of 1965, and the Mir Zakah hoard of 1947. Recent hoard discoveries (near Ai Khanoum and Mir Zakah) have been stunning, but woefully documented under present conditions in Afghanistan: O. Bopearachchi, "Grands trésors recents de monnaies présasanides trouvés en Afghanistan et au Pakistan," *INN* 24 (1994): 2–3, and "Découvertes récentes de trésors indo-grecs: Nouvelles données historiques," *CRAI* 1995: 611–29.

14. On the existence of a second Eucratides, minter of the Apollo types, see the review of evidence by Bopearachchi, *Monnaies* (cit. n. 3 above), 72–73. One such coin appears in the Ai Khanoum hoard published by Holt in *RN* (cit. n. 11 above), listed there with the coins of Eucratides I.

15. That is, two dies with complex errors out of the total of 145 inscribed dies. These complex errors are TQ 158 (ΒΑΣ•ΛΕΩΣ ΕΥΚΙΛΤΙΔΟΥ Μ ΛΛΟV) and TQ 237 (ΕΥΚΙΛΤΙΟΥ). As in many cases, these errors are not mentioned in the publication of these coins by Curiel and Fussman (cit. n. 12 above).

16. The complexity of these four errors mitigates the low incidence of error relative to the earlier coinages of, say, Euthydemus I. These dies are: TQ 309, 310, 333/334 (die linked), and 370.

17. Heliocles I has 21 dies with complex errors out of a total die sample of 180, excluding the possible cases of "barbarian" imitations. The complex errors are found on these dies: TQ 406, 416, 429, 430/431 (die linked), 433, 441, 442, 447, 494, 505, 510, 524, 530, 531, 538, 541, 542, 543, 544/545 (die linked), 561, and 590.

18. Bernard, *Fouilles d'Ai Khanoum* (cit. n. 6 above), 45 n. 2, has identified a series of die errors in the Seleucid issues of Bactria that may be the result either of negligence or of unfamiliarity with Greek.

19. These are royal names, titles, and epithets, mostly in the genitive case. The only verb form is ΒΑΣΙΛΕΥΟΝΤΟΣ, part of a genitive absolute on the rare commemorative coins of Agathocles and Antimachus.

20. TQ 583 (excluded as a possible imitation) has a reversed kappa, and there are elsewhere some Seleucid instances from Bactria: see n. 18 above and E. T. Newell, *The Coinage of the Eastern Seleucid Mints* (1938; reprint, New York, 1978), 232 (nos. 669 and 670). Other dies outside our sample have inverted (as opposed to reversed) letters, which are harder to understand. They generally appear on the coins of Eucratides II and Heliocles I (e.g., Hess/Leu Auction 45 (1970), no. 397, and Persic Gallery Sale 34, no. 44).

21. It is possible, of course, that this practice would be easier for people familiar with other scripts that were normally written from right to left, such as Aramaic and its derivative Kharoshthi. The latter was commonly used on Indo-Greek bilingual issues, and Aramaic was used alongside Greek in the royal administration of Ai Khanoum: Claude Rapin, "La trésorerie hellénistique d'Ai Khanoum," *RA* (1987): 57–59. Note, too, the silver ingot inscribed (by the post-Greek settlers on the site) in an unknown language written from right to left (58).

22. For some examples, see TQ 22, 106, 183, 188, 292, and 509.

23. Every regular issue (excepting only the few commemoratives struck by Agathocles, Antimachus I, and Eucratides I) used ΒΑΣΙΛΕΩΣ in the inscription. Using this as a convenient "control word" for Bactrian coinage, we can see once again the dramatic increase of error under Heliocles I: of the forty-one dies in our sample with errors in this word, the mintage of Heliocles accounts for thirty-one of them (76%).

24. Claude Rapin, "Les inscriptions économiques de la trésorerie hellénistique d'Ai Khanoum (Afghanistan)," *BCH* 107 (1983): 315–72, with an important appendix by Frantz Grenet, "L'onomastique iranienne à Ai Khanoum," 373–81.

25. See the comments on basic mint operations in F. Holt's review of Bopearachchi, *Monnaies* (cit. n. 3 above), *American Journal of Numismatics* 3–4 (1992): 218–19.

26. For a general survey of the role of Aramaic in Bactria and India, see F. Holt,

"Response," 54–64, in Peter Green, ed., *Hellenistic History and Culture* (Berkeley and Los Angeles, 1993), esp. 61–62.

27. On these coins, see Osmund Bopearachchi, "The Euthydemus' Imitations and the Date of Sogdian Independence," *Silk Road Art and Archaeology* 2 (1991–92): 1–21.

28. But written, of course, from right to left. Consult the catalogues cited in n. 3 above: Bopearachchi, *Monnaies,* 95; Mitchiner, *IGISC,* 2: 163–66.

Cleitarchus in Jerusalem

A *Note on the* Book of Judith

Stanley M. Burstein

To find a topic that reflects the interests of as versatile a scholar and man of letters as Peter Green is a daunting task. Peter has been by turns a fine historical novelist, a penetrating critic of the limitations of twentieth-century classical scholarship, and a master historian who has given us authoritative accounts of the reign of Alexander the Great and the history of the Hellenistic Period. Fiction, biography, and history, these have all formed part of Peter's career. There is, however, one topic on which they all converge, namely, on one of the premier works of historical fiction to survive from antiquity, the *Book of Judith*. I hope that he will find something of interest in these reflections on this puzzling work and its problems.

The story of Judith—"the gal who cut off the general's head"[1]—is quickly told. In the twelfth year of his reign, Nebuchadnezzar, the king of the Assyrians (*sic*), ordered all the peoples of his empire to contribute troops for a war against the Medes. Of all his subjects, only those of the West resisted. When all but the Jews had been subdued, Nebuchadnezzar sent his general Holophernes against them. The focus of the campaign became the siege of the mountain stronghold of Bethulia. Reduced to the point of surrender, the Jews were unexpectedly saved by the beautiful widow Judith, who went accompanied only by her maid to Holophernes' camp. There Judith pretended to yield to his desires, but after the drunken general fell asleep,

> she went to the bed-rail beside Holophernes' head, reached down for his sword, and drawing close to the bed she gripped him by the hair. "Now give me strength, O Lord, God of Israel," she said, and struck at his neck twice with all her might and cut off his head. She rolled the body off the bed and removed the mosquito-net from its posts; quickly she came out and gave Holophernes' head to her maid, who put it in the food bag.[2]

The two women then escaped and brought Holophernes' severed head to Bethulia. Meanwhile, the Assyrian army discovered the body of their dead general the next morning, panicked, and fled, leaving the Jews free.

The *Book of Judith* has had a paradoxical history. Despite its ringing affirmation of God's concern for his people and their freedom, the ancient rabbis excluded it from the canon of scripture.[3] According to Origen, the Jews no longer possessed copies of the Hebrew text in his time, roughly the late second and early third centuries A.D.[4] Lack of official sanction for the *Book of Judith* did not, however, prevent Judith herself from becoming one of the most popular figures in the Judeo-Christian tradition.[5] Jewish and Christian preachers quarried the *Book of Judith* for material for sermons, and some of the most famous artists of the West have drawn inspiration from this story of the unexpected victory of a lone woman over the commander of a mighty army.

Not surprisingly, there is an extensive body of scholarship concerning the *Book of Judith*. Although much remains in contention, a scholarly consensus now exists on two key points. First, the numerous historical errors and anachronisms in the book are best explained by the assumption that the events described in it are fictitious;[6] and, second, the *Book of Judith* was originally written in Hebrew by a Palestinian Jew.[7] Two important questions, however, remain in dispute: the date of the composition of the *Book of Judith* and the identification of a prototype for Judith's bloody deed. The purpose of this note is a modest one, to draw attention to two texts that may throw new light on these issues.

Identification of a prototype for Judith's act has proved surprisingly difficult. The absence of any reference to Judith outside the *Book of Judith* and the clearly fictitious character of the events associated with her have convinced most scholars that she is an invention of its author. But what was his model for Judith and her dramatic method for killing Holophernes? There is no lack of suggestions. Mary P. Coote proposed that the creation of Judith resulted from the combination of two common folktale characters: the faithful wife and the female warrior.[8] Other scholars contend that Judith is the product of the conflation of several biblical characters, including Miriam, Deborah, and even David![9] The most widespread view among contemporary scholars, however, is that the author of the *Book of Judith* was inspired by the story of one particular early Jewish heroine, Jael, the wife of Heber the Kenite, who killed Sisera, general of Jabin, king of Hazor.[10]

According to the story in the *Book of Judges,* Sisera sought refuge at the tent of his friend Heber after the forces of Jabin were defeated by the Israelites. Heber was not at home, but Jael welcomed him. After he fell asleep, however, Jael "took up a tent-peg, picked up a mallet, and, creeping up to him, drove the peg into his temple, so that it went down into the

ground, and Sisera died."[11] The general similarity of the two stories is obvious. In both cases, women used deceit to violently dispatch an enemy general through an attack on his head. More striking than this superficial similarity, however, are the differences in the details of the two attacks, which include the type of deceit in question, the weapons used, the nature of the wound, and even the timing of the murder itself. Clearly, although the author of the *Book of Judith* may have found inspiration in the story of Jael, the differences between the acts of Jael and Judith are far too great for the former to be accepted without question as the sole prototype for the latter. There is, however, another possibility that has not yet been considered, namely, that the author of the *Book of Judith* drew on a Greek source, specifically, a historical source, in developing this aspect of the story of Judith.

That the possibility of a Greek source for Judith's deed has not been canvassed earlier is surprising.[12] The *Book of Judith* employs the form and conventions of Jewish historiography, and recent studies have clearly established that the author of the *Book of Judith* was familiar with and used Greek historical works in the composition of his book. Thus, Y. M. Grintz[13] identified close parallels between the account of the siege of Bethulia and that of the siege of Lindus by the Persians in the *Lindus Chronicle*.[14] A. D. Momigliano[15] and M. S. Caponigro[16] have also recognized the existence of similar parallels between the *Book of Judith* and Herodotus's narrative of the Battle of Thermopylae. Finally, stories concerning the remarkable deeds of women constitute an important *topos* in Greek historiography. An anthology of such anecdotes survives in the works of Plutarch, the *Mulierum virtutes*.[17] Moreover, although Plutarch's collection does not include a stratagem similar to that used by Judith, a remarkably close parallel is found in two of the ancient accounts of the reign of Alexander the Great.

In the spring of 329 B.C., Alexander encountered one of the few enemy commanders who seriously challenged his abilities, the Sogdian noble Spitamenes. For almost two years Alexander struggled to suppress the frustratingly successful guerrilla campaign conducted by Spitamenes and his Dahae allies in the marches of Bactria and Sogdiana. By late 328 B.C., however, Alexander's countermeasures were increasingly effective, and he was on the verge of carrying the pursuit of Spitamenes' forces into the territory of the Dahae. The sources disagree about what followed. According to the official tradition preserved by Arrian, Spitamenes was betrayed and murdered by the Dahae, who then sent his head to Alexander in an effort to avert his threatened invasion of their territory.[18] About the same time, Spitamenes' family also fell into Alexander's hands.[19] Spitamenes' murder, the arrival of his head at Alexander's camp, and the capture of his family were all, of course, public facts. The exact circumstances of Spitamenes' death were not, so that it is not surprising that the Vulgate

Tradition explained these "public facts" by a radically different and more pathetic account of his end.

Unlike Arrian and his sources, the Vulgate Tradition treated the death of Spitamenes as a domestic tragedy. Two versions of the story survive, one in the *History of Alexander* of Quintus Curtius Rufus and the other in the *Metz Epitome*. Their accounts differ in emphasis and detail, but both agree in telling the pathetic tale of a brave general undone by his immoderate love for his deceitful wife.

The fuller and rhetorically more elaborate version is that of Curtius Rufus. After setting the scene for the tragedy by recounting how Spitamenes furiously rejected his wife's repeated pleas that he surrender to Alexander, ordered her from his bed, and unsuccessfully tried to find solace with his concubines,[20] Curtius continues as follows:

> But his [sc. Spitamenes'] deep-seated love was actually inflamed by dissatis-faction with his bed-fellows of the moment. So, devoting himself exclusively to his wife once more, he incessantly begged her to eschew such advice as she had given and to acquiesce in whatever it was that fortune had in store for them, since he would find death less painful than surrender. She excused her-self by saying that she had given him what she thought was profitable advice, and that her recommendations, though characteristically feminine, nonethe-less arose from loyal intentions. In future, she said, she would abide by her husband's will.
>
> Spitamenes was taken in by this show of devotion. He ordered a banquet arranged while it was still day, after which he was carried to his room, languid from excessive drinking and eating, and half-asleep. As soon as his wife saw him in a deep, heavy sleep, she drew a sword which she had hidden under her clothes and cut off his head which, spattered with blood, she handed to a slave who had acted as her accomplice. With the slave in attendance she came to the Macedonian camp, her clothes still drenched with blood, and had the message taken to Alexander that there was a matter of which he should hear from her own lips.[21]

The account in the *Metz Epitome* is more succinct but includes significant details concerning the manner of Spitamenes' death that are not in Curtius Rufus' version:

> At winter's end, he [sc. Alexander] led the army towards the Dahae. Spita-menes had not fled from that place because he had there a Bactrian wife of superlative beauty whom he adored and took with him on all his travels and exploits. When she heard of Alexander's approach, she refused to leave the town and later proceeded to make numerous entreaties to her husband to throw himself on Alexander's mercy. Spitamenes refused. Unable to achieve her end, she pressed him to drink a cup at a banquet and when he became drowsy put him to bed. As soon as she felt that all was silent, she rose from the bed and withdrew the pillow from her husband's head. His throat thus extend-

ed, she cut his head from his body with a sword and, taking her leave with one slave, came to Alexander in his camp.[22]

Both Curtius Rufus[23] and the author of the *Metz Epitome*[24] conclude their stories with the claim that Alexander did not reward Spitamenes' wife for the murder of her husband, although they differ in their interpretation of his motives, the former alleging Alexander's horror at her deed and the latter his desire to avoid the suspicion that he had succumbed to her beauty.

Unlike the situation with regard to the story of Jael, the similarities between the *Book of Judith's* account of Holophernes' death and Curtius Rufus's and the *Metz Epitome's* tale of the murder of Spitamenes are numerous and exact. Although the alleged historical circumstances and moral evaluation of the deaths of the two generals differ, the stories agree on the following points: (1) the victim: a general rendered insensible by drink at a banquet; (2) setting: a bed in the general's own sleeping quarters; (3) the murderer: a sexually seductive woman; (4) the weapon: a sword; (5) method: beheading; (6) accomplice: a servant who carries the head of the dead man; and (7) fate of the head: brought to the enemy camp. The similarities between these two stories are so numerous and close that mere coincidence is out of the question, especially in view of the lack of further parallels to them either in Jewish or classical literature.

Clearly, a literary relationship must exist between these three texts, but of what sort? There are two possibilities: either Curtius Rufus and the author of the *Metz Epitome* drew their inspiration from the *Book of Judith* or all three represent independent elaborations of a common source. Two considerations strongly point to the second of these two possibilities as being correct: the ignorance of Jewish literature on the part of classical authors in general and the presence in each of the three texts of details not attested in the other two, a characteristic feature of texts derived from a no longer extant but fuller common source. And there can be little doubt as to the identity of that common source. One of the securest results of classical *Quellenforschung* has been the establishment of the fact that the commonalities in the Vulgate Tradition concerning Alexander the Great result from the ultimate dependence of writers in that tradition on the *History of Alexander* of the late fourth century B.C. Alexandrian historian Cleitarchus.[25] Equally important, this conclusion also has important implications for the date of the composition of the *Book of Judith*.

Two alternative dates have been proposed for the composition of the *Book of Judith:* the mid fourth century B.C.[26] and the late second century B.C.[27] Establishment of the fact that the author of the *Book of Judith* used Cleitarchus's *History of Alexander* indicates that a Hellenistic date is more likely to be correct. The reasons are twofold. First, it establishes the date of the publication of Cleitarchus's work, namely, the late fourth century B.C.,

as the *terminus post quem* for its composition; and second, it helps account for the presence in the *Book of Judith* of the various apparent allusions to circumstances, institutions, and individuals of the late Achaemenid Period such as the eunuch Bagoas[28] and Holophernes[29] that form the principal evidence for the earlier date. Such material would be readily available in a work such as the *History of Alexander,* whose theme was the conquest of the Persian Empire and whose author was the son of Deinon of Colophon, the principal fourth-century B.C. historian of Persia.[30]

The identification of Cleitarchus's *History of Alexander* as one of the sources of the *Book of Judith* does not, to be sure, resolve all of the problems connected with that work, but it does highlight two characteristics of it and the environment in which it was created. The first is literary. Recent scholars have rightly protested against the tendency to underestimate the sophistication of the *Book of Judith* as a literary work.[31] Consideration of the "pure gold" its author created out of the "dross" of Cleitarchus's sensational account of the death of Spitamenes only reinforces the correctness of the new trend toward a more positive assessment of its literary merits. The second is cultural. Scholars such as B. Z. Wacholder[32] and M. Hengel[33] have argued that Greek literary works were more widely available in Hellenistic Palestine than many scholars assume and that the distinction between Palestinian and Alexandrian Jewish attitudes toward Greek culture was less clear, therefore, than is often assumed. That the Palestinian Jewish author of the *Book of Judith* had access to and used works as disparate as Herodotus's *History of the Persian War,* Cleitarchus's *History of Alexander,* and a local history of Rhodes provides further evidence for the essential validity of this interpretation.

NOTES

1. Carey A. Moore, *Judith: A New Translation with Introduction and Commentary* (New York, 1985), xi.

2. Jth. 13.6–10. Quoted from *The Oxford Study Bible: Revised English Bible with the Apocrypha,* ed. M. Jack Suggs et al. (Oxford, 1992), 1083.

3. See Morton S. Enslin and Solomon Zeitlin, *The Book of Judith* (Leiden, 1972), 24–26; Moore, *Judith,* 86–91; Carey A. Moore, "Why Wasn't the Book of Judith Included in the Hebrew Bible?" in *"No One Spoke Ill of Her": Essays on Judith,* ed. James C. VanderKam (Atlanta, 1992), 61–71.

4. Origen, *Epist. ad Africanum* 13.

5. Enslin and Zeitlin, *Book of Judith,* 52–54. Nira Stone, "Judith and Holofernes: Some Observation on the Development of the Scene in Art," in *"No One Spoke Ill of Her,"* ed. VanderKam, 73–86. The Midrash tradition is collected and analyzed in A. M. Dubarle, *Judith: Formes et sens des diverses traditions,* 2 vols. (Rome, 1966).

6. For convenient summaries of the evidence pointing to the fictiousness of the narrative, see Robert H. Pfeiffer, *History of New Testament Times with an Introduction to the Apocrypha* (New York, 1949), 292–97; and Moore, *Judith,* 38–49.

7. Cf. A. Dubarle, "L'authenticité des textes hébreux de Judith," *Biblica* 50 (1969): 187–211; Moore, *Judith*, 66–67. Zeitlin and Enslin's (*Book of Judith*, 31–32) suggestion that it was written in Antioch has found no followers.

8. Mary P. Coote, "Comment on 'Narrative Structures in the Book of Judith,' " in Center for Hermeneutical Studies in Hellenistic and Modern Culture, *Narrative Structures in the Book of Judith*, ed. Luis Alonso-Schökel and W. Wuellner, Protocol series, 11 (Berkeley, 1975), 21–26.

9. Cf. Emil Schürer, *The History of the Jewish People in the Age of Jesus Christ*, rev. ed. by Geza Vermes, Fergus Millar, and Martin Goodman, vol. 3, pt. 1 (Edinburgh, 1986), 217 n. 3.

10. See, e.g., J. Edgar Bruns, "Judith or Jael?" *Catholic Biblical Quarterly* 16 (1954): 12–14; and Zeitlin *apud* Enslin and Zeitlin (*Book of Judith*, 180) "that Jael who slew Sisera in her tent . . . is the prototype of Judith appears to me certain." The fullest presentation of the case is Sidnie Ann White, "In the Steps of Jael and Deborah," in *"No One Spoke Ill of Her,"* ed. VanderKam, 5–16.

11. Judg. 5.21. Quoted from *The Oxford Study Bible*, 251.

12. Affinities between the Book of Judith and classical literature have often been noted. Thus, U. v. Wilamowitz-Moellendorf, *Die Griechische Literatur des Altertums* (Berlin and Leipzig, 1907), 124, and Moses Hadas, *Hellenistic Culture* (New York, 1959), 165–69, both pointed out similarities between Judith and the Greek novel, while J. D. Nancy, ed., *The Shorter Books of the Apocrypha* (Cambridge, 1972), 129, observed that the Book of Judith's *"literary"* qualities do seem to owe something to that Greek culture which had been permeating Palestine for at least two centuries before it was written."

13. Known to me only through reference in Dubarle, *Judith*, 1: 127.

14. Jth. 7.30–8.1–36 = *Lindus Chronicle, FGrHist*, 3A, 532 F D 1.

15. Arnaldo Momigliano, "Biblical Studies and Classical Studies: Simple Reflections upon Historical Method," in id., *On Pagans, Jews, and Christians* (Middletown, Conn., 1987), 9–10.

16. Mark Stephen Caponigro, "Judith, Holding the Tale of Herodotus," in *"No One Spoke Ill of Her,"* ed. VanderKam, 47–59.

17. For other such collections, see Philip A. Stadter, *Plutarch's Historical Methods: An Analysis of the Mulierum Virtutes* (Cambridge, Mass., 1965), 7–8.

18. Arrian, *Anabasis Alexandri* 4.17.7.

19. This is implied by the fact that Spitamenes' daughter Apama married Seleucus at Susa in 324 B.C. (Arrian, *Anabasis Alexandri* 7.4.6).

20. Quintus Curtius Rufus 8.3.1–5.

21. Ibid. 8.3.6–10, in Quintus Curtius Rufus, *The History of Alexander*, trans. John Yardly, with introduction and notes by Waldemar Heckel (Harmondsworth, Eng., 1984).

22. *Metz Epitome* 20–21, translated by J. C. Yardly, in id. and E. Baynham, *The Metz Epitome*, Clarendon Ancient History Series (Oxford, forthcoming).

23. Quintus Curtius Rufus 8.3.11–15.

24. *Metz Epitome* 22–23.

25. See, most recently, A. B. Bosworth, *From Arrian to Alexander: Studies in Historical Interpretation* (Oxford, 1988), 9. For Cleitarchus's date, see E. Badian, "The Date of Cleitarchus," *Proceedings of the African Classical Association* 8 (1965): 5–11.

26. The case for a mid-fourth-century B.C. date has been put most strongly

by M. Heltzer, "Eine neue Quelle zur Bestimmung der Abfassungzeit des Judithbuches," *Zeitschrift für die Alttestamentliche Wissenschaft* 92 (1980): 432; id., "ΜΙΣΘΩΤΟΣ im Buche 'Judith,' " in *Roma Renascens: Beiträge zur Spätantike und Rezeptionsgeschichte: Ilona Opelt von ihren Freunden und Schülern zum 9.7.1988 in Verehrung gewidmet,* ed. Michael Wissemann (Frankfurt a/M, 1988) 118–24; and id., "The Persepolis Documents the *Lindos Chronicle* and the *Book of Judith,"* *Parola del passato* 44 (1989): 81–101.

27. The literature supporting a Hellenistic date is vast. See, e.g., Pfeiffer, *History of New Testament Times,* 297; Enslin and Zeitlin, *Book of Judith,* 26–31; Mathias Delcor, "Le livre de Judith et l'époque grecque," *Klio* 49 (1967): 151–79; and Moore, *Judith,* 67–70. For an attempt to reconcile the two dates, see Doron Mendels, *The Land of Israel as a Political Concept in Hasmonean Literature: Recourse to History in Second Century b.c. Claims to the Holy Land* (Tübingen, 1987), 51, who suggests that the present text is a Hasmonean Period revision of a work composed in the Persian Period.

28. The most famous Bagoas was the eunuch favorite of Alexander who was given to Alexander in Hyrcania by Nabarzanes, like Spitamenes an adherent of Darius III's successor Bessus (Quintus Curtius Rufus 6.5.23).

29. The best-known Holophernes was a general of Artaxerxes III's, who served in his Egyptian campaign of 343 B.C. and was the father of Ariarathes I, the ruler of Cappadocia during the reign of Alexander (Diodorus 31.19.3–4).

30. The fragments of the *Persika* of Deinon are collected in *FGrHist* 3A, 690.

31. Luis Alonso-Schökel, "Narrative Structures in the *Book of Judith,"* in Center for Hermeneutical Studies in Hellenistic and Modern Culture, *Narrative Structures in the Book of Judith* (cit. n. 8 above), 1–20; Toni Craven, *Artistry and Faith in the Book of Judith* (Chico, Calif., l983).

32. Ben Zion Wacholder, *Eupolemus: A Study of Judaeo-Greek Literature* (Cincinnati, 1974), 258–306.

33. Martin Hengel, *Judaism and Hellenism: Studies in their Encounter in Palestine during the Early Hellenistic Period,* trans. John Bowden, 2 vols. (Philadelphia, 1974), 1: 65–102.

NINE

The Hellenistic Images of Joseph

Erich S. Gruen

The figure of Joseph has held great appeal for Jews and Gentiles of every era. His story in the Book of Genesis echoes down the ages, retold, enhanced, or distorted, down to the great novels of Thomas Mann and even the musical theater of Andrew Lloyd Webber. Joseph's character and achievements have exercised unbroken fascination. Few can resist the tale of the righteous man, victimized, sold, enslaved, deported, and imprisoned, whose innate skills and adherence to principle enabled him to rise to power in an alien land, forgive and rescue his own tormentors, and wield widespread political and economic authority in the interests of communal welfare. Joseph's image not only as hero to his people but as potentate in Egypt carried special attraction to Egyptian Jews of the Hellenistic era. But that is only part of the story. Darker and less admirable characteristics of the patriarch recur in the tradition, stemming from Genesis itself. And Hellenistic Jews did not shy away from them; indeed, they developed and manipulated them. The varied versions of Joseph's tale make for an intriguing mix. Their propagation and elaboration offer an illuminating perspective upon Diaspora Jewry.

The Genesis narrative of Joseph portrays a complex and manifold personality, no mere one-dimensional man of virtue. The young Joseph ambushed by his brothers was hardly an innocent waif. His boastful recounting of dreams that forecast ascendancy not only angered his brothers but troubled his father.[1] He flaunted the multicolored coat when he went in search of his brothers on what seems little more than a spying mission—thus leading directly to his humiliation.[2] Joseph, of course, nobly resisted the blandishments of Potiphar's wife in Egypt, preserving his virtue and principles at the cost of imprisonment. He also, however, made a point of displaying his administrative skills, first in Potiphar's household, then in manage-

113

ment of prison personnel.[3] His reputation as interpreter of dreams brought him to Pharaoh's attention, but the administrative talents put him in a position to run the country. With the consent of Pharaoh, Joseph obtained extensive power to govern the land and reorganize the agricultural system, and he took without hesitation the symbols of authority that elevated him to a rank second only to that of the king himself.[4] The rediscovery of and reconciliation with his brothers forms a moving story, underscoring the magnanimity of the now grand vizier who tearfully embraced those who had once sold him into servitude. But one should not omit to note that he calculatingly put them through some severe anxieties and emotional trials before revealing himself.[5] Joseph's magnanimity had its limits. He made certain also to exhibit his mastery. And not only his own. Joseph's stern and exacting management of grain allocation during the famine years brought all Egyptian land under the king's control and transformed the entire Egyptian peasantry into vassals of the crown.[6] The new ordinance obliging every farmer to reserve one-fifth of his produce for the king became a permanent part of the Egyptian system.[7] Genesis thus supplies an intricate tale, a multifaceted personality, and rich material to be exploited by Hellenistic Jews.

~~~~~~

Joseph receives almost no notice in the remainder of the scriptural canon. Abraham, Isaac, and Jacob stand forth as the patriarchal ancestors of the Chosen People; the honor roll does not include Joseph. The ambiguous personality and occasionally dubious behavior of the Genesis figure perhaps suggested a less than altogether edifying model. Only the psalmist of Ps. 105 makes reference to the tale in Genesis. And the verses there allude, not to Joseph's character or uprightness, but to his career as a sign of the Lord's favor, his liberation from the shackles of slavery, and his appointment by Pharaoh as ruler of all royal possessions and as importer of wisdom to the royal household.[8] The portrait is plainly positive, but not especially to the credit of Joseph. A brief mention occurs also in 1 Chronicles, although only to the rights of the firstborn, forfeited by Reuben and thus accorded to Joseph.[9]

Intertestamental texts, composed in Hebrew and deriving from Palestine, gave a little more attention to Joseph. Ben Sira counts him among the ancestral heroes, a man in a class of his own, but he offers no specifics, apart from the transference of his bones from Egypt to the land of his fathers. That notice alludes to the Pentateuchal tale and implies the inclusion of Joseph among the patriarchs.[10]

A far more substantial summary of Joseph's career occurs in Jubilees, a work composed in Hebrew probably in the second century B.C.E. and devoted to retelling the stories contained in Genesis and Exodus.[11] The author of Jubilees supplies a sanitized version. Not a hint of character flaws

invades the portrait of the hero. Joseph's brothers turn upon him and sell him to the Ishmaelites for no apparent reason except their own innate wickedness. The narrator omits mention of dreams, boasts, favoritism by Jacob, embroidered coat, or even fraternal jealousy.[12] Joseph's adventures in Egypt show him only in the most glowing light. He rejects the advances of Potiphar's wife by proclaiming adherence to ancestral precepts taught him by Jacob and stemming from Abraham, a solemn prohibition on adultery.[13] His accuracy in interpreting dreams gains him freedom and power. Pharaoh elevates him to a position nearly equivalent to his own, investing him with all the public symbols of authority and asserting that only his own occupancy of the throne differentiates between them.[14] Jubilees embellishes liberally on Genesis in depicting Joseph's administration of Egypt as one of undeviating righteousness and integrity, devoid of all arrogance or pomposity, earning him the love of all those with whom he came into contact.[15] The discomfort that he puts his brothers through upon seeing them again in Egypt, which receives no clear explanation in Genesis, is rationalized in generous fashion by the author of Jubilees: Joseph simply wished to see whether there was internal harmony among the brothers.[16] This, of course, they amply demonstrated, leading to disclosure and tearful reunion. Jubilees never questions the rather drastic means employed to test the brothers' concord. Nor does the text breathe a hint of dissension among the populace in the wake of Joseph's sweeping economic changes. His powers were wide, tantamount to absolute sovereignty.[17] Jubilees picks up a significant line in Genesis: Joseph was like a father to the Pharaoh. And his new policy, which instituted an enduring system whereby the peasantry would provide one-fifth of their produce to the king, is presented as if it were an act of generosity.[18] Joseph thus combines the application of ascendant power with ethical principles of the highest order.[19]

Those same features reappear in much condensed form in the *Biblical Antiquities* of Pseudo-Philo. That text, preserved now only in Latin manuscripts, is generally agreed to derive from a Hebrew original, via the intermediacy of a Greek translation, and to have been written some time in the first or second centuries C.E.[20] The author, whose extant work retells biblical stories that span from Adam to David, devotes only a few lines to Joseph. But they correspond closely in tone and substance to the much lengthier treatment in Jubilees. Joseph is hated by his brothers without apparent reason, delivered by them to Egypt, brought into the king's service through his repute as interpreter of dreams, then put into the highest official post in the land, where his measures relieve the famine. When his brothers arrive, Joseph seeks no vengeance and exhibits only magnanimity.[21] His resistance to the wiles of Potiphar's wife is omitted here, but it is indirectly alluded to later when the author contrasts Joseph's character favorably with that of Samson.[22] The ambiguous personage who appears in Genesis, gifted and

competent, faithful and sensitive, but also devious, arrogant, and domi-
neering, is flattened out in the postbiblical texts from Palestine, trans-
formed into a one-dimensional paragon of virtue.

A duplicate image shines forth in the Testament of Joseph, one of the
texts included in the *Testaments of the Twelve Patriarchs,* the supposed final
words of the sons of Jacob. Each is presented as a hortatory message by the
dying patriarch, delivering ethical lessons to sons gathered about him at
the end. Unfortunately, the provenance, date, and original language of the
work remain under considerable dispute, with little sign of consensus.
Scholars debate the degree to which Christian interpolations have altered
what were originally Jewish writings, or, conversely, the degree to which
what are fundamentally Christian writings draw on Jewish sources. Dating is
similarly controversial. Parts may go back to the pre-Maccabaean period,
but the final Christian form can be no earlier than the late second century
C.E. Nor is there much agreement on how far, if at all, the Greek texts
depend upon Semitic originals. Hence any secure categorization of the doc-
ument would be illusory.[23] For our purposes it suffices that the character of
Joseph possesses the same spotless virtue that one finds in the intertesta-
mental Hebrew texts from Palestine and gives some reason to place the Tes-
tament of Joseph in that intellectual setting.

The text, like most of the other Testaments, focuses upon an episode in
the dying patriarch's life, which he employs to drive home a moral lesson to
his attentive sons. In the case of Joseph, two events or aspects of his life form
the basis for his sermonizing. An introductory segment recounts the cir-
cumstances that brought him to Egypt, asserting that his brothers hated
him, were deflected by the Lord from killing him, and then sold him into
slavery—once again without any provocation or apparent reason, as in
Jubilees and in Pseudo-Philo.[24] Then the first episode takes over the narra-
tive: Joseph's steadfast refusal to compromise his virtue through a sexual
liaison with Potiphar's wife. The tale, of course, stems from the Bible. But
whereas Genesis treats the matter in a few verses, the Testament of Joseph
elaborates upon it with great flourish. The shameless hussy importunes
Joseph again and again, alternately threatening him with a variety of pun-
ishments and promising him desirable rewards, feigning motherly affec-
tion, offering to abandon her native religion and embrace Joseph's god,
suggesting the murder of her husband and a new marriage so as to avoid
adultery, mixing Joseph's food with drugs, whether poison or aphrodisiacs,
warning that a refusal of intercourse will drive her to suicide, and making
herself as alluring as possible in order to entice him to bed. The virtuous
patriarch, however, withstands every temptation through faith in the Lord's
precepts, bolstered by fasting, prayer, and dogged self-restraint. Such is the
lesson of unyielding chastity that the patriarch passes on to his heirs.[25]
Joseph then proceeds to a second lesson, diverging still further from any

basis in Scripture. Here he emphasizes the importance of fraternal loyalty and devotion. Despite the treachery of his brothers, Joseph does more than forgive them. He avoids any imputation of blame, repeatedly insisting under interrogation that he is a slave of the Ishmaelites, not a free man victimized by his brothers, sticking to his story in the face of torture and imprisonment. The patriarch would thus leave to his sons as legacy the model of unblemished ethical purity.[26] The portrayal, however, omits any reference to Joseph's achievements as chief minister to the crown, the economic czar and governor of the land who set the whole Egyptian system on a new footing. Instead, he emerges as a high-minded but rather priggish prude.

~~~~~~~

Hellenistic Jews writing in Greek, mostly in the Diaspora, developed the image of Joseph beyond the one-dimensional ideal of virtuous self-control. Joseph, to be sure, could still stand as ethical model. That aspect, powerfully delineated in the postbiblical tradition, remained prominent. Mattathias's dying exhortation to his sons in 1 Maccabees listed Jewish ancestors whose adherence to the faith had earned them high renown. Among them he cites Joseph, who under stressful circumstances persevered in keeping a commandment—an obvious allusion to resisting the temptations of adultery.[27] A similar pronouncement occurs in the hortatory philosophical tract *The Wisdom of Solomon,* which seeks to suffuse philosophic wisdom with divine inspiration. The author, among other things, credits Wisdom with rescuing numerous righteous men through the ages, according them glory and reward. One of those men was sold into slavery but saved from sin, bolstered by Wisdom even when in chains. The reference plainly points to Joseph, with emphasis once more upon his unflagging piety.[28] The philosophical orientation of 4 Maccabees, which retells the martyr stories of the Seleucid persecutions with a blend of Jewish faith and Stoic ethics, naturally finds Joseph to be an appropriate *exemplum.* The author recalls Joseph as a prime instance of reason prevailing over passion: Joseph nobly suppressed his sexual urgings and held unremittingly to the commandment that prohibits adultery.[29] Of course, Joseph's time long preceded delivery of the commandments at Mount Sinai, a chronological detail that did not worry the composer of 4 Maccabees or other Hellenistic writers who made the same point. Divine inspiration gave Joseph insight into the morality of abstinence. That lesson echoes in 1 Maccabees, Wisdom of Solomon, and 4 Maccabees in remarkably similar tones. Joseph stands out as emblem of self-restraint, rational control of sexual drive, and dedication to the Law.

Another aspect of the Joseph story, however, got equal billing among Hellenistic Jews: Joseph's swift rise to power and his exercise of dominion in Egypt—a more concrete and pragmatic source of pride. The business-like chronicler Demetrius concerned himself with a range of historical

problems, particularly questions of dating, that arise in certain books of the Bible. The fragments of that historian show no interest in the character, personality, or moral dilemmas of biblical personages. Demetrius strives to straighten out chronological discrepancies and solve historical puzzles, thereby to reinforce the credibility of the Scriptures. Hence the historian ignores Joseph as ethical icon withstanding the allure of Frau Potiphar or beneficently forgiving his brothers' transgressions. Demetrius focuses upon reconstructing the chronology of Joseph's career and offering reasons for the unequal distribution of gifts to his brothers. He does not, however, omit to record Joseph's ascendant position in Egypt. According to Demetrius, the Hebrew forebear ruled the land for seven years.[30] This feature, no small matter for Diaspora Jews in the Greco-Roman period, finds its way also into those texts whose principal concern is with ethical values and moral character. Mattathias's death-bed comments in 1 Maccabees refer not only to Joseph's obedience to the commandment against adultery but to his reward: he became lord of Egypt.[31] *The Wisdom of Solomon* reports that divine Wisdom both saved Joseph from the torments of imprisonment and delivered to him the scepter of royal rule that gave him mastery over those who had been his tormentors.[32] And the Jewish epic poet Philo also sets a scepter in Joseph's hand, placing him directly on the throne of the Pharaohs.[33] Joseph's political power in Egypt stirred the pride of Hellenistic Jews.

The figure of Joseph, therefore, had appeal to later Jewish sensibilities on two principal fronts: as consummate exemplar of rectitude whose piety embraced biblical precepts and encompassed Greek philosophy, and as preeminent statesman whose special gifts and wide authority brought rational order and system to his adopted land. Both of these conceptions are underscored in the full-scale biographical treatise accorded to Joseph by Philo of Alexandria.

Philo's *De Josepho* aimed above all to outline a model for the ideal statesman. He designed the work as a βίος τοῦ πολίτικου. The treatise itself alternates between a close rendering of the Joseph narrative in Genesis and commentary by Philo, often in the form of his characteristically allegorical interpretations. Philo plainly took as his mission the idealization of Joseph, thus to present him as the epitome of statesmanly qualities.[34] The dubious or questionable features that appear in Genesis are smoothed over or rationalized.

Philo's biography, like much of the Hellenistic literature that precedes it, strains to exalt the character of Joseph. So, for instance, the treatise ascribes Jacob's special feelings for Joseph to his early perception of a noble disposition that set the youth apart from others.[35] The hostility of the brothers, therefore, stems from sheer jealousy, not any arrogance or presumptuousness by Joseph.[36] Philo does have Joseph report his dreams, thus infuriating

his brothers and even alarming his father, but explains this as mere innocent naiveté.[37] When Jacob sends him to seek out his brothers, Philo gives the most favorable interpretation: Joseph was to give them greeting and inquire after their well-being and that of the flocks.[38] Philo clearly massages the Genesis story to leave no trace of character deficiency in Joseph.

The theme of Joseph's noble spirit recurs repeatedly in Philo's narrative and interpretation. The youth's καλοκαγαθία and εὐγενεία earn him the complete confidence of Potiphar and a free hand in management of the entire household—a preview of his skills in administering the polity itself.[39] Philo does not dwell on the attempted seduction by Potiphar's wife, a tale rather marginal to his political theme. Unlike some of the other treatments of that episode, however, he has Joseph reject her advances, not because of religious prohibition, but because of social and moral obligations to his benefactor, Potiphar. Joseph punctuates the point by contrasting the practices of the Hebrews with the laxity of other peoples.[40] Philo, in short, stresses the superiority of Jewish conventions as well as the moral self-restraint of Joseph—with the appropriate implications for statesmanship.[41] Joseph's καλοκαγαθία also wins him the admiration of fellow prisoners and sets him in a position of authority even in jail.[42] His qualities immediately declare themselves upon first encounter with the king, leading to his swift elevation to eminence.[43]

Philo further offers a most generous interpretation of Joseph's behavior toward his brothers after their arrival in Egypt. The initial concealment of his identity receives an interesting twist in Philo's hands: it merits praise by contrast with what he *might* have done—namely, exact vengeance through the application of his awesome power. Instead, he curbs his inclinations and elects to hide his relationship to the suppliants.[44] That puts a most liberal construction on Joseph's behavior, but supplies no reason for his deception. The reason surfaces later when Philo accounts for the stratagem that gets Benjamin arrested and terrifies the other brothers. As in Jubilees, it was merely a test to discover whether there was dissension among the children of Jacob's two wives. When they display authentic family solidarity, all can be revealed—and forgiven.[45] Even if the means might be dubious, the motives were noble. Indeed, Joseph protected his brothers' repute throughout, never once disclosing their misdeeds to others, even when sorely tried, and he showed his sensitivity at the close of the episode with a private reconciliation, lest any outsider reproach them.[46]

Joseph proceeded to administer the economy of Egypt with brilliance and effectiveness, while turning down every opportunity for self-aggrandizement and self-enrichment.[47] Philo goes so far as to suggest that Joseph not only stabilized the public revenues of Egypt but raised the level of civilization of a people otherwise decidedly inferior in their manner of life.[48]

And he ends the treatise with a flourish, assigning to Joseph a host of virtues, including intelligence, eloquence, a balanced disposition, great political and administrative skills, and even good looks.[49]

The lavish praise for Joseph's superior traits of character goes hand in hand with emphasis upon political power. That aspect looms large—and inseparable from moral excellence. Philo places considerable weight upon Joseph's talent in running affairs and his lofty position at the center of governance. He interprets the Hebrew name "Joseph" as equivalent to "addition of a lord" in Greek, thus presaging his hero's career.[50] The coat of many colors also forecasts the statesman's future: it represents the flexibility and variety of means whereby the true leader must deal with a range of contingencies.[51] As already noted, Joseph ran Potiphar's household and then took charge of the very prison in which he was incarcerated. Philo properly notes that when Pharaoh put Joseph in authority at court, the young man, showered with the emblems of power, was technically second in command. He was a διάδοχος.[52] Yet the treatise subtly suggests an ambiguity of roles, even a reversal of positions. When Joseph first encountered the Pharaoh, he was unimpressed by his elevated status and spoke to him more as king to a subject than vice-versa.[53] Even when describing Joseph's appointment as the number two man in the realm, Philo notes that Pharaoh retained only the title of ruler, while Joseph exercised dominion in fact.[54] The Alexandrian underscores the role reversal alluded to by Genesis. Joseph remarks to his brothers that not only does he hold the post of highest honor with Pharaoh but that the latter, though the older man, reveres him as a father.[55] The Joseph of Philo's *De Josepho* represents more than the abstract image of the ideal statesman. His exercise of power in Egypt rescued the land and its people, turned Pharaoh himself into a subordinate, and made preservation of the Egyptian legacy dependent upon a forefather of the Jews.

The golden image, however, becomes tarnished elsewhere. The Joseph tale in Genesis opened itself to diverse interpretations. And Joseph's image in the Hellenistic period could be turned to various ends. Philo himself, who manipulated the figure of the patriarch to advance his own conception of model statesmanship, also refashioned it to express undesirable characteristics and detrimental qualities. In his tract *On Dreams,* Philo takes a stunningly different line on Joseph. The youthful dreamer's report on his nocturnal visions was far from naive and inoffensive. It exhibited boastfulness and presumptuousness. Philo, in fact, surprises the reader by setting the conventional interpretation on its head. He justifies the brothers' righteous indignation against Joseph as appropriate resistance to premature overreaching.[56] A still more ambitious dream earned him the sharp rebuke of Jacob.[57] The coat of many colors, which Philo interpreted in the *De Josepho* as signifying laudable political flexibility, gets a more sinister exegesis in the *De somniis:* it symbolizes craftiness, deceit, and insincerity.[58] Joseph becomes

emblematic of the shifting temperament that pursues diverse aims with no stability of purpose.[59] Pride and pomposity take over. The dignities and honors bestowed upon him as Pharaoh's right-hand man constitute not rightful elevation to power but hubristic ambition aimed at eradicating equality.[60] Joseph's elation at the trappings of high office disclose his empty vanity.[61] Grandiose self-importance induces him to exalt himself over people, cities, laws, and ancestral practices.[62] The name "Joseph," rendered by Philo as "addition of a lord" in the *De Josepho* and thus forecasting his proper station, becomes in *De somniis* the addition of meaningless, corrupting, and alien features to one's natural character, unnecessary material goods and wealth to innate quality.[63] Or, in another formulation elsewhere, the name "Joseph" is tantamount to the mentality of the politician who seeks to juggle human and divine values, shifting back and forth between true and apparent virtue.[64] The assessment of the biblical figure's character here takes on a much more cynical cast.

The inconsistencies and tensions in this dual portrait create a baffling paradox.[65] How to account for Philo's glowing tribute to Joseph in his biographical treatise and his censorious disapproval elsewhere? On one theory, Philo employs the Joseph figure as a smokescreen to advance political ideas growing out of his immediate experience in an Alexandria governed by incompetent and malevolent Roman prefects. The *De Josepho*, therefore, constitutes a form of mirror for princes in which Joseph represents the ideal governor whom Roman officials should emulate, whereas the Joseph of *De somniis* serves as whipping boy for Philo's criticisms, a surrogate for the Roman regime in Alexandria. The inconsistency, on this view, is deliberate and calculated, a twisting of the Joseph character for political ends, depending upon intended audience: *De Josepho* for Gentile readers, *De somniis* for Jews.[66] Alternatively, one might postulate a change of mind or change of direction by Philo, who composed these works at different times and under different circumstances. *De Josepho* thus presents a general philosophy of proper governance, whereas *De somniis* was composed in reaction to the turmoil and anti-Semitism provoked or aggravated by the Roman prefect Avillius Flaccus—or possibly even by Philo's nephew, the apostate Jew Ti. Julius Alexander.[67] In a quite different vein, it can be argued that Philo's divergent treatments depend upon the method adopted in a particular treatise. Philo designed *De Josepho* as a relatively straightforward and faithful recreation of the Genesis story, drawing out the lessons for ideal rulership through allegorical commentary. Elsewhere, however, as in *De somniis*, an individual figure is himself allegorized, Joseph becoming emblematic of κενή δόξα, vacuous glory, and a vehicle for Philo to attack a human character flaw.[68] It is even possible to soften the inconsistencies between the two texts and find a certain amount of common ground between the ostensibly conflicting portraits. *De somniis* indeed holds out hope for Joseph's reformation and his

brothers' reconciliation with him (not vice-versa!), symbolized by Joseph's wish to have his bones buried in the homeland.[69]

The diverse explanations need not here be weighed and assessed. Whatever one's view of Philo's intentions and objectives, striking discrepancies remain in the images of Joseph transmitted in his works. And that has important implications. The predominantly positive picture of the abstemious, although rather sanctimonious, patriarch, the self-restrained, wise, and upright ruler, that appears in Hellenistic texts like Jubilees, Pseudo-Philo, the *Testaments of the Twelve Patriarchs*, *The Wisdom of Solomon*, 1 Maccabees, 4 Maccabees, and Philo's *De Josepho*, did not altogether repress the more dubious characteristics of the manipulator, the artful schemer, and the man enamored of worldly goods and power. The latter was certainly no invention of Philo's. He observes that ascription of the name "Joseph" to the disposition of the politician who moves between real and merely ostensible virtue was a conventional one.[70] Similarly, attraction to material goods and the comforts of the body, according to Philo, customarily receive the designation of "Joseph" as well.[71] All of this suggests that for Hellenistic Jews, Joseph was more persona than personage, an acknowledged literary artifice, available and versatile. No monolithic figure determined the discourse. The ambiguities of Joseph's personality and achievements made him readily malleable for Hellenistic Jews to serve a variety of purposes. For Philo, the moralizing ends took precedence. In the hands of other writers, more imaginative constructs could emerge.

~~~~~~~~

Artapanus offers a useful case in point. A Hellenized Jew in Egypt, he composed a work on the Jews that seems to have combined a refashioning of biblical stories, historical reconstruction, and inventive fiction. The genre of the work, if any, can hardly now be ascertained. Only a few fragments survive, quoted by Alexander Polyhistor and preserved by Eusebius. The Egyptian context of the fragments gives Artapanus's provenance, and Polyhistor provides a date prior to the early first century B.C.E. Moderns frequently label his work as "competitive" or "apologetic" history, a response to writers hostile to the Jews, a defense of the biblical past against critics like Manetho.[72] That may not be the most profitable approach. Discussion has dwelled almost entirely upon the lengthiest extant fragment, that on Moses. Apologetic tendencies even there take a back seat to creative retelling. In the extract on Joseph, they can barely be detected, and, in any case, need not be hypothesized. Artapanus freely adapted and molded the Genesis story to his own taste.

The fragment is compact and highly condensed. But it discloses clearly enough the scope available for Hellenistic writers to reshape biblical traditions. Artapanus interestingly reconceives the narrative of Joseph's transfer

from Palestine to Egypt. The young man's brothers conspired against him because he surpassed them in knowledge and intelligence. But, instead of falling into their trap, Joseph foresaw the plot and persuaded some neighboring Arabs to convey him to Egypt.[73] Joseph landed in Egypt, therefore, through his own shrewdness, escaping the machinations of his brothers, not victimized by them. For Artapanus, he engineered the sequence of events, an account sharply divergent from the Genesis tale. Upon arrival in Egypt, Joseph became acquainted with the king and was installed as his chief economic minister, in charge of the entire land.[74] Not a word about Joseph as dream interpreter—let alone about a stint in prison as target of Mrs. Potiphar's spleen. Joseph evidently impressed Pharaoh with his talent and intellect upon first encounter and received his lofty post immediately, no sorcery or divine intervention needed. And the new minister proceeded to restructure Egyptian agriculture, placing land tenure for the first time on an equitable footing. He put an end to exploitation of the weak by the powerful, allocating possessions in designated lots, with clearly delineated boundaries, bringing neglected land back into cultivation, and setting aside property for the priests.[75] This account, truncated and terse though it be, is a far cry from the biblical narrative. The Book of Genesis describes Joseph's agricultural changes as extending royal authority and ownership and making the peasantry of Egypt dependent upon the crown.[76] Artapanus evidently felt free to ignore the testimony of the Scriptures. Further, he omitted the whole rationale for Joseph's policy as given in Genesis, the need to shore up resources in the years of plenty in order to preserve them for the coming famine. For Artapanus, Joseph received his post simply to reorganize the country's economic system.[77] The subsequent arrival of Jacob and the brothers appears unmotivated by any crisis, merely a reunion with Joseph and a resettlement.[78] More striking still, Artapanus makes Joseph the discoverer of measurements, a lasting contribution of magnitude, for which he was much beloved by the Egyptians.[79]

Artapanus's reconstruction plainly used the biblical tale as no more than a springboard. He cast his Joseph in a very different mold. In the preserved fragments, divine aid plays no part, moral lessons are absent, and the hero's inner character is irrelevant. Joseph appears as a clever calculator who impressed Pharaoh, a farsighted economic reformer, and even a pragmatic inventor. Artapanus's version skirts any ethical concerns. His Joseph merits neither praise for self-control nor blame for ambition and material desires. The trappings of power, for good or ill, make no appearance in the text. Joseph gains authority through his wits and employs it to reorder the institutional structure of Egypt. That nation owed its success, in short, to the brains of an Israelite.

A remarkable text highlights still further the malleability of the Joseph figure and the multiple forms it could take. The romantic story *Joseph and*

*Aseneth* moves in a realm quite different from those discussed above, that of novelistic fantasy. Genesis provides barely a pretext for this invention. The Scriptures report only that Pharaoh gave to Joseph as his wife Aseneth, daughter of Potiphar the priest of On, and that she subsequently bore him two children.[80] All else is embellishment. And *Joseph and Aseneth* embellishes in style.

A summary of the yarn would be apposite. Joseph, gathering grain in the course of his duties as Pharaoh's agricultural minister at the outset of seven plenteous years, reached the territory of Heliopolis. There he encountered the eminent Pentephres, priest of Heliopolis, a royal official of the highest station, adviser to Pharaoh, and a man close to the throne. Pentephres had a beautiful eighteen-year-old daughter, Aseneth, likened by the author of the tale to the most celebrated women of the patriarchal age, Sarah, Rebecca, and Rachel. Aseneth, however, like Puccini's Turandot, scorned all men and rudely rejected suitors from noble houses in Egypt and royal families elsewhere. Pharaoh's son himself pressed hard for her hand but was overruled by his father, who preferred a match with another ruling house. The report of Aseneth's celebrated beauty depended upon rumor rather than witnesses, for she shut herself up in a lofty tower, not to be seen—let alone touched—by any man.[81] Pentephres, upon learning of Joseph's imminent arrival, immediately proposed that Aseneth be betrothed to this righteous, pious, and powerful man. But Aseneth recoiled in anger: she would have nothing to do with one who was a stranger in the land, a shepherd's son from Canaan, sold as a slave and imprisoned as an adulterer. The arrogant Aseneth would accept marriage only with the son of Pharaoh.[82] Once the young maiden spied Joseph from her bedroom window, however, everything turned topsy-turvy. Aseneth was smitten; her haughty aloofness was immediately abandoned, and she was overcome with self-reproach that she had despised as a shepherd's son one who turned out to be a dazzling divinity.[83] Joseph himself had his doubts when he caught a glimpse of Aseneth: he feared that she was yet another predatory female determined to bed him, like Potiphar's wife and a host of others who could not keep their hands off him. But Pentephres reassured his noble guest: Aseneth was a man-hating, committed virgin, and no threat to Joseph's chastity. Pentephres then brought the two people together, even suggesting that they exchange a kiss as brother and sister, only to have Joseph recoil this time from the eager Aseneth. The purist devotee of a sole god would have no congress of any kind with an idolatress. Joseph took some pity on the crestfallen Aseneth, offering up a prayer to the Lord to have her mend her ways and acknowledge the true god, for only such a drastic conversion could justify any relationship.[84] Aseneth grasped at the hope and turned her religious life around at a stroke. Much weeping and wailing ensued as she repented of former heresies, removed all false idols from her home, and fell

to fasting and mourning, self-flagellation and humiliation, uttering desperate prayers to her newly found god, seeking forgiveness for past sins and rescue from the fury of spurned divinities.[85]

The maiden's prayers were answered. An angel of the Lord materialized, resplendently garbed, bathed in light, with sparks shooting forth from hands and feet. He braced the young woman's courage, offered her absolution for prior offenses, proclaimed her acceptance by God, and bade her put off sackcloth and dress herself in bridal attire to prepare for a wedding with Joseph. The happy encounter climaxed with a ritual meal, featuring a magical honeycomb and bees. The angel then flew off in a fiery chariot, pulled by lightning-like steeds.[86] Aseneth's new dress restored her to the fullness of her beauty. And when Joseph returned for a second visit, she declared her renunciation of false idols and embrace of the true god. Joseph's kisses now came freely, infusing his betrothed with the spirit of life, wisdom, and truth. Pentephres offered to host the wedding festivities, but Joseph declined, preferring to have Pharaoh himself preside over the ceremonies. The king therefore gave the bride away, placed crowns on the heads of the couple, and sponsored a spectacular banquet that lasted for seven days. The marriage was consummated, and Aseneth subsequently produced two sons as Joseph's legacy.[87]

The happy ending, however, had not yet come. A second part of the tale, quite different from the love story that preceded, now takes the narrative in a new direction. The seven years of plenty had come and gone, famine set in, and Joseph's family migrated from Palestine. Internal friction began to show itself both in the Hebrew patriarch's household and in that of Pharaoh. Joseph's brothers Simeon and Levi, the sons of Leah, immediately took joy in the company of Aseneth, while other brothers, the offspring of Leah's and Rachel's servants, felt only envy and hostility. Further, Pharaoh's son, still nursing fierce resentment at the loss of Aseneth, determined to take her by foul means. He hoped to win over Joseph's brothers for a plot to murder Joseph and carry off Aseneth. Simeon and Levi refused firmly, the former dissuaded from assaulting Pharaoh's son only by Levi's pacifist stand. But the villain of the piece did have success with other brothers, notably Dan and Gad, who proved willing to share in the nefarious enterprise. They would lead Egyptian armed men in an ambush of Aseneth and her entourage, to be followed by massacre of Joseph and his sons, while the heir to the throne prepared to murder his own father.[88] The schemes, of course, were foiled. The Egyptians cut down Aseneth's companions, forcing her to flee, with Pharaoh's sons and fifty men at her heels. Fortunately, however, Benjamin, now a strapping lad of eighteen, stood with Aseneth in her chariot. Leaping from the vehicle, he launched fifty stones, each of which felled an Egyptian, including Pharaoh's offspring. The sons of Leah wiped out the remaining foes. And when the other brothers made a final effort to slay Ben-

jamin and Aseneth, their swords miraculously fell to the ground and dis-
solved into ashes.[89] The sons of Leah, headed by Simeon, sought vengeance
upon their evil half-brothers, threatening a new bloodbath. But Aseneth
intervened to urge forgiveness and concord. The peace-loving Levi then
stayed Benjamin's hand when he attempted to finish off Pharaoh's helpless
son. Their enemies were thus spared—those who survived. Pharaoh pros-
trated himself before Levi in gratitude. His heir, however, perished anyway
from the effects of the wound, thus bringing about the death of the grief-
stricken Pharaoh himself shortly thereafter. But not before the ailing ruler
turned his kingdom over to Joseph, bestowing upon him the diadem that
signaled royal authority. Joseph then reigned as monarch of Egypt for forty-
eight years, before yielding the diadem in turn to Pharaoh's youngest son,
whom Joseph had treated as his own child through all those years.[90]

So ends the narrative, an edifying and uplifting one. In fact, it consists of
two narratives, a love story followed by an adventure tale, the two only
loosely connected with one another. Its strikingly unusual character has
called forth an extensive scholarly literature. Controversy swirls around the
language, date, provenance, genre, message, and audience of the text.[91]
Mercifully, most of the discussions have only a marginal bearing on our sub-
ject and the issues can be treated with brevity. A broad consensus now holds
that the original language of the piece was Greek rather than Hebrew. The
influence of Septuagintal vocabulary is readily documentable, as is the pres-
ence of Greek philosophical ideas. By contrast, no trace survives of a Semitic
original, and later rabbinical versions of the Aseneth tale seem quite
unaware of this one.[92] The work very probably emanated from Jewish cir-
cles. Christian interpolations, if any, are few and conjectural. The text as a
whole betrays little knowledge of Christian ideas and advances no Christian
doctrines.[93] Attribution to any particular Jewish sect, whether Pharisees,
Essenes, Therapeutae, or others, is highly speculative and largely point-
less.[94] Composition by a Jewish writer or writers, presupposing awareness of
the Septuagint, with a narrative setting in Egypt, suggests but by no means
proves an Egyptian provenance.[95]

Efforts to pinpoint the date of composition founder for lack of any clear
historical references. In a work of imaginative fiction, the search for such
allusions may itself be illusory. The scenario of Egypt in the patriarchal
period hardly lends itself to precise parallels with Ptolemaic or Roman soci-
ety, and it would be misguided to manufacture them. The author's famil-
iarity with Septuagintal language would place the text no earlier than the
second century B.C.E. A *terminus ante quem* remains beyond our grasp. Even
the standard assumption that it must precede Hadrianic times on the
ground that no conversion narrative would have been produced thereafter
depends on the notion that this *is* a conversion narrative—an unestablished
premise. The attitudes reflected therein with regard to relations between

Jews and Gentiles, tense but resolvable, may tip the balance slightly toward a Ptolemaic rather than a Roman setting. Comparable attitudes are discernible in works like the Letter of Aristeas, 3 Maccabees, and the writings of Artapanus. Beyond that it would be unsafe to go.[96]

The genre of *Joseph and Aseneth* has, of course, evoked discussion and commentary. Obvious affinities exist between the work and Greek romances like those of Chariton, Heliodorus, Achilles Tatius, or Xenophon of Ephesus, affinities rightly stressed by most moderns. Yet the erotic features are subordinated in the first part of the narrative and altogether absent in the second. Indeed, the love story and the adventure tale in *Joseph and Aseneth* bear relatively little relation to one another. Other parallels can be found in Jewish fiction of contemporary or near contemporary eras, like the books of Judith, Esther, and Tobit. Here again, the pattern is not perfect. Romantic elements play an insignificant role in those narratives, and differences loom larger than similarities. The conversion in *Joseph and Aseneth* prompts a comparison with mystical tales and sacred epiphanies, as in Apuleius's *Metamorphoses*. But that places too much weight upon a particular aspect of the work and does not account for the bulk of it. Additional speculation would pay few dividends. Placement of *Joseph and Aseneth* in a particular genre, even if that were an appropriate process, cannot illuminate the intent and significance of the tale.[97]

The work is not readily classifiable, nor is its objective readily definable. The "conversion" aspect has perhaps received undue emphasis. Most commentators ascribe a missionary purpose to *Joseph and Aseneth,* with Aseneth's adoption of Joseph's religion and his god seen as the core of the narrative, the tract aimed at demonstrating the value of embracing Judaism.[98] The text as a whole, however, gives small comfort to that idea. Joseph certainly conducts no active campaign to convert Aseneth, and neither is he present when the conversion takes place. The heroine's adoption of Joseph's creed does not inspire professions of the new faith by any other character in the tale, not even those like Pentephres and Pharaoh who show conspicuous favor to the religion. One might observe, in fact, that no mention of "Jew" or "Gentile" occurs in the text. Aseneth's transformation essentially meant the abandonment of idolatry. The very concept of active Jewish proselytism in this period is debatable. *Joseph and Aseneth,* in any case, would hardly stimulate it. The work, presupposing familiarity with the tales of the patriarchs in the Septuagint, can have found few knowledgeable Gentile readers. And an author engaged in missionary efforts would not likely feature a story in which the impulse to conversion came from the convert's passion for her intended lover![99]

The imaginative tale of Joseph and Aseneth offers insight into a matter of broader consequence than chronology, provenance, literary genre, or even proselytism: the relation between Jew and Gentile in the Diaspora.

Scholars often interpret the text as pitting the two cultures against one another. Joseph's insistence upon the purity of the faith and the pollution of idolatry, Aseneth's abject debasement and thorough break with her past to achieve absolution, the rigorous separation of Jews and Egyptians, and the favor of God supporting the faithful against their idolatrous opponents all seem to suggest a stark dichotomy between the forces of good and evil.[100] But the breakdown is not so simple, and the polarity not so sharp. Friction exists after all *within* each of the two communities. Joseph's brothers engage in potentially murderous activities against one another, and Pharaoh's son plots the assassination of the king. The fact that the wedding of Joseph and Aseneth takes place under the auspices of Pharaoh, who had not himself become a convert, holds central symbolic significance. The enemies of the faithful had been forgiven, harmony and reconciliation followed, and the Gentile ruler of Egypt presided over the union of a Hebrew patriarch and the daughter of an Egyptian priest. The fable plainly promotes concord between the communities. Equally important, it asserts the superiority of Jewish traditions and morality—even against some Jews themselves.

Aseneth holds central place in the narrative, and scholarly focus has properly concentrated upon her.[101] The figure of Joseph, however, occupies our attention. His treatment in a work of imaginative fancy, a form quite different from the other literary contexts in which he appears, adds a valuable dimension to the image of the patriarch in the Hellenistic era.

Joseph as the embodiment of piety and purity comes through loud and clear. But that aspect of character is by no means an unmixed blessing. Joseph's fussiness bespeaks a cramped disposition, and his public display of abstinence borders on the offensive. Upon entrance into Pentephres' house, he immediately planted himself upon his host's "throne" (evidently Pentephres' official seat as royal representative).[102] He took his meal in private, for he would not eat with Egyptians, an abomination in his view.[103] Having caught a glimpse of Aseneth at her window, Joseph leaped to the conclusion that she was yet another in the long line of females who lusted after his body. And he did not hesitate to recount to Pentephres his stoical resistance to the flocks of beauties, the wives and daughters of Egyptian aristocrats and royal appointees, and indeed women of all classes, who were desperate to sleep with so handsome a creature. Joseph, of course, so he announced, was impervious to their charms and scorned the costly gifts with which they sought to win his affection.[104] This was not behavior designed to endear him to his hosts—who, however, were too dazzled by his position to care. Joseph consented to receive Aseneth only when told that she was a virgin who hated all men, for this suggested that he was safe from molestation. The text adds, quite notably, that he too was a παρθένος.[105] But when Aseneth eagerly approached him, ready to offer a kiss, Joseph shoved her away disdainfully: no true worshiper of God could touch the lips of an alien

woman polluted by contact with dead and dumb idols.[106] Joseph thus kept his principles intact and his body undefiled. But, like the Joseph figure in the *Testaments of the Twelve Patriarchs,* he boasts rather unsparingly, even unpleasantly, of his chastity and ritual purity. Only more so. This time it is not just Potiphar's wife but a host of lascivious ladies whom he had to fight off. Nor does he hesitate to humiliate Aseneth in front of her father, thus driving her to self-abuse and mental torture before he would acknowledge her rejection of idolatry. The hero of this saga evidently did not prize graciousness or even civility.[107]

Instead, Joseph exudes power and authority—more strikingly here than in Genesis or any of the other Hellenistic elaborations. The author of *Joseph and Aseneth* introduces Pentephres as chief of all satraps and grandees in the realm.[108] Yet, when he learns of Joseph's imminent visit, he is beside himself with excitement and goes to every length in preparing his household to receive so eminent a guest—one to whom he refers as "powerful man of God."[109] Pentephres breathlessly describes Joseph to his daughter as ruler of all the land of Egypt and Pharaoh's appointee as all-powerful governor.[110] Joseph then enters the gates of his host's estate in a royal chariot, resplendent in purple robes and a gold crown with precious stones. Pentephres and his entire family hasten to perform *proskynesis.* The text could not make plainer the fact that, no matter how lofty the position of Pentephres in the court and in the realm, he was far below the station of Joseph the Jew.[111] In fact, Joseph possesses an aura that sets him apart from any mortal potentate. He is not only the "powerful man of God." His crown radiates twelve golden rays, emblematic of a sun god. Aseneth makes a direct identification: Joseph is the sun from heaven, arriving in a chariot and shining its beams upon the earth.[112] Still more significant, the text refers to Joseph repeatedly as "son of God." This does not designate a title, nor should it be seen as Christian interpolation. But it lifts Joseph well out of the ordinary and sets him in the glow of the divine.[113] Aseneth's prayer to the Lord describes Joseph as beautiful, wise, and powerful. That last adjective has major import.[114] Phrases of this sort always issue from other persons' mouths. But Joseph's demeanor and behavior would certainly not have discouraged them. Indeed, he underscored his stature by dismissing Pentephres' offer to provide a wedding banquet. Joseph would have none other than Pharaoh himself perform that task. The king consequently not only presided over the occasion but placed golden crowns upon the couple's heads.[115] Joseph disappears in the second part of the narrative, the adventure story. But he turns up again at its conclusion, to have the dying Pharaoh present him with the diadem, symbolic of royal authority. And the text has Joseph reign as king of Egypt for forty-eight years, before relinquishing the diadem to Pharaoh's youngest son. This goes well beyond the biblical tale and probably beyond any subsequent Hellenistic version of it.[116] The

absence of Joseph in the second part of the tale has significance. When his enemies are forgiven, it is Aseneth and Levi who extend the clemency. Joseph would not have done so. In *Joseph and Aseneth,* he remains mighty and unbending from start to finish.[117]

The superiority of the Hebrews, their character, faith, and traditions, constitutes a central theme of the work. Joseph's contemptuous refusal to have a meal with Egyptians deliberately reverses the biblical passage that has the Egyptians shun any table occupied by Hebrews.[118] Aseneth's smashing of idols and her abject submission to the Lord accentuate the inferiority of her native religion. It is noteworthy that the author forecasts Aseneth's transformation early in the text, when he describes her beauty as unlike that of any of the Egyptians but akin to that of Sarah, Rebecca, and Rachel.[119] Pharaoh makes obeisance to Joseph's god when he conducts the wedding ceremony.[120] The second segment of the narrative points up the Hebrews' physical as well as spiritual superiority. Pharaoh's son acknowledges that they are powerful men, beyond all others on the face of the earth.[121] Benjamin's superhuman strength enables him to fell fifty Egyptians.[122] And, in a climactic scene that emblematizes the Hebrews' military and moral supremacy, Pharaoh leaves his throne to prostrate himself before Levi, who has spared his defeated son.[123] The harmonious resolution stands at the core of the tale. But it comes only through affirmation of Jewish ascendancy.

*Joseph and Aseneth* supplies revealing testimony on the manipulation of the Joseph image in Hellenistic times. The romantic tale diverges in most respects from the other vehicles conveying that image. And certainly it bears little relation to or concern for the biblical narrative. Yet the personality of Joseph that appears in Genesis interestingly reappears in this fictitious fantasy, modified but unmistakable. Joseph emerges again as the favorite of God, trusting in divine beneficence, the loyal upholder of the faith, the fierce proponent of piety and rectitude, and the wielder of extensive authority in Egypt. But the author of the romance also heightens and intensifies those characteristics, subtly (or perhaps not so subtly) transforming them into haughtiness, prudery, self-righteousness, authoritarianism, and contemptuousness.

In this writer's hands, Joseph could effectively carry the sense of Jewish superiority in a multiethnic society—but also some of the disagreeableness that can accompany that superiority. The ambiguous personality of Joseph gave itself readily to refashioning. This work, it may be suggested, both celebrates Jewish pride and cautions against its excess.

<hr />

The complex and multiform features of the Joseph character recur in an indirect way through still another and altogether different vehicle. Josephus transmits an elaborate family saga of intrigue, escapade, and adven-

ture in the historical context of Jewish experience under the Ptolemies and Seleucids. On the face of it, the biblical Joseph is nowhere in evidence. The account follows the family of the Tobiads over two generations, spanning the third and second centuries B.C.E., enmeshed in the turmoils and rivalries of the Hellenistic age, ostensibly a serious historical narrative. Yet echoes of Genesis resonate in the background, and Joseph resurfaces in altered form.

The tale of the Tobiads, as presented by Josephus, warrants brief rehearsal. The account commences at the outset of the second century B.C.E., following conclusion of the Fifth Syrian War. Josephus reports a treaty between Antiochus III and Ptolemy V that ceded to the latter control of Coele-Syria, Judaea, Samaria, and Phoenicia. This put the revenues of the area in Ptolemaic hands and set the stage for tensions that embroiled the Jews. Onias, High Priest in Jerusalem, motivated by niggardliness and avarice, refused to pay the annual tribute that his predecessors had rendered to their Hellenic overlords, thus stirring the fury of Ptolemy. The king's envoy arrived with threats of land confiscation, spreading anxiety among the Jews but leaving Onias unmoved.[124] A young man then came to the rescue, a certain Joseph, son of Tobias and nephew of Onias on his mother's side, a man of gravity and prescience, with a reputation for uprightness. Joseph rebuked Onias for placing his people in jeopardy and failing in his roles as High Priest and chief official of the state. The youth offered to go as envoy to Ptolemy himself and, after having secured permission, skillfully prepared the way by ingratiating himself with Ptolemy's representative, who was still in Jerusalem.[125]

The advance preparation did the trick. By the time Joseph reached Egypt, Ptolemy's envoy had already smoothed the path by reporting on the obstinacy of Onias and the excellence of the young man who would come as spokesman for the Jews. Ptolemy greeted Joseph with graciousness and favor, even invited him into his chariot. Joseph's wit and aplomb charmed the king still more, earning him a stay in the palace and a place at the royal table. The timing proved to be propitious. It was the occasion for the gathering of leaders and chief officials from various cities in Syria and Phoenicia, each bidding for the tax-farming rights in his region. Joseph, who had been ridiculed by these men on the journey to Egypt, now seized the opportunity to retaliate. He denounced their low bids as the product of collusion and promised to deliver twice the amount. When he then capped his offer with another witticism, suggesting the king and queen themselves as guarantors of his proposition, Joseph had Ptolemy in the palm of his hand. The king assigned him all tax-farming rights without demanding surety, thus deflating his arrogant competitors and sending them back empty-handed.[126] Joseph proceeded to borrow 500 talents from friends of the king and 2,000 troops from the royal army to help in the collection of rev-

enues in Palestine and Syria. Nor did he tolerate any resistance. With Ptolemy's authority behind him, Joseph terrorized reluctant or recalcitrant cities, gathered the requisite taxes for the king, and amassed a fortune for himself.[127]

Joseph the Tobiad enjoyed his position and his prosperity for twenty-two years. In the course of it, one wife produced seven sons, and another gave him an eighth. A romantic anecdote accounts for the second marriage. Joseph's brother, through a subterfuge, placed his own daughter in Joseph's bed during a visit in Alexandria, lest Joseph's infatuation with an Egyptian dancing girl lead him to unlawful intercourse with an alien. So Joseph, despite himself, kept faith with ancestral traditions, married his niece, and received Hyrcanus, an eighth son, as reward.[128] Hyrcanus, while still a teenager, outstripped his half-brothers in innate courage and intelligence, thus winning special favor from his father and exciting the envy of his siblings.[129]

Hyrcanus soon had occasion to reproduce the exploits of his father. King Ptolemy announced the birth of a son, and planned great festivities to mark the event. Old age prevented Joseph from making the trip to Egypt, and none of his older sons proved willing to go, urging him instead to send Hyrcanus, in the expectation that he would not return. The youth was happy to oblige. He requested only a modest sum for the trip and no money at all for a gift to the king. Instead, he sought a letter from Joseph to his financial agent in Alexandria, who could supply the needed cash for a handsome gift, an idea that appealed to his father. Hyrcanus departed to carry out his plan, while his brothers communicated with friends of the king's, who were to do away with him.[130] The young man, of course, had hatched a scheme to outwit his rivals. He delivered Joseph's letter to the financial agent Arion and then requested the sum of 1,000 talents. The flabbergasted agent, assuming that Hyrcanus wanted the cash for extravagant personal expenditures, refused to relinquish it, and was immediately put in irons on Hyrcanus's orders. Word of this reached Ptolemy, who demanded an explanation and got a pointed witticism about the need for discipline at every level of society, even Ptolemy's own. The king was as charmed by Hyrcanus as he had been by Joseph. The young man used his 1,000 talents to purchase one hundred boys and one hundred girls as presents for the court. Hyrcanus thereby outshone and humbled all the eminent guests who had scorned him through both the acuity of his wit and the lavishness of his gifts. He even had enough cash left over to buy off the would-be assassins whom his brothers had recruited![131]

The story would not, however, have a happy ending. Hyrcanus's cleverness endeared him all the more to Ptolemy but further alienated his family. Ptolemy showered him with honors and wrote glowing letters of recommendation back home. The brothers nevertheless redoubled their efforts,

and even Joseph had become disenchanted. A fraternal war ensued. Hyr-
canus's forces slew many of his enemies, including two brothers. But he
could gain no entry to Jerusalem and was compelled to withdraw for safety
across the Jordan, where he turned to military and financial oppression of
the natives.[132] Hyrcanus entrenched himself by constructing an elaborate
fortress, replete with a moat, caves carved out of rock, and artistic embel-
lishments. He held forth there for seven years until the accession of Anti-
ochus IV in Syria and the death of his patron Ptolemy V of Egypt. Acknowl-
edging the irresistible power of Antiochus, Hyrcanus then elected to take
his own life.[133]

Arguments over the historical value of this narrative persist, constituting
the chief focus of scholarly attention. Josephus's blunders are readily dis-
cernible. Confused chronology bedevils the account from start to finish.
Neither the twenty-two years of Joseph's tax supervision nor the seven years
of Hyrcanus's installation across the Jordan fit into the circumstances
reported by Josephus. And the scenario of Ptolemaic fiscal control in Pales-
tine and Cocle-Syria demands a period prior to Josephus's starting point.
Other inconsistencies and difficulties require no rehearsal here.[134]

To be sure, a historical substratum exists. The tales of the Tobiads did not
spring up out of the whole cloth. Independent testimony, literary, papyro-
logical, and archaeological, confirms the eminence of that family in late
biblical and Hellenistic times. The Tobiads, in fact, go back to the period of
the Babylonian Exile. A Tobiah receives mention among Judaean leaders
who will return to crown the High Priest in the new Temple. Another
Tobiah plays a prominent role among principal houses in the time of
Nehemiah. And the name "Tobiah" appears in rock-cut inscriptions at the
Transjordanian site of Araq el Emir in Aramaic lettering, now dated to the
fourth century B.C.E.[135] The fortress itself, excavated at Araq el Emir, corre-
sponds closely to Josephus's description of the elaborate structure built by
Hyrcanus, although it plainly predates Hyrcanus by perhaps a century.[136]
The prestige of the clan gains further confirmation from the Zenon papyri
of the mid third century. They record a Toubias, clearly a notable person-
age in the Transjordan, in contact with the Ptolemaic ruler, his *oikonomos*
Apollonios, and Apollonios's agent Zenon. The papyri attest to his wealth in
the form of gifts and supplies and his authority as head of a military cleruchy
situated on his own estates.[137] The site itself is termed "the Birta of the
Ammonitis," which may well coincide with the powerful "Baris" or fortress
that Josephus ascribes to Hyrcanus. And the "Saurabitt" that appears in
another papyrus, evidently a Greek transcription of the Hebrew "Zur," or
stronghold, can be linked to "Tyros," the name that Hyrcanus applied to his
structure. Thus the edifice and possessions that Josephus assigns to Hyr-
canus had actually been in the family for several generations.[138] It was
known also in the third century as the "land of Tobiah," a name that clung

to it still in the period of the Maccabaean rebellion a century later.[139] Finally, the wealth and standing of Hyrcanus obtains verification from an important passage in 2 Maccabees: the man of high distinction, here identified as "son of Tobiah," had a substantial sum of money deposited in the treasury of the Temple itself.[140] That the house of the Tobiads had a long and influential history in Palestine and Transjordan from postexilic times through the Maccabaean era cannot be gainsaid.

The significance of Josephus's narrative, however, lies elsewhere. Whatever relation it bears to historical reality, the account has obvious folktale elements and the appealing qualities of imaginative fiction.[141] More pertinently, it reverberates with allusions to Genesis. The recollections are indirect, transmuted, and modified. The biblical Joseph does not correspond in a one-to-one relationship with a particular character in the tales of the Tobiads. But the scriptural similarities are hardly random coincidences.

A number of biblical resonances can be detected. Both Joseph the Tobiad and Hyrcanus ingratiate themselves as young men with the ruler of Egypt and swiftly obtain positions of high authority, leading to substantial wealth, as did Joseph in Genesis. The division between brothers born of different mothers recalls the house of Jacob, as does the eclipse of older brothers by the younger, and the favor of the father bestowed upon the latter. Even select details offer parallels, such as Joseph's mounting the king's chariot, and the last-minute substitution of a bed partner who becomes a wife.[142] But we need to pass beyond the parallels. What traits and qualities of the Joseph figure draw attention in this narrative? And what are their implications for the Hellenistic conception of that figure?

The tales of the Tobiads do not aim at moral uplift. As in the case of Artapanus's fanciful reconstruction, the virtuous and virginal Joseph is absent. No indication points to the episode of Potiphar's wife, nor to forgiveness and magnanimous reconciliation. Perhaps more surprisingly, the saga omits reference to administrative restructuring and economic reform. The characters in this narrative evoke other features of the biblical patriarch. Joseph the Tobiad is introduced as a young man with a reputation for righteousness, an evident echo of the Genesis Joseph.[143] But that trait nowhere emerges in the story. Instead, emphasis rests upon the shrewd and calculating youth who first undermined Onias's authority, usurped his place as leader of the Jews, won the endorsement of Ptolemy's agent with extravagant gifts and entertainment, gained the king's favor through charm and wit, and outmaneuvered all the tax-bidders with clever ploys.[144] This portrait resembles the biblical Joseph who impressed Pharaoh with acuity and talents superior to those of the royal counselors. And it approximates still more closely the Joseph of Artapanus who stole a march on his brothers and earned the king's favor immediately upon arrival at court, apparently through sheer intellect.[145] The Tobiad proceeds to implement his power

ruthlessly, running roughshod over opponents, and squeezing revenues from the cities to fill the royal coffers and line his own pockets. The description has its roots in Genesis, where Joseph shows little clemency to despairing peasants and exploits their plight to entrench crown control over all land in Egypt.[146] Josephus's stress on the amassing of personal wealth in order to solidify personal power also has analogies with Philo's image of Joseph as exemplifying greed for material goods.[147] The concluding remarks on Joseph the Tobiad after his death make reference to his lifting of the Jews from poverty and idleness to far more splendid styles of life—a description that applies better to the patriarch than to the Tobiad.[148]

Hyrcanus carries even stronger reminiscences of the biblical and post-biblical Joseph. He outwits and outdoes his brothers, thereby rousing their ire, rather than innocently suffering at their hands, a close analogy to the dark picture drawn in Philo's *De somniis*.[149] Hyrcanus's clever escape from his brothers' assassination plot resembles a comparable tale of Joseph in Artapanus's work.[150] The young man's wheedling of Ptolemy, his surpassing of rivals, the remorseless treatment of the financial steward, and severe repression of his subjects all duplicate in different forms his father's behavior, additional reminders of the less scrupulous side of Joseph the patriarch.[151] Open warfare between the brothers, as occurred after Hyrcanus's return to Palestine, has no analogue in Genesis but neatly parallels the battles recounted in the second part of *Joseph and Aseneth*.[152]

A point of importance needs to be insisted upon. The Tobiad stories deliver no negative verdict upon their principal characters. The saga underscores cleverness and wit, conscious manipulation of competitors and patrons, and fierce oppression of subjects. But the presentation endorses its heroes. Success counts, and the traits that bring it win admiration. When the Tobiad tales evoke the image of Joseph the patriarch, they highlight those dimensions of his character that appealed as much to Hellenistic Jews as did moral righteousness and religious piety.[153]

~~~~~~~

The figure of Joseph lent itself to a variety of shapes. Genesis itself supplied a disjointed combination: a person of high moral principles, mingled with pride and prudery, resourceful but calculating and manipulative, a political and economic reformer who also advanced the centralization of royal authority, a wielder of power but one largely impervious to the sufferings of its victims. Hellenistic writers exploited the biblical material at will, taking and rewriting what they liked, omitting or freely adapting what they found unpalatable. What strikes the reader most sharply, however, is how much they found *palatable*.

The Hellenistic texts certainly or probably composed in Hebrew generally take a benign position. Jubilees lavishes praise upon Joseph for his

moral integrity, his unselfish and effective administration, his forgiving temperament, and his application of power for the advantage of the community. Failings are repressed or explained away. A similarly spotless character appears in the comments of Ben Sira and Pseudo-Philo. And the Testament of Joseph gives him full treatment as unbending devotee of personal chastity and fraternal loyalty, whatever the temptation. The one-sided presentation, however, stripped Joseph of balance and complexity, leaving him a pompous purist.

Hellenized Jews took a more broad-minded line and expanded the dimensions of the character. Joseph as epitome of ethical dedication still endured, cited as exemplary in works like 1 and 4 Maccabees and in the *Wisdom of Solomon*. But philosophical and historical texts also found other features to admire, particularly the vast authority that Joseph had acquired in an alien land. 1 Maccabees, Demetrius, and *Wisdom* underline that element, an appropriate means to bolster Jewish pride in the Diaspora. Joseph as a figure of eminence and dominance could be pushed further still, in imaginative ways that left the Bible far behind. So Artapanus credits Joseph not only with reordering the economic system of Egypt but with introducing its inhabitants to the knowledge of measures. In Artapanus's hands, moral and religious issues recede, and acuity of intellect and breadth of vision take precedence.

The malleability of the Joseph figure comes on exhibit in pronounced fashion through the works of Philo. The philosopher's biography of Joseph combines the patriarch's qualities of moral excellence with his instincts for leadership to paint a portrait of the ideal statesman. The biblical account supplied adequate material with which to fashion a pattern for imitation. But a different perspective might also discern more troubling traits. Leadership could slip into manipulativeness, self-assurance into arrogance, high station into lust for wealth and material benefits. Philo—and not he alone—employed Joseph simply as emblem, whether of political wisdom and morality or lack thereof. Philo's inconsistencies dissolve, for Joseph was representation, not reality. The richness and the riddles of the Genesis narrative gave Hellenistic Jews ample scope for imagination.

Joseph had become a stimulus for inventive minds and a model for manifold constructs. Faithfulness to the Bible story did not hold high priority. A few lines in Genesis sufficed to inspire an elaborate tale of romance and adventure. *Joseph and Aseneth* owes little to the biblical narrative, but much to postbiblical and Hellenistic fiction. Nonetheless, the multilayered character of Joseph, stemming from Genesis and a range of subsequent texts, pokes through even in creative fantasy. Joseph breathes rectitude and piety, displays a dazzling presence, wields intimidating authority, but also conducts himself with pomposity and offensive sanctimoniousness. The latter traits do not convey primarily a negative message or moral. Joseph remains

a hero to the end, a devout champion of Hebrew ethical and religious superiority, elevated to royal rank with absolute sovereignty over Egyptians. Self-esteem, even when spilling over into arrogance, and a commitment to Jewish ascendancy, even when expressed through swagger and condescension, exhibit, indeed intensify, the pride of Hellenistic Jews. The figure of Joseph catered perfectly to those purposes.

The varied forms of the image could be exploited also without direct reference to Joseph. The tales of the Tobiads involve historical personages rather than legendary ones, and deal with recent history rather than a fabled past. Yet embellishment and elaboration permeate the story, replete with echoes of Joseph's escapades. In this incarnation, the characteristics that come to the fore emphasize cunning and clever schemes to outsmart competitors, accumulate wealth, and crush opponents. And here again the narrative intends no critical judgment. It condones the actions and applauds the results.

Hellenistic Jews found multiple means to express their relationship to surrounding society. A strong strain in Judaic culture pushed beyond accommodation and adjustment to stress Jewish advantage and superiority. The pliable portrait of Joseph suitably ministered to those objectives. He appeared in various genres and in various guises, recreated by historians, philosophers, exegetes, propagandists, and writers of creative fiction. Joseph could represent moral righteousness, commitment to religious principle, surpassing sagacity, fierce pride, haughty condescension, consummate shrewdness in the accumulation of wealth and power, crafty outmaneuvering of rivals, and unrelenting suppression of subordinates—or any combination thereof. Jewish intellectuals had a free hand in reshaping, excerpting, expanding, or even ignoring the Genesis narrative. The ostensibly cavalier attitude toward Scripture, however, did not constitute irreverence or creeping secularism. The adaptation of Jewish legend and the appropriation of Hellenic forms marched in tandem to reassert the admirable values and superior attainments of the Jews. The images of Joseph, in all their disparate manifestations, had that mission in common.

NOTES

A slightly different version of this essay appeared as a chapter in E. S. Gruen, *Heritage and Hellenism: The Reinvention of Jewish Tradition* (Berkeley and Los Angeles, 1998).

1. Gen. 37.5–11. This is not to mention the disputed text in Gen. 37.2b, which has Joseph deliver an evil slander against his brothers. On this, see E. Hilgert, *Biblical Research* 30 (1985): 5–6, with bibliography.

2. Gen. 37.3, 37.12–24.

3. Gen. 39.1–23.
4. Gen. 41.39–44.
5. Gen. 42–45.
6. Gen. 47.13–26. The Septuagint version minces no words: 47.21: καὶ τὸν λαὸν κατεδουλώσατο αὐτῷ εἰς παῖδας.
7. Gen. 47.26.
8. Ps. 105.16–22.
9. 1 Chron. 5.1–2.
10. Ben Sira, 49.15; cf. Gen. 50.25–26; Exod. 13.19; Josh. 24.32. On the bones of Joseph and the subsequent tradition, see J. L. Kugel, *In Potiphar's House* (New York, 1990), 128–55.
11. On the date, provenance, and objectives of Jubilees, see A. M. Denis, *Introduction aux pseudépigraphes grecs d'Ancien Testament* (Leiden, 1970), 150–62; J. VanderKam, *Textual and Historical Studies in the Book of Jubilees* (Missoula, Mont., 1977), 1–6, 207–85; O. S. Wintermuth, in J. H. Charlesworth, *The Old Testament Pseudepigrapha* (Garden City, N.Y., 1985), 2: 35–50; E. Schürer, *A History of the Jewish People in the Age of Jesus Christ*. rev. ed. by G. Vermes, F. Millar, and M. Goodman (Edinburgh, 1986), 3.1: 308–18. A salutary and skeptical assessment by R. Doran, *JSJ* 20 (1989): 1–11.
12. Jub. 34.10–11, 34.18–19.
13. Jub. 39.5–8.
14. Jub. 40.6–7.
15. Jub. 40.8–9.
16. Jub. 42.25, 43.14.
17. Jub. 43.19–20, 43.24, 46.3.
18. Jub. 43.19; 45.8.12; see Gen. 45.8, 47.20–25.
19. Cf. the analysis by M. Niehoff, *The Figure of Joseph in Post-Biblical Literature* (Leiden, 1992), 41–46.
20. See D. J. Harrington, *HTR* 63 (1970): 503–14; id., in Charlesworth, *Old Testament Pseudepigrapha*, 2: 297–302; C. Perrot and P.-M. Bogaert, *Pseudo-Philon: Les Antiquités Bibliques* (Paris, 1976), 2: 66–74; Schürer, *History of the Jewish People*, 3.1: 325–31; F. J. Murphy, *Pseudo-Philo: Rewriting the Bible* (New York, 1993), 3–7; H. Jacobson, *A Commentary on Pseudo-Philo's Liber Antiquitatum Biblicarum* (Leiden, 1996), 1: 199–210, 215–24.
21. Ps. Philo, 8.9–10.
22. Ps. Philo, 43.5.
23. Voluminous literature exists on the subject. Among the more valuable, see R. H. Charles, *The Testaments of the Twelve Patriarchs* (London, 1908), xv–xviii, xlii–lxv; J. Becker, *Untersuchungen zur Entstehungsgeschichte der Testamente der zwölf Patriarchen* (Leiden, 1970), 371–496; M. de Jonge, *The Testaments of the Twelve Patriarchs* (Leiden, 1953), 31–36, 77–110, 117–28. As guides to the controversy, see esp. Denis, *Introduction*, 49–59; H. D. Slingerland, *The Testaments of the Twelve Patriarchs: A Critical History of Research* (Missoula, Mont., 1977), 1–115; J. J. Collins, in M. E. Stone, *Jewish Writings of the Second Temple Period* (Philadelphia, 1984), 331–44; id. in R. A. Kraft and G. W. E. Nickelsburg, *Early Judaism and its Modern Interpreters* (Atlanta, 1986), 268–76; H. C. Kee, in Charlesworth, *Old Testament Pseudepigrapha*, 2: 775–81; D. Mendels, *The Land of Israel as a Political Concept in Hasmonean Literature* (Tübingen,

1987), 89–105; M. Delcor, in W. D. Davies and L. Finkelstein, *The Cambridge History of Judaism* (Cambridge, 1989), 2: 436–43. On the Testament of Joseph in particular, see G. W. E. Nickelsburg, *Studies in the Testament of Joseph* (Missoula, Mont., 1975), 1–12.

24. T. Jos. 1.3–4.

25. T. Jos. 2–10. See the analysis of H. W. Hollander, *Joseph as an Ethical Model in the Testaments of the Twelve Patriarchs* (Leiden, 1981), 33–42. On the importance of the story for subsequent exegetes, see Kugel, *In Potiphar's House*, 28–124.

26. T. Jos. 11–18. Cf. W. Harrelson, in Nickelsburg, *Studies in the Testament of Joseph*, 29–35; Hollander, *Joseph as an Ethical Model*, 42–48. On references to Joseph in the other Testaments, see Hollander, op. cit., 50–92. For the Testament of Joseph as a Jewish romance, see L. M. Wills, *The Jewish Novel in the Ancient World* (Ithaca, N.Y., 1995), 163–70.

27. 1 Macc. 2.53.

28. Wisdom 10.13–14. On this work, see D. Winston, *The Wisdom of Solomon* (Garden City, N.Y., 1979), 3–69, a fine analysis, although too confident about a dating in the reign of Caligula. Cf. also Schürer, *History of the Jewish People*, 3.1: 568–79, with bibliography.

29. 4 Macc. 2.1–6. The work has received much discussion; see the treatment and bibliography in Schürer, *History of the Jewish People*, 3.1: 588–93; H. Anderson, in Charlesworth, *Old Testament Pseudepigrapha*, 2: 531–43.

30. Demetrius, *apud* Euseb., *PE* 9.21.12: Ἰωσὴφ ... ἄρξαι Αἰγύπτου ἔτη ἑπτά. On Demetrius, see the cogent remarks of E. Bickermann, in J. Neusner, *Christianity, Judaism, and Other Greco-Roman Cults* (Leiden, 1975), 3: 72–84. A convenient text, with translation, commentary, and bibliography in C. R. Holladay, *Fragments from Hellenistic Jewish Authors*, vol. 1: *Historians* (Chico, Calif. 1983), 51–91.

31. 1 Macc. 2.53: Ἰωσὴφ ἐν καιρῷ στενοχωρίας αὐτοῦ ἐφύλαξεν ἐντολὴν καὶ ἐγένετο κύριος Αἰγύπτου.

32. Wisdom 10.13–14: ἤνεγκεν αὐτῷ σκῆπτρα Βασιλείας καὶ ἐξουσίαν τυραννούντων αὐτοῦ.

33. Philo, *apud* Euseb., *PE* 9.24.1: σκηπτοῦχος ἐν Αἰγύπτοιο θρόνοισι. See the text of Philo's fragments, with extensive commentary and references, in Holladay, *Fragments from Hellenistic Jewish Authors*, vol. 2: *Poets* (Atlanta, 1989), 205–99.

34. On Philo's notion of kingship and use of the Joseph story to advance that notion, see R. Barraclough, *ANRW* 2.21.1 (1984): 491–506; Niehoff, *Figure of Joseph*, 54–83. The provocative analysis of E. R. Goodenough, *The Politics of Philo Judaeus: Practice and Theory* (New Haven, 1938), 42–63, sees Philo's treatment of Joseph as a code message, subtly reminding the new rulers of Egypt of how the land should properly be governed.

35. Philo, *Jos.* 4: ἐνορῶν οὖν ὁ πατὴρ αὐτῷ φρόνημα εὐγενὲς καὶ μεῖζον ἢ κατ᾽ ἰδιώτην.

36. Philo, *Jos.* 5.

37. Philo, *Jos.* 6–9: χρώμενος οὖν ἀκάκοις τοῖς ἤθεσι ... ὁ δὲ οὐδὲν ὑπιδόμενος. Cf. Niehoff, *Figure of Joseph*, 65–66.

38. Philo, *Jos.* 11.

39. Philo, *Jos.* 37–39.

40. Philo, *Jos.* 42–48.

41. Cf. Philo, *Jos.* 54–57.
42. Philo, *Jos.* 85–87.
43. Philo, *Jos.* 105–6, 117–19.
44. Philo, *Jos.* 166.
45. Philo, *Jos.* 232–36.
46. Philo, *Jos.* 237, 247–48; cf. T. Jos. 11–18.
47. Philo, *Jos.* 257–60.
48. Philo, *Jos.* 203–4: τὸν ἄλλον χρόνον . . . τῆς χώρας ἀμαθέστερον τὰ περὶ δίαιταν ἀγούσης, ὁ ἀνὴρ οὗτος τοῖς κοινοῖς ἐμιστὰς οὐ μόνον τοῖς μεγάλοις πράγμασιν ἥρμοσεν εὐταξίαν . . . ἀλλὰ καὶ τοῖς εὐτελεστέροις εἶναι δοκοῦσιν.
49. Philo, *Jos.* 268–70.
50. Philo, *Jos.* 28: παρὰ μὲν Ἐβραίοις Ἰωσὴφ καλεῖται, παρα δ᾽ Ἕλλησι κυρίου πρόσθεσις. See the discussion of V. Nikiprowetsky, *REJ* 127 (1968): 387–92.
51. Philo, *Jos.* 32–34.
52. Philo, *Jos.* 119–20, 148–50, 166.
53. Philo, *Jos.* 107:
54. Philo, *Jos.* 119: τὸ μὲν ὄνομα τῆς ἀρχῆς ὑπολειπόμενος αὐτῷ, τῆς δ᾽ ἐν ἔργοις ἡγεμονίας ἐκστὰς ἐκείνῳ.
55. Philo, *Jos.* 242: τιμὴν δὲ ἔχω τὴν πρώτην παρὰ τῷ βασιλεῖ καὶ μὲ νέον ὄντα πρεσβύτερος ὢν ὡς πατέρα τιμᾷ. Cf. Jub. 43.19. Note also Pharaoh's respectful awe for Jacob, treating the Israelite patriarch as if he were his own father; Philo, *Jos.* 257.
56. Philo, *Somn.* 2.93–100.
57. Philo, *Somn.* 2.110–13.
58. Philo, *Somn.* 1.219–20.
59. Philo, *Somn.* 2.10–11.
60. Philo, *Somn.* 2.15–16: ἐμφαίνεται καὶ τὸ τῆς κενῆς δόξης, εφ᾽ ἥν ὡς ἐφ᾽ ἅρμα διὰ τὸ κοῦφον ἀναβαίνει, φυσώμενος καὶ μετέωρον αἰωρῶν ἑαυτὸν ἐπὶ καθειρέσει ἰσότητος.
61. Philo, *Somn.* 2.42–46.
62. Philo, *Somn.* 2.78–79.
63. Philo, *Somn.* 2.47, 2.63; *Mut.* 89–90; *Migr.* 203–4.
64. Philo, *Migr.* 158–63: μεθόριον ἀνθρωπίνων τε καὶ θείων ἀρετῶν τιθέντες, ἵν᾽ ἑκατέρων ἐφάπτωνται, καὶ τῶν ἀληθείᾳ καὶ τῶν δοκήσει.
65. A summary of scholarship on Philo's inconsistencies generally in R. Hamerton-Kelly, *Studia Philonica* 1 (1972): 3–26.
66. So Goodenough, *Politics of Philo Judaeus*, 21–63. See also J. Laporte, *De Josepho* (*Les Oeuvres de Philon d'Alexandrie*, 21) (Paris, 1964), 13–18; A. M. Goldberg, *Bibel u. Kirche* 21 (1966): 13–14; S. Sandmel, *Philo of Alexandria: An Introduction* (New York, 1979), 103.
67. See Barraclough, *ANRW* 2.21.2 (1984): 491–506, who devotes most of his discussion to arguing with Goodenough, only to accept his basic premise that Philo had two different political objectives in mind when composing the two works; see esp. 501–2. In general, Barraclough stresses the influence of Greek philosophy and Hellenistic theory of kingship, rather than particular efforts to criticize Roman rule. But he offers little help in accounting for the inconsistencies in the Joseph presentations. That Philo's negative depiction of Joseph represents Ti. Julius Alexander is a thesis independently arrived at by D. R. Schwartz, *Studia Philonica Annual* 1 (1989):

63–73, and R. Kraft, in B. Pearson, *The Future of Early Christianity* (Minneapolis, 1991), 131–41. But chronological difficulties compromise that idea, requiring either a quite elderly Philo composing allegorical treatises after Ti. Julius Alexander's prefecture of Egypt in 66 C.E. or the postulate of reaction to him in some lesser capacity earlier on. Neither hypothesis is compelling.

68. See Hilgert, *Biblical Research* 30 (1985): 7–13, drawing on the analysis of Philo's exegetical methods by B. Mack, *Studia Philonica* 3 (1974–75): 71–112.

69. Philo, *Somn.* 2.105–9; cf. *Migr.* 16–22. See the analysis of J. Bassler, *JSJ* 16 (1985): 240–55. Niehoff's discussion of Philo's views, *Figure of Joseph*, 54–83, takes no note of any text beyond the *De Josepho.*

70. Philo, *Migr.* 158–59: τούτου τοῦ δόγματος ὁ πολιτευόμενός ἐστι τρόπος, ὃν Ἰωσὴφ ὀνομάζειν ἔθος.

71. Philo, *Migr.* 203: τοῦ καὶ τὸ σῶμα καὶ τὰ ἐκτὸς ἀσπαζομένου, ὃν ἔθος καλεῖν Ἰωσήφ. Rightly noted by Hilgert, *Biblical Research* 30 (1985): 10–11.

72. See, e.g., J. Freudenthal, *Alexander Polyhistor* (Breslau, 1874–75), 143–74, 215–18; P. M. Fraser, *Ptolemaic Alexandria* (Oxford, 1972), 704–6; N. Walter, *Jüdische Schriften aus hellenistischer und römischer Zeit* (Gütersloh, 1976), 1.2: 121–26; Holladay, *Theios Aner in Hellenistic Judaism* (Missoula, Mont., 1977), 199–232, id., *Fragments*, 1: 189–93, J. J. Collins, *Between Athens and Jerusalem* (New York, 1983), 32–38; id., in Charlesworth, *Old Testament Pseudepigrapha*, 2: 889–895; Schürer, *History of the Jewish People*, 3.1: 521–24; E. Gabba, in Davies and Finkelstein, *Cambridge History of Judaism*, 2: 639–40.

73. Euseb., *PE* 9.23.1: συνέσει δὲ καὶ φρονήσει παρὰ τοὺς ἄλλους διενεγκόντα ὑπὸ τῶν ἀδελφῶν ἐπιβουλευθῆναι. προιδόμενον δὲ τὴν ἐπισύστασιν δεηθῆναι τῶν ἀστυγειτύνων Ἀράβων εἰς τὴν Αἴγυπτον αὐτὸν διακομίσαι.

74. Euseb., *PE* 9.23.2: ἐλθόντα δὲ αὐτὸν εἰς τὴν Αἴγυπτον καὶ συσταθέντα τῷ βασιλεῖ διοικητὴν τῆς ὅλης γενέσθαι χώρας.

75. Euseb., *PE* 9.23.2: τοῦτον πρῶτον τήν τε γῆν διελεῖν καὶ ὅροις διασημήνασθαι καὶ πολλὴν χερσευομένην γεωργήσιμον ἀποτελέσαι καί τινας τῶν ἀρουρῶν τοῖς ἱερεῦσιν ἀποκληρῶσαι.

76. Gen. 47.13–26.

77. The last sentence of the fragment as reported by Eusebius does make allusion to the storage of grain surplus during seven years of plenty (*PE* 9.23.4). But the passage is out of place, unconnected, and inconsistent with what went before, an afterthought at best and perhaps wrongly inserted and attributed to Artapanus; cf. Walter, *Jüdische Schriften*, 3.2: 287.

78. Euseb., *PE* 9.23.3.

79. Ibid. 9.23.3: τοῦτον δὲ καὶ μέτρα εὑρεῖν καὶ μεγάλως αὐτὸν ὑπὸ τῶν Αἰγυπτίων διὰ ταῦτα ἀγαπηθῆναι.

80. Gen. 41.45, 41.50–52, 46.20.

81. *Jos. As.* 1–2.

82. *Jos. As.* 3–4.

83. *Jos. As.* 5–6.

84. *Jos. As.* 7–8.

85. *Jos. As.* 9–13.

86. *Jos. As.* 14–17.

87. *Jos. As.* 18–21.

88. *Jos. As.* 22–25.

89. *Jos. As.* 26–27.

90. *Jos. As.* 28–29.

91. See now the thorough and analytic review of the scholarship by R. D. Chesnutt, *From Death to Life: Conversion in Joseph and Aseneth* (Sheffield, 1995), 20–93.

92. See, esp., C. Burchard, *Untersuchungen zur Joseph und Aseneth* (Tübingen, 1965), 91–99; M. Philonenko, *Joseph et Aséneth* (Leiden, 1968), 27–32, 53–57; G. Delling, *JSJ* 9 (1978): 29–56; Chesnutt, *From Death to Life,* 69–71.

93. See the arguments of V. Aptowitzer, *HUCA* 1 (1924): 260–86; M. Delcor, *Bull-LittEccl* 63 (1962): 5–22; Burchard, *Untersuchungen,* 99–107; Philonenko, *Joseph et Aséneth,* 99–102; Chesnutt, *From Death to Life,* 71–76. The effort of T. Holtz, *NTS* 14 (1967–68): 482–97, to revive the Christian hypothesis has won few converts. Additional bibliography in Collins, *Between Athens and Jerusalem,* 239 n. 72. This matter has now been thoroughly reassessed by R. S. Kraemer, *When Aseneth Met Joseph* (New York, 1998), whose book arrived too late for consideration here.

94. The sensible remarks of Burchard, *Untersuchungen,* 107–12, merit reading on this score, with references to earlier views. See further D. Sänger, *Antikes Judentum und die Mysterien* (Tübingen, 1980), 22–58; Chesnutt, *From Death to Life,* 185–216. Cf. Collins, *Between Athens and Jerusalem,* 218. Further literature noted by Chesnutt, *JSP* 2 (1988): 45 nn. 7–11.

95. Burchard, *Untersuchungen,* 142–43; Philonenko, *Joseph et Aséneth,* 102–8; Chesnutt, *From Death to Life,* 76–80. Some skepticism expressed by S. West, *CQ* 68 (1974): 79, without alternatives offered. The proposition is also questioned by A. Standhartinger, *Das Frauenbild im Judentum der hellenistischen Zeit: Ein Beitrag anhand von "Joseph und Aseneth"* (Leiden, 1995), 14–16. Philonenko, op. cit., 61–79, strains to make the case that Aseneth's portrait is modeled on that of the Egyptian goddess Neith; accepted by M. Goodman, in Schürer, *History of the Jewish People,* 3.1: 548, but adequately refuted by D. Sänger, *JSJ* 10 (1979): 13–20.

96. Among efforts to locate a more precise time, all speculative and inconclusive, see Aptowitzer, *HUCA* 1 (1924): 286–306; Delcor, *BullLittEccl* 63 (1962): 26–27; Burchard, *Untersuchungen,* 143–51; Philonenko, *Joseph et Aséneth,* 108–9; Sänger, *ZNW* 76 (1985): 90–104; G. Bohak, *Joseph and Aseneth and the Jewish Temple in Heliopolis* (Atlanta, 1996), 84–87. More cautious and sane remarks by West, *CQ* 68 (1974): 79–81; cf. Collins, *Between Athens and Jerusalem,* 89–91; Burchard, in Charlesworth, *Old Testament Pseudepigrapha,* 3: 187–88; Chesnutt, *From Death to Life,* 80–85; Standhartinger, *Frauenbild,* 16–20. A much later date in the Christian era is defended by Kraemer, *When Aseneth Met Joseph,* 225–244.

97. On *Joseph and Aseneth* as a Hellenistic romance, see Philonenko, *Joseph et Aséneth,* 43–47; West, *CQ* 68 (1974): 71–77; Burchard, in W. C. van Unnik, *La littérature juive entre Tenach et Mischna* (Leiden, 1974), 84–96. For parallels with Jewish fiction, see Burchard, *Untersuchugen,* 106–7. The influence of the mystical tradition is emphasized by Kee, *NTS* 29 (1983): 394–413. That aspect is given fuller but more skeptical treatment by Sänger, *Antikes Judentum,* 88–190, evidently unknown to Kee. See also Chesnutt, *From Death to Life,* 217–53. A variation on earlier ideas was advanced by R. I. Pervo, *SBL Seminar Papers* (1976): 171–81, who set *Joseph and Aseneth* in a Jewish sapiential tradition, but oddly applied that characteristic to works like Daniel, Judith, Esther, and Tobit, which hardly qualify as wisdom literature.

Wills, *Jewish Novel*, 170–84, sees two layers of composition, a national hero romance overlaid by a symbolic conversion story. Ingenuity will allow the detection of whatever one wishes to emphasize in the text. Even echoes of the Homeric *Iliad* have been discovered in the second part of the narrative; Philonenko, *Joseph et Aséneth*, 41–43. The recent and stimulating but highly speculative thesis of Bohak, *Joseph and Aseneth, passim*, sees the work as a fictional history designed to justify Onias's temple in Heliopolis.

98. See, e.g., Aptowitzer, *HUCA* 1 (1924): 299–306; Philonenko, *Joseph et Aséneth*, 53–61; Collins, *From Athens to Jerusalem*, 217–18; Nickelsburg, in Stone, *Jewish Writings*, 67–70.

99. See the climax of Aseneth's prayer for acceptance by the Lord—so that she might be a maidservant and slave for Joseph; *Jos. As.* 13.11–12. Doubts about the missionary character of the tale have been expressed by West, *CQ* 68 (1974): 78; Sänger, *Antikes Judentum*, 209–15; id., *JSJ* 10 (1979): 33–36; id., *ZNW* 76 (1985): 94–95; Burchard, in Charlesworth, *Old Testament Pseudepigrapha*, II, 194–95; Chesnutt, *JSP* 2 (1988): 37–40; Bohak, *Joseph and Aseneth*, 88–90. Sänger's idea that it aimed to promote mixed marriages, however, has little to recommend it. So, rightly, Delcor, in Davies and Finkelstein, *Cambridge History of Judaism*, 2: 503. Chesnutt's extensive study, *From Death to Life*, 153–84, 254–65, questions proselytism as a motive but still sees conversion as the central motif of the work, its aim to enhance the status of Gentile converts. On the question of Jewish proselytism generally, see now S. McKnight, *A Light among the* Gentiles (Minneapolis, 1991), passim; M. Goodman, *Mission and Conversion* (Oxford, 1994), 60–90, with references to earlier literature. A different view in L. H. Feldman, *Jew and Gentile in the Ancient World* (Princeton, 1993), 288–341.

100. Philonenko, *Joseph et Aséneth*, 48–52; Collins, *Between Athens and Jerusalem*, 212–13; Sänger, *ZNW* 76 (1985): 96–100; Chesnutt, *JSP* 2 (1988): 22–30; id., *From Death to Life*, 97–108.

101. See now the extensive treatment by Standhartinger, *Frauenbild*, passim.

102. *Jos. As.* 7.1: καὶ εἰσῆλθεν Ἰωσὴφ εἰς τὴν οἰκίαν Πεντεφρῆς καὶ ἐκάθισεν ἐπὶ θρόνου.

103. *Jos. As.* 7.1: παρέθηκεν αὐτῷ τράπεζαν κατ᾽ ἰδίαν, διότι οὐ συνήσθε μετὰ τῶν Αἰγυπτίων, ὅτι βδέλυγμα ἦν αὐτῷ τοῦτο.

104. *Jos. As.* 7.2–5: ἠνόχλουν γὰρ αὐτῷ πᾶσαι αἱ γυναῖκες καὶ αἱ θυγατέρες τῶν μεγιστάνων καὶ τῶν σατραπῶν πάσης γῆς Αἰγύπτου τοῦ κοιμηθῆναι μετ᾽ αὐτοῦ. καὶ πολλαὶ γυναῖκες καὶ θυγατέρες τῶν Αἰγυπτίων . . . κακῶς ἔπασχον ἐπὶ τῷ κάλλει αὐτοῦ καὶ . . . ἀπέστειλον πρὸς αὐτὸν μετὰ χρυσίου καὶ δώρων πολυτίμων. καὶ ἀντέπεμπεν αὐτὰ ὁ Ἰωσὴφ μετὰ ἀπειλῆς καὶ ὕβρεως.

105. *Jos As.* 7.8–8.1, so also 4.9.

106. *Jos. As.* 8.4–5.

107. To be sure, Joseph does take pity upon the crestfallen and abject Aseneth, offering her a blessing and prayer for her repentance, that she may be brought into the fold (*Jos. As.* 8.8–11). But the young woman still had some lengthy ordeals to endure before she could cross that threshold.

108. *Jos. As.* 1.4.

109. *Jos. As.* 3.1–6: Ἰωσὴφ ὁ δυνατὸς τοῦ θεοῦ.

110. *Jos. As.* 4.8; cf. 20.7.

111. *Jos. As.* 5.4–10.
112. *Jos. As.* 6.2; cf. 5.6.
113. *Jos. As.* 6.3, 6.5, 13.13, 18.11, 21.4, 23.10. See the discussion of Burchard, *Untersuchungen,* 115–17; id. in Charlesworth, *Old Testament Pseudepigrapha,* 2: 191–92.
114. *Jos. As.* 13.11: κάλλος . . . σοφὸς καὶ δυνατὸς; 18.1–2, 21.21.
115. *Jos. As.* 20.6–21.5.
116. *Jos. As.* 29.10–11: κατέλιπε τῷ διάδημα αὐτοῦ τῷ Ἰωσήφ. καὶ ἐβασίλευσεν Ἰωσὴφ ἐν Αἰγύπτῳ ἔτη τεσσαράκοντα ὀκτώ. There may be an indirect allusion to this in the Testament of Levi, 13.9, which refers to Joseph as enshrined among kings. A direct mention of Joseph as king comes in the fragmentary papyrus now labeled "History of Joseph," but this occurs in the context of Joseph's renewed encounter with his brothers and the gathering of grain—while Pharaoh was still alive and on the throne. See the text in A. M. Denis, *Fragmenta Pseudepigraphorum Graeca* (Leiden, 1970), 235–36, recto, 16–19, verso, 25–28. And the work is probably much later than the Hellenistic and early Roman periods; cf. G. T. Zervos, in Charlesworth, *Old Testament Pseudepigraphia,* 2: 468–69.
117. The sole exception is *Jos As.* 8.8–11. See n. 107 above.
118. Gen. 43.32; *Jos. As.* 7.1.
119. *Jos. As.* 1.6–8.
120. *Jos. As.* 21.4.
121. *Jos As.* 23.3; cf. 24.7.
122. *Jos. As.* 27.1–5.
123. *Jos. As.* 29.5–7.
124. Jos. *Ant.* 12.154–59.
125. Jos. *Ant.* 12.160–66.
126. Jos. *Ant.* 12.167–79.
127. Jos. *Ant.* 12.180–85.
128. Jos. *Ant.* 12.186–89.
129. Jos. *Ant.*12.190–95.
130. Jos. *Ant* 12.196–202.
131. Jos. *Ant.* 12.203–18.
132. Jos. *Ant.* 12.219–22, 12.228–29.
133. Jos. *Ant.* 12.230–36.
134. Many of the problems were pointed out long ago by J. Wellhausen, *Israelitische und jüdische Geschichte* (Berlin, 1897), 239–24, and H. Willrich, *Juden und Griechen vor der makkabäischen Erhebung* (Göttingen, 1895), 91–107, who deny historicity to the bulk of the narrative. For an incisive and influential reconstruction of the events, see A. Momigliano, *AttiTorino* 67 (1931–32), 165–200, who, however, is too schematic in seeing the divisions among the Jews as reflection of pro-Ptolemaic or pro-Seleucid leanings. Similarly, V. Tcherikover, *Hellenistic Civilization and the Jews* (New York, 1959), 126–42; cf. M. Stern, *Tarbiz* 32 (1962): 35–47 (Hebrew); M. Hengel, *Judaism and Hellenism* (London, 1974), 1: 267–77. J. Goldstein, in Neusner, *Christianity, Judaism, and Other Greco-Roman Cults,* 3: 85–123, offers some provocative insights, but surprisingly pronounces the stories of Joseph and Hyrcanus as almost entirely true. A much more skeptical treatment by D. Gera, in A. Kasher, U. Rappaport, and G. Fuks, *Greece and Rome in Eretz Israel* (Jerusalem, 1990), 21–38.

135. Zech. 6.9–15; Neh. 2.10, 2.19, 6.1, 6.11–19, 7.61–62, 13.4–8; Ezra, 2.59–60. See the discussion of B. Mazar, *IEJ* 7 (1957): 141–45, 229–38. For the dating of the inscriptions, see J. Naveh, *Proceedings of the Israel Academy of Sciences and Humanities* 5 (1971–76): 62–64; Gera, in Kasher et al., *Greece and Rome in Eretz Israel*, 25, with bibliography.

136. See Gera, in Kasher et al., *Greece and Rome in Eretz Israel*, 24–26, with references to the literature.

137. The texts are printed in Victor Tcherikover, Alexander Fuks, and Menahem Stern, eds., *Corpus Papyrorum Judaicarum* (Cambridge, Mass., published for the Magnes Press, Hebrew University, by Harvard University Press, 1957–64) (henceforth *CPJ*), vol. 1, nos. 1–2, 4–5; see discussion by Tcherikover, 115–16, and see also id., *Hellenistic Civilization and the Jews*, 64–66.

138. *CPJ*, 1, no. 1, line 13: ἐν Βίρται τῆς Ἀμμανίτιδος; no. 2a, col. 1, line 6; Jos. *Ant.* 12.230, 12.233. See Mazar, *IEJ* 7 (1957): 140; Tcherikover, *CPJ*, 1: 116.

139. *CPJ*, 1: no. 2d, col.9, line 16: ἐν τῆι Τουβίου; 1 Macc. 5.13: ἐν τοῖς Τουβίου 2 Macc. 12.17: τοὺς λεγομένους Τουβιανοὺς cf. 2 Macc. 12.35. See Mazar, *IEJ* 7 (1957): 139; Hengel, *Judaism and Hellenism*, I, 276; J. Goldstein, *I Maccabees* (Garden City, N.Y., 1976), 298–99; id., *II Maccabees* (Garden City, N.Y., 1983), 439–40; Gera, in Kasher et al., *Greece and Rome in Eretz Israel*, 27–30.

140. 2 Macc. 3.10–11: τινὰ δὲ καὶ Ὑρκανοῦ τοῦ Τωβίου σφόδρα ἀνδρὸς ἐν ὑπεροχῇ κειμένου.

141. See S. Niditch, *JJS* 32 (1981): 47–55; Wills, *Jewish Novel*, 187–93.

142. For the ascending into a royal chariot, see Gen. 41.43; Jos. *Ant.* 12.172. The story of the substitute bed partner alludes to the switch of Leah for Rachel on Jacob's wedding night (Gen. 29.21–23; Jos. *Ant.* 12.186–89). Parallels with the biblical text were pointed to by Willrich, *Juden und Griechen*, 94–95; Niditsch, *JJS* 32 (1981): 50–51. Gera, in Kasher et al., *Greece and Rome in Eretz Israel*, 31–33, adds a number of others, some of them unduly stretching the point.

143. Jos *Ant.* 12.160: δικαιοσύνης δόξαν ἔχων.

144. It is possible even that Joseph had wrested the προστασία τοῦ λαοῦ away from Onias before going to Egypt; cf. Jos. *Ant.* 12.161, 12.167; see Momigliano, *Atti Torino* 67 (1931–32): 182–84; Tcherikover, *Hellenistic Civilization and the Jews*, 132–33. But the phrase may not be a technical one; see 12.167: . . . τὸ πλῆθος, εἶναι γὰρ αὐτοῦ προστάτην.

145. Artapanus, *apud* Euseb., *PE* 9.23.2.

146. Gen. 47.13–26; Jos *Ant.* 12.180–84.

147. Philo, *Somn.* 2.47, 2.63; *Mut.* 89–90; *Migr.* 203–4; Jos. *Ant.* 12.185.

148. Jos. *Ant.* 12.224: τὸν τῶν Ἰουδαίων λαὸν ἐκ πτωχείας καὶ πραγμάτων ἀσθενῶν εἰς λαμπροτέρας ἀφορμὰς τοῦ βίου καταστήσας. Cf. Hengel, *Judaism and Hellenism*, 1: 270. The passage also recalls a similar comment by Philo on the biblical Joseph; Jos. 204. See n. 48 above.

149. Philo, *Somn.* 2.93–100; Jos. *Ant.* 12.190–95.

150. Artapanus, *apud* Euseb., *PE* 9.23.1; Jos. *Ant.* 12.202, 12.218.

151. Jos. *Ant.* 12.203–20.

152. *Jos. As.* 26–27; Jos. *Ant.* 12.221–22, 12.228–29.

153. Speculation on the author or authors of the tales would not be profitable. Willrich's idea, *Juden und Griechen*, 99–102, that Josephus used a Samaritan source

no longer finds favor, rightly so. Tcherikover, *Hellenistic Civilization and the Jews,* 140–42, assigns it to an Alexandrian Jew who drew on the family history of the Tobiads. In the view of Stern, *Tarbiz* 32 (1962): 36–40 (Hebrew), the story derives from Ptolemaic circles in the late second or early first centuries with a favorable slant toward the faithful Hyrcanus. For Hengel, *Judaism and Hellenism,* 1: 269–70, the author was an advocate of Hellenism for the Jews and propagator of the contemporary values represented by the Tobiads, namely, close collaboration with the Gentiles. These suggestions seem to miss the central features of the tale. Goldstein, in Neusner, *Christianity, Judaism, and Other Greco-Roman Cults,* 104–16, sees it as a propaganda work by Onias IV—which makes it difficult to account for the narrative's attitude toward the Oniads. Gera's idea, in Kasher et al., *Greece and Rome in Eretz Israel,* 35–38, that the author wrote to bolster the spirits of Jews in Ptolemaic Egypt, is more plausible, but misplaces the emphasis by shifting it away from the personalities of the heroes, and, like Goldstein, misconceives the tales as "propaganda."

Egyptians and Greeks

Diana Delia

An ethnic profile of Alexandria was sketched by the historian Polybius, who visited the city during the reign of Ptolemy VII Euergetes II (145–116 B.C.E.).[1] The original text is lost, but it was fortunately paraphrased by the historian-geographer, Strabo, as follows:

> Πολύβιος γεγονὼς ἐν τῇ πόλει βδελύττεται τὴν τότε κατάστασιν, καί φησι τρία γένη τὴν πόλιν οἰκεῖν, τό τε Αἰγύπτιον καὶ ἐπιχώριον φῦλον, ὀξὺ καὶ <ἀ>πολιτικόν, καὶ μισθοφορικόν, βαρὺ καὶ πολὺ καὶ ἀνάγωγον· ἐξ ἔθους γὰρ παλαιοῦ ξένους ἔτρεφον τοὺς τὰ ὅπλα ἔχοντας, ἄρχειν μᾶλλον ἤ ἄρχεσθαι δεδιδαγμένους διὰ τὴν τῶν βασιλέων οὐδένιαν· τρίτον δ᾽ ἦν γένος τὸ τῶν Ἀλεξανδρέων, οὐδ᾽ αὐτὸ εὐκρινῶς πολιτικὸν διὰ τὰς αὐτὰς αἰτίας, κρεῖττον δ ἐκείνων ὅμως· καὶ γὰρ εἰ μιγάδες, Ἕλληνες ὅμως ἀνέκαθεν ἦσαν καὶ ἐμέμνην-το τοῦ κοινοῦ τῶν Ἑλλήνων ἔθους.᾽[2]

All of the extant manuscripts of Strabo's *Geography* are believed to derive from a common archetype because they share gaps, errors, and textual changes. Thus an identical reading in all manuscripts might be genuine or may reflect an error in the archetype reproduced in all copies thereof. With this in mind, early editors proposed emendation of the text to read that Polybius considered the Egyptian class to be οὐ πολιτικόν or ἀπολιτικόν.[3] In his Teubner edition of Strabo, Meineke reproduced the actual manuscript reading, πολιτικόν, but marked it as corrupt and irresolvable.[4] Subsequently, C. Müller and F. Dübner proposed emendation to ὀχλητικόν, which aptly reflects Polybius's aversion to unruly masses but radically diverges from the reading as preserved.[5]

At first glance, emendation would appear to be mandated by οὐδέ in the clause describing Alexandrians as οὐδ᾽ αὐτὸ εὐκρινῶς πολιτικόν. As a conjunction, οὐδέ regularly links two negative clauses, so the editors might well

have expected a negative antecedent. Moreover, unamended, the text attributes to Polybius the view that contemporary Egyptians were πολιτικοί whereas Alexandrian Greeks were not—a claim that surely struck editors as surprising in a Greek author. Hence considerations both of syntax and significance rendered the passage suspect to editors who treated it as corrupt.

Yet if οὐδέ functions here adverbally, to emphasize and modify εὐκρινῶς in the sense of "not even" (ne . . . quidem), emendation is unnecessary, a logical sequence results and a very different meaning is conveyed:

> Polybius, who visited the city, is disgusted with the conditions then existing, and he says that three groups inhabited the city: the Egyptian and native class, who were astute and community-minded; [second,] the mercenary class, who were oppressive, abundant, and uncultivated, for foreigners were maintained under arms according to an ancient custom, and due to the weakness of the kings, they had learned to rule rather than be ruled; and the third class was that of the Alexandrians, and they were not even manifestly civic-minded for the same reasons, but nevertheless they surpassed the others, for although mixed, still they were Greeks by origin and mindful of the customs common to Greeks.[6]

Immediately preceding and following this passage, Strabo describes the administrative appointments and military allocations carefully maintained in his day by Romans in Egypt and Alexandria, noting, by way of contrast, that the Ptolemies had governed Egypt badly and the consequent lawlessness had diminished the city's prosperity.[7] The paraphrase of Polybius is then adduced in support, indicating that already, by the mid second century B.C.E., the Greek population of Alexandria had been reduced to political ineffectiveness. Moreover, vast numbers of rapacious and brutish mercenaries dominated the city and Egypt's feeble dynasts—conditions, Polybius elsewhere reports—that ambitious courtiers or commanders deftly exploited to enhance their own influence and power. Only the native Egyptians had, typically, resisted change, retaining their fundamentally shrewd and cultivated character. To such a state had the brave new world of Thyonichos been reduced![8]

Even more significant than the conundrum allegedly posed by this passage is that it serves as a snapshot of Alexandrian society at this particular time, albeit colored by the historians' own biases. P. M. Fraser dubbed it "impressionistic,"[9] although it is not nearly as fanciful as the reflections or refractions of Alexandrian mores in poetical works on which historians must also rely. Its importance lies precisely in the fact that portraits of the Hellenistic city and its inhabitants are extremely rare as, also, are historical narratives of the Hellenistic period: for the years following 302 B.C.E., only fragments of Diodorus's *Library of History* survive, and the primary focus of Polybius's *Histories,* covering the years 264–146 B.C.E., is Rome's rise and acquisition of empire.

In Polybius's day, few Romans other than merchants, mercenaries, and the occasional Roman envoy to Egypt would have had direct contact with Egyptians. Hence the general antipathy of Romans toward Egyptians (and other Orientals), immortalized by Juvenal[10] and manifested by the legal and social categories and distinctions enforced in Roman Egypt that aimed at arresting the process of racial assimilation,[11] can scarcely have affected Polybius's views. Moreover, Polybius's favorable appraisal of Egyptians does not stand alone. More than a century later, Strabo's portrayal of Egyptians, of whom he had firsthand knowledge,[12] corroborated Polybius's claims. From the outset, writes Strabo, Egyptians have led a community-minded and civilized life and have been settled in well-known divisions (i.e., nomes), so that their organizations are a matter of comment. Moreover, they have so diligently administered and cultivated their land that they have mastered nature, rather than been its victims.[13] The historian Diodorus Siculus, Strabo's contemporary, likewise stressed the impact of Egypt's orderly government, excellent customs, and laws that aimed at inculcating virtue and good character—the best preparation, he noted, for public life.[14]

With regard to non-Hellenes, the term πολιτικός signified living in a settled community, perpetuating a national identity, and fulfilling public responsibilities.[15] Foremost among the latter with respect to Egyptians were the care and feeding of the gods, cultivation and defense of their land, and the manufacture of all good things to enhance the quality of life. Since pharaonic times, a military class of native Egyptians known as μάχιμοι, recompensed by means of small land allotments, had been maintained as a reserve army.[16] Egyptian participation in at least some military engagements continued after the Macedonian conquest,[17] although their role was eclipsed by the extensive employment of foreign, primarily Greek-speaking, mercenaries.[18] Egyptians only exceptionally rose to high public office under the early Ptolemies, and this disparity no doubt engendered resentment.[19]

When the agents of Ptolemy IV Philopator fully armed a vast number of Egyptians for the Fourth Syrian War and their efforts contributed to the victory sustained at Raphia (218 B.C.E.), the natives, Polybius claims, returned home infused with pride and began to stir up insurrections throughout Egypt aimed at establishing national sovereignty.[20] We do not know what their conditions of service for this campaign had been nor the extent to which military enrollment may have been compulsory. Nevertheless, upon the return of the seasoned veterans, some may have hoped to expel the foreign regime characterized by a feeble and indolent ruler crippled by the sinister authority of his chief minister, Sosibius, and the royal catamite, Agathokles. Egyptian writings of the period, e.g., the *Demotic Chronicle* and *Oracle of the Potter*, express nationalist longings for deliverance from foreign oppression and reestablishment of the old, divinely sanctioned order.[21] By

205/4 B.C.E., disaffection was rife, and much of Upper Egypt had been lost to the rebels and native kings who had seized power, and these now gained the support of the Egyptian priestly class. Royal building activity was suspended at Edfu, which henceforth served as a rebel hideout, and did not resume for some two decades.[22] It took more than thirty years to undo this state of anarchy.[23]

The political manifestations of Egyptian nationalism during this conflict cannot be denied.[24] A noticeable consequence appears to have been the greater role henceforth exercised by Egyptians in public life.[25] In Polybius's own day, Dionysios, aka Petosarapis, was a favorite among the intimate group of Ptolemy VI Philometor's advisors known as "Friends." His influence was purportedly so great that numerous mercenaries of the Ptolemies defected to his camp and many Egyptians also joined in his rebellion against Philometor and Euergetes II (ca. 167 B.C.E.).[26] His was a political enterprise, and, as in the earlier insurrections, Egyptian allegiance may have been secured by appeals to nationalist sentiments and resentment of Greek privilege.[27]

At other times, curiosity and reciprocity characterized Egyptian-Greek relations, since Egyptian nationalism did not oblige antagonism toward all Greeks and Greek culture. Fluency in the Greek language and understanding of Greek manners and customs were requisite for Egyptians hoping to pursue public careers, if only at the nome administrative level. Such accomplishments, not incompatible with retaining an Egyptian identity, were widely sought after. During the next century and a half before Roman annexation imposed legal and social stigmata on the native population of Egypt, Egyptians and Greeks—even Greek citizens—also appear to have freely married; such unions resulted in assimilation of some cross-cultural elements and retention of other native characteristics.[28] Roman laws penalizing such unions indicate that they still continued to be contracted, although surely more covertly, well into the Roman Principate.[29] In the early third century C.E., the universal grant of the Roman franchise under the *constitutio Antoniniana* would abolish these legal status distinctions.

The streets of Alexandria during a celebration of the Adonis festival in the third century B.C.E. were depicted by Theocritus as a crush of cavalry, army boots, and uniforms.[30] Even under ordinary circumstances, soldiers would have been a common sight, since the largest military garrison in Egypt was stationed at Alexandria for the defense of the royal family and palace.[31] They served both as an elite royal guard (a[ghma), stationed in the Royal Quarter, and as regular infantry and cavalry encamped in the eastern suburb of the city known today as Bulkeley. Many, if not most, of these soldiers were mercenaries.[32]

The *Bellum civile* contains a description of the mercenaries serving under Caesar's opponent, Ptolemy XII. The passage also permits us to glimpse

Caesar's considerable rhetorical talent, most notably his command of calumny. The Alexandrian mercenaries are denigrated as a mass of bandits, pirates, condemned criminals, exiles, and runaway slaves "accustomed to demand the execution of royal 'Friends,' to plunder the possessions of the wealthy, to besiege the royal palace for an increase in pay, to banish some from power and bid others to assume it, according to some ancient tradition of the Alexandrian army."[33] Plus ça change, plus c'est la même chose. One century later, Alexandrian mercenaries had scarcely changed at all! They were still numerous, overbearing, and unrefined.

Polybius's narrative is replete with examples of the rise and fall of ambitious courtiers and generals whose power was grounded on the weakness of dynasts and the tenuous loyalty of the Alexandrian palace and city garrisons. The loyalty of soldiers and their officers had to be continually ensured,[34] and generous bribes were needed to secure their compliance concerning especially nefarious deeds.[35] They might be employed to arrest personal political enemies,[36] or might fickly turn against their leaders to champion a rival.[37] The shifting fortunes of Agathokles, from constant to precarious, well illustrate the maxim that armies that make leaders can also break them.

By "Alexandrians," Polybius meant the Greek population of the city, comprising mixed nationalities, including both citizens and resident aliens—although only the former might properly be lamented as οὐδ' εὐκρινῶς πολιτικόν. With regard to Greeks, πολιτικός signified membership in a polis and participation, to a greater or lesser extent depending on the type of constitution, in its government.[38] This description implies that already by the mid-second century B.C.E., the Alexandrians may have lost their municipal council.[39] That it no longer existed at the time of Roman annexation (30 B.C.E.) is attested by the *Boule* Papyrus and Claudius's *Letter to the Alexandrians.*[40]

The presence in the city of numerous rough and overbearing mercenaries enabled Ptolemy VII Euergetes II, as soon as he was installed as monarch, to use them to carry out mass purges and drive out intellectuals who had sided with his sibling rivals, Philometor and Kleopatra II. The Polybian passage paraphrased by Strabo goes on to relate that obliteration of the Greek population of Alexandria was chiefly caused by the repeated forays of Euergetes' troops against them.[41] Such vicious reprisals inspired the caustic wit of the enervated yet intrepid population to mock him as "Malefactor" instead of "Benefactor";[42] brutality might dissolve the political rights of Greeks, but it rarely curtailed their freedom of speech.

It should occasion no surprise that Polybius, a citizen of Achaea, esteemed Hellenic institutions more highly than all others. Accordingly, he lamented the decline of Alexandria and the impotence of its citizens occasioned by misrule and the immense power of foreign mercenaries. After two

centuries of Macedonian rule, it transpired that Egyptians and not Alexandrians had sustained the full vitality of their civilization. And this irony did not go unnoticed.

NOTES

1. Perhaps accompanying the embassy led by Scipio Aemilianus ca. 140 B.C.E.: Diod. 33.28b.1–3; see also P. M. Fraser, *Ptolemaic Alexandria* (Oxford, 1972), 2: 145 n. 187.

2. Strabo 17.1.12.

3. T. Tyrwhitt, *Coniecturae in Strabonem* (Erlangen, 1788); G. Kramer, *Strabonis Geographica recensuit, commentario critico instruxit* (Berlin, 1844).

4. Strabo, ed. Meineke (Berlin, 1967), praefatio, 1: iii. In the Teubner edition of Polybius (Berlin, 1967), at 34.14, Bütner-Wobst likewise retained the actual manuscript reading but cited Kramer's emendation, ἀπολιτικόν, in the apparatus criticus. F. W. Walbank, however, argued in favor of Tyrwhitt's emendation to οὐ πολιτικόν: *Historical Commentary on Polybius* (Oxford, 1971), 3: 629.

5. *Strabonis Geographica graece* (Paris, 1853–58).

6. Translation by the author.

7. Strabo 17.1.12–13.

8. Theocr. 14.54–70.

9. Fraser, *Ptolemaic Alexandria*, 1: 75. Indeed, until a manuscript with the actual Polybian text is discovered, scholars will not even know whether Strabo's paraphrase is close or liberal.

10. Juvenal, *Sat.* 15. See also M. Reinhold, "Roman Attitudes towards Egyptians," *AncWld* 3 (1980): 97–103.

11. See, for example, the *Gnomon of the Idios Logos*, in W. Schubart, ed., *Aegyptische Urkunden aus den Königlichen Museen zu Berlin, Griechische Urkunden*, vol. 5 (Berlin, 1919). See also J. W. B. Barnes, "Egyptians and Greeks," *Pap. Brux.* 14 (Brussels, 1978): 14–15.

12. Strabo was in Egypt circa 26–25 B.C.E., when he accompanied Aelius Gallus on a Nile expedition: Strabo 2.5.12.

13. Strabo 17.1.3.

14. Diod. 1.69–93. Such qualities distinguished civilized peoples from barbarians: Poly. 1.65.7.

15. Settled: Strabo 7.4.6; 13.1.25; 17.1.3; 17.3.15; living under common ordinances: Strabo 16.2.38; participation in public life: Poly. 16.17.11; 21.5.4; 22.10.4; 23.10.4; 30.4.16; possessing the caution or tact of a statesman: Poly. 4.19.11 and 18.48.7; civilized: Poly. 34.14.3–4; 36.9.9 and 11; Strabo 3.3.8; 3.4.18; 14.13.2; cultivated: Strabo 1.1.22; 2.5.1. Even Aristotle's classic definition of man as a political animal is based on association of individuals to form households, households to form villages, and villages to form cities or states: *Pol.* 1.1–2.

Among the early editions of this text, A. Letronne's rendering of ὀξὺ καὶ πολιτικόν as "intelligens et soumis aux lois" has most closely captured the author's meaning: Στράβωνὸ γεωγραφικῶν βιβλία (Paris, 1819), loc. cit.

16. Hdt. 2.164–68; Diod. 1.73.7–9.

17. Diodorus relates that a great number of Egyptians served in the army of Ptolemy I Soter at Gaza (312 B.C.E.); some carried missiles, others baggage, and still others were armed for battle: 19.80.4; see also G. T. Griffith, *The Mercenaries of the Hellenistic World* (Cambridge, 1935), 112.

18. J. Lesquier, *Les institutions militaires de l'Égypte sous les Lagides* (Paris, 1911), 5–21; W. Peremans, "Les égyptiens dans l'armée de terre des Lagides," in H. Heinen, ed., *Althistorische Studien: Festschrift H. Bengston zum 70 Geburtstag* (Weisbaden, 1983), 94–97. See also Peremans, "Un groupe d'officiers dans l'armée des Lagides," *AncSoc* 8 (1977): 175–85.

19. Consult *Prosopographia Ptolemaica,* vol. 6, passim. See also W. Peremans, "Égyptiens et étrangers à Alexandrie au temps des Lagides," *AncSoc* 7 (1976) 167–76, and id., "Classes sociales en Égypte ptolémaïque," *Orientalia Lovaniensia Periodica* 6–7 (1975–76): 451–52. Egyptians appear to have been far more conspicuous as holders of administrative posts on the nome and village level: see Peremans, "Égyptiens et étrangers dans l'administration civile et financière de l'Égypte ptolémaïque," *AncSoc* 2 (1971): 33–45.

20. Twenty thousand Egyptian infantry (Poly. 5.65.9); during this campaign, Egyptians also served in the cavalry (5.65.5); see also 5.107.1–3 and 14.12.4.

21. *P. Oxy.* XXII 2332 (late third or possibly second century B.C.E.); W. Spiegelberg, *Die sogennante demotische Chronik,* Demotische Studien 7 (Leipzig, 1914).

22. E. R. Bevan, *A History of Egypt under the Ptolemaic Dynasty* (London, 1927), 239–40. See also W. Peremans, "Ptolémée IV et les Égyptiens," in J. Bingen, G. Cambier, and G. Nachtergael, eds., *Le monde grec: Hommages à Claire Préaux* (Brussels, 1978), 393–401.

23. Poly. 22.17.

24. Nevertheless, scholarly opinion has been divided as to whether Egyptian nationalism or royal social and economic abuses occasioned the revolts. The arguments are neatly summarized in W. Peremans, "Les revolutions égyptiennes sous les Lagides," in H. Maehler and V. M. Strocka, eds., *Das ptolemaïsche Ägypten* (Mainz, 1978), 39–49.

25. In keeping with his thesis that progressive Egyptianization resulted in the decline of Alexandria, Fraser exaggerates in claiming that the Egyptian element henceforth began to predominate (*Ptolemaic Alexandria,* 1: 60–61).

26. Diod. 31.15a.

27. N. Lewis, *Greeks in Ptolemaic Egypt* (Oxford, 1986), 85–87, suggests that the mistreatment by Egyptian authorities and attacks by temple workers on Ptolemaios, son of Glaukias, a recluse in the Memphite Serapeum during the ensuing decades, was motivated by analogous hostility toward Greeks perceived as intruders. For the documents, see U. Wilcken, *Urkunden der Ptolemäerzeit* (Berlin and Leipzig, 1927), 1: 7, 8 and 15 (163–157 B.C.E.).

28. Consider, for example, Apollonia, aka Senmuthis, in the Dryton archive. For an overview of the archive, consisting of several documents published in *P. Grenf.*, vol. 1, and others scattered throughout several collections, see Lewis, *Greeks in Ptolemaic Egypt,* 88–103. On retaining national identity while assimilating another culture, see Peremans, "Classes sociales en Égypte ptolémaïque," esp. 450–53.

29. *Gnomon of the Idios Logos* (cit. n. 11 above).

30. Theocritus 15.5–6 and 51–53.

31. Griffith, *Mercenaries,* 131.

32. Polybius relates that ca. 220 B.C.E., there were four thousand mercenaries of Peloponnesian and Cretan origin alone stationed at Alexandria (5.36.4). See also Griffith, *Mercenaries,* 126–28. See D. Delia, "'All Army Boots and Uniforms?'—Ethnicity in Ptolemaic Alexandria," in *Alexandria and Alexandrianism* (Malibu: 1996), 41–53.

33. Caes.,*BC* 3.110.

34. Poly. 15.26.

35. Poly. 15.25.11.

36. Poly. 18.53–54.

37. Poly. 15.25.31; 15.29–32.

38. Poly. 6.52.5.

39. *Pace* Fraser, *Ptolemaic Alexandria,* 1: 94–95.

40. *PSI* X 1160 (first century B.C.E.): G. Vitelli and M. Norsa, eds., *Papiri greci e latini.* Pubblicazioni della Società italiana per la ricerca dei papiri greci e latini in Egitto (Florence, 1932). See also *P. Lond.* VI 1912.66–68 (Philadelphia, 41 C.E.): H. I. Bell, ed., *Jews and Christians in Egypt: The Jewish Troubles in Alexandria and the Athanasian Controversy* (London, 1924).

41. Strabo 17.1.12.

42. Bevan, *History of Egypt,* 323; see also Fraser, *Ptolemaic Alexandria,* 1: 86–88.

ELEVEN

Autobiography and the Hellenistic Age

Frances B. Titchener

It is no bad thing, once in a while, to stand back, take the long view, and meditate upon the sum of things.
PETER GREEN, *Alexander to Actium*

Mimesis, the "representation by means of art," was the particular interest of Hellenistic artists and philosophers. Though history and biography may have strong claims to the title, the preeminent example of literary mimesis in Greek literature is autobiography, for in that genre alone do the authors predominate as their own subjects. Hence, the individual stands forth in a fashion unlike in history or biography. There, the accumulation of facts outweighs critical analysis and astute observation. For its usefulness, written history depends greatly upon the acuity and writing skills of that observer, whose inspiration is held in check by the documents that constitute the data, even when plentiful and contradictory. Biography, on the other hand, revolves around the accumulation of events, which are more susceptible to subjective interpretation, particularly since we are at such a remove as we are from ancient evidence. Powers of observation and critical analysis become central. While there are certainly ways of verifying a biographer's interpretation, especially when there are multiple sources, in the case of autobiography we are at the mercy of the author. How does one verify what was in the subject's heart or mind at any given time, or what was a true intention and what was *prophasis,* or excuse? How can we criticize or disagree with an autobiographer's assertion that he hated or feared or admired someone? And, although Momigliano asserts correctly that "biography became a precise notion and got an appropriate word only in the Hellenistic age,"[1] the literary form that best reflects the Hellenistic age's preoccupation with common individuals and everyday lives proves to be neither history nor biography, but autobiography.

ORIGINS OF HISTORY, BIOGRAPHY, AND AUTOBIOGRAPHY

Scholars have long attempted to describe and analyze the origins of history, biography, and autobiography. Typically, such studies examine extant works and fragments, classify the texts by genre, draw conclusions from the textual similarities within a genre and the differences one text exhibits from another in a different genre, and factor in any authorial statements of intent.[2] Ideally, this clarifies the parameters of and distinctions among the genres. However, in the case of autobiography, even the most critically rigorous of these studies descends inevitably to hairsplitting. If any use of the first personal singular may be taken as autobiographical, answering questions like what is or is not autobiography, or where it first arose, becomes a futile and not particularly useful exercise. Momigliano sums up the problem well:

> Any account in verse or prose that tells us something about an individual can be taken as preparatory to biography; and any statement about oneself, whether in poetry or in prose, can be regarded as autobiographical. . . . But it seems reasonable to restrict the search for the antecedents of biography to works or sections of works whose explicit purpose is to give some account of an individual in isolation (instead of treating him as one of the many actors in a historical event). Similarly, I shall look for the antecedents of autobiography among accounts, however partial, of the writer's past life rather than among expressions of his present state of mind. In other words I incline to take anecdotes, collections of sayings, single or collected letters, and apologetic speeches as the truest antecedents of either biography or autobiography.[3]

This is a compelling case. Although biography and autobiography existed in various forms during the fifth century B.C.E., they were not what Momigliano calls "prominent literary genres" until the fourth (see above). But when he traces the actual term "autobiography" back to 1797 C.E., making it thus a modern invention unknown to antiquity, he shows that his interest in autobiography's roots centers for the most part on the question of the extent of Peripatetic influence on the genre's development.[4] His conclusion, that "Aristotelianism was neither a necessary nor a sufficient presupposition of Hellenistic biography....The educated man of the Hellenistic world was curious about the lives of famous people,"[5] is an unfortunate overstatement, since a prime characteristic of Hellenistic art is its interest in every-day people and situations. Theophrastus's *Characters,* whatever purpose they may have been written to fulfill, are not kings and generals, but friends, neighbors, colleagues, relatives, and (*horrendum dictu!*) our own selves. So are the individuals described in Aristotle's *Nicomachean Ethics.* But the most obvious example of the everyday nature of Hellenistic art is New Comedy, particularly in the hands of the playwright Menander, whose work forms most of the extant corpus of that genre. Menander's stock characters,

such as the Old Man, the Parasite, and the Braggart Soldier, lie closer to the
Hellenistic hearth than the noted figures who people the comedies of the
fifth century. It is simply easier for an audience to identify with Smicrines,
the miserly, "small-minded" old man of New Comedy, than with Pericles,
Lamachus, Demosthenes, Nicias, Alcibiades, Cleon, or Socrates, to name
just a few statesmen lampooned (be it openly or semi-transparently) in Old
Comedy. Not so much of style or fashion, this change was the result of the
social and political upheavals that reshaped the Greek world and engen-
dered what we call the Hellenistic era.[6] As the grander, epic *Weltansicht* gave
way to a smaller, more seemingly realistic vision, escapism edged out public
service. Peter Green points to "the central criterion of visual art throughout
the Hellenistic and Greco-Roman period: deceptively realistic naturalism"
and later extends this criterion to literature as well.[7] And as in New Comedy,
details of people's lives predominate and aid the reader in illuminating the
ethical species of characters that are seen "through their actions." In both
cases, we study the person to learn the lessons of life. Interesting though
such analogies may be, however, in light of the topic, the interrelationship
of life and art, the focus here must remain strictly on the literary genres of
history, biography, and autobiography.

COMPARISON OF HISTORY, BIOGRAPHY, AND AUTOBIOGRAPHY

These three genres are often identified with confidence, but defined with
difficulty. By the first century C.E., Plutarch, attempting to deflect antici-
pated criticism, asserted that he was writing biography, not history: "Because
of the large amount of pertinent material, we say nothing beforehand other
than to entreat our readers not to slander us, should our narrative of note-
worthy events not be exhaustive, nor in each case absolutely complete, but
for the most part summarized. For we undertake to write not histories, but
Lives" (*Alex.* 1.1; Loeb ed.).

This statement is significant for a number of reasons. The passage itself
is often cited in discussions of Plutarch's biographical method, and he
makes a clear distinction between history and biography. Distinction, how-
ever, may not be really the right word, since Plutarch is almost defensive in
his request that his readers not hold him responsible for what he does not
intend to do. Yet perhaps most interesting is Plutarch's use of the word *syko-
phantein*, which has associations not only of blame or complaint, but of slan-
der, by definition undeserved. Plutarch insists not only on what his genre is,
but that he not be accused of false intentions. However rhetorical that pas-
sage, the conclusion is unavoidable that he sees a difference between his-
tory and biography, and that somehow biography is an enterprise less wor-
thy than history. In the introduction to the *Life of Nicias*, Plutarch expresses
a similar fear that his intentions may be misinterpreted, particularly that he

may appear to be challenging Thucydides by dealing with the same time period and events covered by the great historian in his *History of the Peloponnesian Wars*. Plutarch states that such a challenge would be undignified in any case (*mikroprepes*), and in the particular case of the matchless (*amimeta*), senseless even (*anaistheton*). Again he attempts to forestall criticism: "In any case, since it is not possible to pass over the events which Thucydides and Philistus have narrated, especially since these events lift away the veil of his great and mighty sufferings from the nature and character of the hero, I will run through them quickly and out of necessity, lest I appear to be completely careless and lazy" (*Nicias* 1.4–5; Loeb ed.).

In both these passages, the expected criticism centers on incompleteness. Comparison to Thucydides would reveal that the great classical author was more complete than Plutarch, and thus better. Plutarch argues that this is a case of apples and oranges, since he is, after all, not writing history, and should not be compared to one who is. The standards of one genre do not necessarily apply to another, particularly in questions of "truth" and "completeness."

"An intelligent person reads autobiography for two things: for the facts and for the lies, knowing that the lies are often more interesting than the facts," Joseph Epstein observes.[8] The more unflattering the information, the more likely it is to be taken as true, and the reverse. That is why interviews in which the interviewer can elicit information that the subject would not necessarily have volunteered are considered the most successful, and those interviewers are held to be the most skilled. Modern autobiographies written by public figures, often aided by a professional co-author, are not read with the lip-licking zeal afforded "unauthorized" biographies, presumed to contain unflattering and therefore incontrovertible material, sure to have been omitted by the subject. For modern readers as well as ancient, then, completeness carries less weight than "truth." And yet many ancients would likely agree with the statement that in biography what an individual did was much less important than what he was likely to do. Even Thucydides, when dealing with individuals in his *History*, had recourse to "likelihood" to characterize their speeches. "A fact of our existence is of value not insofar as it is true, but insofar as it has something to signify," says Goethe.[9]

Needless to say, this element of likelihood can compromise the use of autobiographical material for traditional historical purposes. Marc Dolan lists five formal objections to the "indiscriminate use of formal autobiographies as primary sources of historical evidence."[10] These are as follows. First, a single viewpoint distorts and limits historical perspective. Second, the nature of autobiography emphasizes the life of an individual rather than a group (i.e., community, nation, era). Third, autobiography almost always follows a linear narrative. Fourth, the "literariness" of autobiography is

obfuscatory. And fifth, autobiographies are of necessity some distance away in time from the events described.

Dolan sets these problems in the context of the historiographic debate over "the relative merits of so-called 'objective' and 'subjective' approaches to history." But the key to this dilemma lies in his use of the word "indiscriminate," a problem he sets out to resolve by explaining: "Another way of putting this would be to say that, in order to employ formal autobiographies as historical evidence we must read them as myth, not fact; as simultaneously personal and tribal myths; as myths not just of the self or the age, but myths of the relation between the two."[11] So there is no reason to reject autobiography as a historical source so long as the document is used with care and awareness of its nature. Since this caveat should apply to almost any kind of historical evidence, our misgivings about autobiography amount to a non-problem for the careful historian.

Another reason autobiographies have the undeserved reputation of second-rate historical sources is that the reader often has "only" the author's word for the veracity of the detail, and the author's motives are suspect since an autobiographer has a vested interest in presenting him- or herself in a certain light. Indeed, the willingness of an autobiographer to include unflattering details stands in direct proportion to the audience's willingness to accept the more flattering material as true (see above).

The main difference between biography and autobiography is the lack of closure in autobiography. The end can never be written. "The best time to write one's autobiography, surely, is on one's deathbed," Epstein suggests.[12] In Plutarch's biographies, for instance, the circumstances surrounding the death of his subject make important contributions to the overall moral effect that Plutarch claims as one of his principal impulses for writing biographies in the first place. So important does he find this that he gives it as the prime reason for comparing Nicias to Crassus (*Nicias* 1.1) and for finding the former the less worthy: "When it came to death, however, Crassus was less blameworthy in that he did not surrender himself nor was he constrained or tricked, but yielded to friends who begged him and was done in by enemies, treacherous although under truce. Whereas Nicias surrendered himself to his enemies out of hope of a shameful and inglorious safety, and made his death the more shameful" (*Comp., Nicias and Crassus,* 5.3).

It is amusing to contemplate one exception to the dictum that autobiography cannot include the end of the subject's life, and that is the sole surviving *fabula praetexta* in Roman literature. As genre dictates, the plot of *Octavia* derives from a historical event. It comes down to us in the corpus of Senecan writings, despite its inclusion of Seneca's death within the play. Clearly, so successful was Seneca at intruding himself into his dramas in autobiographical fashion that it seemed appropriate to someone to credit

him with writing about his own demise in a play composed after and including his death, a feat that one might note the detailed records of his suicide come very close to achieving.[13] After all, deathbed autobiographies have at least one great attraction, the avoidance of consequence, or in Epstein's words "—oh, screw it, let 'er rip, I shall tell the truth at last."[14]

Another difference between autobiography and related genres is the presence of a certain element of performance in autobiography that is, ideally to some, lacking in biography. The biographer traditionally should not intrude on the subject of the biography, but rather recede gracefully into the background.[15] Conversely, the autobiographer is, by definition of *protagonist,* the star of the show. What autobiographers say about themselves cannot be controverted. Every statement in some way must echo a truth of a sort, even if it just "protests too much." This makes up a bit for the fact that no autobiography can ever be the final word on the subject, since someone else will always get in the last word. There comes at some point, after all, a finality of sorts.

Autobiography is the literary version of individuals' life stories expressed in their own words but shaped for a reader. Or, more elegantly, in the words of V. S. Pritchett, "All autobiography is a selection of the past written from the standpoint of the present."[16] These definitions, however, fail to consider interesting questions. What motivates an individual to write an autobiography? Why do people like to read them? The answers of course are as different as the number of readers, but are worth pursuing.

WHY DO PEOPLE READ THEM?

People read autobiographies for many of the same reasons that people write them, for instance, as Pritchett says, to "[fall] into the mysterious sea of memory and [struggle] to find out who *he* is and who *he* was."[17] G. W. Bowersock argues persuasively that Momigliano, while searching for the *persona* in literary works, was in reality seeking for himself, concluding that "Momigliano's quest for the person, in the sense that Marcel Mauss had tried to define it, was in part, as Momigliano's writings had shown it had to be, a quest for one particular person. That was himself."[18] This view of autobiography as a voyage of discovery for both author and readers is attractive, and it is easy to agree with Richard White that "a true autobiography will...still [provide] us with a relevant model of self-disclosure which may illuminate the meaning of our life."[19] This is not quite the same as the ancients' attitude toward biography. Plutarch states clearly that he chose the subjects of his biographies to provide good examples for men to emulate, believing that contemplation of their noble deeds would instill in readers the desire to act likewise (*Pericles* 1.1–5). He later concluded that bad examples would be just as useful in teaching men how not to act (*Demetrios* 1.2),

although he naturally would prefer his readers to emulate good men rather than discover their own, possibly bad, natures. But perhaps this is all too analytical, and the truest reason why people read autobiography, or any literature for that matter, is because, as Eudora Welty says simply: "It's entertaining when it's done well."[20]

WHY DO PEOPLE WRITE THEM?

"Telling the truth" is one reason why individuals feel compelled to write autobiographies. But more usual is a desire to find a deeper truth and unity in one's life, to define one's place in the greater scheme of things. It may well be that, as Richard White says, "Every true autobiography is an attempt to answer the question, 'Who am I, and how did I become what I am now?' "[21] All of us are or should be interested in this question, and the answer, when deftly rendered, will be universally intriguing.

Advanced age is not necessarily a requirement for an autobiography to be interesting. Epstein cites the example of *Keeper of the Moon: A Southern Boyhood*, whose author Tim McLaurin "already, in his thirties, [has] shored up experience out of proportion to his years."[22] Specifically, McLaurin's development of cancer provided him with time and material to contemplate, and imbues his opinions with a gravity unusual in a young man in his thirties. Adversity can certainly make young people old before their time;[23] so can tremendous success at a young age. The autobiography of Martina Navratilova, for instance, although produced with the help of a professional writer, is captivating because of the professional heights Navratilova had already reached by age thirty, when she wrote her book, and because in her case, the experience of defecting from what used to be called an Iron Curtain country also matured her outlook.[24] Thus we may say that although autobiographers do not know the end of the big story (his or her life), they can often see the end of some defining experience.

CONCLUSION

Autobiography has, it seems, always existed in one form or another. The inscriptions of ancient Mesopotamian kings describing their exploits and conquests are in some way autobiographical; so, in some ways, is the *Book of Job*. The so-called "Narmer Palette," which stands on the very dawn of literacy and records the exploits of an early king of Egypt, shows that autobiography begins with writing itself and may, paradoxically, even predate it. The poetry of Archilochus has many autobiographical elements. The "Leagros Kalos" inscriptions on red-figure vases can be called autobiographical. Nevertheless, it is not until the fourth century B.C.E. that autobiography begins to exist in any modern sense of the word. Because the quality of or level of

interest in a given autobiography is largely dependent on the skill of the author, much more so than in the related genres of biography and history, the role of the individual is proportionately magnified. One explanation for this increased interest in autobiography is that Hellenistic art, in contrast with that of the classical age before, was characterized by an interest in the small, everyday, and ordinary. Audiences who wanted to escape from political reality identified with the individuals about whom they were reading or hearing. Yet although the attention of an average fourth-century Greek was focused largely on himself, he proved willing to focus it on others like himself as part of the growing cult of ethos, and to see himself in others, be they "characters" in comedy or philosophy or history, as long as in some way he caught his own reflection in their pool. And since, with or without verifiable truth, it is in autobiography that personality most effectively emerges, because there the author or individual by definition reigns supreme, it is autobiography that is the most essentially Hellenistic form of literature.

NOTES

1. A. Momigliano, *The Development of Greek Biography,* expanded ed. (Cambridge, Mass., 1993), 13.

2. Any representative bibliography of such works in chronological order would have to include F. Leo, *Die griechische-römische Biographie nach ihrer litterarischen Form* (Leipzig, 1901); D. R. Stuart, *Epochs of Greek and Roman Biography* (Berkeley, 1928); W. Steidle, *Sueton und die antike Biographie* (Munich, 1951); A. Dihle, *Studien zur griechischen Biographie* (Göttingen, 1956). Momigliano, *Development of Greek Biography,* 123–32, gives a good if somewhat Eurocentric overview.

3. Momigliano, *Development of Greek Biography,* 23.

4. Ibid., 14.

5. Ibid., 120.

6. For lengthy discussion of this important idea, see Peter Green, *Alexander to Actium,* and Erich S. Gruen, *The Hellenistic World and the Coming of Rome* (Berkeley and Los Angeles, 1991).

7. Green, *Alexander to Actium,* 92, 243.

8. Joseph Epstein, "First Person Singular," *Hudson Review* 45 (1992): 370.

9. Goethe, *Fiction and Truth,* quoted in Epstein, ibid.

10. Marc Dolan, "The (Hi)story of their Lives: Mythic Autobiography and 'The Lost Generation,' " *Journal of American Studies* 27 (1993): 35.

11. Ibid., 36, 39.

12. Epstein, "First Person Singular," 367.

13. I am indebted to my colleague Mark L. Damen for this example.

14. Epstein, "First Person Singular"; see also Peter J. Bailey, "Why Not Tell the Truth?": The Autobiographies of Three Fiction Writers," *Critique* 32 (1991): 211–23.

15. Naturally, there are notable exceptions, like Janet Malcolm's struggle with literary executors over *The Silent Woman,* her 1995 biography of Sylvia Plath.

16. V. S. Pritchett, "Autobiography," *Sewanee Review* 103 (1995): 24.

17. Ibid., 25.

18. G. W. Bowersock, "Momigliano's Quest for the Person," *History and Theory* 30 (1991): 27–36; see also C. Ginzburg, "Momigliano and De Martino," ibid., 37.

19. Richard White, "Autobiography against Itself," *Philosophy Today* 35 (1991): 291.

20. Sally Wolff, "Some Talk about Autobiography: An Interview with Eudora Welty," *Southern Review* 26 (1990): 81.

21. White, "Autobiography against Itself," p. 291, which also contains a good bibliography of modern works on "philosophical autobiography" (302 n. 1).

22. Epstein, "First Person Singular," 389–92.

23. For one perspective on this idea, see Susan Sontag, *Illness as Metaphor* (New York, 1978) and *AIDS and Its Metaphors,* (New York, 1989).

24. Martina Navratilova, with George Vecsey, *Martina* (New York, 1985).

The Classical City Reconsidered

Donald Engels

In the opening scene of Aristophanes' *Clouds,* the Athenian farmer Strepsiades is shown despairing over his ledgers. The problem, as he ruefully tells his drowsy son Pheidippides, is that the boy and his aristocratic mother are ruining the old man's fortune with their spendthrift ways:

> Forever cursed be that same match-maker,
> Who stirred me up to marry your poor mother.
> Mine in the country was the pleasantest life,
> Untidy, easy-going, unrestrained,
> Brimming with olives, sheepfolds, honey-bees.
> Ah! then I married—I a rustic—her
> A fine town-lady, niece of Megacles.
> A regular, proud, luxurious, Coesyra. . . .
> Well, when at last to me and my good woman
> This hopeful son was born, our son and heir. . . .
> This boy she took, and used to spoil him, saying,
> "Oh! When you are driving to the acropolis, clad
> Like Megacles, in your purple," Whilst I said
> "Oh! When the goats you are driving from the fells,
> Clad like your father, in your sheepskin coat."
> Well, he cared nought for my advice, but soon
> A galloping consumption caught my fortunes.[1]

Strepsiades is a simple man who has made a good living from the land that is being squandered by his upper-class wife and her coddled son. The thrifty farmer is a producer of wealth far in excess of that needed for subsistence.

K. J. Dover notes that Strepsiades' situation was well within the common experience of Aristophanes' audience. It is clear that he is a comic carica-

ture of a real type, a non-aristocrat of lowly stock who made good and pre-
served his patrimony because of his thrift and hard work.[2]

The idea that hard work can make the farmer rich and therefore
upwardly mobile is quintessentially Greek. As Hesiod observes in the *Works
and Days:*

> Famine is the unworking man's most constant companion.
> Gods and men alike resent that man who, without work
> Himself, lives the life of the stingless drones,
> Who without working eat away the substance of the honeybees'
> Hard work; your desire then, should be to put your works in order
> So that your barns may be stocked with all livelihood in its season.
> It is from work that men grow rich and own flocks and herds;
> By work too, they become much better friends of the immortals.
> [And men too, for they hate people who do not labor].
> Work is no disgrace; the disgrace is in not working;
> and if you do work, the lazy man will soon begin to be envious
> as you grow rich, for with riches go nobility and honor.[3]

The primordial association of the land with wealth was not unique to
Hesiod, but was a fundamental concept of Greek religion. Demeter, the
goddess of grain, and the Cretan Iasion lay in the thrice-plowed field and
engendered Ploutos, the god of wealth. Not the least important point of
the myth is that farming can make a man rich. Moreover, Hades, the god of
the underworld, who abducted Persephone, the daughter of Demeter and
the goddess of sprouting grain, is also called "Plouton," the wealthy one,
because of his connection with fertility and the earth.

In the more mundane world of Athenian constitutional arrangements,
Aristotle observed that in both the pre-Solonian and Solonian constitutions,
the census standing of an Athenian citizen was determined by the number
of *medimnoi,* measures of dry and liquid agricultural produce, his land pro-
duced in a year. P. J. Rhodes notes that this classification takes account of no
other form of wealth, a fact so disagreeable to modern notions that scholars
have suggested that the passage must be emended to allow for a more ver-
satile classification, and that in time a monetary assessment replaced the
agricultural one. But Rhodes observes that there is no evidence to support
either assumption.[4] These examples (which could be multiplied indefi-
nitely) make it clear that, for the Greeks, farming the land was intimately
connected with their conception of wealth. With luck and determination,
the poor could become rich from honest husbandry, and even the wealth of
the rich was originally derived from the produce of their own estates.[5]

The Romans too viewed land as a source of wealth for the astute farmer.
Cato the Elder, Varro, and Columella wrote treatises on farming for profit.
In the first chapter of *De agri cultura,* Cato states that the optimum size for a
profitable farm is 100 *iugera* (25 hectares), larger than the average farm but

very modest in extent compared with the great latifundia of his day and afterwards.

The issue of the productivity of the ancient farmer is of cardinal importance, since it influences our conception of the dynamics of the ancient economy and the nature of the classical city itself. Did the average farmer of antiquity produce enough to support himself and his dependents, pay his obligations (including taxes and rents), and create a surplus that was exchanged for the goods and services of the city? If he was productive enough to be a consumer, then we can conceive of the ancient city as a service city, whose economy was partially based on the exchange of urban goods and services for agricultural surpluses. If not, we may conceive of the ancient city as more parasitic, creating from the taxes and rents of the outlying districts, an urban and interurban economy in which the countryside did not participate except as an exploited source of labor. The latter view has been advanced by two influential schools of interpretation of the ancient polis, the consumer city notion and the related concept of primitivism.

The consumer city concept, while not universally accepted, has dominated thought concerning the political economy of classical cities for some 70 years. It is one of the few economic concepts from the 1920s not to have been discarded or fundamentally changed over the past three generations. This model claims that classical cities were based on rents and taxes collected from the peasants living in their rural territories.[6]

During the 1960s and 1970s, another ideology, primitivism, was uneasily grafted to the consumer city. The laudable goal of primitivism was to return the Greeks and Romans back to their own time and to see them on their own terms, divorced from any modern social, economic, and political categories and modes of thought.[7] The problem has been that the past to which the Greeks and Romans are being returned is often inauthentic and, in some instances, delusional. This is especially true of the primitivist view that the Greeks and Romans were too innocent and naive to have any knowledge of a market, and that in any event, the peasantry produced so little surplus, perhaps only 2 percent over and above what they needed for their own maintenance, that there was little possibility for them to exchange any surplus in a market. In other words, the peasants were supposed to support huge cities with their rents and taxes, but at the same time they could barely support themselves. It seems one should postulate either the consumer city or the primitivist concept of an underdeveloped economy with limited surplus, but not both at the same time. In any event, the numbers do not support either theory and certainly do not support their combination.

Furthermore, the classical world built a 450-foot lighthouse in Alexandria, Egypt, a 110-foot bronze colossal statue in the city of Rhodes, and another of similar height in Rome. A knowledge of history tells us that such societies could not be considered primitive by any reasonable definition,

since such feats were not duplicated until the late nineteenth century. A historical perspective also tells us that such artistic and technological achievement does not occur in a vacuum but requires a sophisticated social, economic, and political basis that places the society well beyond the primitive, underdeveloped stage. It is in this context that I would like to offer some additional thoughts that cast further doubts on the primitivist, consumer city concept and the moral basis of that paradigm.

The first problem I wish to discuss is the nature of our economic evidence. All too often, in typical journalistic style, anecdotes are used in place of data; indeed, it seems that some are unaware that a distinction between the two exists. I would next like to offer some additional thoughts concerning rent rates and the economic surpluses produced by ancient peasants. These indicate that a consumer city and an underdeveloped economy were not characteristic of the classical world. Finally, I would like to make some additional comments concerning the metapolitical social and religious values shared by the Greeks and Romans that shaped their cities. It is hoped that these observations will encourage further debate.

I

History, including economic history, should not be written on the basis of anecdotes; it is data, not anecdotes, that we need. An anecdote is a specific instance or event that may or may not be representative of a broader trend. Data, on the other hand, refer to a broad range of instances that are representative of larger phenomena.

Our popular culture is inundated with journalistic anecdotes concerning society, the economy, and the environment. The anecdotes are almost always of a sensational and negative character, since this sells, while contradictory evidence is usually ignored. The use of anecdotes cannot pass for legitimate analysis, although their influence has become pervasive, even in our own field.

Sources concerning the *hektemoroi* or sixth-parters of early sixth-century B.C. Athens, for example, constitute data and not anecdotes, since they refer to a large number of individuals, not just one or two. So too the 10 percent rent rate for Roman public land in Appian (*b.c.* 1.1.7). Once again, there were many farmers who farmed public land, not just a few, so it is more likely to be representative of rent rates as a whole than a stray anecdote about an oppressive landlord or some peasants' temporary inability to pay rent.[8] For every anecdote about a struggling farmer, there are a dozen about prosperous ones.

Some specific data can be representative of a larger whole, provided that they are not biased. The use of such representative data or samples is important not only for history but for many other fields, such as demography,

biology, epidemiology, economics, and sociology. One example of a specific sample that is representative of a larger whole is the census data from the Arsinoite, Oxyrrhynchite, and Prosopite homes of second-century A.D. Egypt. Here, the age and sex records for some 700 survive, which represent only about 1/10,000 of the population of the province.[9] Nevertheless, the data show a population with a life expectancy at birth of 25 years and a generally balanced sex ratio, which was probably representative, not only of Egypt, but much of the rest of the Roman world as well.[10]

How can a census of some 300 households and 700 individuals be representative of a country of some 5,000,000 and an empire of some 50,000,000? It is because the census is generally without bias and the population does not have any exceptional, abnormal characteristics. The census takers had no reason to over- or underrepresent any age category or sex, nor did the population engage in practices such as high rates of euthanasia or female infanticide, for example, that would have fundamentally altered its structure.[11]

II

I would like to add some additional comments on rent rates, beginning with the *hektemoroi* or sixth-parters, of sixth-century Athens. In the debate concerning this group of tenant farmers, one important fact is often overlooked: either he gave one-sixth of his produce to his landlord and kept five-sixths for himself, or he gave five-sixths and kept one-sixth.[12] If he gave five-sixths and kept one-sixth for himself (presumably able to feed himself and his family from that), this means that the *hektemoros* could have fed five households (some twenty people), excluding his own, making him the most productive farmer in human history before the twentieth century. If it is true that the *hektemoros* paid an unparalleled rent rate of five-sixths of his produce (83 percent), it cannot also be true that the Greek and Roman peasant in general produced a surplus of only 2 percent or so after he supplied his own maintenance at a tax rate of 10 percent and a rent rate of 10 percent at the same time.[13] The reasonable alternative is that he paid one-sixth.

Another rent rate occurs for the island of Rhenia. Here, the total rent derived from lands owned by the temple of Apollo on neighboring Delos in the 280s B.C. is known, as is the total land area in question. The rent rate averaged seven drachmas per hectare, and wheat or barley was the principal crop. At the contemporary exchange rate, seven drachmas could purchase, on average, one medimnos of wheat, about 52 liters, or 41 kilograms. In general, yield rates in the region during antiquity were, at the very least, 1,000 kg per hectare. So, with a two-field system, where half the land was under cultivation in any given year, the average yield of the land would be about 500 kg. per hectare. With a rent of seven drachmas per hectare, or 41 kg. of wheat per hectare, the rent rate would be about 8 percent.[14] This is

an average rate, since many farms were involved, and some may have paid more, others less. But it is precisely the averages that we need in economic history, not the bizarre or extremes. When the price of wheat was high and production was maintained, the rent as a portion of the crop would have declined, since the rents were paid in money at a fixed rate. When the price of wheat was low, the rent as a portion of the crop would have increased. This rent rate, 8 percent, is the same as Stratocles charged on his estate in the Thriasian plain and similar to other rent rates in Athens.[15]

How representative is the average rate for Rhenia? It is low, like the other known rent rates for the classical world. If the rent rates at Rhenia were substantially higher than in surrounding areas, no one would want to rent the properties. If the rents were lower, the temple would not realize all its potential income, which is not a reasonable assumption. When the generally accepted rate of one-sixth (17 percent) for the *hektemoroi* and the 8 percent at Rhenia are combined with the other known rent rates from the classical era, we see that they were historically low and that cities could not have been maintained from them.

As I have shown elsewhere, this is because there is a mathematical relationship among the area of cultivable land in a city-state, rent rates, and the potential numbers of landlords in that state.[16] Take the city-state of Corinth for example. This state had a rural area (*chora* or *territorium*) of 318 square miles (825 square kilometers), making it one of the larger ones of the Greco-Roman world. Of this area, some 80 square miles (207 square kilometers) could be cultivated. If we allow each individual a mere 2.9 acres (1.17 hectares) for food, giving him the barest minimum to maintain life, a maximum of 17,600 could be supported by agriculture. The actual numbers supported by agriculture were considerably less, perhaps only 8–10,000, when one includes the agricultural surplus needed to pay for clothing, shelter, equipment, animal feed, and seed that was wasted or spoiled.

Let us assume that all the cultivable land was owned by landlords, and that the rent rate was 10 percent of the crop. This means that 1,760 landlords could have been supported from rents in the city-state of Corinth, giving each landlord a bare minimum subsistence. If some of the land was farmed by proprietors not employing tenants, landlords would have been fewer; if the rents were higher, there would have been more of them. Again, the actual number of landlords was considerably smaller than their potential maximum, probably only a few hundred. Even the maximum number of landlords was minuscule compared to the total population of the city (*asty* or *urbs*) of Corinth, which seems to have been around 80,000 in the Roman era.

Therefore, in large city-states, the maximum number of landlords was small, and their proportion among urban residents minuscule. Although landlords are prominent in our ancient literary sources—Pliny the Younger,

for example—their actual number was small, given the low rent rates and widespread peasant proprietorship in antiquity.

If larger cities could not have been consumer cities supported by rents, except perhaps imperial capitals, what about smaller ones? It has been suggested that small city-states, those with a total population of, say, 5,000, may have been consumer cities.[17] Let us take a small city-state of 5,000 total population. To give the consumer city notion the greatest advantage, let us assume that all 5,000 were supported by agriculture and none of the inhabitants engaged in commerce, manufacturing, or the delivery of services. There were no priests, no temples, no stonemasons to build public buildings, no carpenters to build private homes, no cobblers to make shoes, no weavers, jewelers, quarrymen, warehousemen, leather workers, potters, lamp makers, millers, no hotels, public baths, or taverns, in fact, nothing that would make a city a city; only farmers and landlords.

Let us give the consumer city a further advantage and assume that *all* the land was owned by landlords, who charged their peasants a rent rate of 10 percent, and that 5,000 was the maximum number that could have been supported by agriculture in the city-state. At this rate, a *maximum* of 500 landlords could have been supported in the city-state, which the 4,500 peasants farmed for themselves and their landlords. Let us further assume that all the landlords lived in the *asty* or *urbs,* that is the city of the city-state. Five hundred individuals would constitute about 100–125 families. Under any reasonable accounting, the 100 or so landlord families would be far outnumbered by the 1,100 families of the farmers, who would also live largely in the *asty,* such as we see in the tens of thousands of agrotowns throughout the world. It is only by arbitrarily excluding the farmers from living in the *asty* that such an artificial consumer city could exist. No Greek or Roman city-state had a policy of excluding farmers from living in its *asty;* such a notion would have been preposterous and absurd.[18]

III

Some further discussion of the evidence for large surpluses produced by ancient peasants is also necessary, since some still believe that peasants retained almost no surplus after their maintenance, taxes, and rents were paid.

First, there is the very important argument in Plato's *Republic,* 369e–370a. Plato is discussing the role of the farmer in his ideal city:

> Then how should they proceed? Should what each produces be made available to all? I mean, should the individual farmer produce food for himself and also for the rest? That would require him to produce, say, four times as much food as he could use himself. Correspondingly, he would invest four times as

much labor in the land than if he were supplying only himself. Or should he decline to concern himself with the others? Should he produce food for his own needs alone, devoting only a fourth of his total effort to that kind of work? Then he could allot the other three-fourths of his time to building a house, making clothes, and cobbling shoes. Choosing the latter, he would not have to bother about associating with others; he could supply his own wants and be his own man.[19]

Plato then proceeds to argue that each individual has a natural aptitude for a specific type of work, and that it is best for individuals to devote all their attention to that calling, rather than to try to do everything for themselves. In other words, the farmer should produce enough food for himself and his family in addition to three other citizens and their families. This is a much more efficient use of time than to devote one-fourth of his time farming and the rest of the time to building a house and making shoes and clothes for himself and his family.

This argument is a critical one in the development of Plato's ideal state. Just as it is more sensible for those good at farming to farm for others and those with an aptitude for making shoes to make them for others, so too, Plato believes, those with an aptitude for governing should govern others. This is in fact one of the central concepts of the *Republic,* and most subsequent arguments are based largely upon it.

Plato's ideals were based on the processes of dialectics and eristics. These processes in turn were based on commonly held knowledge, opinions, and beliefs. Unlike some of his beliefs, about love, truth, beauty, and so on, which may have been based on arguable assumptions, the notion that the Greek farmer could produce a substantial surplus was based on the common experience of his audience. For Plato to have based central arguments of the *Republic* on an assumption about Greek agricultural productivity that was preposterous or ludicrous to his readers, would have been a sign of the most profound stupidity.

Aristotle (*Politics* 1267a–1268b) maintained that the average farmer should have sufficient resources to support his own family plus another one. It has been maintained that this passage concerning Greek agricultural productivity is unreliable since it is "hypothetical."[20] This is incorrect. Aristotle, unlike Plato, was an empiricist; he based his principles and ideals on reality and the common experience of humanity as he and his students discovered them through empirical research. His method can be seen in all his works, but especially in the *Politics.*

Plato established an ideal state based on principles derived from dialectics and then deducing the institutions of the state from these principles. Aristotle on the other hand, (with the help of his students) studied the constitutions of 158 different states from the Greek world, the Near East, and North Africa. From this exhaustive empirical research, he derived not one

but four types of ideal state. Monarchy, aristocracy, and moderate democracy (such as Solon's Athens) could work well as long as the ruling element ruled for the public good and not for its own self-interest (*Pol.* 1279a). The best type of all, however, was a state with a mixed constitution that would combine democratic, aristocratic, and monarchical elements. In this way, the three elements would check and balance each other to prevent the state from degenerating into inferior forms. Subsequent human experience has confirmed the wisdom of the general principles of checks and balances in government and the mixing of differing institutions, such as the executive, judicial, and legislative branches. It is Aristotle's model as interpreted by Polybius and others that forms the basis of the United States constitution, which has become an example for many throughout the world.[21]

Aristotle's criticisms of ideal states advocated by other philosophers, most notably by Plato, are not based on hypothetical notions but on universal experience. In this passage, he criticized Hippodamus's ideal state, where the soldiers fought for the state, the craftsmen worked for others as well as for themselves, but the farmers only farmed for themselves. Aristotle maintains that this would be a major failure for the state, since the farmer ought to provide enough surplus for *at least two households,* the farmer's own and that of the soldier, even if the land is owned publicly, and not privately by the farmer. If the land was privately owned, Aristotle implies, the surplus should be larger.

Farming public land was unproductive, Aristotle maintained, because,

> the greater the number of owners, the less respect for the property. People are much more careful of their own possessions than of those communally owned; they exercise care over public property only in so far as they are personally affected. (*Pol.* 1261b)

> There are two impulses which more than all others cause human beings to love and care for each other: "this is my own," and "this I love." In a state constituted after the manner of Plato's *Republic,* no one would be able to say either of these. (*Pol.* 1262b)

> If they [the citizens] themselves work the land for their own benefit, there will be greater ill-feeling about the common ownership. For if the work done and the benefit accrued are equal, well and good; but if not, there will inevitably be ill feeling between those who get a good income without doing much work and those who work harder but get no corresponding extra benefit. (*Pol.* 1263a)

> If the responsibility for looking after property is distributed over many individuals, this will not lead to mutual recriminations; on the contrary, with every man busy with his own, there will be increased productivity all around. (*Pol.* 1263a)[22]

Aristotle, like Hesiod before him, argues that it is human nature for people to work best when they work for themselves. He believes that the polis

will be most productive if private ownership of land, or at least a significant personal stake in its cultivation is characteristic of its farmers.

The notion of a limited surplus available to Greek farmers has the unenviable distinction of contradicting the joint testimony of both Plato and Aristotle, two of the greatest intellects of the classical world, with an unsurpassed knowledge of the ancient economy. Although they employed different methods and often reached different conclusions, they both agreed that the Greek farmer had a substantial surplus at his disposal. If the Greek dirt farmer did, then why not his Roman counterpart?

It has been known now for almost two millennia that the Romans expected an adult male laborer to be able to farm 25 iugera, or 6.3 hectares (15.6 acres), devoted solely to cereal cultivation.[23] For *arbustum*, that is, land with a mixed cultivation of cereals, vine crops, and orchard produce, an adult male was expected to manage 18 iugera, or 4.5 hectares.

So, taking the latter figure, a family with, say, the labor equivalent of two adult males, should be able to farm nine hectares, including fallow, and feed about eight individuals, allowing each individual a little more than one hectare for food.[24] Thus, a small family, say of four, with an equivalent of two adult male labor inputs, should be able to support itself and feed another family of four.

If the family were larger, having say four adult male labor inputs, the father, perhaps a grown son, and two slaves, then it should be able to cultivate about 18 hectares, which would be enough to feed sixteen or seventeen individuals, or about three or four families, including itself.

With the addition of a 10 percent land tax (for imperial Romans, not Greeks) and a 10 percent rent rate (assuming the farmer was not a proprietor), then the latter family would retain the produce of 14.4 hectares after it paid its tax and rent, which would be enough to feed itself plus about two other families. In other words, the Roman agrarian sources agree with Plato and Aristotle. The small farmer should be able to support his own family plus another. Under optimal circumstances, a larger farm with four male laborers should be able to feed two to three families in addition to itself.

Whether a farmer would be able to produce enough to feed other individuals depended on the size of his farm and not on whether he was too primitive, ignorant, and childlike to know how to produce a surplus. It is undeniable that many farms were only large enough to support a single family. This seems to have been the case in classical Athens, where the average small farm was about 50–60 *plethera*, or 4.5–5.5 hectares,[25] enough for zeugite status. Nevertheless, many farms in Attica were larger than this. The average size of large family farms was 200–300 plethera, or 18–27 hectares. This would have been large enough to have fed fifteen to twenty-five people altogether.

In the Roman world, new colonists were given allotments of land amounting to 10–12 iugera (2.5–3.0 hectares) in the time of Caesar, which would have been barely adequate to maintain a small family.[26] On the other end of the scale, under the Empire, some estates were hundreds of thousands of iugera in size. The average size of estates at Leontini, Sicily, in 70 B.C. was 1,900 iugera, or 475 hectares, including fallow.[27] These estates were devoted to wheat cultivation and each was probably farmed by a large family with slaves; approximately 100 individuals would be needed to farm a holding of this size. In a two-field system, 238 hectares would be farmed in a given year, enough to feed about 400 people including the cultivators.

Verres assessed an illegal and exorbitant "tithe" of approximately three-eighths (37 percent) of the crop, and even as much as five-eighths (62 percent) in some cases, from these farmers. Although the latter rate ruined many of them, others managed to survive. The higher rates did not make the farmers more prosperous and productive.

Finally, of what value would it be to purchase a large estate if it only produced enough surplus to feed the cultivators, with almost no surplus for the market? The larger estates in Attica for example, 200–300 plethra in extent, sold for two to four talents, depending on the quality of the land and other factors.[28] Reckoning a value of 80 drachmas per plethron (.09 hectare), a 300-plethra estate (27 hectares) would cost four talents (24,000 drachmas) and would produce 329 medimnoi (13,500 kg) of wheat per annum under a two-field system. With a price of 7 drachmas per medimnos (41 kg), the gross return would be 2,303 drachmas per year. If (as on the primitivist model), the farmer had only 2 percent of this surplus to exchange at the market, this would amount to only a 46 drachma return on investment per year, or .19 percent. At this rate, it would take the buyer 522 years to recoup his investment! If the cost of the farm buildings and equipment were factored in, it would take the buyer even longer to recoup his cost.

If this farm were twice as productive, because more profitable crops were grown, or for other reasons, and yielded 4,606 drachmas per year, a 2 percent return would still be only 92 drachmas per year, or .38 percent. It would take 261 years for the buyer to recover his costs.

Similar arguments also can be made for the Roman world. The price of land in Italy was about 1,000 sesterces (HS) per iugerum (Columella, *De re rustica* 3. 3. 8). On average, the price of wheat was four HS per modius, which weighed about seven kg.[29] If one purchased 100 iugera of land (25 hectares) for 100,000 HS, it would produce about 12,500 kg of wheat per annum with a two-field system. If the farm produced a 2 percent surplus for sale at the market, this would be 36 modii or 250 kg, which would be worth 144 HS. This gives a rate of return of .14 percent per year and the buyer could recoup his cost in a mere 700 years. Again, if the costs of buildings and equipment were added, the investment would yield a lower rate.

If the price of land were only 500 HS per iugerum, one could buy 200 iugera (50 hectares) for 100,000 HS and produce 25,000 kg of wheat. A 2 percent surplus would be 500 kg, or 71 modii, worth 284 HS. The rate of return on investment would be .28 percent per annum, and the pay-back time would be 352 years.

The rate of return on capital invested in Italian agriculture also indicates that productivity was high. Normal returns in Italy were six percent per annum (not .14 or .28 percent),[30] and our sources make it clear that such a rate was not only expected but received. Most of the rate of return was based on wheat production, since this was the most widespread crop in Italian agriculture.[31] Vines may have had a higher rate of return, and olives or barley less. Thus, a farm that cost 100,000 HS should have yielded 6,000 HS per annum. In comparison, an ordinary 200-iugera farm (*fundus*) belonging to Q. Axius at Reate brought in 30,000 HS per year. This was half as much as a villa belonging to Varro's aunt on the Via Salaria that produced specialized goods for the urban market at Rome.[32] Land was valuable, and it would not have been worth so much if it were not productive.

Recent research by Forbes, Gallant, and others has shown that the Greek farmer had to cope with large interannual variations in rainfall and hence crop yields.[33] If the farmer only produced 2 percent surpluses during good years, he would have been ruined during a bad one. Substantial surpluses were necessary to avoid disaster.

One of the prime supports of primitivism has been the notion that the Greeks and Romans were unaware of the concept of profit and loss because they lacked a system of double-entry bookkeeping.[34] Rathbone has destroyed this view in his recent book on agriculture in third-century A.D. Egypt.[35]

IV

In conclusion, the ancient evidence shows that the average farmer was able to produce a surplus and participate in the economy of the city as a consumer of goods and services. This fact calls into question the consumer city and primitivist models of the ancient polis. We should not be surprised. It is difficult to understand how a society in which most free farmers were exploited drudges could have produced a vision of the dignity of humanity that prevailed in Greco-Roman antiquity. The anthropomorphic nature of the ancient gods and the philosophical identification of reason with the divine implied that human beings had a kinship with the highest principles of the cosmos. As Ovid puts it in his description of the creation of the world,

A holier creature, of a loftier mind,
Fit master for the rest, was lacking still.

Then man was made, perhaps from seed divine
Formed by the great Creator, so to found
A better world, perhaps the new-made earth,
So lately parted from the ethereal heavens,
Kept still some essence of the kindred sky—
Earth that Prometheus moulded, mixed with water,
In likeness of the gods that govern the world—
And while the other creatures on all fours
Look downward, man was made to hold his head
Erect in majesty and see the sky
And raise his eyes to the bright stars above.[36]

This vision does not deny the terrestrial component of the human race: those who must eat must also toil. But Ovid asserts, in unanimity with thinkers as diverse as Homer, Hesiod, Xenophanes, Sophocles, Plato, Aristotle, Vergil, Cicero, Seneca, and Marcus Aurelius, that the human being is more than *homo economicus.* "Consciousness precedes being, and not the other way around, as the Marxists claim," Václav Havel has said.[37] The values of a society, as revealed by its art and literature, are the basis of its economy and must be understood before the economy can make sense.

NOTES

I am pleased to dedicate this essay to my former teacher Peter Green, who has the rare quality of seeing potential in even the most eccentric student. I am also grateful to the editor, Richard Moorton, and the referee for their useful suggestions and advice.

1. Aristophanes, *Clouds* 42–48, 60–61, 68–74, trans. B. B. Rogers, *Aristophanes,* vol. 1 (London, 1978), 271, 273.

2. K. J. Dover, ed., *Aristophanes' Clouds, Abridged Edition* (Oxford, 1970), xvii: "Strepsiades lives 'far off in the country' (138). He is ignorant, stupid, and boorish, a son of the soil and smelling of the soil (43 ff.)—but one of its richer sons. He seems to have had no difficulty in borrowing, from people who knew him, very large sums of money, such as are not readily lent to farm laborers or poor peasants. A distinguished aristocratic family sought him out (41 f.) as a husband for one of its daughters, and since this (to us) surprising marriage is taken for granted, we may be justified in supposing that it did not surprise Ar.'s audience. Strepsiades, although he knows how to tighten his belt and has a farmer's mistrust of extravagance (421), is to be thought of as owning farm land which would nowadays sell for £60,000."

3. Hesiod, *Works and Days,* 302–14, trans. R. Lattimore (Ann Arbor, Mich., 1959), 55.

4. P. J. Rhodes, *A Commentary on Aristotle's Athenaion Politeia* (Oxford, 1981), 140.

5. The latter point is made by C. Starr, *Individual and Community: The Rise of the Polis, 800–500 b.c.* (Oxford, 1986), 63.

6. For the consumer city view, see P. Garnsey and R. Saller, *The Roman Empire: Economy, Society, and Culture* (Berkeley and Los Angeles, 1987), 48–49, with references to the history of the idea.

7. See ibid., 43–63. Primitivism does not imply a lack of complexity or sophistication. Often, primitive rites, rituals, and kinship terminology are a marvel of complexity. In addition to the books by Freeman and Kuper on primitivism cited in my book on Corinth (cit. n. 12 below), see now M. Torgovnick, *Gone Primitive: Savage Intellects, Modern Lives* (Chicago, 1990).

8. J. K. Evans, *AHR* 97 (1992): 172, maintains that because some of Pliny's poor tenants had trouble paying their rent one year, this implies that all peasants throughout the Roman Empire for 500 years could not pay their rent. Because Apuleius in his *Golden Ass* mentions a ruthless landlord, so all landlords in the Roman world must have been exploitive. Perfection is not to be found in this world, but a few anecdotes are not sufficient to contradict the massive evidence for the peasants absorbing a tripling of their taxes during the late Empire and the high surpluses they achieved according to Plato, Aristotle, Cicero, Columella, and Varro.

9. M. Hombert and C. Preaux, "Recherches sur le recensement dans l'Egypt romaine," *Papyrologica Lugduno-Batavia* 5 (1952): 156–57; R. Bagnall and B. Frier, *The Demography of Roman Egypt* (Cambridge, 1994).

10. M. K. Hopkins, "On the Probable Age Structure of the Roman Population," *Population Studies* 19 (1966): 264, n. 33; M. K. Hopkins, "Brother-Sister Marriage in Roman Egypt," *Comp. Stud. in Soc. and Hist.* 22 (1980): 317–20. The same conclusion is also reached by Bagnall and Frier, *Demography of Roman Egypt* (cit. n. 9 above), 173, with caveats.

11. The unusual practice of brother-sister marriage did not lead to any increase in the death rate caused by inbreeding. The numbers that would die as a result were small compared to the numbers that would ordinarily die from natural causes. See Hopkins, "On the Probable Age Structure of the Roman Population," (cit. n. 10 above), 317–20. Males also seem to be slightly underrepresented. Some did not register for the census, so that they could evade the taxes on registered individuals, but this bias can be easily corrected.

12. Attempts to find a middle ground by, e.g., T. Gallant, have contradicted our ancient evidence and are not convincing; see D. Engels, *Roman Corinth: An Alternative Model for the Classical City* (Chicago, 1990), 243 n. 4.

13. M. K. Hopkins, *Conquerors and Slaves* (Cambridge, 1978), 17. Hopkins has subsequently modified his views; others have not.

14. R. Osborne, *Classical Landscape with Figures* (London, 1987), 45–47. If barley were the crop instead of wheat, the rate would still be about the same. Although barley is cheaper, the crop yields are also higher than wheat. Osborne mentions another rent rate for Thespiae for the late third century of 20 drachmas per hectare. It is not stated, however, whether the rental lands included a dwelling, as was often the case at Athens, or what crops were grown, or where the land was located in relation to the city. Wheat was not the sole product of the Rhenian estates; they also had vineyards and cattle pasture. If the rentals at Rhenia included a dwelling (they probably did not), they would have been a bargain indeed. For consistency, I use these figures—41 kg of wheat per medimnos (1.5 bushels), and a yield rate of 1,000 kg of wheat per hectare—in this chapter.

15. Isaeus 11.42; A. Burford Cooper, "The Family Farm in Greece," *CJ* 73 (1977–78): 169 n. 38.

16. These relationships are discussed in greater detail in Engels, *Roman Corinth* (cit. n. 12 above), 189–92.

17. R. Saller, *Classical Philology* 86 (1992): 354; Engels, *Roman Corinth* (cit. n. 12 above), 123.

18. Ironically, passages in Pausanias (7.18.7, 10.38.4) on the foundation of Patrae and Nikopolis are used by Garnsey and Saller, *The Roman Empire: Economy, Society, and Culture* (cit. n. 6 above), 30, to show the nefarious nature of Roman imperial government during the Principate. But here local farmers were supposedly "herded" into the cities, not excluded by them! It is assumed that the downtrodden, poor, exploited, etc., peasants had no choice but to live in Patrae and Nikopolis. This is incorrect. Augustus brought the Achaeans to live in Patrae, which, as a Roman colony was granted freedom from imperial taxes, one of the only colonies in Greece to have been so honored, and other privileges. Pausanias says that when Augustus settled (*sunoikismon epoiesen*) Aetolians at Nikopolis, most decided to live at Amphissa instead.

19. Plato, *The Republic,* trans. R. W. Sterling and W. C. Scott (New York, 1985), 65.

20. Saller, *Classical Philology* 86 (1992): 354.

21. For this, see now P. Rahe, *Republics Ancient and Modern: Classical Republicanism and the American Revolution* (Chapel Hill, N.C., 1992), esp. 569, 584–86, 600–14.

22. Aristotle, *Politics* trans. T. A. Sinclair (New York, 1962), 58, 61–63.

23. R. Duncan Jones, *The Economy of the Roman Empire: Quantitative Studies* (Cambridge, 1974), 327–33; Columella, *De re rustica* 2.12.7 including the two plowmen; cf. Varro, *Res rusticae* 1.18 for manning ratios for viticulture. Evans (cit. n. 8 above) believes that the contemporary view of a large surplus available to Greek and Roman farmers will be short-lived. However, since the time of Plato, it has been known to any interested reader that large surpluses were produced. It is more likely that the view of limited surplus, which is only based on anecdotal evidence, will not last long. See, e.g., Caesar, *BG* 4.1, where one half the German Suebi support themselves and the other half of their military population while they are on campaign. In the following year, the group that farmed go on campaign, and those that campaigned now become farmers. Although the ethnography may be questionable, the notion that about one half of the adult male population can support both itself and the other half while they campaign (which was indeed Aristotle's point in his criticism of Hippodamus) was not remarkable to Caesar.

24. Osborne, *Classical Landscape with Figures* (cit. n. 14 above), 45, believes, mistakenly in my opinion, that an individual can be fed from just half a hectare in a two-field system, including seed. However, this would give the individual only about .62 kg per day, or about 1,350 calories, not enough to sustain life in any meaningful way. If Osborne is correct, then the peasants could feed twice as many people as I suggest. See Engels, *Roman Corinth* (cit. n. 12 above), 27.

25. See A. Burford Cooper, "Family Farm in Greece" (cit. n. 15 above), 169–70; and id., *Land and Labor in the Greek World* (Baltimore, 1993), 67–68, an invaluable work that also discusses the low rent rates, widespread landownership, and limited tenancy in ancient Greece.

26. Cicero, *Epistulae ad Atticum* 2.16.1; Suetonius, *Caesar* 20.3.

27. Cicero, *Verr.* 2. 3. 113; 116; 120; Duncan-Jones, *Economy of the Roman Empire* (cit. n. 23 above), 325. Before Verres assumed office, there were 84 farmers cultivating 60,000 iugera, or an average of 714 iugera, including fallow. During his third year, there were only 32 left farming.

28. Burford Cooper, "Family Farm in Greece" (cit. n. 15 above), 169–70.

29. Duncan-Jones, *Economy of the Roman Empire* (cit. n. 23 above), 33 ff., 48–49, 146, 345.

30. Ibid., 33. Characteristically, M. I. Finley, *The Ancient Economy* (Berkeley and Los Angeles, 1973), 98 and 198 n. 7, calls Columella's price for land "mythical." I would like to suggest that if we continue to ignore what our ancient sources have to say about agriculture, the result will be myth and not history. In any event, the price of land in Italy, 4,000 HS or 1,000 denarii per hectare is very close to the price of land in classical Attica, 890 drachmai per hectare.

31. J. K. Evans, "Wheat Production and its Social Consequences in the Roman World," *CQ* 31 (1981): 428–42.

32. Duncan-Jones, *Economy of the Roman Empire* (cit. n. 23 above), 36 n. 7; Varro 3.2.14–17.

33. H. Forbes, *Strategies and Soils: Technology, Production and Environment in Methana* (Ann Arbor, Mich., 1985); T. W. Gallant, *Risk and Survival in Ancient Greece: Reconstructing the Rural Domestic Economy* (Stanford, Calif., 1991).

34. An oft-repeated assertion, made recently by Garnsey and Saller, *The Roman Empire: Economy, Society, and Culture* (cit. n. 6 above), 52, 74, although not in as extreme a form as by others.

35. D. Rathbone, *Economic Rationalism and Rural Society in Third Century a.d. Egypt* (Cambridge, 1991). Cf. Engels, *Roman Corinth* (cit. n. 12 above), 26–27; Burford Cooper, "Family Farm in Greece" (cit. n. 15 above), 175.

36. *Metamorphoses* 76–86, trans. A. D. Melville in *Ovid: Metamorphoses* (Oxford, 1986), with introduction and notes by E. J. Kenny, 3.

37. Václav Havel to a joint session of the U.S. Congress in 1989. Cited by G. Himmelfarb, *On Looking into the Abyss* (New York, 1994), 50.

THIRTEEN

Augustan Classicism
The Greco-Roman Synthesis

Karl Galinsky

As any student of ancient history or classics can attest, the quantitative increase of scholarly publication in the past few decades has been enormous; the size of *L'Année Philologique* almost doubled from 1963 to 1993. The downside, as in humanistic scholarship in general, has been increasing compartmentalization. Peter Green's synoptic work, of course, provides a contrarian model—a model, I'm afraid, that is just as unique as Peter himself.

A corollary of these developments has been that generalizations about major historical and cultural periods increasingly tend to proceed from the limited perspective of one research specialty or the other. The Augustan age is a case in point. A common characterization of its culture is "classicism." As defined by scholars of Augustan art and architecture in particular, Augustan classicism in essence is the emulation of the Greek classical period and the rejection of *Hellenismus* with its supposed baroque excrescences. In this context, Nietzsche's dated oppositional schema of Apollo and Dionysus was revived once more for the personal contrast between Octavian/Augustus and Mark Antony, *neos Dionysos.* Central to this concept of Augustan classicism, therefore, is the antithesis between Greek classical art with its exalted values—ancient art theory, after all, speaks of *pondus, dignitas,* and *to semnón*[1] —and the unbridled excess of the so-called Hellenism. The visual paradigms—exemplars of the fabled power of images—are the Prima Porta Augustus, whose model, the Doryphoros of Polykleitos, is characterized by Quintilian (5.12.20–21) as *gravis* and *sanctus,* and the Farnese Bull, which Mark Antony undoubtedly would have ridden from Pollio's Atrium Libertatis through the streets of Rome had he been victorious at Actium.

Such polarities are convenient for structuring the academic discussion and some of the observations made within this framework can be useful. The basic antithesis, however, which needs to be modified even in its appli-

cation to Augustan sculpture, is irrelevant to other areas of Augustan culture, such as poetry. One of the central characteristics of the oeuvre of the Augustan poets is their integration of many impulses from Hellenistic poetry. This is true even of Vergil's *Aeneid,* which also exemplifies the true nature of Augustan classicism: far from exhausting itself in the opposition between the classical and the Hellenistic, it consisted of the creative coexistence and reworking of all Greek traditions—archaic, classical, and Hellenistic, together with Roman traditions. The goal of this compleat *aemulatio* was a synthesis, a new creation, that comprised and surpassed all these traditions—or perhaps I should say "aimed to surpass," since the honoree of this volume is a confirmed Grecist.

The phenomenon is pervasive, and I shall have to limit myself to a few salient examples. Before I do so, one further perspective. Augustan classicism did not fall from Winckelmann's Greek sky, let alone from heaven. It was not a blessed given that was preconceived, unchanging, and static. Rather, and parallel to Augustus's mode of government, Augustan classicism was experimental and evolutionary. Many of the developments of the Augustan age became routine later, such as the shape of the Principate, certain genres in art and poetry, and the imperial cult. To the imitators of Augustan classicism in England, France, and Saxony, this cultural and historical high point appeared fixed and monolithic. That was not the case in Augustus's time. Rather, it was a time of transition and experimenting—the term "essay" is quite appropriate here.[2] To express it with a paradox: it was evolution that was lasting. This evolution continued even in the second half of Augustus's reign, a period that seems characterized by less movement—with the exception of a very mobile Julia—in part because there are substantial gaps in Dio's account.

To turn to classicism in Augustan sculpture. Rather than being a momentous *Wende* from the Hellenistic to the classical and archaic, it was a typically nuanced continuation of existing traditions in new ways. To survey the principal perspectives: the so-called Hellenism—and we should be mindful that this periodizing notion did not exist until 1832, when Droysen invented it—had an abiding archaistic and classicizing component. It is noticeable especially from the middle of the second century on. Good examples, *inter plurima alia,* are the cult statues by Damophon of Messene, such as his Demeter and Artemis, and, somewhat later, the Zeus by Eukleides. Other well-known statuary includes a neoclassical version of the Phidian Athena from Pergamon (fig. 13.1). A recent study has documented that Rome made this tradition her own in the second century in connection with the temple foundations of the triumphant generals.[3] A surviving example of such a cult statue is the head of Fides from her temple on the Capitoline, which was restored by Aemilius Scaurus in 58 B.C. (fig. 13.2).

Another factor was the mania of Roman conquerors for establishing

private art collections. Here again it was the works of the old masters and works in their manner that were coveted most. The supposed ethical or moral dimension of classical art did not affect this choice. Aesthetic considerations may have, and investment-oriented reasons certainly did. Cicero's correspondence provides some insight into the operative mentality: we find no mention of classical art in terms of any ethos, though plenty about unscrupulous art dealers and inflated prices (e.g., *Fam.* 7.23.1–3), concern for the aesthetic suitability of certain statue types for certain parts of the villa (*Att.* 1.8.3, 1.9.2), preoccupation with proper arrangement (*Att.* 1.10.3), and the understandable desire to buy as many artifacts as possible (*quam plurima: Att.* 1.8.2) at the lowest possible price. The growth of the so-called neo-Attic workshops can be attributed directly to the preferences of their Roman clients; several of the workshops subsequently settled in Rome.[4] Their best-known representative was the sculptor Pasiteles, who wrote five books on *Opera nobilia* in the first half of the first century B.C. One of his disciples was Stephanos; among his creations was the classicistic statue of an athlete (fig. 13.3) of which seventeen replicas are in existence.

These examples are not unique. For many of them it cannot be ascertained whether they date from the late Republic or the early Augustan Principate, and that is precisely the issue. The Augustan Principate was in every respect "a binding link between Republic and Empire"; the formulation is Sir Ronald Syme's, albeit with somewhat different connotations.[5] Augustus was intent on avoiding any striking rupture and discontinuity. Instead, his goal was to continue Republican traditions amid innovation; innovation was based on the meaningful revival of such traditions. The phenomenon informs Augustan sculpture, too. It is impossible, therefore, in many cases to assign an archaizing or classicizing work to either late Republican or Augustan times, because it can belong to both. A representative example is a much discussed relief found in Ariccia near Rome (fig. 13.4). It represents the killing of Aegisthus by Orestes; Clytemnestra and Electra are companion figures. The point is that works in the archaic style were valued highly by the aristocratic Republican collectors, the very *nobiles* without whom Augustus could not or would not govern.

Household furnishings from the villas of the *nobiles* of the second and first centuries before the onset of Augustus's reign convey the same message: classicizing and archaizing decor was in great demand.[6] Marble candelabras are a case in point: the relief decoration is typically eclectic in terms of style. Archaic, classical, and Hellenistic elements are mixed, as on an example found at Praeneste and dating from the last quarter of the second century (fig. 13.5). The same is true of marble craters, such as one attributed to Sosibius (ca. 50 B.C.): two deities, Mercury and Diana, who are rendered in the archaic style, are leading two groups with other, non-

archaizing figures, toward an altar (fig. 13.6). This mixture of styles and, in literature, genres, was typical of the Augustan age, too.

The transition to Augustan classicism proper was a differentiated process. Its individual steps or characteristics may be summarized as follows:

(1) Augustan sculpture used the classical/classicizing and archaic/archaizing idiom esteemed by the Republican aristocracy.

(2) Whereas Republican aristocrats had increasingly appropriated much of this art for their private realms, the Augustan endeavor was to restore all such art to the public domain, *res publica*. Agrippa announced this programmatically in one of his speeches: private collections were to be given back to the public instead of languishing in the "exile of villas" (Pliny, *HN* 35.26). Like so much else in the Augustan program, this was a call for the restoration of true Republican values; similar pleas had been voiced by the elder Cato and by Cicero (who did not actually dispose of his collection in this manner). Pollio, by contrast, was intent on making his collection (which, incidentally, was not limited to Hellenistic showpieces) *res publica*, while Cicero polemically exploited Mark Antony's failure to do so. Another dimension of this effort was the Republican tradition of using mostly classical or classicizing statuary for the cult images in the temples. These various factors lie behind the emphatic use of the classicizing and archaizing styles for the new public monuments of the Augustan age. The placement and, therefore, the actual function of the sculptures were important; "classical" is not simply an immanent, absolute quality that transcends any limitations of context.

(3) Since the classicizing/archaizing style was adopted for works of art, such as the Prima Porta Augustus and the Ara Pacis, that express ideas and values, it acquired—or recovered—dimensions beyond the aesthetic and material ones it had in the private villas. In Augustan art, a limited number of almost emblematic subjects and scenes was carefully chosen to be repeatedly expressed in this style. Grandeur of meaning, therefore, was restored to grandeur of form.

(4) An additional aspect—and all these characteristics are connected with one another—is the complementing of the sophisticated stylistic eclecticism (exemplified by a neoclassical statue with a Myronian head, Praxitelean arms, and a Polycleitan chest; *Auct. ad Her.* 9) that was mostly aesthetic with an equally sophisticated eclecticism of rich and meaningful associations. A paradigm is the much discussed deity on the southeast relief of Ara Pacis. She is deliberately polysemous and her iconography incorporates allusions to Venus, Pax, Ceres, and Tellus. And she is connected in various meaningful ways to the other mythological and historical reliefs of the Altar.

(5) The Ara Pacis also illustrates that eclecticism and the utilization of *all* Greek traditions were essential to Augustan classicism. On the Aeneas relief (fig. 13.7), for instance, the figure of Aeneas is represented in the

early classical manner, while the drapery of his legs recalls late Hellenistic models, and the setting is one familiar from Hellenistic landscape reliefs.

(6) A corollary of this deliberate selection and combining of traditions, genres, and styles is that art and poetry become more reflective and even self-reflective. Hence their intensified inner dimension (*Verinnerlichung*). For the *Aeneid*, Richard Heinze expressed this characteristic with the sort of pithy precision that marks it at once as not being a product of the current Vergilian interpretation industry: "What occurs in the *Aeneid* is, when looked at from the outside, rather the same as in the *Iliad* and the *Odyssey*. The deeper difference between the two actions is based on Vergil's shifting the emphasis, much more decisively than Homer, from external to inner processes, from the physical to the mental."[7] Paul Zanker has aptly characterized the same phenomenon in Augustan art as "contemplative image" (*Andachtsbild*).

Like Augustan culture in general, Augustan art was universal. Even sculpture, therefore, included a strong Hellenistic component. The sculptural decoration of the Sosius's Apollo Temple (30–20 B.C.) exhibits the resultant, typical mixture of styles. The pedimental figures, which depicted Theseus's Amazonomachy and could be viewed at eye level from the Theater of Marcellus, were transplanted from a fifth-century Greek temple. One part of the interior frieze represented Octavian's battles against the Illyrians and Pannonians in the Hellenistic manner. It was complemented by the subsequent triumphal and sacrificial procession in a "more matter-of-fact narrative style."[8] The cynosures of the late Augustan reign were the temples of Castor (A.D. 6) and Concordia (A.D. 10); if more had remained of them, our evidence for Augustan artistic and architectural tendencies would be considerably enriched. A study of the remains of the architectural ornamentation of the Castor Temple led Strong and Ward-Perkins to emphasize the "very great variety and the extraordinary amount of detailed experiment that took place within the broad framework of conventional architectural practice."[9] A relief that wound up in the Palazzo Ducale in Mantua may have belonged to this temple; the fragment represents a battle of Romans and Gauls and owes much to Hellenistic traditions (fig. 13.8). Further Augustan examples in this tradition include the portraiture of Agrippa—leading in some cases to a confusion of some of his portraits with those of Mark Antony—and Hellenistic victory trophies in the Pergamene style, though they are appropriately Romanized by virtue of including religious symbols. Finally, Augustus's programmatic Victoria in the Curia Iulia was an early Hellenistic statue from Tarentum.

Augustan architectural classicism, even more obviously than its counterpart in the arts, was not simply a return to the classical architecture of fifth-century Athens but a deliberate and variable *mixtum compositum* of different styles and traditions. It is remarkable in this context that in contrast to the

Pergamene revival of Athenian classical architecture, Augustan architecture generally avoided the Doric style, the paradigm of noble simplicity and quiet grandeur. In this regard the Temple of Mars Ultor was not the counterpart of the Parthenon, although Vitruvius explicitly recommended the Doric order as being the appropriate one for temples of Mars (1.2.5). My hypothesis is that there were enough antique shrines in Rome, which Augustus studiously restored to their original state, and therefore there was no need to resort to the most ancient of the Greek orders. Quite the contrary: the new Augustan temples, such as that of Concordia, were remarkable for their almost extravagant *magnificentia*, as evidenced by remains of the entablature. This is a manifestly different classical style from that of fifth-century Athens.

The Forum of Augustus is an intentional showcase of these tendencies. There are deliberate citations of fifth-century Athenian architecture. Some of the column capitals that were found in the Forum are modeled on those of the Erechtheum. The bases of the outer columns of the Mars Ultor Temple suggest that the architects looked very carefully at those of the Propylaea.[10] More obvious and more elevated, in every meaning of the word, is the most famous reminiscence of the Acropolis, the Caryatids in the upper story of the porticoes (fig. 13.9). They were virtual replicas of those of the Erechtheum, except that they were not freestanding. The Erechtheum had been associated with a number of ancestral cults, and the tomb of Cecrops, Athens's legendary first king, was at one of its corners. Similarly, the Caryatids of the Augustan Forum accompanied, in the upper story, the statues of the Roman ancestors, beginning with Rome's mythical first king, who were displayed at the ground level of the colonnades and the exedrae.

We have to look only at the relief decoration between the Caryatids to realize that the Forum's framework of reference included much more than the Acropolis and fifth-century Athens. That is, of course, the shields with the heads of Jupiter Ammon. They continue the association with Alexander the Great that was manifest throughout the Forum. Two large canvasses by Apelles were one of its chief attractions, as we know from Pliny (*HN* 35.27 and 93 f.). One depicted him with the goddess Victoria—who was, I would add, the quintessential deity of Augustus, much more so than Apollo—and with the Dioscuri. The other showed him riding triumphantly in his chariot, paralleling the statue group of Augustus in his quadriga. Augustus also had two statues placed in the Forum that had been used as poles for Alexander's tent in Alexandria (Pliny, *HN* 34.48), and the monumental statue in the so-called "Room of the Colossus" at the rear of the north exedra may have been that of Alexander before the head of Augustus was placed on it at the time of the perceptive Claudius. In the context of world domination, which the Augustan Forum conveyed so powerfully, the image of Alexander, the world conqueror, was more compelling than that

of Pericles. In typically Augustan fashion, there were multiple reasons for this association, including the young age at which both men entered on the stage of history and the Alexander *imitatio* during the Republic. Not that Athenian democracy would have been a deterrent to an association with Pericles, given Thucydides' famous dictum that Athens under Pericles was a democracy in name, but in reality was ruled by one man. The true Augustan counterpart to Athenian "democracy" was, as Walter Eder has recently put it, "his striving to have as many citizens as possible participate in the life of the state. [This] represents a common characteristic of Augustus' religious policy, his building program, and his support of the arts."[11]

The essential point is, once more, that neither of these inspirations— fifth-century Athenian and what we now call "Hellenistic"—were considered mutually exclusive in Augustan culture. Nor were they compartmentalized from each other, let alone in the rigorous fashion that is sometimes posited especially in scholarship on Augustan art. Instead, there was a constant blending. There are further examples from the Forum Augustum alone, such as the typically experimental capitals with Pegasoi (fig. 13.10). The style of their manes is late archaic, while that of the acanthus leaves is late classical. Their wings end in imaginative acanthus shapes reminiscent of the fantastic vegetal creatures that populate Augustan wall paintings. The Caryatids, as we have seen, recall the Acropolis, and the shields, Alexander. Taken jointly, they are also an allusion to Alexander's hanging shields from the epistyle of the Parthenon after the battle of the Granicus. The configuration of the Forum had its predecessors in Hellenistic temple squares. An intermediary in Rome was the Porticus Metelli, rebuilt by Augustus as the Porticus Octaviae (fig. 13.11).[12] The Porticus Metelli enclosed the first marble temple in Rome, that of Jupiter Stator, built by a Greek architect, and twenty-five bronze equestrian statues by Lysippus of Alexander and his companions at the battle of the Granicus were the prize exhibit in the portico's extensive sculpture gallery.

Overall, therefore, the Augustan Forum was meant to bring together, in both its architecture and in its sculptural and pictorial decoration, many Greek and Roman traditions. Fifth-century classicism is only one of these and operates within this much larger context. The Forum was intended to represent the *imperium Augustum*, the more complete heir to Alexander's *oikumenē*. Rome was shown to be an all-encompassing cultural power and not just the successor of Athens. Of the Athenophilia practiced by the Attalids there is no trace in this Augustan classicism, which was conceived much more broadly.

There was an instance of reciprocity of sorts, though it was probably not received too warmly by the Athenians whose relations with Augustus were not the smoothest anyway. I am referring to the reconfiguration of the Athenian Agora in Augustan times. The placement of the Odeion and of a temple,

which had been transplanted from another location in Attica, in its midst made it resemble the Porticus Octaviae, but amounted to curtailing the open space reserved for traditional civic activities (fig. 13.12). Moreover, the new temple was dedicated to Ares, and its function as counterpart of the Mars Ultor Temple is suggested even more by an Athenian inscription, from the Theater of Dionysos, to the "new Ares," Gaius Caesar, with whom Augustus had inaugurated the Temple of Mars Ultor in the Forum of Augustus.[13] The Agora in Athens thus acquired, even if not *in toto,* the character of a dependency on the Augustan Forum in Rome. The contrast between this forcible restructuring and the Stoa of Attalus, which accommodated itself readily to the Agora's function and layout, could not be more striking.

The posited dichotomy between classicism, including archaism, and Hellenistic tendencies finds no support in Augustan poetry. Instead, that medium provides another illustration that eclecticism and the utilization of all Greek traditions, including especially the Hellenistic one, are essential to Augustan classicism. Augustan classicism is "classical" in the sense that it does not follow only one model, but chooses the best and most suitable characteristics from a variety of traditions, styles, and genres. It then recombines them and adapts them to achieve a yet more complete, surpassing work of art or poetry. This is as true of the Prima Porta Augustus and the Ara Pacis as it is of the poetry of Vergil, Horace, and Ovid.

It is in this context that Athenian fifth-century poetry, tragedy in particular, was adapted in Augustan poetry. With infrequent exceptions, such as Varius's *Thyestes,* there was no formal counterpart to Athenian drama. Instead, Attic tragedy became part of a much broader and universalizing synthesis. Let me illustrate this with a brief reference to the *Aeneid.* What is typical of the *Aeneid,* and of other aspects of Augustan culture too, is that it incorporates a classical model, in this case Greek tragedy, more in spirit than in form. The first seven lines of the epic are an exquisite commingling of the main themes of the *Iliad* and *Odyssey* with a new Roman orientation. Only then comes the invocation to the Muse (1.8–11), and it centers squarely on a cardinal theme from Greek tragedy: the question of divine justice and deserved or undeserved human suffering. This is followed (up to line 296) by a device also taken from Greek tragedy—an exposition and anticipation of the action by means of a prologue. A further consequence is that, just as in Greek tragedy, the outcome is known, and the hearers' attention after the prologue can be focused, not on the externals of the plot, but on the real drama: the motivations and psychology of the characters, their emotions, dilemmas, and inner conflicts. That is the underlying reason for Vergil's many "borrowings" from the Greek tragedians, including, most famously, in the Dido episode. There was more than an aesthetic aspect to it. Aristophanes merely expressed the *vox populi* in the *Frogs* when he emphasized the role of the tragic poet as a moral educator of the city, and

the *Aeneid* and the *Oresteia*. for instance, can certainly be compared in terms of being, in the words of Philip Hardie, "both highly public works of literature which seek to validate a social and political order."[14] Suffice it to say that this is a commonality of these two works, but not their only dimension.

There is another poetic text that illustrates the nuanced character of the resonances of fifth-century Athens in Augustan Rome. It concerns the unusual emphasis that Horace puts, in the *Ars Poetica* and, especially, in the *Letter to Augustus,* on the state of Roman drama and on Attic drama. In his comparison of Greek and Roman culture, he clearly has the fifth century in mind (*positis bellis; Epist.* 2.1.93), and he ascribes its vitality and versatility to *paces bonae* (101). These are the same conditions as in Augustan Rome, but there is no flowering of drama there. The condition of the Roman theater, as Horace goes on to detail it, is a sorry one. It is backward—it has not gotten past Plautus; if anything, it has regressed in sophistication and artistry. The only progress that has been made is in the area of material opulence. The shows now are replete with chariots, bears, camels, and even the proverbial white elephant. The double tide of materialism and traditionalism is an impediment to any achievement in tragedy and comedy.

Different reasons have been suggested for Horace's insistence, which, incidentally, should not be confused with any eagerness on his part to write drama. To these reasons I would add, as deep background, the cultural competition between fifth-century Athens and Augustan Rome. The theater was one area in which Augustan Rome did not surpass its occasional model. Sociologically and demographically, of course, Augustan Rome could not simply replicate fifth-century Athens and all its forms of public culture. But so far from being anti-Augustan or oppositional, Horace's lament exemplifies the typically Augustan tendency not to stand still, but to identify further challenges, and to engage in ongoing quests. What comes to mind, with regard to the fifth century, is the characterization, in book 1 of Thucydides, of the Athenians by the Corinthians in very similar terms. For reasons like these, there can be no doubt that Augustan Rome perceived itself to be similar, in some ways, to fifth-century Athens. The articulation, however, of these affinities on the part of the Augustans is neither as straightforward nor as one-sided as is often assumed.

Instead of the poetic forms of classical Athens, it was those of archaic and Hellenistic Greece that figure prominently in Augustan poetry. As always in Roman poetry, such "receptions" are creative and interact with Roman elements and traditions. The resulting synthesis is Augustan "classicism." Fittingly enough, the *sphragis* of Horace's first collection of *Odes, carmen* 3.30, is an excellent paradigm. Since I have discussed the poem in detail from this aspect elsewhere,[15] it suffices to concentrate on a few of its key tropes.

Exegi monumentum aere perennius: there are reminiscences here of Pindar, Bacchylides, and Simonides, and, of course, both Greek and Roman tomb

inscriptions and epigrams. *Exigere* has the strong connotation of careful craftsmanship in the tradition of Hellenistic poetry (cf. Prop. 3.1.8). As for Roman *Realien*, the largest tomb monument at the time was the mausoleum of Augustus, itself a mixture of multiple inspirations: Hellenistic, Roman, Etruscan, and even Troy.[16] It would guarantee its occupant, the *princeps* who rose from a humble family, the immortality that Horace's poetry would give him, who

> ex humili potens
> princeps Aeolium carmen ad Italos
> deduxisse modos.
>
> (lines 12–14)

Deducere ("spinning finely") again is an operative term for the special quality of Hellenistic poetry; archaic Greece (*carmen Aeolium*), Italy, and Hellenistic Greece are synthesized in one breath. To return to *aere perennius:* the special backdrop to this phrase in Augustan Rome was the ever-increasing number and size of honorific inscriptions, usually with the full titulature of the still living honoree, that were made of bronze letters inlaid or affixed to the stone surface.[17] They would be exposed to the edacity of the elements indeed.

The coalescence of Greek and Roman continues throughout this poem, which is a Hellenistic *sphragis* as well as a bow to the *archipoeta* on the Roman side, Ennius. The means vary, a good example of Horace's typical avoidance of "aesthetic indigestion," in the apt phrase of N. E. Collinge. The rule, for instance, of the Apulian king Daunus, an emblem of old Italy, is expressed by means of the Greek genitive (11–12: *et qua pauper aquae Daunus agrestium / regnavit populorum*).

The last example of the Greco-Roman synthesis is the concluding image of the crowning of the poet (13–16):

> sume superbiam
> quaesitam meritis et mihi Delphica
> lauro cinge volens, Melpomene, comam.

It is the Delphic Muse who crowns him, but the imagery in the preceding lines suggests that the poet is also a Roman triumphator who deserves his laurels. For contemporaries of Augustus, there was an even more specific connotation. The laurels were his permanent emblem, granted to him in recognition of his achievements: "quo pro merito senatus consulto Augustus appellatus sum et laureis postes aedium mearum vestiti publice"—"for these merits of mine I was named Augustus by decree of the senate, and the door posts of my house were publicly adorned with laurel." There are good reasons for this coincidence between the concluding portion of the *Res gestae* (34.2) and the conclusion of Horace's *Ode* 3.30, which is itself the conclusion to the first collection of *Odes*. Both are the proud acknowledgment

of the reception of extraordinary honors because of extraordinary accomplishments. Horace, of course, did not have to wait for the publication of the *Res gestae;* the Augustan phrase no doubt mirrors the honorific terminology of 27 B.C., which must have become coinage as common as the proliferation of the laurel and the oaken crown as emblems in Augustan art, including coins. Once more, Horace presents himself as equal to Augustus, but the balance is finely spun. With almost tautological hyperbole he had announced at the beginning of the poem that his lyric poetry would be even more permanent than the mightiest edifices of rulers. Horace does not need to lessen Augustus to build himself up. On the contrary, his own permanence is bound up with that of Rome (lines 6–9), and he owes to Roman society and to Augustus his rise to being, in his own realm, the equal of Augustus.

Quite fittingly, therefore, the poem ends with a gift exchange. As a literary motif, gift exchange is found in Hellenistic epigrams. In contemporary actuality, it was a prominent means of communication between Augustus and the populace. On the occasion of the new year, for example, all segments of the populace contributed money to him. In contrast to modern politicians, he did not keep it for himself but used it for donations of cult statues for the various *vici* and *collegia*. A good illustration is found on a votive altar of the *collegium* of carpenters (fig. 13.13). On the occasion of the establishment of a new cult by this guild, Augustus contributed a votive statue, and the functionaries of the cult "respond with the dedication of a votive altar or yet another statue of a god or goddess. . . . This religious give-and-take created a direct link between ruler and *plebs*."[18] A pattern of exchange also inhered in the cult of Augustus in the Greek world.[19]

This programmatic ode by Horace is exemplary in its joining of the various traditions and art forms on which Augustan classicism was based. There is no trace of incompatibility, for example, of archaic and Hellenistic components, and for good reason. A primary concern of the Hellenistic poets and savants had been the rediscovery of the poets of archaic Greece. The Roman poets, in turn, came in contact with archaic Greek poetry through the mediation of Hellenistic culture. There was, however, an important difference. Tonio Hölscher has discussed it in connection with Hellenistic art,[20] but it applies to poetry, too. For the Greeks in Egypt, it was a matter of transferring and revitalizing their cultural heritage. For the Romans, "the oedipal mesh of anxiety which necessarily entangled Callimachus and his peers"[21] did not exist. They could be more distanced; for them, it was a matter of reception. The Augustan poets, artists, and architects could make synchronic use of a repertory of art forms and traditions that had developed diachronically. They had no classical period in Roman culture on which they could fall back or, just as important, by which they could be inhibited. The Augustans, then, were free to create their own *Klassik*. This is another reason why the so-called Augustan classicism was so vital and became normative.

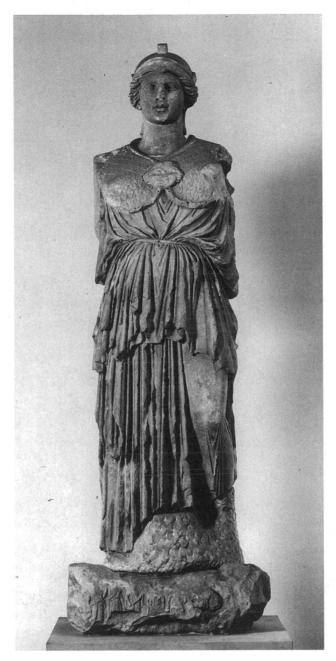

Figure 13.1. Colossal statue of Athena from Pergamon.
Ca. 175 B.C. Antikenmuseen, Berlin, inv. P116.

Figure 13.2. Head of cult statue of Fides. Ca. 58 B.C. Capitoline Museums, Rome. *Kaiser Augustus und die verlorene Republik*, exhibition catalogue (Mainz, 1988), fig. 116.

Figure 13.3. Athlete by Stephanos. Ca. 50 B.C. Villa Albani,
Rome. Alinari / Art Resource, New York, 27564.

Figure 13.4. Orestes killing Aegisthus. Marble relief, late Republican or early Augustan. Ny Carlsberg Glyptothek, Copenhagen, cat. no 30. Museum photograph.

Figure 13.5. Marble candelabra base with the god Dionysos. 125–100 B.C. Museo Archeologico, Palestrina. Photograph by Barbara Malter.

Figure 13.6. Marble crater by Sosibios. Ca. 50 B.C. Louvre, Paris, inv. MA442. Photograph by Patrick Lebaube.

Figure 13.7. Aeneas's arrival in Latium. Ara Pacis Augustae, Rome. Alinari / Art Resource, New York, Anderson 2021.

Figure 13.8. Late Augustan relief with battle between Romans and Gauls. Palazzo Ducale, Mantua. Alinari / Art Resource. New York, 1880s.

Figure 13.9. Caryatids framing a shield with the head of Jupiter Ammon. Forum of Augustus, Rome. Fototeca Unione 3562.

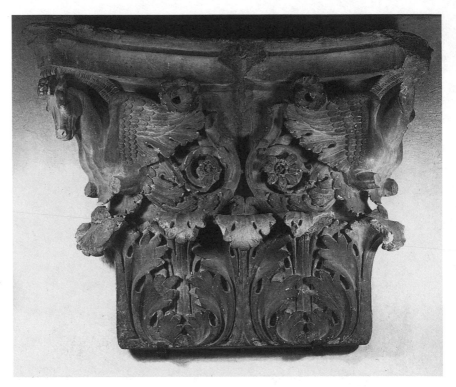

Figure 13.10. Column capital with Pegasus head. Forum of Augustus, Rome. Photograph by Gisela Filtschen-Badura.

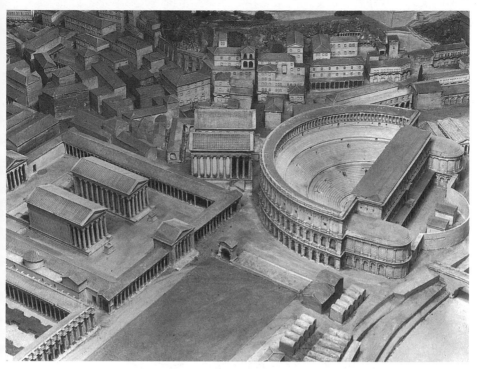

Figure 13.11. Porticus Octaviae and Theater of Marcellus, Rome. From the model of the city of Rome in the Museo della Civiltà Romana, Rome. Photograph by Barbara Malter.

Figure 13.12. Model of the Athenian Agora with Odeion, Temple of Ares, and Stoa of Attalos. Photograph by the American School of Classical Studies, Athens, Agora Excavations, neg. 86–586.

Figure 13.13. Votive altar of a carpenter guild: Augustus presents a cult statue. Capitoline Museums, Rome, inv. 1909. DAIR 50.45.

NOTES

This chapter is based, in great part, on a lecture given at the universities of Freiburg and Cologne and at the Free University of Berlin in June 1994. I am grateful to the audiences for various suggestions. The topics addressed here are discussed at greater length in my book *Augustan Culture* (Princeton, 1996), esp. chapter 7, where detailed documentation can be found.

1. See the entries in J. J. Pollitt, *The Ancient View of Greek Art* (New Haven, 1974). It is problematic to consider these terms as expressing "moralische Werte," as is done by P. Zanker, *Augustus und die Macht der Bilder* (Munich, 1987), following H. Jucker, *Vom Verhältnis der Römer zur bildenden Kunst der Griechen* (Frankfurt, 1950). It is even more problematic to translate the phrase into English as "moral values"—to say the least, "moral" here is rather distinct, e.g., from Augustus's "moral" legislation. In essence, the terms are valuations of quality; cf. the judicious discussion by F. Preißhofen, "Kunsttheorie und Kunstbetrachtung" in H. Flashar, ed., *Le classicisme à Rome aux I^{ers} siècles avant et après J.C.*, Entr. Fond. Hardt 25 (Geneva, 1979), 263 ff. For some stimulating observations, see also T. Hölscher, *Römische Bildsprache als semantisches System* (Heidelberg, 1987).

2. It should be communicated to posterity that Peter Green's original subtitle of his *Alexander to Actium* was "An Essay on the Historical Evolution of the Hellenistic Age." According to apocryphal tradition, the word "essay" was taken out after some of his colleagues alerted our graduate students that their essays henceforth would be expected to run to about 1,000 pages.

3. H. G. Martin, *Römische Tempelkultbilder* (Rome, 1987).

4. Cf. R. R. R. Smith, *Hellenistic Sculpture* (London, 1991), 258 ff.; J. J. Pollitt, *Art in the Hellenistic Age* (Cambridge, 1986), 164 ff.; D. E. E. Kleiner, *Roman Sculpture* (New Haven, 1992), 29 ff.

5. Sir Ronald Syme, *The Roman Revolution* (Oxford, 1939), vii, where he uses it with reference to "the composition of the oligarchy of government." It is interpreted more widely by W. Eder in his essay of the same title on the evolutionary nature of Augustus's reign in K. Raaflaub and M. Toher, eds., *Between Republic and Empire* (Berkeley and Los Angeles, 1990), 71 ff.

6. For collections and discussions of the materials see, e.g., H.-U. Cain, *Römische Marmorkandelaber* (Mainz, 1985); R. Cohon, "Greek and Roman Stone Table Supports with Decorative Reliefs" (diss., New York Univ., 1984); D. Grassinger, *Römische Marmorkratere* (Mainz, 1991); C. F. Moss, "Roman Marble Tables" (diss., Bryn Mawr, 1989).

7. Richard Heinze, *Virgils Epische Technik*, 3d ed. (Leipzig and Berlin, 1915), 281.

8. Kleiner, *Roman Sculpture* (cit. n. 4 above), 86.

9. D. Strong and J. Ward-Perkins, "The Temple of Castor in the Forum Romanum," *PBSR* 30 (1962): 28.

10. Details in B. Wesenberg, "Augustusforum und Akropolis," *JdI* 99 (1984): 161 ff.

11. Eder (cit. n. 5 above), 118 f.

12. See H. Kyrieleis, "Bemerkungen zur Vorgeschichte der Kaiserfora," in P. Zanker, ed., *Hellenismus in Mittelitalien* (Göttingen, 1976), 431 ff.

13. *IG* II. 3250. Good details in G. W. Bowersock, "Augustus and the East: The Problem of Succession," in F. Millar and E. Segal, eds., *Caesar Augustus: Seven Aspects* (Oxford, 1984), 171 ff. Cf. also T. L. Shear, "Athens: From City-State to Provincial Town," *Hesperia* 50 (1981): 356 ff.

14. Philip Hardie, "The *Aeneid* and the *Oresteia*," *PVS* 20 (1991): 29. Cf. now id., "Virgil and Tragedy," in C. Martindale, ed., *The Cambridge Companion to Virgil* (Cambridge, 1997), 312–26.

15. Galinsky, *Augustan Culture*, 350–55.

16. H. von Hesberg and S. Panciera, *Das Mausoleum des Augustus* (Munich, 1994), and R. Holloway, "The Tomb of Augustus and the Princes of Troy," *AJA* 70 (1966): 171 ff.

17. See G. Alföldy, "Augustus und die Inschriften: Tradition und Innovation," *Gymn.* 98 (1991): 293 ff.

18. P. Zanker, *The Power of Images in the Age of Augustus* (Ann Arbor, Mich., 1988), 134.

19. See S. R. F. Price, *Rituals and Power: The Roman Imperial Cult in Asia Minor* (Cambridge, 1984), 65 f., 173 f.

20. "Römische Nobiles und Hellenistische Herrscher," in *Acts of the 13th Int. Congress of Class. Archaeology* (Berne, 1990), 73 f.

21. D. Feeney, "Horace and the Greek Lyric Poets," in N. Rudd, ed., *Horace 2000: A Celebration* (Oxford, 1993), 55.

The Founding Mothers of Livy's Rome

The Sabine Women and Lucretia

Elizabeth Vandiver

Over thirty years have passed since M. J. Cousin pointed out the crucial role of women in book 1 of Livy's *Ab urbe condita* and suggested that further study of the topic could prove fruitful.[1] Little attention had been paid to Livy's women before that time; since then, a great many articles and even a few books dealing in whole or in part with various aspects of female characters in Livy's work have in fact appeared.[2] However, most of these studies have treated women either as purely symbolic representations of abstract concepts (Lucretia in particular has been seen as a symbol of *libertas,* of the *res publica* and of *virtus,* and of course especially as an example par excellence of *pudicitia*) or in terms of the effects their actions (including their deaths) have on the male protagonists of the various stories.[3]

This chapter will treat women in the crucial first book of Livy's history as subjects in their own rights, as actors in the dramas of their stories, not as effects on male actors and not simply as two-dimensional symbolic equivalents of broad concepts.[4] To be sure, the stories of women have important symbolic or—better—thematic functions; but these can be fully appreciated only when the autonomy of characters such as the Sabine women and Lucretia is recognized.

Any attentive reader will surely notice Livy's use of individuals and themes as exempla and paradigms. Scholarly interest in this aspect of Livy's narrative technique has increased greatly in recent years, resulting in a considerable bibliography on Livy's adaptation of his sources to provide exempla, paradigms, and thematic patterns.[5] Of course, Livy relied on earlier writers for many of his facts, but as Gary Miles says, "even if we concede that most of the themes and many of the details in Livy's account are derived from his sources, it is nonetheless clear that Livy imposed his own shape on that material and gave it its own meaning."[6] Nowhere, perhaps, is this more

clear than in Livy's account of the legendary beginnings of Rome in book
1. This chapter examines the "shape and meaning" that Livy imposed on
the stories of the Sabine Women and Lucretia, and then considers some of
the possible implications these stories and their particular form may have
for our understanding of Livy's method in the context of his own time.

Certainly, Livy did not invent the stories of memorable women in book
1; but he placed those stories carefully to enhance certain themes and ideas.
Given the extremely rich narrative material of book 1, it would obviously be
an exercise in futility to claim to have discovered "the" theme of the book;
but one important theme that has not been widely discussed is the necessity
of balancing the public and private spheres and the extreme difficulty of so
doing.[7] In order for Roman society to be founded in the first place, to over-
come the unjust rule of the kings, and to thrive in the long run, the citizens
had to find an *aurea mediocritas* between their private affections and desires
and their public loyalties. Such an idea no doubt had long been a com-
monplace for men. The conflict of men's public and private duties and
affections, and the underlying premise that the state's needs must take
precedence over the masculine individual's desires, is a standard Greek
topos, enunciated by such diverse characters as Hector, Thucydides' Pericles,
and Plato's Socrates.[8] But Livy enlarges this time-honored model and makes
it characteristically Roman by attributing the same conflict of responsibili-
ties to his female characters. From the very beginning of Rome's history,
Livy's narrative thus suggests, Roman society recognized that women, no
less than men, must make moral decisions about public as well as private
matters, and that society will benefit from women whose moral character is
strong enough to make appropriate choices.

Throughout book 1, women are powerful figures in the formation and
survival of the Roman state; their decisions about the proper balance and
relative importance of the private and the public spheres, and their actions
based on those decisions, have profound results for the young city, for ill as
well as for good. Livy uses women's stories in the first book to demonstrate
both positively and negatively the necessity of control, courage, and *pietas*.
In their very different stories and through their very different characters,
the women of book 1 (the Sabines, Tarpeia, Horatia, Tanaquil, the two Tul-
lias, Lucretia) all indicate more vividly than would any direct statement of a
moral principle the idea that the newly fledged *res Romana* will flourish only
if its women no less than its men exercise self-control and self-motivated
courage and patriotism.[9] These women do not by any means wait for their
men (husbands, fathers, or brothers) to tell them what to do; in fact, one of
their most noticeable shared characteristics is that they all act on their own
initiative, at times against the direct advice of men.[10] Through the stories of
these women, Livy examines the possibility of conflict between women's
personal desires and affections and the good of the nascent *res Romana* from

every possible angle.[11] This chapter discusses the first and last appearances of this theme: the story of the Sabine women's abduction by their soon-to-be husbands, and the rape and subsequent suicide of Lucretia.

These two episodes, which open and close Livy's treatment of women in Rome,[12] form a ring composition (to use a term that has fallen somewhat out of fashion) in Livy's narration of Rome's development under the kings. This ring composition is both conceptual and formal: conceptual, since Roman society could not begin in any real sense without the valor of the Sabine women, and the Republic could not begin without the valor of Lucretia; formal, since the two stories exhibit strong structural parallelism, which—surprisingly enough—apparently has not been remarked previously.[13] This parallelism consists of a series of scenes that are markedly similar in narrative form; indeed, on the most superficial level, the two narratives are variations of the same basic story. In this basic story, men (or a man; but for simplicity I shall use the plural) seize women for sexual purposes, using surprise and superior physical force to subdue the women. The men then persuade the women to agree to sexual intercourse. After they have had sex with the men, the women initiate a confrontation with their male relatives (husbands and fathers). This confrontation includes the women suggesting their own death. The aftermath of the story is the formation a new type of society.

Clearly, when the narrative structure of the two episodes is thus stripped to its bare bones, a remarkable degree of similarity emerges. But no less remarkable is the difference that appears in the episodes' overall content as they flesh out this narrative skeleton. In fact, the two stories are in many ways opposites, as can be seen by even the quickest examination: the Sabines are unmarried women; Lucretia is a *matrona*. The Sabines are abducted for the purpose of marriage; Sextus attacks Lucretia despite her marriage. Romulus persuades the Sabines to accept marriage with the Romans by pointing out the honorable benefits they will gain; Sextus persuades Lucretia to stop resisting him by pointing out the dishonor that he can cause her if she refuses. The Sabines offer to die at the hands of their husbands and fathers; Lucretia does die at her own hand. The Sabines act against their husbands' and fathers' will by interposing themselves between the two armies; Lucretia acts against the will of her husband and father by refusing to continue living.

Obviously, these two episodes are related to each other in a complex and intriguing manner. In order to bring out both the similarities and the differences of the two stories, I shall consider each of the following points in greater detail: (1) the men's motivation for seizing the women; (2) the type of sexual relations that result; (3) the type of persuasion that the men use, and the reason for the women's reaction; (4) the reason for the women's confrontation with their male relatives; (5) the women's reason for offering to die, and why they do or do not follow through on it; (6) how the women's experiences lead to a new form of society.

MOTIVATIONS AND RESULTS

The first two points can best be discussed together, since the type of sexual relationship that results in each case is closely bound up with the men's motivations for seizing the women. The traditional English usage of the word "rape" to refer to both stories has obscured the fact that there are profound differences between the situations faced by the Sabines and by Lucretia. As noted already, the Roman men abduct the Sabine women for the purpose of marriage, but Sextus assaults an already married woman. Clearly, the Sabine women are *abducted* against their wills, but Livy does not ever state that they are actually raped. Indeed, I believe a careful reading of Livy's account of the Sabine women shows that they were *not* forced to submit sexually to the Roman men after their abduction, but that their consent was essential for the fait accompli of their marriages to have moral validity.[14] This difference between the Sabines' experience and Lucretia's is crucial for understanding the role that these two episodes play in the overall effect of Livy's first book. Lumping the two together as "rape" stories diminishes our understanding of women's importance as autonomous actors in both stories and undermines the horror of Lucretia's experience. English-speaking readers must not be misled by the fact that the English word "rape" is derived from the Latin verb *rapere;* the Sabine women are called *raptae,* but this means "stolen" or "abducted" women, not rape victims.[15] A brief discussion of Livy's terminology should help to explain why I believe that the Sabine women were not raped.

Classical Latin apparently did not have a word corresponding precisely to the modern English "rape" in the sense of violent sexual assault against an unwilling victim, but the Latin word that comes closest to expressing this concept is *stuprum.* This is the word used to describe Sextus Tarquinius's crime against Lucretia; it is not used in reference to the Sabine women.[16] And here we must consider the motivations of the men in the two stories. The Romans desire the Sabines, not so much for their own personal attractions but rather for the formation of a city: Rome cannot exist in any lasting manner without the stable citizen body provided by recognized marriage and the resulting progeny.[17] In fact, the text strongly implies that there were two steps necessary for the true founding of Roman society: first, the creation of senators (called *patres* [1.8.7]) and second, the acquisition of actual *matres* through the abduction of the Sabine women.[18] Before acquiring wives, the Romans are called *populus turba omnis* (1.8.6), *Romana pubes* (1.9.6), and *iuventus Romana* (1.9.10); Romulus's new citizens only become *viri*—in the sense of men as well as of husbands—when they acquire wives.[19] An essential quality for a Roman wife was *pudicitia,* chastity. In fact, this was "the virtue in women which corresponds to *virtus* in men."[20] Furthermore, *pudicitia* was precisely the virtue that women lost through illicit sexual intercourse,

including rape, as Lucretia herself says: "quid enim salvi est mulieri amissa pudicitia?" (1.58.7) Livy says nothing at all about the Sabine women's *pudicitia;* the word does not occur in connection with them. Arguments from silence are of course always dangerous, but given that *pudicitia* was an essential qualification for a Roman wife, and given that "raped women lose their *pudicitia,*"[21] it seems reasonable to assume that the Sabine women, sought out specifically as wives for the Roman men, were not raped by those men.

Thus far, my argument only shows that Livy does not present the Roman men's sexual intercourse with the Sabine women as rape from the *men's* point of view; one might still think that the *women* did perceive what happened to them as rape. But I think Livy in fact excludes this possibility as well. To explain why I think so, I must turn to my third point of comparison, the types of persuasion used by the men in each story and the women's reaction to their persuasion.

PERSUASION AND REACTION

Although Livy does not directly say when sexual intercourse between Romans and Sabines first took place, he certainly implies that the women themselves had to become consenting partners before the marriages were consummated.[22] At first, he says, the women were as outraged as their parents by the Romans' actions in abducting them, and had little hope: "nec raptis aut spes de se melior aut indignatio est minor" (1.9.14). It seems clear that the "hope" referred to here is hope of keeping their *pudicitia*, that is, of avoiding rape (*stuprum*). Livy continues: "sed ipse Romulus circumibat docebatque patrum id superbia factum, qui conubium finitimis negassent; illas tamen in matrimonio, in societate fortunarum omnium civitatisque, et quo nihil carius humano generi sit, liberum fore; mollirent modo iras et, quibus fors corpora dedisset, darent animos" (1.9.14–15)

These words do not threaten the women with *stuprum*. First, Romulus makes it clear that the point at issue is marriage, not illicit intercourse. And second, while it is true that the possibility of the women returning to their parents is not seriously entertained by the text, nevertheless the women's consent, in some degree at least, is presented as necessary. Romulus does not simply inform the young women that the Roman men are going to keep them whether they like it or not; he asks them to allay their wrath and accept their new position as necessary partners in the founding of the Roman state. Many scholars seem to agree with Patricia Joplin's implied assumption that the women were sexually violated first and only then married ("the women were . . . forced to consent to sex, marriage, and childbirth"), but it is surely more likely that the Roman men did not actually have sex with their Sabine wives until after the women had consented to marriage, since the consent of the bride *before*

the marriage was essential in Roman law and custom.[23] "The giving of consent gave rise to a marriage," Susan Treggiari observes.[24]

From a modern point of view, of course, "consent" given under such circumstances hardly qualifies as consent at all, as Joplin's statement that the women were "forced to consent" clearly exemplifies. However, it must be remembered that most marriages for most upper-class women in Livy's own day were arranged. As far as the relationship between bride and groom is concerned, the situation that the Sabine women have to accept is not really so radically different from that facing any young woman of good family. Gary Miles, who notes the similarities between the Sabines' marriage and the marriages of "Cicero's Tullia and Augustus' Julia," comments that the Sabines' story "provides a precedent and a sanction for such marriages of convenience."[25] This point is well taken, but the comparison need not be restricted to the daughters of powerful politicians; the Sabine women's experience was close to the standard experience of marriage of any upper-class girl, when the Sabines' situation is looked at purely from the *women's* point of view. They are taken from their parents, given over to husbands whom they know little if at all, and expected to participate willingly in sexual relations because of the needs of society for stable families and for children. Obviously, from the point of view of the Sabine *parents* this is a completely irregular marriage; but for the young women themselves, their position is perhaps even better than that of many young brides since, as Romulus himself tells them, their husbands will be especially careful to try to please them. Although the Sabine women undergo an abduction, their subsequent relationships with their husbands are no more rape (and, admittedly, no less rape) than those of any other Roman bride. They are therefore able to accept their new status and urge their parents to accept it as well, without loss of honor. When Romulus asks the young women to "give their hearts to those to whom Chance has given their bodies," he is in effect articulating the duty of every Roman bride from then on.[26]

In view of the story's development as a whole, it is ironic that Livy adds the information that the Roman men themselves claimed to have been motivated by personal desire: after Romulus puts the rational arguments for the marriage before the abducted women, the men themselves argue on the basis of "cupiditate atque amore, quae maxime ad muliebre ingenium efficaces preces sunt." Livy's authorial comment here, in which he employs the sexist commonplace that women can only react to and be motivated by appeals that touch (at worst) their personal vanity and (at best) their personal emotions and preferences, actually works against the clear trend of the rest of the story.[27] These young women are not, in fact, moved by personal preferences, as their actions in parting their warring husbands and fathers clearly show in a scene that gives the lie to this pseudo-psychology. I argue this point further below.

The Sabine women agree to sexual relations with their Roman husbands, Livy implies, once they have understood that they are being offered legitimate and honorable marriage. Lucretia's story could not offer a stronger contrast. Sextus Tarquinius desires Lucretia purely for his own pleasure and to satisfy his own lust.[28] He therefore tries to persuade Lucretia to put lust and personal desire before her duty and honor as a Roman *matrona*, but he is unsuccessful: "tum Tarquinius fateri amorem, orare, miscere precibus minas, versare in omnes partes muliebrem animum." When his attempts at persuasion fail, Sextus then forces Lucretia to submit by threatening her not only with death but also with extreme dishonor. Significantly, the reason for the different reactions of the Sabines and Lucretia does not lie in the means of persuasion initially used by the different men. As Livy describes Sextus Tarquinius's speech, his original arguments are very similar to the ones the Roman men addressed to the Sabine women's *muliebre ingenium*, and are intended to appeal to Lucretia's *muliebrem animum*. But the superficial similarity of the persuasive argument used in the two scenes—men excusing their forceful seizing of women on the grounds of *amor*—underscores the essential difference in the women's reactions, which are based on what the men in each story have to offer the women. The Romans can offer the Sabines great public good consistent with their personal honor, while Sextus can offer Lucretia only private pleasure inconsistent with her personal honor. The different reactions by the different women reiterate that private desire or pleasure is not an appropriate basis on which to act. The Sabine women are asked to become cofounders, and crucial ones, of a great city, and to do so through entering an honorable state, marriage; and although the possibility of their refusal is not directly addressed in the text, it seems implicit that they could, theoretically at least, have refused to moderate their wrath and to accept their role. I am not attempting to excuse or deny the violence of their abduction, but once that abduction is a fait accompli, the Sabine women are actors in their own rights whose consent is an important element in their story.[29] Lucretia, conversely, is asked to gratify a secret and private lust, and by doing so to dishonor her marriage and herself. Lucretia tries to refuse, but Sextus does not leave her this option; where the Romans used the violence of abduction as a means by which to offer the Sabine women the honorable state of marriage, Sextus enacts violence and dishonor upon Lucretia by using the threat of further violence and even greater dishonor.

CONFRONTATIONS WITH RELATIVES AND OFFERS OF DEATH

The next narrative points to consider are the reasons for the women's confrontations with their relatives and for their offers (whether fulfilled or unfulfilled) of their own deaths. In both stories, the women confront their

husbands and fathers in a pivotal scene that will decide the women's life or death. Of course, the outcomes are different in the two stories: the Sabine women live, and Lucretia dies. But it is important to realize that the different outcomes of the two stories do not depend on differing responses by the male relatives; in both stories, the fathers and husbands want their women to live. Nor does the difference in outcome depend on the women's moral guilt or innocence: in both stories, the women are good, decent, and blameless. Here again it is important to realize that the Sabine women were not raped; if they had been, then as good chaste Roman women concerned with their *pudicitia,* they should react as Lucretia does. And, if the Sabine women had been raped, then the Roman men would be the equivalents of Sextus Tarquinius in Lucretia's story. In actuality, however, the Roman men are the equivalents of Collatinus, Lucretia's husband; both stories deal with blameless women offering before their husbands and fathers to die if the good of society requires it. The difference in outcome depends on what has happened *before* the confrontation scene. Lucretia has been raped and dishonored; this pivotal scene of the Sabines' story makes sense only if they have *not* been raped.

The Sabine women's confrontation with their menfolk occurs when their fathers have attacked Rome and are fighting with the Romans who are now the Sabines' husbands. Those of the captured women who came from Caenina and Antemnae had already entreated Romulus's wife Hersilia until, *precibus raptarum fatigata,* she pled with her husband that the parents of these women should be allowed to join the Roman state (1.11.2).[30] Romulus graciously agreed; the only remaining stumbling block for the assimilation of the rest of the Sabines was the attitude of the Sabine fathers themselves.[31] When the Sabine men met their Roman sons-in-law in battle, the women rushed between the two armies to part them. Livy describes the women's actions, and his description merits quoting at length:

> Tum Sabinae mulieres, quarum ex iniuria bellum ortum erat, crinibus passis scissaque veste victo malis muliebri pavore, ausae se inter tela volantia inferre, ex transverso impetu facto dirimere infestas acies, dirimere iras, hinc patres hinc viros orantes ne se sanguine nefando soceri generique respergerent, ne parricidio macularent partus suos, nepotum illi, hi liberum progeniem. "Si adfinitatis inter vos, si conubii piget, in nos vertite iras; nos causa belli, nos volnerum ac caedium viris ac parentibus sumus; melius peribimus quam sine alteris vestrum viduae aut orbae vivemus." Movet res cum multitudinem tum duces; silentium et repentina fit quies; inde ad foedus faciendum duces prodeunt; nec pacem modo, sed civitatem unam ex duabus faciunt. Regnum consociunt: imperium omne conferunt Romae. (1.13.1–5)[32]

By interposing their own bodies between their warring husbands and fathers (an act requiring a degree of courage that Livy implies is unusual in women), the Sabine women risk their own lives to create the new society.[33]

The Sabines' courageous risk of their lives gives the impetus for the forma-
tion of a society that is finally, truly Roman: the seat of power is established
at Rome, the marriages are accepted by the Sabines' fathers, and the two
societies become one.[34]

Modern critics have tended to see both the Sabine women and Lucretia
as helpless and passive victims in these scenes in which the women propose
their own deaths.[35] I think that this view is profoundly mistaken and does
not do justice to the women's roles in the text; these women are actors and
agents in their own rights. It is true that Livy's underlying assumptions
about what is most to be desired—the continuance of Rome—conflict with
our own underlying assumptions and cherished beliefs; it is also true that
(of course) Livy places women within the context of a patriarchal system in
which their marriages are arranged and their chastity is of the utmost
importance. But, given the context in which Livy writes, I cannot agree with
those scholars who see Livy's women, especially the Sabines, as passive vic-
tims, who are then "blamed" by the text. Joplin, for instance, says that "Livy
records two contradictory versions of the story of the Sabine women's posi-
tion in Rome: first, they are abducted and raped, forced to consent to
marry; then they are said to identify themselves as the origin of violence
between men." She elaborates further: "[A]s if he had not written the pre-
ceding account of why and how the women were abducted and forced to
consent to sex, marriage, and childbirth with the Romans, Livy speaks of the
women with marvelous self-forgetfulness. . . . [T]hey can[not] be said in
any way . . . to bear primary responsibility for the 'strife' between their
fathers and their husbands."[36]

But in reality there is no contradiction, and Livy does not say that the
women are the cause or origin of the strife between the Sabines and the
Romans.[37] His words are, in fact, "quarum ex iniuria bellum ortum erat,"
"from whose injury the war had arisen," which surely indicates that the
women were themselves injured parties, not that they caused the injury.[38] A
wrong has been done to the Sabines, female and male both; the point of the
women's action seems to be precisely that they, as members of the injured
group and indeed the most immediately wronged parties, have the moral
authority to ask both husbands and fathers to stop fighting.[39] Their request
that the men "turn your anger against us" does not, as Joplin would have it,
indicate that the women themselves are "blaming the victim." Rather, they
are recognizing what for Livy is the crucial fact: that *adfinitas* now does in
fact exist between Sabines and Romans, that a link has been forged by the
marriage and through the Sabine women's offspring, and that it cannot
now be destroyed.[40] Whether the Roman and Sabine men like it or not, they
are now sons- and fathers-in-law, which (as any reader of Catullus 72 will
remember) was one of the strongest bonds in Roman society.[41] The women
themselves embody (literally and metaphorically) that bond; if the men

wish to destroy their own *adfinitas,* they can do so only by destroying the women who personify it. The women's words, in fact, serve as a kind of reductio ad absurdum; clearly they know that their fathers and husbands will not kill them—what would that serve?—and their passionate plea draws its force from the fact that although a wrong has been done, these women are the ones who suffered it most directly and therefore have most reason to be hostile; yet they are able to set aside their original emotions in consideration of the greater good of their new society and to form the emotions appropriate to their new status. At their words, Livy says, one city was made from two;[42] in other words, the Sabine women's fathers and husbands now acknowledge what the women have already recognized, that through the link of children, borne by these women, they already *are* one state. These women are hardly helpless victims; rather, this scene, with their central words, forms one of the crucial points at which it can be plausibly argued that Rome truly comes into existence as a *civitas.*[43]

The Sabine women's voluntary acceptance of their role as the *matres* of the Roman people is the essential condition for the emergence of this new *civitas.* Livy underscores the women's importance in the formation of Roman society by saying that their actions led Romulus to name the *curiae* for them: "Ex bello tam tristi laeta repente pax cariores Sabinas viris ac parentibus et ante omnes Romulo ipsi fecit. Itaque cum populum in curias triginta divideret, nomina earum curiis inposuit" (1.13.6).

The logical progression is clear: the women acted to preserve the honor of their families and to further the existence of Rome; their courage made peace between the warring Roman and Sabine men possible; *and so* (*itaque*) Romulus incorporated their names into the very fabric of his society.[44] The whole description reiterates the idea that these women were responsible agents who could have refused to accept their role as *matres.* Had they done so, Rome could not have continued to exist; their voluntary action to further Roman society explains the emphasis of the solemn tricolon "cariores . . . viris ac parentibus et ante omnes Romulo ipsi," which stresses that Romulus had most reason of all to feel grateful to the Sabine women.

Lucretia's confrontation with her husband and father is, of course, radically different in many respects. The Sabines interpose themselves between warring men on a field of battle and by their words and actions bring peace; Lucretia summons her menfolk to her house, normally an area redolent of peace, and by her words and actions causes war. Lucretia's father and her husband consider her blameless and entreat her to continue to live. But Lucretia's offer of death, unlike the Sabines', is not a rhetorical gesture intended to bring her men to their senses.[45] Rather, it is a carefully thought-out and necessary consequence of her situation. In her case, she explains, her life would no longer contribute to the greater good of society. If she continued to live after her rape, this would leave open the possibility that

other women could, in fact, willingly commit adultery and claim they had been forced, thus undermining the entire moral framework of marriage and by extension of society insofar as it depends on regulated and recognized forms of marriage for its continuance. Lucretia's death, however, will close off forever that avenue of self-justification by the unchaste.[46] By asking her to continue to live, Lucretia's men, whether they mean to or not, are asking her to put her affections (for them) and her personal desires (for life, children, etc.) before her duty to Rome. She therefore resists their pleas as firmly as can be imagined. In an extraordinary reversal of normally expected roles, the men plead on the basis of private, personal, familial affections, while the woman argues for the good of society as a whole.[47] She must die, Lucretia says: "ego me etsi peccato absolvo, supplicio non libero; nec ulla deinde inpudica Lucretiae exemplo vivet."[48]

This scene has puzzled readers from St. Augustine on; if Lucretia is blameless, why must she die?[49] And yet when Lucretia's story is read in the light of the overall theme of the relative claims of public and private duties, there is no reason for puzzlement. The blameless Lucretia dies for the same reason that blameless soldiers die, for the greater good of Rome.[50] If the public good of society requires it, all private desires, even that for life itself, must be subjugated to the *res publica*. Lucretia means exactly what she says. She is guiltless, but that is no longer the important point.[51] She realizes that she will forever serve as an exemplum for Roman women; and she refuses to allow for the possibility that anyone could cynically misuse her story as a negative exemplum. Her voluntary death shows, without equivocation, the possibility of self-sacrifice and courage on the part of private Roman citizens, female as well as male, when necessity requires it.[52] In this way, Lucretia serves as an exemplum for any one, male or female, faced with any situation of dire necessity, whether concerning a sexual transgression or not; when the state requires one's life, one must and can find the strength to give it.[53]

AFTERMATH

The results of the women's actions are closely parallel in the two stories. The Sabines' risk of their lives leads to the foundation of the Roman state; Lucretia's sacrifice of her life (although she cannot know it) gives the impetus for the foundation of the Republic. Thus in both stories, the women's courageous actions lead to the formation of a new type of society.[54] But the manner in which this happens is very different. The Sabines' unfulfilled offer of their own death *ends* the hostilities between their husbands and fathers and results in the foundation of Roman society, but Lucretia's actual death *begins* hostilities that will lead to the overthrow of the kings and the foundation of the Republic. Here again, the crucial difference lies in the type of

sexual relationship that the women have undergone in the story. The Sabines are joined in lawful marriage with all its honors and benefits and can therefore serve as agents who stop hostility and initiate peace. Lucretia, the victim of a violent rape, can only initiate the eventual peace of the Republic through further violence, both in her own death and the subsequent overthrow of the kings.

IMPLICATIONS

My analysis has shown various ways in which the stories of the Sabine women and Lucretia set up and reiterate the theme that women no less than men must be able to suppress their private emotions and deny their private desires—whether for life, for a marriage of their choice, or for any other personal *desideratum*—in the light of the public good. It remains to consider possible reasons for the development of this theme in Livy's work. At this point I shall turn from close analysis of Livy's text to admittedly speculative consideration of its context, and shall address the possibility that the women I have been discussing appeared not simply as exempla in general but as exempla directed toward a specific group of people and a specific set of problems.

In perhaps the most famous and frequently quoted passage of the preface, Livy says that he includes legends that can neither be confirmed nor denied, because he wants his readers to pay attention to what life and morals were like throughout the entire period of Rome's development, so that they can see how the decline of morals led to the state of affairs in his own day, when "nec vitia nostra nec remedia pati possumus perventum est."[55]

Sir Ronald Syme argues cogently against interpreting these famous words too narrowly as referring *only* to the moral reforms perhaps tentatively proposed in 28 B.C.[56] He is no doubt correct that these words do not refer only to sexual license and its remedies; however, it seems equally narrow to assume that Livy means only "a political crisis [phrased] in terms of morality."[57] Surely Livy's memorable and justly famous phrase refers to *vitia* of all types, political, sexual, and otherwise, and the *remedia* are, as Sir Ronald suggested, "order and concord," but in all areas of life, not just the political.[58] Catharine Edwards puts this well when she notes that for the Romans,

> The political and the moral were . . . overlapping categories. Issues which for many in the present day might be "political" or "economic" were moral ones for Roman writers, in that they linked them to the failure of individuals to control themselves. It was the weakness or perversity of individuals, their lack of self-control, on this view, which caused undesirable events. Problems could be solved only if individuals embraced virtue. Thus what now might be seen as . . . political problems were explained in terms of the ambition of individuals, economic ones in terms of their greed.[59]

Given this overlap between the political and the moral, the vices that book 1 illustrates so clearly as antithetical to the flourishing of Rome—greed, personal desires placed before the good of the state, unregulated sexual desire and unregulated affection—are all part of the *vitia* of Livy's own day.[60] Arguing in favor of this wider interpretation are the next few lines of the prologue, in which Livy tells us that he considers the chief benefit of the study of history to lie in its provision of examples to follow and to shun: "hoc illud est praecipue in cognitione rerum salubre ac frugiferum, omnis te exempli documenta in inlustri posita monumento intueri; inde tibi tuaeque rei publicae quod imitere capias, inde foedum inceptu, foedum exitu, quod vites."

It is not necessary to argue for restricting the *vitia* and *remedia* of the preface to Augustus's moral legislation of 28 B.C. (εἴ ποτ᾽ ἔην γε), but it seems very reasonable to assume that the overall moral state of Roman society that gave rise to that legislation was *among* the *vitia* Livy had in mind.[61] If this is granted, then the Sabine women and Lucretia take on a specific application to a specific group: those educated, well-to-do Roman women who followed lives of luxury and pleasure rather than emulating the old-fashioned morals of Rome's earliest *matronae*.[62] It is worth comparing in this context the brilliant speech castigating Clodia Metelli that Cicero puts into the mouth of Appius Claudius Caecus; is this, the old man thunders, the way the Claudiae of old behaved?[63] Cicero's speech indicates that holding up the *matronae* of the "good old days" as exempla for their modern daughters to follow made sense to a Roman court audience; such exempla would be even more appropriate in a history, which would be implicitly addressed to a mixed-gender audience.

Livy could assume that his work would be read by aristocratic women as well as by men.[64] The *tu* of his preface, assuring each individual reader of exempla to follow, can thus be seen as addressing an assumed female reader no less than an assumed male reader.[65] In the crucial first book, in which Livy must capture the interest of his audience, he offers exempla constructed to touch and appeal to readers of both sexes. "Livy's technique in reflecting or suggesting the present is careful and subtle;"[66] we do not find in him the direct, scornful approach used by Cicero vis-à-vis Clodia Metelli. Rather, Livy appeals to the pride and amour propre of well-to-do Roman ladies of his day by showing them examples of courage, nobility, and even *auctoritas* to follow among the *matronae* of the old days, as well as examples to avoid of ambition, greed, and self-interest run amok.[67] "[C]ould any reader in the time of Augustus fail to observe the symphonic pitch in epic and present-day political pronouncements?" H.-P. Stahl asks in reference to the *Aeneid*.[68] Mutatis mutandis, the same question applies to Livy's work. His advice to his female readers is subtle and delicately presented, but is nonetheless clearly there. Of course, it is only to be expected that in a work lauding the *mos maiorum*, Livy's examples of female greatness should be set

in the context of traditional patriarchal marriages. We shall find no brief in him for women managing their own affairs and living without the *manus* of a father or husband.[69] But the degree to which Livy allows for women's autonomy and decisive action within the framework of traditional society is nevertheless worth noting.

"Moribus antiquis res stat Romana virisque." As Edwards points out, the term *viris* cannot include women; "morality and manliness are constructed here as the distinguishing features of Rome."[70] But by his use of women as examples of *pietas*, self-sacrifice, and courage, Livy implicitly adds *feminisque* to Ennius's celebrated statement of essential *Romanitas*.

NOTES

Part of the research for this chapter was done at the American Academy in Rome during the summer of 1994, when I was a participant in the NEH Summer Seminar on "The Roman Art of Emulation." I would like to thank the NEH and the seminar's directors, Professors Elaine Gazda and Miranda Marvin, for giving me the opportunity to use the Academy's resources for my work on this project.

1. M. J. Cousin, "Le rôle des femmes dans le livre I de Tite-Live," *REL* 44 (1966): 60–61. He comments, "Que l'on suprime les figures féminines de ce livre I: il ne restera que des guerres banales et le relief des caractères de certains règnes s'affadira totalement" (60).

2. This increased attention to Livy's women is, of course, part of the wider burgeoning of interest in ancient women in general. The recent bibliography on women in antiquity is vast, and I make no attempt to summarize it here. The following is a sampling of works that deal specifically with female characters in Livy's text: R. A. Bauman, "The Rape of Lucretia, *Quod metus causa* and the Criminal Law," *Latomus* 52 (1993): 550–66; Robert Brown, "Livy's Sabine Women and the Ideal of *Concordia*," *TAPhA* 125 (1995): 291–319; J. Collart, "À propos de Tite-Live I, 13, 1–3: Quelques remarques formelles sur l' 'intervention' des Sabines," in *Hommages à M. Renard*, vol. 1, Collection Latomus 101 (Brussels, 1969): 250–55; Ian Donaldson, *The Rapes of Lucretia: A Myth and Its Transformations* (Oxford, 1982), esp. chs. 1 and 2; C. Gallardo Mediavilla and A. Sierra de Cozar, "Tópicos sobre la mujer en la historia romana de Tito Livio," in E. Garrido Gonzalez, ed., *La mujer en el mundo antiguo* (Madrid, 1985), 298–306; Lidia Haberman, "*Nefas ab libidine ortum:* Sexual Morality and Politics in the Early Books of Livy," *Classical Bulletin* 57 (1980): 8–11; John F. Hall III, "Livy's Tanaquil and the Image of Assertive Etruscan Women in Latin Historical Literature of the Early Empire," *The Augustan Age* 4 (1985): 31–38; J. Hemker, "Rape and the Founding of Rome," *Helios* 12 (1985): 9–20; M. J. Heurgon, "L'expression *muliebris audacia* chez Tite-Live I.46.6," *REL* 38 (1960): 38–41; Patricia Klindienst Joplin, "Ritual Work on Human Flesh: Livy's Lucretia and the Rape of the Body Politic," *Helios* 17 (1990): 51–70; Sandra R. Joshel, "The Body Female and the Body Politic: Livy's Lucretia and Verginia," in Amy Richlin, ed., *Pornography and*

Representation in Greece and Rome (New York and Oxford, 1992), 112–30; Christina Kraus, "*Initium turbandi omnia a femina ortum est:* Fabia Minor and the Election of 367 B.C.," *Phoenix* 45 (1991): 314–25; Bernadette Liou-Gille, "L'Enlevement des Sabines," *Latomus* 50 (1991): 342–48; T. Davina McClain, "Gender, Genre, and Power: The Depiction of Women in Livy's *Ab urbe condita*" (diss., Indiana University, 1994); Iain McDougall, "Livy and Etruscan Women," *Ancient History Bulletin* 4 (1990): 24–30; G. B. Miles, "The First Roman Marriage and the Theft of the Sabine Women," in R. Hexter and D. Selden, eds., *Innovations of Antiquity* (New York and London, 1992), 161–96; Timothy J. Moore, "Morality, History, and Livy's Wronged Women," *Eranos* 91 (1993): 38–46; J. D. Noonan, "Livy I.9.6.: The Rape at the Consualia," *CW* 83 (1990): 493–501; S. N. Philippides, "Narrative Strategies and Ideology in Livy's Rape of Lucretia," *Helios* 10 (1983): 113–19; Jane E. Phillips, "Livy and the Beginning of a New Society," *Classical Bulletin* 55 (1979): 87–92; Linda J. Piper, "Livy's Portrayal of Early Roman Women," *Classical Bulletin* 48 (1971): 26–28; Adele Scafuro, "Livy's Comic Narrative of the Bacchanalia," *Helios* 16 (1989): 119–42; S. E. Smethurst, "Women in Livy's *History*," *G & R* 19 (1950): 80–87; J. B. Solodow, "Livy and the Story of Horatius, 1.24–26," *TAPhA* 109 (1979): 251–68; Eva Stehle, "Venus, Cybele, and the Sabine Women: The Roman Construction of Female Sexuality," *Helios* 16 (1989): 143–64. There are, of course, also scattered remarks about women and their portrayal in such standard works as T. J. Luce, *Livy: The Composition of His History* (Princeton, 1977), R. M. Ogilvie, *A Commentary on Livy Books 1–5* (Oxford, 1965) and P. G. Walsh, *Livy: His Historical Aims and Methods* (Cambridge, 1961), but these are generally more superficial and less useful than one might expect.

3. According to Haberman, "*Nefas ab libidine ortum,*" 9–10, Lucretia and later Verginia symbolize, obviously, *pudicitia* and, more metaphorically, *libertas:* "the equation of Lucretia, the victim of rape, to the rape of Roman liberty is made explicit . . . in Livy's language in the parallel situation between Appius and Verginia" (10); cf. Philippides, "Narrative Strategies and Ideology," 115: "the opposition between Lucretia and Sextus Tarquinius is transmuted into an opposition between *pudicitia* and overturned *virtus.*" Barbara Feichtinger argues that Lucretia's story demonstrates "die Zusammenschau von *libertas* und *pudicitia.* . . . Alles in der Darstellung des Livius zielt auf ein Augzeigen des Spannungs- und Abhängigkeitsverhältnisses zwischen *virtus,* moralischer Integrität, und *libertas,* der politischen Grundfeste des römischen Staates, ab" ("*Ad maiorem gloriam Romae:* Ideologie und Fiktion in der Historiographie des Livius," *Latomus* 51 [1992]: 28). Moore, "Morality, History, and Livy's Wronged Women," discusses the role that Lucretia, Verginia, Heraclia, Theoxena, and the wife of Orgiagon each plays, as a "suffering woman," in causing the downfall of the immoral man who caused her suffering. Even Elaine Fantham et al. say that "Lucretia and Verginia . . . earn their fame as much by their role in stimulating male political action as for their undoubted virtue," leaving completely unconsidered the idea that Lucretia, at least, might earn her fame because of *her own* actions (*Women in the Classical World: Image and Text* [New York and Oxford, 1994], 225). Brown, "Livy's Sabine Women," and McClain, "Gender, Genre, and Power," are welcome exceptions to this overall pattern. There is, of course, a vast bibliography on the story of Lucretia in postclassical literature; see Donaldson, *Rapes of Lucretia.*

4. Obviously, I strongly disagree with, and argue against, the view of Livy's women typified by Francesca Santoro L'Hoir's chapter title, "Livian Ladies: Cardboard Characters in Feminine Attire," in *The Rhetoric of Gender Terms: "Man"*, *"Woman"*, *and the Portrayal of Character in Latin Prose*, Mnemosyne suppl. 120 (Leiden, New York, and Cologne, 1992), 77. Santoro L'Hoir elaborates this idea by saying that "Livy's only reason for inserting women into his history is to further or hinder the action taken by men. Consequently, his female characters are shadowy impersonations of womanhood" (ibid.). Cf. Haberman, *"Nefas ab libidine ortum,"* who says that Lucretia (and the other women of book 1) "apart from [her] . . . typical Roman womanly virtues, do[es] not possess any individuality" (9), and Smethurst, "Women in Livy's *History*," esp. p. 82.

5. It is generally accepted among scholars that the first pentad stands as a unified whole, and that within it the divisions into separate books were a matter of conscious planning on Livy's part (see, e.g., J. Briscoe, "The First Decade," in T. A. Dorey, ed., *Livy* [London and Toronto, 1971], 1–2; Ogilvie, *Commentary on Livy Books 1–5*, 30; P. G. Walsh, *Livy*, Greece & Rome: New Surveys in the Classics 8 [Oxford, 1974], 8). Given this assumption, it seems legitimate to look for patterns within an individual book of the first pentad. Konstan touches on the idea that women's stories are one such means of patterning in book 1, but devotes very little space to this suggestion (David Konstan, "Narrative and Ideology in Livy: Book I," *Classical Antiquity* 5 [1986]: 210–13).

6. Gary B. Miles, "The Cycle of Roman History in Livy's First Pentad," *AJP* 107 (1986): 13. Miles is, of course, referring specifically to Livy's account of Camillus in book 5, but his comment is generally applicable as well. See also, e.g., Feichtinger, *"Ad maiorem gloriam Romae"* (1992): 25–30; Konstan, "Narrative and Ideology," 212–13. Ogilvie, *Commentary on Livy Books 1–5*, referring to the story of the Sabine women, says that there is "no doubt that the artistry is directly due to L[ivy]" (65).

7. Writing in reference to Roman poetry, Karl Galinsky has referred to an "intentional and authorially defined polysemy" contained in the texts, similar to that found in art, where mythological figures can represent "a multi-referential, complex iconography whose many strands the viewer is invited to discover and reflect on" (*The Interpretation of Roman Poetry: Empiricism or Hermeneutics?* [Frankfurt, 1992], 12; he refers in particular to figures such as that of Venus/Tellus/Pax on the Ara Pacis). Such "intentional and authorially defined polysemy" is not often discussed in reference to Augustan prose. However, this division between the critical vocabulary and methods used to discuss prose and those used to analyze poetry is perhaps more a reflection of our own biases than of anything inherent in the nature of those genres as they existed in the ancient world; the treatment of poetry as somehow more "literary" than prose is perhaps a trace of what Thomas N. Habinek has called the "prolonged process of self-dismemberment" of Latin literature as studied in the United States. See his "Grecian Wonders and Roman Woe: The Romantic Rejection of Rome and Its Consequences for the Study of Latin Literature," in Galinsky, op. cit., 227–42; esp. comments on 239.

8. See, e.g., Hector's words to Andromache, *Il.* 6.441–65; Pericles' funeral oration, Thuc. 2.35–46, esp. chs. 42–43; Socrates' explanation of why he did not use emotional appeals to the jury, Plato, *Apology* 38d–9b.

9. In using exempla as opposed to direct precepts, Livy is, of course, following the standard practice of Roman writers of his time. For a discussion of the overall role of *exempla* as opposed to *praecepta* in the Augustan Age and in Augustus's own propaganda, see Zvi Yavetz, "The *Res Gestae* and Augustus' Public Image," in Fergus Millar and Erich Segal, eds., *Caesar Augustus: Seven Aspects* (Oxford, 1984), 18–20.

10. In this interpretation, I strongly disagree with Joshel, "Body Female and the Body Politic," who says that in Livy's writing "Woman . . . is a blank space, a Void, for Livy effectively eliminates her voice" (121), and, again, with Santoro L'Hoir's treatment of Livy's women (*Rhetoric of Gender Terms,* 77–99).

11. Unfortunately, there is not space for me to include all the memorable women of book 1 here. I plan to examine the stories of Tarpeia, Horatia, Tanaquil, and the Tullias in a future essay.

12. Although the story of Rhea Silvia contains interesting parallels to the themes of this chapter, since she lived before the founding of Rome she is not immediately germane to my topic.

13. The similarities between the stories of Lucretia and the Sabine women have been the subject of very little scholarly discussion. Joshel, "Body Female and the Body Politic," touches on this point when she says, "The Sabines, *matronae . . .* who voluntarily take up proper control of their own bodies, are reflected in Lucretia, the noble wife who will herself act and speak the proper use of her body" (122); however, she does not discuss the parallelism of the two stories any further. Konstan, "Narrative and Ideology," argues that "problems of descent and marriage constitute significant patterns" in Livy's first book (198); he discusses the Sabines, but does not mention Lucretia.

Lucretia's story, as has often been noted, obviously resembles the story of Verginia in book 3; in fact, these two episodes are very frequently discussed as doublets. E. Cantarella, for instance, says that "the syntactic structure of the two legends is almost identical" (*Pandora's Daughters: The Role and Status of Women in Greek and Roman Antiquity* [Baltimore, 1987], 130). See also Ogilvie, *Commentary on Livy Books 1–5,* 477; Haberman, "*Nefas ab libidine ortum,*" 9–10; Fantham et al., *Women in the Classical World,* 225; Joplin, "Ritual Work on Human Flesh," 52–53; Moore, "Morality, History, and Livy's Wronged Women," esp. 39. Kraus, "*Initium turbandi,*" identifies close structural parallels to Lucretia's story (transposed into a comic mode) in the story of Fabia Minor (6.34–35). For an analysis of the parallels between Livy's account of the husbands' "contest" that introduces Lucretia's story and Herodotus's tale of Gyges and Candaules (1.5–13), see W. Schubert, "Herodot, Livius und die Gestalt des Collatinus," *RhM* 134 (1991): 80–96.

14. The tendency to assume that the "rape" of the Sabine women must mean sexual assault, not abduction alone, appears in a great deal of modern scholarship. Some scholars state this directly: see, e.g., Judith Hallett, *Fathers and Daughters in Roman Society: Women and the Elite Family* (Princeton, 1984), 114, 116; Hemker, "Rape and the Founding of Rome," passim; Joplin, "Ritual Work on Human Flesh," 56–59, esp. 57 where she says that the women are "abducted and raped"; Joshel, "Body Female and the Body Politic," 126; Santoro L'Hoir, *Rhetoric of Gender Terms,* 82. Richlin, ed., *Pornography and Representation,* says that "Livy's narrative of the Sabine women elides their experience of rape" (xx). Others scholars assume more tacitly that the Sabine women were sexually assaulted (e.g., Moore, "Morality, His-

tory, and Livy's Wronged Women," 39 n. 5). Stehle, "Venus, Cybele, and the Sabine Women," whose analysis of the story gives a great deal of importance to the women's own actions, does not directly address the question of whether they were sexually assaulted (149–51); neither does Miles, "First Roman Marriage." However, Miles's overall discussion of Livy's narrative seems to assume that the Sabines were not assaulted (175–83); cf. his reference to the Sabines' "abduction and rape" in Ovid's narrative (175).

15. Theoretically, of course, "rape" can still mean "abduction" in modern English; Brown, "Livy's Sabine Women," is apparently using it in this sense when he refers to "Livy's account of the rape itself." But only a page later, he seems to mean "sexual assault" when he speaks of "contrasting marriage with rape" (296–97). But the primary sense "violent sexual assault" is so strong that most modern scholars seem to find it impossible to exclude that meaning when they see the word "rape." The Loeb translation renders *raptis* as "stolen maidens" (1.9.14); Aubrey de Sélincourt, *Livy: The Early History of Rome* (New York, 1971), avoids the point at issue by translating *raptis* as "young women" (44). Phillips, "Livy and the Beginning of a New Society," is unusual in consistently referring to the "capture" of the Sabine women (89).

16. J. N. Adams says that "*stuprum* originally meant 'disgrace' in general. . . . But it came to be specialised of a sexual disgrace, i.e. an illicit sexual act. . . . The word is not necessarily used of a violation perpetrated against the will of the victim. . . . But often it denotes a forcible violation" (*The Latin Sexual Vocabulary* [Baltimore, 1982], 200–201). As for *rapere*, Adams cites Livy 1.9.10 for evidence that "The basic sense . . . was 'drag off into captivity' (sc. *coeundi causa*)," and speculates that it is "possible that it tended to be weakened into a synonym of *vim afferre, vitiare,* etc." (175). However, Adams gives no evidence that *coeundi causa* had to be understood after *rapere*.

The meaning of *rapere* apparently changed in the first century A.D.; Quintilian seems to use *raptarum* to mean "raped women" (7.7.3) and in Seneca *Controversiae* 7.8, *raptor* and *rapere* are used interchangeably with *vitiator* and *vitiare* in discussing what is very clearly a case of rape (the act is also referred to as *stuprum*). By the time of Justinian, *rapere* and *rapina* apparently meant sexual assault: "qui nuptas mulieres ausi sunt rapere . . . duplici crimine tenentur tam adulterii quam rapinae" (Codex Justinianus 9.13.1a; see also Bauman, "The Rape of Lucretia . . . and the Criminal Law," 558). But in first-century B.C. usage, *rapere* does not seem to have meant rape. In fact, the distinction between *rapere* and *stuprum* was such that Sallust (according to Nonius Marcellus, 456.16) could write "fugitivi contra praeceptum ducis rapere ad stuprum virgines matronasque." If *rapere* alone had carried the sense "violate sexually," the additional words of explanation would have been unnecessary (Wallace M. Lindsay, ed., *Nonii Marcelli De compendiosa doctrina* [Leipzig, 1903; repr. Hildesheim, 1964], 3: 731).

Lewis and Short's entry on *rapere* covers three columns and includes only one citation of a purely sexual usage: they gloss *rapta* as "the ravished one, the seduced," in Ovid *AA*1.680: *gratus raptae raptor fuit.* In fact, however, even this instance is questionable. It is true that the line occurs in a passage in which Ovid is discussing the use of sexual force ("vim licet appelles: grata est vis ista puellis"[1.673]). However, the women here referred to as *raptae*, Phoebe and Hilaira, were in fact *kidnapped* by the Dioscuri (as Ovid himself implies at *Fasti* 5.699–700: "Abstulerant raptas

Phoeben Phoebesque sororem/Tyndaridae fratres"; see also Theocritus *Idyll* 22, esp. lines 137–38). When Ovid discusses the rape of Deidamia by Achilles a few lines later, the word he uses for the act is *stuprum*: "haec illum stupro comperit esse virum" (*AA* 1.698); "auctorem stupri" (1.704). In sum, then, even in *AA* 1.680, *raptae* and *raptor* may in fact imply abduction, not sexual assault, even though clearly sexual activity followed this particular abduction (which Theocritus says was for the purpose of marriage; 22.147–48). In all its other citations, Lewis and Short demonstrates that the primary sense of the word is clearly "to seize and carry away," particularly "to carry off by force"; for this usage it specifically cites several instances with *virgines,* including Livy 1.9, and translate "to carry off, abduct."

Lewis and Short defines *stuprum* generally as "defilement, dishonor, disgrace," saying, in particular, that it refers to dishonor or disgrace "by unchastity of any sort . . . always implying the infliction of dishonor on the subject, whether male or female." Similarly, Lewis and Short defines *stuprare* as "in partic., to dishonor by unchastity, to debauch, deflour [*sic*], ravish, stuprate." For a discussion of the precise meaning of *stuprum* and its overlapping with *adulterium,* see Bauman, "The Rape of Lucretia . . . and the Criminal Law," 556–61; see also Pál Csillag, "Das Eherecht des Augusteischen Zeitalters," *Klio* 50 (1968): 134–35. Susan Treggiari says that at the time of Augustus's legislation on marriage (18 B.C.), *stuprum* "was in general use for any irregular or promiscuous sexual acts, especially rape or homosexuality" (*Roman Marriage: Iusti coniuges from the Time of Cicero to the Time of Ulpian* [Oxford, 1991], 264).

17. Livy makes it unmistakeably clear that this, and not lust, is the motivation for the abduction in his introduction to the story of the Sabine women: "iam res Romana adeo erat valida ut cuilibet finitimarum civitatum bello par esset; sed penuria mulierum hominis aetatem duratura magnitudo erat, quippe quibus nec domi spes prolis nec cum finitimis conubia essent" (1.9.11). Brown, "Livy's Sabine Women," notes that this emphasis was a matter of authorial choice; Cicero, Dionysius of Halicarnassus, and Ovid all recognize other possible motivations for the abduction (295).

18. It is noteworthy that the most beautiful of the Sabine women are marked out for *primoribus patrum* (1.9.11). Romulus's acquisition of Hersilia is conspicuous in its absence in the abduction narrative, perhaps because Romulus stands outside the scene, as it were, as an instigator and advisor to both the Roman men and the Sabine women.

19. Before the establishment of Rome as an independent state, in fact, the young Roman men's very status as humans can be seen as problematic; R. J. Schork has pointed out the degree to which Livy uses animal imagery to describe the young men who gather around Romulus and Remus ("Moral Metamorphosis in Livy," *Latomus* 47 [1988]: 98–104).

Santoro L'Hoir, *Rhetoric of Gender Terms,* says that in Livy, the term *vir* "embodies the epic hero who displays his courage over and over" (p. 69; see also her entire discussion of the meaning of *vir,* pp. 63–69). She does not comment directly on the fact that this word is used for the Roman men only *after* their acquisition of Sabine wives, although she does flag the word with an exclamation point: "the Roman *viri* (!) employed *blanditias* to assure the Sabine *mulieres* that their gang ravishment was motivated *cupiditate atque amore*" (82).

20. Timothy J. Moore, *Artistry and Ideology: Livy's Vocabulary of Virtue*, Beiträge zur klassischen Philologie 192 (Frankfurt, 1989), 123.

21. Moore, *Artistry and Ideology*, 122 n. 7; he cites several passages that make the loss of *pudicitia* through rape "evident," including in addition to Lucretia's story 2.7.4, 3.50.6, 3.50.8, 3.61.4, 38.24.10, 39.15.14.

22. Miles, "First Roman Marriage," 188–189, recognizes that the women's consent is necessary and cannot be taken for granted.

23. Joplin, "Ritual Work on Human Flesh," 57; cf. Santoro L'Hoir's statement that Livy presents the Sabines (and other women) "if not as cooperative victims of rape, then as those who will forgive violence done to their person as long as it is accompanied by the right words" (*Rhetoric of Gender Terms*, 82). A notable exception to this tendency to assume that the Sabines were sexually assaulted *before* their marriage is McClain, "Gender, Genre, and Power," who states that "there is nothing in the passage [describing the capture of the Sabines] that states any sexual activity has taken place" (151–152). But even she blurs the distinction by adding "in each of the *other episodes of rape*, Livy reports the act, but here there is no specific mention of intercourse" (153; emphasis added).

On the necessity of the bride's consent, see Susan Treggiari, "Consent to Roman Marriage: Some Aspects of Law and Reality," *Echos du Monde Classique / Classical Views* 26, n.s., 1 (1982): 34–44, and id., *Roman Marriage* (cit. n. 16 above), 54–57, 170–80. A. Watson has argued that the bride's consent was *not* required prior to ca. 200 B.C. (*The Law of Persons in the Later Roman Republic* [Oxford, 1967], 41–44); however, for my purposes the question of what early Roman law *really* required is less important than the attitude of Livy's own day, and there is no doubt that the bride's consent was required in the late Republic. (This is not meant, of course, to deny that fathers could and did coerce their daughters into accepting marriages that were not congenial to the young women.)

24. Treggiari, *Roman Marriage*, 170.

25. Miles, "First Roman Marriage," 186; cf. Linda Piper, "Livy's Portrayal of Early Roman Women," 26–28, who compares the Sabines to Caesar's daughter Julia, married to Pompey for purely political reasons.

26. From a modern feminist standpoint, of course, it could easily be argued that sexual intercourse in *all* Roman marriages, indeed in all arranged marriages in any society, was and is in fact rape from the bride's point of view (a viewpoint with which I have some personal sympathy). But the fact remains that when Livy's work is considered within its own cultural context, the Sabine women's experience is still by and large the same as the experience of all Roman women, whatever we as twentieth-century readers may think of that experience. The important point here is that *Lucretia's* experience is different; unlike the Sabine women, she undergoes a horrifying violation, by her society's standards no less than by her own.

27. Smethurst, "Women in Livy's *History*," thinks that this comment by Livy amounts to the imputation of "base motivations" to the Sabine women in their later intervention on the battlefield, and concludes that Livy considers them and all other Roman women "incapable of positive action" (82); Santoro L'Hoir, citing Smethurst approvingly, says that "Livy's dim view of the *muliebre ingenium* borders on the misogynistic"; she further argues that the word *mulier* (as contrasted with *femina*) and its derivatives is used specifically to depict women as victims who "can only submit"

(*Rhetoric of Gender Terms*, 82). As my further discussion will show, I think that Smethurst's and Santoro L'Hoir's interpretations of this passage gravely underestimate the importance of the Sabines' later actions and misrepresent Livy's treatment of them and of other women.

For an interesting interpretation of the Roman men's pleas as evidence that women respond to different types of persuasion than do men, see McClain, "Gender, Genre, and Power," 153–54. Brown, "Livy's Sabine Women," reads this scene as "a paradigm of male and female nature in conflict and complementarity" (300).

28. I cannot agree with Joplin, "Ritual Work on Human Flesh," that Sextus's threat to kill Lucretia and a slave, and to say that he caught them in the act of adultery, makes it "clear that the issue is not erotic desire but the use of Lucretia to dishonor Collatius [*sic*] in revenge for winning the wager" (61). The point of the threat seems clear enough: Lucretia is willing to die rather than submit. Therefore, Sextus's only recourse is to threaten *her* honor with something worse than *stuprum* alone, so that she will submit to *stuprum*. Of course, Lucretia's honor is inextricably bound up with her husband's honor, but this does not mean that Collatinus's honor, rather than Lucretia's body, is Sextus's primary target. It seems unnecessary to postulate "hidden" motivations for Sextus beyond that given by the text itself, which states Sextus's motive quite unambiguously: "Sextum Tarquinium mala libido Lucretiae per vim stuprandae capit; cum forma tum spectata castitas incitat." This is the only occurrence of the noun *castitas* in Livy, according to Moore, *Artistry and Ideology*, 120, who defines the noun as signifying "a state of purity, especially the purity of an *univira*." On Lucretia's personal honor, see further n. 53 below.

For an examination of the Roman attitude toward sexual relations between free women and slave men, see Judith Evans-Grubbs, " 'Marriage More Shameful Than Adultery': Slave-Mistress Relationships, 'Mixed Marriages,' and Late Roman Law," *Phoenix* 47 (1993): 125–54. Margaret Higonnet's statement that if Lucretia "does not submit to the rape she will be killed with a *black* slave" serves as a salutory indication of how dangerously easy it is to import modern assumptions into the ancient narrative ("Speaking Silences: Women's Suicide," in Susan R. Suleiman, ed., *The Female Body in Western Culture: Contemporary Perspectives* [Cambridge, Mass., 1986] 75; emphasis added).

29. Hemker, "Rape and the Founding of Rome," identifies and discusses several crucial differences in tone between Livy's treatment of the Sabines' story and Ovid's presentation of the same story in *AA* 1.101–34. I cannot agree with her contention that Ovid "criticizes the philosophy of those who subscribe to the narrator's attitude toward women" (46); I would explain the difference in tone between the two accounts of the same events by noting that Livy is concerned with the Sabine women's role as founders of the Roman state and Ovid with the sexual titillation of his readers. See also Miles, "First Roman Marriage."

30. It is interesting to note that Livy identifies Hersilia simply as Romulus's *coniunx* (1.11.2) and does not say who she was or why she in particular was chosen to be Romulus's wife. Ogilvie notes that "Hersilia was remembered as the person who mediated between the Romans and Sabines" and cites other authors (Macrobius 1.6.16; Dionysius of Halicarnassus 2.45; Plutarch *Romulus* 14) who identified her as a widow and mother of daughters when she came to Rome; but he does not comment on Livy's extreme reticence about her origins (73). According to *RE*, Hersilia

"wurde entweder aus Versehen zusammen mit den Jungfrauen geraubt" (Jessen, *RE*, 8: 1149, s.v. Hersilia). For a thorough discussion of who Hersilia was, see T. P. Wiseman, "The Wife and Children of Romulus," *CQ* 33 (1983): 445–52. Hallett, *Fathers and Daughters*, sees the fact that Hersilia's intervention did not prevent "a full-fledged Roman-Sabine battle" as a sign of Hersilia's "ineffectuality" (220); Brown, "Livy's Sabine Women," argues that Hersilia's appearance here serves to "enhance the role of the women, who represent for Livy the spirit of forgiveness and harmony" (303).

31. Most modern scholars refer to the Caeninians, the Crustumnians, and the Antemnates on the one hand and the Sabines on the other, while using "the Sabine women" in general as a term for all the abducted women. This is somewhat confusing since Caenina, Crustumnium, and Antemnae were all apparently Sabine towns. However, the confusion is based on Livy's own usage, since he distinguishes between the *Sabini*, meaning those who were governed by Titus Tatius, and the *Crustumini*, *Antemnates*, and *Caeninenses* (see 1.10.1–3).

32. For a close analysis of the vocabulary, syntax, and prosody of the women's speech, see Collart, "À propos de Tite-Live I, 13, 1–3."

33. There is a rich vein of irony here; to create the new society, the Sabine women have already risked their own lives—and will continue to do so—in childbirth. Cf. Euripides, *Medea*, 249–51.

34. For the necessity of consent by the *paterfamilias* to a marriage, see Treggiari, "Consent to Roman Marriage."

35. For the clearest articulation of this view, see Joplin, "Ritual Work on Human Flesh," esp. 56–59. See also Haberman, "*Nefas ab libidine ortum,*" 9; Hemker, "Rape and the Founding of Rome," 42; Santoro L'Hoir, *Rhetoric of Gender Terms*, 82–83. Miles, "First Roman Marriage," is a notable exception; he refers to the Sabine women's "role as active agents in the reconciliation between men when, *at their own initiative,* they intervene between warring communities and affirm their married status" (171; emphasis added).

36. Joplin, "Ritual Work on Human Flesh," 57.

37. The women themselves *do* say so, in direct speech: "*nos causa belli. . . .*" But this is rhetorical exaggeration, used to make a point, not a factual statement.

38. Joplin, "Ritual Work on Human Flesh," cites Aubrey de Sélincourt's translation (cit. n. 15 above), 48, which reads: "The Sabine Women, the original cause of the quarrel." The Loeb translation is ambiguous here: "whose wrong had given rise to the war" (B. O. Foster, trans., *Livy* [New York and London, 1925], 1: 47).

39. Professor Richard F. Moorton's comments about this point have been very helpful to me.

40. See Brown, "Livy's Sabine Women," 309–10.

41. "Dilexi tum te non tantum ut vulgus amicam, sed pater ut gnatos diligit et generos" (c. 72, lines 3–4). For discussion of the emotional bond implied by these lines, see, i.a., Frank Copley, "Emotional Conflict and Its Significance in the Lesbia-Poems of Catullus," *AJP* 70 (1949): 22–40; J. P. Elder, "Notes on Some Conscious and Unconscious Elements in Catullus' Poetry," *HSCP* 60 (1951): 127–28; Judith P. Hallett, "The Role of Women in Roman Elegy: Counter-Cultural Feminism," *Arethusa* 6 (1973): 109–11; D. P. Harmon, "Catullus 72, 3–4," *CJ* 65 (1970): 321–22. J. Granarolo discusses several of the different scholarly explanations for what

Catullus may have meant by this comparison in "La dimension 'familiale' de l'amour dans l'âme et la poésie de Catulle," in M. Renard and P. Laurens, eds., *Hommages à Henry Bardon*, Collection Latomus 187 (1985), 163–72. On the importance of the bond between father-in-law and son-in-law in legends of the regal period, see Hallett, *Fathers and Daughters*, 299–300.

42. Again, de Sélincourt's translation (cit. n. 15 above) here is misleading. He says that "the rival captains stepped forward to conclude a peace. Indeed, they went further: the two states were united under a single government, with Rome as the seat of power" (48). But the Latin actually says that one city/state was made from two, not the much weaker statement that the two were united under one government.

43. Cf. the comments of Miles, "First Roman Marriage": "From separation, rivalry, and hostility come . . . not just a reconciliation, but a union of peoples" (168); Stehle, "Venus, Cybele, and the Sabine Women": "When the women interposed themselves between the battle lines, they were signaling their approval of their marriages, the fact that they had transferred their *fides* and become Romans. Once their allegiance was revealed as unequivocal, the Sabine women were able to bring their families also into Rome and unite the two people" (150) and Hallett, *Fathers and Daughters*: "The embryonic Roman state managed to incorporate once-hostile Sabine elements only because a group of daughters . . . and the appeal of common male descendants . . . were able to reconcile warring fathers and sons-in-law" (112–13). In view of this statement, it is all the more remarkable that Hallett almost immediately refers to these same women as "the raped, self-abnegating and conciliatory Sabine women" who "tak[e] the blame for their own rapes" (114, 116).

44. Again, my interpretation here differs profoundly from Joshel's. She sees the names of the *curiae* as one instance (along with others such as the name of the Tarpeian Rock) signifying that female characters "move from animate life into inanimate matter. . . . Women's bodies literally become building material—the stuff of physical and political topography" ("Body Female and the Body Politic," 122). However, this ignores the fact that men's names, too, were very commonly applied to what Joshel calls "places and spaces" (ibid.); the Lacus Curtius and the month Julius (formerly Quinctilis) are only two of the most obvious examples. Brown's interpretation is much closer to mine; he says the Livy's account of the *curiae's* names "redounds to the credit of the Sabine women" ("Livy's Sabine Women," 311).

45. This distinction is unfortunately missed by Joshel's statement that Lucretia's "language kills no less than her actions: like the Sabines, she 'asks for it' " ("Body Female and the Body Politic," 128). Indeed, nowhere in her discussion does Joshel directly confront the implications of the fact that the Sabines do *not* die, but in fact help form the new society; instead, she lumps the Sabines (and Rhea Silvia) together with various women who *are* killed. So, for instance, discussing Lucretia's suicide, she says, "As with Rhea Silvia, *the Sabines*, Tarpeia, Horatia, and Verginia, men's liberation and political advances require the sacrifice of Woman" ("Body Female and the Body Politic," 128; emphasis added).

46. For a very thorough discussion of the legal implications of Lucretia's forced adultery and her reaction to it, see Bauman, "The Rape of Lucretia . . . and the Criminal Law," passim.

47. This point has been insufficiently recognized. It is a commonplace that "Roman society distinguished between masculine or public life and female or

domestic life" (Maureen Flory, "Honorific Statues for Women in Rome," *TAPhA* 123 [1993]: 304); the two men's arguments and Lucretia's reaction are an inversion of what one would expect.

48. H. S. Versnel states that "in myth and legend self-sacrifice takes place in critical situations where the salvation of a total society is at stake; the victim is the highest valued possession of the state" ("Self-Sacrifice, Compensation, and the Anonymous Gods," in J. Rudhardt and O. Reverdin, eds., *Le sacrifice dans l'antiquité* [Geneva, 1980], 162–63). Of course, the Sabines and Lucretia are not victims (potential or actual) of ritual sacrifices of the kind Versnel is primarily discussing, but their willingness to die for the greater good of their society does arise at a moment of crisis and does result in the "continued existence of society as a whole" (143).

49. On Augustine's attitude toward Lucretia, see Donaldson, *Rapes of Lucretia*, 28–33. It is often assumed that Lucretia is concerned with the possibility of having conceived a bastard and that she therefore kills herself to avoid "pollution" of the bloodline (Ogilvie, *Commentary on Livy Books 1–5*, 225; Maurizio Bettini, *Anthropology and Roman Culture: Kinship, Time, Images of the Soul*, trans. John Van Sickle [Baltimore, 1991], 64; Donaldson, *Rapes of Lucretia*, 23–24; Joplin, "Ritual Work on Human Flesh," 63). See, *contra*, Bauman, "The Rape of Lucretia . . . and the Criminal Law," 551 n. 3. The fear of bastard children is of course a primary motivating force behind the strict requirement of female chastity in any patriarchal society; but Lucretia's own statement of her motivation is much more direct. While her refusal to serve as a precedent for any later *inpudica* undoubtedly includes distaste for the idea of bastard children being passed off as legitimate, her motivation should not be limited to this. Nor, I think, should it be limited purely to a desire to "affirm the supreme value of conjugal fidelity," as Cantarella, *Pandora's Daughters*, would have it (130). See further n. 53 below.

50. Cf., e.g., the death of M. Curtius (7.6.1–6) or the self-sacrifice of the Roman general P. Decius Mus (8.9.10). For a discussion of Decius Mus's *devotio* in the overall context of ancient sacrificial practice, see Versnel, "Self-Sacrifice, Compensation, and the Anonymous Gods," 139–63.

51. Watson seems to miss the point of both Lucretia's own words and of the men's pleas when he says "Lucretia killed herself because death was the appropriate punishment for infidelity" (A. Watson, *Rome of the XII Table: Persons and Property* [Princeton, 1975], 35; see also 167). In fact, the men argue that Lucretia has *not* been unfaithful. Similarly, Philippides undervalues the importance of Lucretia's guiltlessness by saying that "the innocent victim, Lucretia, finds herself in the false position of criminal and feels compelled to die" ("Narrative Strategies and Ideology," 116); this wording underrates the importance and nobility of Lucretia's voluntary sacrifice (see n. 46 above). Schubert, "Herodot, Livius und die Gestalt des Collatinus," is unusual in recognizing that Lucretia is indeed guiltless; he argues that Tarquinius and Collatinus "beide Schuld haben," and comments "Verschärft wird die Tragik des Lucretia-Geschehens dadurch, dass dort die einzig Unschuldige ihr Leben lässt" (95).

52. Despite the frequently held impression that suicide was common in the later Republic and the early Empire, Yolande Grisé has demonstrated that, as far as we can tell from our sources, it was in fact not widespread: "Si l'on considère

l'ensemble de l'histoire romaine, on arrive à la conclusion que le suicide a été vu comme une solution 'exceptionelle' devant des problèmes 'exceptionnels' " ("De la fréquence du suicide chez les Romains," *Latomus* 39 [1980]: 46).

53. I do not mean to claim that Lucretia's interest in the good of the *res publica* is her *only* motivation for suicide. Lucretia's motivations, like her story, can support various interpretations, which need not be mutually exclusive. Her interest in restoring her *private* honor is also of great importance, and it is worth remembering that Lucretia is operating within the *mores* of a "shame" culture, according to which her suicide is both understandable and honorable. The rape dishonors her; her suicide restores her honor. This motive for suicide—the desire to restore her personal honor—is identical to the motives of Sophocles' Ajax or of the Spartan warrior Pantites, who survived Thermopylae because he was carrying a message into Thessaly. Pantites was, obviously, innocent of any cowardice, but nevertheless his sense of dishonor at missing the battle was so great that he hanged himself (Hdt. 7.232). The parallel with Lucretia is instructive.

The crucial point that in a "shame" culture suicide may, in fact, be seen as a *positive,* honorable, and honor-restoring action is missed by, e.g., Santoro L'Hoir, who says that Lucretia's "reaction to her defilement is utterly negative. Although . . . [there are] beneficial results of her rape and suicide, self-immolation, after begging one's husband and father to be *viri* and take vengeance, hardly represents positive action" (*Rhetoric of Gender Terms*, 82–83). This statement may indeed be true in *our* culture; but in the culture depicted by Livy's narrative, Lucretia's action is, indeed, a positive one.

I am grateful to Professor Richard F. Moorton for drawing my attention to the "shame culture" aspect of Lucretia's story and for suggesting these parallels to me.

54. It is at this point that my interpretation differs most from Santoro L'Hoir's. She notes that Lucretia's whole story is motivated by a *muliebre certamen,* and comments, "Any episode that is *muliebre* is bound to end in disaster" (*Rhetoric of Gender Terms,* 83). But the aftermath of Lucretia's suicide, far from being a "disaster," is in fact the formation of the Roman Republic.

55. For a close reading of the preface and relevant bibliography, see John Moles, "Livy's Preface," *PCPS* 39 (1993): 141–68.

56. On the question of whether or not any moral legislation was in fact proposed in 28, see R. A. Bauman, *Women and Politics in Ancient Rome* (London, 1992), 105–8 and notes; Csillag "Das Eherecht des Augusteischen Zeitalters," 118–19; Karl Galinsky, "Augustus' Legislation on Morals and Marriage," *Philologus* 125 (1981): 126–44; A. Mette-Dittmann, *Die Ehegesetze des Augustus,* Historia Einzelschriften 67 (Stuttgart, 1991), 16–19; G. Williams, "Poetry in the Moral Climate of Augustan Rome," *JRS* 52 (1962): 28 ff., and *Tradition and Originality in Roman Poetry* (Oxford, 1968), 532–34, 614–16; A. J. Woodman, *Rhetoric in Classical Historiography* (London, 1988), 132–33. Ernst Badian argues forcefully against any such law having been either proposed or passed in "A Phantom Marriage Law," *Philologus* 129 (1985): 82–98; Williams has promised an answer to Badian's argument ("Did Maecenas Fall from Favor: Augustan Literary Patronage," in K. Raaflaub and M. Toher, eds., *Between Republic and Empire: Interpretations of Augustus and His Principate* [Berkeley and Los Angeles, 1990], 267). On the significance of the law against adultery, see Catharine Edwards, *The Politics of Immorality in Ancient Rome* (Cambridge, 1993), 34–62.

For the probable date of book 1, see T. J. Luce, "Dating of Livy's First Decade," *TAPhA* 96 (1965): 209–40; Sir Ronald Syme, "Livy and Augustus," *Roman Papers* (Oxford, 1979), 416–25 (= *HSCP* 64 [1959]: 41–50).

57. Syme, "Livy and Augustus," 416.

58. Ibid. But Andrew Wallace-Hadrill is surely correct: "*Vitia* have been alternatively explained as civil discord . . . or as immorality. . . . The mistake is to treat these as mutually exclusive. For Livy as for Horace, civil war and immorality are intertwined" ("The Golden Age and Sin in Augustan Ideology," *Past and Present* 95 [1982]: 26). On the meaning of *remedia* and *vitia*, see also R. von Haehling, *Zeitbezüge des T. Livius in der ersten Dekade seines Geschichtswerkes: nec vitia nostra nec remedia pati possumus* (Stuttgart, 1989), esp. 19, 213–15; Moles, "Livy's Preface," 150–53; W. Nethercut, "Additions to the Search for Augustan Influence in Livy," Classical Bulletin 45 (1969): 36; Woodman, *Rhetoric in Classical Historiography*, 132–34. For further bibliography, see Moles, "Livy's Preface."

59. Edwards, *Politics of Immorality*, 4.

60. The similarity of these terms to the social discourse of our own day is no less striking for having been noted before.

61. The very vexed question of whether Livy was pro- or anti-Augustan is obviously beyond the scope of this chapter. For a brief survey of the literature on both sides, see Walsh, *Livy*, 5–7. His *caveat* that "Livy's political ideas are in fact more fruitfully studied against national traditions than against Augustus' political aspirations" (7) deserves notice.

62. The *locus classicus* for a description of such a woman is, of course, Sallust's portrait of Sempronia (*Cat.* 25). It is worth noting Edwards's cogent observation that "a striking feature of Roman discussions of immoral behavior . . . is that they are concerned overwhelmingly with the behaviour of the upper classes. Roman moralists of the late Republic and early principate seem to have found the vices of the poor uninteresting" (*Politics of Immorality*, 24). Compare also Horace, *Odes* 3.6, esp. lines 25–34; and see Williams's comment in *Tradition and Originality in Roman Poetry*, 615, "That there was ripe material in the themes of *Odes* iii.6 for sermons is shown by Livy's *praefatio*."

Santoro L'Hoir, *Rhetoric of Gender Terms*, suggests in passing that Livy used "*femina* as an editorial word, as it were, to foreshadow *exempla* of good or bad comportment, directed towards the ladies of the aristocracy—that is, the wives of his readers, since said ladies would, presumably, be too busy at their theoretical looms to tackle Livy's multi-volumed work" (77). However, she does not develop this idea.

63. Cicero, *Pro Caelio* 14.33–34. For an interesting comparison of Cicero's Clodia and Sallust's Sempronia, see M. J. Wheeldon, " 'True Stories': The Reception of Historiography in Antiquity," in Averil Cameron, ed., *History as Text: The Writing of Ancient History* (Chapel Hill, N.C., 1989), 42–44. For a discussion of Livy's admiration for Cicero, see Syme, "Livy and Augustus," 428.

64. On women's literacy among the "elite" in the late Republic, see William V. Harris, *Ancient Literacy* (Cambridge, Mass., 1989), 252–53, and Elizabeth Rawson, *Intellectual Life in the Late Roman Republic* (Baltimore, 1985) 46–48. E. J. Kenney refers to women as "a not inconsiderable part of the literate public" and refers to the evidence for their existence in Catullus, Propertius, Ovid, Pliny's letters, and Juvenal ("Books and Readers in the Roman World," *CHCL* 2.1 [1982]: 9).

65. Moles, "Livy's Preface," well notes that "Livy stresses the moral implications for his readers in a direct personal appeal to the individual . . . so framed as to overturn the distinction between self-interest and national interest" (152). However, he implies throughout his excellent discussion of these lines that the "tu" referred only to men (152–54; see, e.g., his statement that "the reader has chosen an active life within the *res publica*," 154). Oddly, Joshel, "Body Female and the Body Politic," too apparently assumes only male readers in her discussion of readers' reactions to Lucretia's story (127). For Santoro L'Hoir's sarcastic dismissal of the possibility of women readers, see n. 62 above.

66. Syme, "Livy and Augustus," 422.

67. Discussing the "social forces [that] led freeborn women of good family to reject their protected respectability and claim the sexual license of the outsider," Fantham et al., *Women in the Classical World,* note that "these generations had seen the social order itself repeatedly disrupted. Women were released from surveillance by the absence of their menfolk. . . . While older or more sober women showed their emancipation by taking on responsibility for family finances, political negotiations, or petitions for their husbands' survival, others in less stable marriages might see no reason for fidelity, and daughters married off as a political bond between their fathers and his allies . . . might assert themselves" (288–89). It is interesting to compare the situation in the United States immediately after World War II, when politicians and pundits strongly encouraged women to relinquish the jobs they had held during the war and return to their "proper" roles; see, e.g., Doris Weatherford, *American Women and World War II* (New York and Oxford, 1990), 306–17.

68. H.-P. Stahl, "The Death of Turnus," in Raaflaub and Toher, eds., *Between Republic and Empire,* 176.

69. For an argument that marriage *sine manu* did not in fact result in any significant increase in women's freedom or autonomy, see A. S. Gratwick, "Free or Not So Free? Wives and Daughters in the Late Roman Republic," in Elizabeth M. Craik, ed., *Marriage and Property* (Aberdeen, 1984), 30–53.

70. Edwards, *Politics of Immorality,* 20.

Modern Pagans in a Classical Landscape

Norman Douglas and D. H. Lawrence in Italy

Robert Eisner

We are born into a world we must one day leave. In anticipation of that departure we search out or construct special places that match our ideal of the final destination, and perhaps of our pre-cradle origins: paradises on earth, whether a walled garden or Bali-ha'i.

Since at least the Renaissance, for culture-hungry northern Europeans that Edenic destination has usually lain south, over the Alps, in Italy. Here the sensual as well as the cultural appeals of the region soon exercised their charms on visitors. Patrick Leigh Fermor has described the phenomenon of so-called transalpinism most eloquently:

> All dwellers in the Teutonic north, looking out at the winter sky, are subject to spasms of a nearly irresistible pull, when the entire Italian peninsula from Trieste to Agrigento begins to function like a lodestone. The magnetism is backed by an unseen choir, there are roulades of mandoline strings on the air; ghostly whiffs of lemon blossom beckon the victims south and across the Alpine passes. It is Goethe's law and is ineluctable as Newton's or Boyle's.[1]

And Norman Douglas, writing in 1911, ostensibly puts the case for the whole Mediterranean, but in his heart of hearts, he is speaking really for Italy:

> Here, true beauty resides with its harmony of form and hue—here the works of man stand out in just relation to those of nature, each supplementing the other. Elsewhere, she is apt to grow menacing—gloomy or monstrous. In the North, the sun refuses her aid and man struggles with the elements; he vegetates, an animated lump of blubber and dirt, or rushes frantically in starving hordes to overrun the bright places of the earth; in the tropics his works shrink into insignificance, he is lost in a fierce tangle of greenery, sucked dry by the sun, whom he execrates as a demon—he dwindles into a stoic, a slave.[2]

Douglas was to sound this contrapuntal theme of the fortuitous Mediterranean marriage of Nature with Culture on a much grander scale in his great novel of ideas, *South Wind* (1917).

One of the more unusual tributes to Italy is put by Kenneth Grahame into the mouth of a swallow, describing southward migration to the Water Rat in *The Wind in the Willows* (1908), that paean to English rentier-class domesticity and country living: "It was snowing hard as I beat through the passes of the great mountains, and I had a stiff fight to win through; but never shall I forget the blissful feeling of the hot sun again on my back as I sped down to the lakes that lay so blue and placid below me, and the taste of my first fat insect!"[3]

Both Norman Douglas and D. H. Lawrence found that contrast had much to do with the appeal of Italy. North, or at least England, meant dingy skies, dingy cities, grinding poverty, and the industrialization responsible for much of the first three blights. Whereas the sibilant South meant sun, gaiety in the midst of a snowless poverty, and the sort of easy living that allows for an active leisure—that is, conversation and art—at least for those not condemned to fourteen hours of grinding labor a day, trying to fill their families' bellies from a few stony acres: namely, for Englishmen able to take advantage of a good exchange rate.

The North also meant puritanism, the legacy of Protestantism that oppresses the natural impulses whenever and wherever they arise. In Lawrence's case, he summarized these impulses under the term *phallicism,* of which we shall hear more in a few moments. In Douglas's case, we are talking of something less obscure, pederasty, boy-love, or, as we would say today, child molestation. In *The Victorians and Ancient Greece,* Richard Jenkyns has explained the attractiveness of Italy for homosexuals:

> Sexual activity was unsafe in England [particularly for members of the upper classes who were attracted to the lower classes, since it was class structure rather than morality that the relevant laws sought to enforce], but in Italy one was out of danger, and there were plenty of peasant boys and fisher lads who would be happy to oblige. Hence that well-heeled succession of minor littérateurs who expired in Tuscan villas or Venetian palazzi, surprising their relations by the size of the legacies bequeathed to their devoted manservants.[4]

The trial of Oscar Wilde in 1895 reminded fin-de-siècle English homosexuals of the risks they ran at home; Italy never looked more appealing. Ancient Greece might be the literary and idealistic topos for homosexual activity, but modern Italy was the practical topos. That situation has altered somewhat today. Modern Greece is the mise-en-scène for many a gay Romance novel. And an ancient historian I know, of unimpeachable fame and respectability, has dined out quite a few times on the hilarious story of two local boys on a beach in southern Crete who tried to extract a few drachmas

from him for a private sex show they would put on. "Maybe when I'm older," is how he declined.

It might seem that these two contemporaries, Lawrence and Douglas, who loved the same country, hated the same constraints of English conventionalism, and who knew each other for years, should agree about what Italy stood for and engage in friendly competition to portray that meaning in print. Not so, alas, and the three books each wrote about Italy might as well have been set in two different countries.

Indeed, they are about different countries. Douglas, despite a lengthy residence in Florence, set his two travel books, *Siren Land* and *Old Calabria*, and his novel *South Wind* in southern Italy, and a major theme in them all is the still-pervasive influence of the ancient Greek colonists of the region. (Douglas's two monographs on southern Italy, *A Footnote on Capri* and *Summer Islands*, are purely antiquarian rather than argumentative.) Despite a long stay in the south, on Sicily, Lawrence set his first two Italy books, *Twilight in Italy* and *Sea and Sardinia*, in the peripheries of Roman influence, around the Lago di Garda and on Sardinia, and he loathed the expatriate scene on Capri that so amused Douglas. He wrote to Lady Cynthia Asquith that the view was beautiful, "but Capri itself is a gossipy, villa-stricken, two-humped chunk of limestone."[5] It was, however, among the Etruscan settlements and cemeteries of Tuscany, a topos antithetical to all he defined as Roman, that he at last found or imagined a sympathy between the spirit of place and the spirit of Lawrence, and he commemorated that sympathy in one of his last works, *Etruscan Places*. And so we have two modern pagans, each claiming Italy as a region that embodies, or receives, his peculiar notion of earthly paradise—and arguing with the other over the difference, like two peasants from rival villages, each insisting the Blessed Virgin of *his* village's church is the only true one.

Douglas first came to southern Italy at the age of nineteen, on a holiday with his brother. Nine years later, after several more brief visits, he bought a villa on the Bay of Naples, sight unseen. Although he paid a brief visit to Greece in 1920, wrote a pleasant enough fragment about Athens, "One Day,"[6] and combined an interest in natural history with his rather specialized philhellenism in *Birds and Beasts of the Greek Anthology*,[7] in fact he did not care for the country or its modern inhabitants. Instead, he preferred to admire ancient Greece chiefly through its cultural and genetic persistence in that part of the Italian peninsula called Magna Graecia, the region from the Bay of Naples on south that was colonized by the Greeks in the eighth and seventh centuries B.C. In this preference he was like those eighteenth-century travelers—Goethe and Winckelmann, for example—who sought Greece not directly but via Rome, believing that the best in a dying Hellenic culture had been taken up by imperialist Rome and passed on to the West, where it safely resides in museums and libraries. Greece itself was thought

to have little to offer besides vague associations, hardly worth the considerable effort of getting there. But Douglas was also unlike those early travelers: he found, and devoted himself to finding, in the countryside of southern Italy, a substantial residue of what he understood to be the Greek ethos, a kind of rational sensuality. In the words of his biographer Mark Halloway, "He looked askance at the present, preferred to look backwards rather than forwards, thought humanity had reached its peak in ancient Greece, and that the chief business of life was to enjoy oneself, by which he meant to be able to do what one wants to do."[8]

One thing he wanted to do was research: the dusty monographs and treatises about his chosen region both delighted and enraged him quite as much as the people Lawrence met on his travels delighted and enraged *him.* But Douglas was also after more than the pleasures of the printed word.

While the history, *petite histoire,* geology, and botany of southern Italy entertained his mind, which doted on abstruse information and anecdote, the girls, hired on long-term arrangement from their families, and later the catch-as-catch-can boys, entertained his body. The sexual license that the ancient Greeks extended to men bridged the gap for him between the mind and body, since anything the Greeks did was profoundly intellectual. And their notorious idealization of boy-love enfranchised his own growing proclivities for pederasty. "And the Greeks?" he wrote in *Siren Land,* in a passage that strongly suggests a tendentious reading of Nietzsche:

> The idea that we entered the world tainted from birth, that feeling of duty unfulfilled which is rooted in the doctrine of sin and has hindered millions from enjoying life in a rational and plenary manner—all this was alien to their mode of thought. A healthy man is naturally blithe, and the so-called joy of life of the ancient Greek is simply the appropriate reaction of the body to its surroundings.

The southern Italians, being Greek in origin, withstood the ravages of Christianity better than Douglas's northern kin:

> They received Jewish ascetics upon a foundation of a classical culture, as men; we, "as a little child" whose organism was susceptible like that of the Pacific islanders when catarrhs were introduced. They were never taught to disrespect the *encumbrance* of Oriental dreamers—the human body, that exquisite engine of delights; the antagonism of flesh and spirit, the most pernicious piece of crooked thinking which has ever oozed out of our poor deluded brain, has always been unintelligible to them.[9]

Although Douglas goes on to admit that Plato and various mystery cults overthrew this ancient ideal—just as Lawrence blames Socrates and Greek rationalism for the overthrow of Etruscan symbolic thought[10] —he finds it persistent in the easy, disingenuous Neapolitan attitude toward life's pleasures. In a footnote to *Late Harvest* (1946), a collection of casual reflections

on his life and writings, he makes explicit in connection with *South Wind* what he chose to keep strictly implicit in the novel: "What calls for treatment is not so much homosexuality as the diseased attitude adopted towards it in non-Latin countries. This attitude is the outcome of Judeo-Christian teaching, as interpreted by Puritanism."[11] Douglas was, of course, making the then-commonplace identification of homosexuality with pederasty.

The whole point of the novel *South Wind* (1917), set on an island called Nepenthe ("Forgetfulness")—an only thinly fictionalized version of Ischia and Capri combined—is that the northern landscape requires more labor on the part of its inhabitants, allows for less play of the mind and body, and thus suits, reinforces, embodies the Puritan ethic. A Mediterranean landscape, with its comparatively easy living and pagan undercurrent, *au contraire*, embodies the Greek way. "We have only a certain amount of energy at our disposal. It is not seemly to consume every ounce of it in a contest with brute nature. Man is made for better things," Count Caloveglia, an impoverished stand-in for Douglas, says to Bishop Heard, a visiting Anglican on his way home to England from missionary work in Africa. The Mediterranean, consequently, is the hope for civilization as well as its source: "Living in our lands, men would have leisure to cultivate nobler aspects of their nature. They would be accessible to purer aspirations, worthier delights. They would enjoy the happiness of sages."[12]

Such a prediction rings ridiculous now that the shores of the Mediterranean, from Malaga to Marmaris, have been inundated with hordes of tourists and time-sharers, and civilization is none the better for it.

In the course of the novel, Bishop Heard enjoys an improbable conversion to pagan ways, defined chiefly in terms of their opposition to Christianity and the northern European ethos. In conversation with Mr. van Koppen, a fabulously wealthy American who has made his fortune in the manufacture of condoms, he admits: "What is the use of civilization if it makes a man unhappy and unhealthy? The uncivilized African native is happy and healthy. The poor creatures among whom I worked in the slums of London are neither the one nor the other; they are civilized."[13] The Africans, in Douglas's almost Hegelian construct, are blessed with rude animal health and happiness. Northern Europeans have a civilization of a cold and pleasureless sort. Only the Mediterraneans enjoy a synthesis of the best in both Nature and Culture.

By the end of the novel, Bishop Heard has witnessed the murder of a scoundrel by a fine woman who has no other way to protect herself, her honor, and her child. For the first time in his life, he allows his emotions, now instructed by the ways of Nepenthe, to outweigh his moral reason. The spirit of the place has boxed his English heart. He keeps mum about the murder and finds he is happy to do so. The conversion is complete. Paganism has vanquished the Church of England. Q.E.D., in this novel of ideas,

and *finis* to Douglas's intellectual development: once he settled into the expatriate role of antiquarian roué, he stayed with it. Lawrence, on the other hand, played vagabond artist first, then primitivist, and at last apocalyptic visionary of a gilded Arcadia.

Lawrence's choice of places for his first two Italy books seems almost accidental in contrast with Douglas's programmatic preference. In the fall of 1912, he came to Lake Garda with Frieda von Richtofen, wife, but not for much longer, to one of Lawrence's professors at Nottingham University, a Professor Weekly, who authored a rather famous book called *Adjectives and Other Words*. Frieda also happened to be cousin to the Red Baron, although he wasn't yet called that. On the bare face of it, their temperaments seemed doomed to divorce.

Tuberculosis, to which Lawrence eventually succumbed, was the most deadly disease in Britain until the 1870s; and Mediterranean travel, especially in the wintertime, was seen as a refuge for consumptives.[14] The shores of Garda gave Lawrence and Frieda a sunny picturesque setting in which to enjoy each other and provided him with the peace he needed both to work hard on three novels in progress and to absorb impressions for six travel sketches collected under the inappropriately somber title *Twilight in Italy* (1913–16).

While Douglas as a travel writer was concerned with the historical and literary associations of a place—in other words, antiquarian lore—Lawrence was entirely taken up with personal confrontations in a landscape, or personal confrontations *with* the landscape. Dusty facts only got in the way. In *Etruscan Places* he mocks the antiquarian, as personified by a young German archaeologist, full of information but no meaning.[15] He scorned the European cultural mainstream that Douglas found his natural element. And yet, as Clive James remarks, "Lawrence is beyond the reach of any other modern writer writing about what can be seen, since whatever could be seen he saw instantaneously and without effort—which is probably why he could regard it as nothing but the periphery of the real."[16] We hear what Douglas tells us about a place, we see what Lawrence tells us about it.

Lawrence's excellent eye, at once sensitive to detail and given to symbol making, partly excuses the breeziness of his descriptions. Rebecca West, taken to meet him by Norman Douglas in Florence in 1921, recalled the experience:

> So it was a small room in which [Lawrence] sat tapping away at a typewriter. Norman Douglas burst out with a great laugh as we went in and asked if he were already writing an article about the present state of Florence; and Lawrence answered seriously that he was. This was faintly embarrassing, because on the doorstep Douglas had described how on arriving in a town Lawrence used to go straight from the railway station to his hotel and immediately sit down and hammer out articles about the place, vehemently and

exhaustively describing the temperament of the people. This seemed obviously a silly thing to do, and here he was doing it.

But some nine years after the encounter she came to understand

that he was writing about the state of his own soul at that moment, which, since our self-consciousness is incomplete, and since in consequence our vocabulary is also incomplete, he could only render in symbolic terms: and the city of Florence was as good a symbol as any other.[17]

Like countless transalpine travelers before and after him,[18] Lawrence felt the appeal of the South: "It is strange how different the sun-dried, ancient, southern slopes of the world are, from the northern slopes. It is as if the god Pan really had his home among these sun-bleached stones and tough, sun-dark trees. And one knows it all in one's blood, it is pure, sun-dried memory."[19]

He noted the earthy friendliness and joie de vivre that has delighted many a visitor to the Mediterranean, as in this passage about his hosts in San Gaudenzio: "We ate in the kitchen, where the olive and laurel wood burned in the open fireplace. It was always soup in the evening. Then we played games or cards, all playing; or there was singing, with the accordion, and sometimes a rough mountain peasant with a guitar."[20]

But Lawrence also found in Italy a carnal spirituality that he elevated into his private religion, as when he witnesses a childless man playing with a relative's baby boy:

This, then, is the secret of Italy's attraction for us, this phallic worship. To the Italian the phallus is the symbol of individual creative immortality, to each man his own Godhead. The child is but the evidence of the Godhead. And this is why the Italian is attractive, supple, and beautiful, because he worships the Godhead in the flesh. We envy him, we feel pale and insignificant beside him. Yet at the same time we feel superior to him, as if he were a child and we adult.[21]

The Italian peasants are the acolytes of this cult. Lawrence fantasizes about the married life of his landlord and landlady, Paolo and Maria, quondam aristocracy, to be sure, but still people of the soil. First in vague generalities:

Paolo and she were the opposite sides of the universe, the light and the dark. Yet they lived together now without friction, detached, each nature passionate, vehement. But the lines of their passion were opposite. Hers was the primitive, crude, violent flux of the blood, emotional and undiscriminating, but wanting to mix and mingle. His was the hard, clear, invulnerable passion of the bones, finely tempered and unchangeable. . . . They were both violent in desire and of strong will. They came together at once, like two wrestlers almost matched in strength. Their meetings must have been splendid.[22]

And then, in ten pages of detailed description, he dotes on their daily routine, their way of procuring a livelihood, and their various opinions on the state of the world: as if he were any of a thousand culture-shocked scribblers of tedious travel books.

For Lawrence, in common with a number of English travel writers such as Leigh Fermor, was what the Russians call a *narodnik*, a peasant-fancier like old Count Tolstoy. He could admit the crushing effect of savage peasant life, as in the "Califano" chapter of *The Lost Girl* (1920): "There is no mistake about it, Alvina was a lost girl. She was cut off from everything she belonged to. Ovid isolated in Thrace might well lament. The soul itself needs its own mysterious nourishment. This nourishment lacking, nothing is well."[23]

Peasants and other primitives supplied some of the mysterious nourishment that Lawrence's soul needed—namely, proof that the good old instinctual ways still survived in the interstices of evil mechanized civilization. At least, he needed the peasants until they offended or disappointed him, after which he would transfer their attributes to the next people and place he moved on to. What he seems most of all to admire in peasant society is the male bonding, as in this passage, which reads like something by a Hemingway out of the closet:

> Sometimes we had a dance. Then, for the wine to drink, three men came with mandolines and guitars, and sat in a corner playing their rapid tunes, while all danced on the dusty brick floor of the little parlour. No strange women were invited, only men; the young bloods from the big village on the lake, the wild men from above. They danced the slow, trailing, lilting polka waltz round and round the small room, the guitars and mandolines twanging rapidly, the dust rising from the soft bricks. There were only the two English women: so men danced with men as the Italians love to do. They love even better to dance with men, with a dear-blood friend, than with women. "It's better like this, two men?" Giovanni says to me, his blue eyes hot, his face curiously tender.[24]

Norman Douglas, on the other hand, writing in *Old Calabria* roughly about the same time (1915), scorns peasants as that "shifty, retrogressive and ungenerous brood, which lives like the beasts of the field and has learnt all too much of their logic":

> Apart from the creature of fiction, the peasant *in fabula* whom we all know, I can find little to admire in this whole class of men, whose talk and dreams are of the things of the soil, and who knows of nothing save the regular interchange of summer and winter with their unvarying tasks and rewards. None save a Cincinnatus or Garibaldi can be ennobled by the spade.[25]

Lawrence fictionalized Douglas as James Argyle in *Aaron's Rod* (1922) and has him describe some Old World peasants around Monte Cassino, "with the hard, small bony heads and deep-lined faces and utterly black minds, crying their speech as crows cry, and living their lives as lizards

among the rocks, blindly going on with the little job in hand, the present moment, cut off from all past and future, and having no idea and no sustained emotion, only that eternal will-to-live which makes a tortoise wake up once more in spring."[26]

And yet Lawrence, too, had to admit that peasant Italy had been spoiled beyond redemption, that the peasant's life was now a slave life, one of poverty and drudgery, without the satisfactions of the old organic society: "It is passing away from Italy as it has passed from England. The peasant is passing away, the workman is taking his place. The stability is gone."[27]

Sea and Sardinia is Lawrence's best travel book—indeed, one of the best travel books ever, with a short opening paragraph to challenge every future attempt at the genre: "Comes over one an absolute necessity to move. And what is more, to move in some particular direction. A double necessity then: to get on the move and to know whither."[28] The typically Laurentian repetition of words and the syncopation and inversion of syntax capture the viatic urgency.

With much mention of food and market prices, it is also Lawrence's most down-to-earth book. He (with rucksack) and the q-b, or queen-bee, Frieda (with large handbag), together (with the kitchenino, a holdall containing thermos, spirit stove, plates and basic supplies), travel around the island for a mere week and thoroughly disabuse themselves of enchantment with modern Italy and the peasantry. (Norman Douglas, by contrast, carried a silk handkerchief the exact shade of yellow he wished restaurants to season his risotto to with saffron.)

Theirs is the standard tourist's lament over a place ruined for and by money: "Romantic, poetic, cypress-and-orange-tree Italy is gone. Remains an Italy smothered in the filthy smother of innumerable lira notes: ragged, unsavoury paper money so thick upon the air that one breathes it like some greasy fog. Behind some greasy fog some people may still see the Italian sun. I find it hard work."[29] And again, where the neat and frugal Englishman in Bert Lawrence's soul is affronted by the conditions of a Sardinian inn:

> "Why," say I, lapsing into the Italian rhetorical manner, "why do you keep an inn? Why do you write the word Ristorante so large, when you have nothing to offer people and don't intend to have anything. Why do you have the impudence to take in travellers? What does it mean that this is an inn. What, say, what does it mean?"[30]

In contrast to which we have Douglas's cavalier disdain:

> An average white man will seldom find, in any Calabrian hostelry, what he is accustomed to consider as ordinary necessities of life. . . . On your entrance nobody moves a step to enquire after your wants; you must begin by foraging for yourself, and thank God if any notice is taken of what you say.[31]

And even when, rather late in the day (1952), Douglas admits the ruination of his beloved Capri, he does so with a world-weary sigh rather than an enraged Lawrentian blast: "The gentle islanders have grown rich, rich beyond the dreams of avarice, and almost turn up their noses at *soldi;* while travelers are beginning to turn up their noses at Capri, whose odors, to tell the truth, are not always of violets." And he remarks on the transformation from a producing economy to a service economy with only a wry, "Where will it end?"[32]

The first paragraph of Lawrence's book explains how the cultural crudity of Sardinia drew him to choose that island as his destination: "Sardinia, which has no history, no date, no race, no offering. Let it be Sardinia. . . . It lies outside; outside the circuit of civilization. . . . It lies within the net of this European civilization, but it isn't landed yet. And the net is getting old and tattered. . . . Sardinia then. Let it be Sardinia."[33] Yet it is a book full of observations as bright and striking as sunbeams: "Lemon trees, like Italians, seem to be happiest when they are touching one another all around."[34]

Nevertheless, it is not a place he was drawn back to, for it never loomed as a fit representative of "the old phallic consciousness." It was up to a land unreachable without a time machine to claim that honor—Etruria, as inhabited by the people of Lawrence's dreams.

Etruscan Places is a strange little book, as eerily lighted as the subterranean world of Jules Verne's *Journey to the Center of the Earth.* The heat from the author's pen transforms the dusty facts until they glow like the miraculous relics of a new religion on the patron saint's feast day. On the one hand, we have the archaeology of the place—which Lawrence studied on and off for ten years, so that his most rhapsodic fancies usually have some basis in fact—and we have also the mundane details of a travel book. On the other hand, we have pronouncements on Etruscan culture of such wide-sweeping egotism that we soon realize that Lawrence under the guise of describing other people and other places is, as always, writing about himself at home in his own heart—and that at long last he has found apt recipients for this projection of self. In Lawrence's case, the pathetic fallacy claims a kernel of truth to justify its swagger.

Why the Etruscans, those Harpo Marx–like figures who scamper curly-haired through early Italic history, affecting everyone they come across, always smiling, always chasing the girls, always hungry, revealing before long a surprising dexterity with physical objects and an equally surprising talent for music, never ever saying a word, at least not a word we can understand? Well, for three reasons and then some.

They were in truth the sort of people to appeal to Lawrence and fit to serve as sacred icons of the "old phallic consciousness." In Compton

Mackenzie's *The West Wind of Love,* Daniel Raynor, a character based on Lawrence, says:

> "I want to find people who think here," and points to his fly, continuing, "I may find them in the South Pacific. I may find them in Mexico. They're not to be found any longer in Europe. I believe they vanished with the old religion of Etruria. I believe those damned Romans destroyed them in Europe."[35]

By way of corroborating what Lawrence is going to say about his chosen people, let us glance first at Michael Grant's description of them in *The Etruscans* (1980), a reliable survey of the sort Lawrence was quite familiar with (namely, works by George Dennis, Pericles Ducati, Fritz Weege):[36] "Uninterested in the classical principles of propriety, they went all out to capture the instant, unrepeatable visual flash . . . they expressed the world of their own imaginings by inconsequential improvisations, characterized by force and fantasy and charm."[37]

Indeed, Grant's description of the Etruscans could very well apply to Lawrence's own style and intent. But there's more: "All the ancient library sources agree, and wall-paintings and reliefs of banquets and other festivities abundantly confirm, that the women of Etruria, or at least the more important of them, enjoyed far greater freedom than their Greek counterparts."[38] In this connection it is important to note that Lawrence, despite his proselytizing of phallicism, admired strong, even rebellious, women, for without them phallicism would languish.

"They retained the sort of magical, mystical, illogical interpretation of phenomena which the Greeks had early begun to discard in favour of a gradually strengthening rationalism that remained meaningless to the Etruscans," Grant says. "Like Romantics and Freudians of later ages, the Etruscans believed that there are mighty spheres of activity in which reason does not and cannot penetrate at all."[39] And for Lawrence at the end of his life, perhaps the most important thing was the Etruscan attitude toward death. Grant continues: "Most Greeks, in their various ways, believed in a life after death, but their views included nothing to compare with the intense conviction of the Etruscans that death was not a real break in continuity at all but a prolongation and perpetuation of life on earth."[40] This belief in the afterlife is declared in and confirmed by the wall-paintings in their tombs, so full of scenes of feasting, dancing, piping. Grant refers to "the unrestrained gaiety of these paintings, all metaphors for a happy activity after death."[41]

Secondly, the Etruscans appealed to Lawrence because they were conveniently dead and mute. Their past could be titled a Golden Age, and no annoying incident at an inn or on a ferry could turn them for Lawrence from charming primitives to filthy degenerates, as happened to him on Sardinia and

elsewhere. Nor could any texts refute his pronouncements, since the Etruscan language was dead by the first century A.D. and the surviving texts too brief to allow decipherment. Lawrence had only visual evidence to interpret, at which he was much more adept than at dealing with documents that might refute his exegesis.

And finally, Lawrence had run out of places to visit and nearly out of life to live. "Headquarters," as Clive James puts it, "tended to be where Lawrence was not."[42] Eventually he'd been almost everywhere, and been disappointed. If he was to have his say about a people and a place that once upon a time embodied phallicism, then he had best get on with it about the Etruscans. Since he claimed their language and religion were aboriginal,[43] and thus as instinctual as human institutions can get, they served him better than any living peasants.

There's a codicil of little reasons, too, for Lawrence's interest. The Etruscans were not the obvious dead civilization to idolize, like the Greeks: Lawrence's egotism shied away from obvious choices. The Greeks, moreover, were popular with the Bloomsbury group—located so conveniently near that greatest Greek colony of them all, the British Museum—and Lawrence loathed the Bloomsbury group. Also, in dealing with the Greeks, Lawrence would have had to confront his own homosexualist side, to borrow a terminological angle from Gore Vidal that seems the best way to deal with the unresolved issue of Lawrence's sexual bent—unresolved because *he* never resolved it. The one time he did confront it in writing, he destroyed the work (a bit more of this in a moment).[44] But if the Etruscans were not the Greeks, they also weren't the Romans.

Always the dualist, like his Zoroastrian admirer Anthony Burgess, Lawrence needed a hellish *that* to oppose to the paradisiacal *this* he had at last settled on:

> The Etruscans were the people whom the Romans, in their usual neighborly fashion, wiped out entirely in order to make room for Rome with a very big R. This seems to be the inevitable result of expansion with a big E., which is the sole *raison d 'être* of people like the Romans . . . those, pure, clean-living, sweet-souled Romans, who smashed nation after nation and crushed the free soul in people after people.[45]

On the other hand, the notorious viciousness of the Etruscans he blithely writes off to mere human nature.

Etruscan artifacts, viewed in the museum at Perugia, first attracted Lawrence to this people and their region and drew him to visit the tombs at ancient Caere, modern Ceveteri. First stop in the town is what passes for a tavern, so that Lawrence can complain about the food and the wine. But this gives him the opportunity to observe a local shepherd and compare him to a faun—hairy legs, tuft of black beard, sly yellow eyes, long lashes,

vulnerable lips, and presumably other goatish attributes. Lawrence was fas-
cinated with goats. Two of the best poems in *Birds, Beasts and Flowers*
(1923) are "He-Goat" and "She-Goat." A handsome fellow passenger on a
train in *Sea and Sardinia* "seems as if he wears a black undervest. Then sud-
denly, one sees it is his own hair. He is quite black inside his shirt, like a
black goat."[46] The eyes of a rich peasant named Faustino in *Twilight in Italy*
have a strange half-diabolic gleam like a goat's. He is a vine-grafter, and
Lawrences writes: "It filled me with a sort of panic to see him crouched
flexibly, like some strange animal god, doubled on his haunches, before
the young vines, and swiftly, vividly, without thought, cut, cut, cut at the
young budding shoots, which fell unheeded on to the earth. Then again
he strode with his curious half-goatlike movement across the garden to
prepare the lime."[47] It was a fascination that Norman Douglas, with his
predilection for leafy trees and imberb boys, didn't share. He wrote in *Old
Calabria* about goats: "These miserable beasts are the ruin of south Italy, as
they are of the whole Mediterranean basin. What malaria and the Barbary
pirates have done to the seaboard, the goats have accomplished for the
regions further inland."[48]

Now as for that treatise Lawrence wrote on homosexuality, he called it
"Goats and Compasses," and he destroyed it in 1917.[49] The funny thing, of
course, is that goats are the least homosexual of creatures. Not that they're
especially heterosexual either. They are purely and simply phallic—a trait
that Lawrence doesn't seem to have been especially gifted with but admired
extravagantly in others. In his estimation, there was no more phallic a race
than the ancient Etruscans.

As he approaches the tombs at Caere, he immediately twigs, in his habit-
ual way when traveling, the spirit of the place: "There is a queer stillness and
a curious peaceful repose about the Etruscan places I have been to, quite
different from the weirdness of Celtic places, the slightly repellent feeling
of Rome."[50] The great symbol Lawrence found in Etruscan places was that
of phallicism, which he thought was symbolized in their art by the duck,[51]
and which I suppose could be defined as a sensual joy that transcends death,
a *rigor vitae* rather than a *rigor mortis*. It is responsible, he claims, even for the
easy, natural proportions of the tombs. "And death, to the Etruscan, was a
pleasant continuance of life, with jewels and wine and flutes playing for the
dance. . . . It was just a natural continuance of the fullness of life."[52]

The tomb paintings moved him most strongly, the festive scenes of
eating, flute-playing, dancing, drinking that are popularized in color
reproductions:

> It is the death-banquet; and at the same time it is the dead man banqueting in
> the underworld; for the underworld of the Etruscans was a gay place. While
> the living feasted out of doors, at the tomb of the dead, the dead himself feast-
> ed in like manner, with a lady to offer him garlands and slaves to bring him

wine, away in the underworld. For the life on earth was so good, the life below could but be a continuance of it.[53]

Ten pages later, he extracts from the corpus of Etruscan art an epitome of their philosophy of life; *epitome* may be the wrong word for anything Lawrence has to say, but *philosophy of life* about names it: "Behind all the Etruscan liveliness was a religion of life. . . . To the Etruscan all was alive; the whole universe lived; and the business of man was himself to live amid it all. He had to draw life into himself, out of the wandering huge vitalities of the world."[54]

Resting at a café near Tarquinia after visiting the tombs, he starts to envisage, or fantasize, the Etruscans as living in a Golden Age—very much as he fantasized about the lives of Paolo and Maria by the Lago di Garda:

> On a fine evening like this, the men would come in naked, darkly ruddy-coloured from the sun and wind, with strong, insouciant bodies; and the women would drift in, wearing the loose, becoming smock of white or blue linen; and somebody, surely, would be singing. . . . And surely, in those days, young nobles would come splashing in on horseback, riding with naked limbs on an almost naked horse, carrying probably a spear, and cantering ostentatiously through the throng of red-brown, full-limbed, smooth-skinned peasants.[55]

This is a world that never existed, except in Lawrence's mind, or in the murals of Puvis de Chavannes, crowded with youths who pose and caper in the nude for the sheer sport of it. Eroticism has been intellectualized here in this pagan City of God just as surely as it has been in Douglas's earthly paradise. This Arcadian realm was the only world left for Lawrence's imagination to dwell in. Having exhausted the globe in search of his ideal place, and exhausted himself in the process, he was ready to leave it and join those frescoed revelers in the Golden Age.

NOTES

1. Patrick Leigh Fermor, *A Time of Gifts* (New York, 1977), 211.

2. Norman Douglas, *Siren Land* (Harmondsworth, Eng.:, 1983) 196.

3. Kenneth Grahame, *The Wind in the Willows* (New York, 1908), 123. On the call of the south in Grahame's work, see Peter Green's introduction to the World's Classics edition (New York, 1983), vii–xx, and also Green's *Kenneth Grahame, 1859–1932: A Study of his Life, Work, and Times* (London, 1959), 163–64, 254–55, 296–98.

4. Richard Jenkyns, *The Victorians and Ancient Greece* (Cambridge, Mass., 1980) , 291.

5. D. H. Lawrence, letter of January 25, 1920, in Harry T. Moore, ed., *The Collected Letters of D. H. Lawrence*, vol. 1 (New York, 1962), 617.

6. Norman Douglas, "One Day," collected in *Three of Them* (London, 1930).

7. Norman Douglas, *Birds and Beasts of the Greek Anthology* (New York, 1929).

8. Mark Halloway, introduction, *Siren Land* (cit. n. 2 above), 1.

9. Douglas, *Siren Land,* 151–52.

10. D. H. Lawrence, *Etruscan Places* (New York, 1932), 94.

11. Norman Douglas, *Late Harvest* (London, 1947), 8 n. 4.

12. Norman Douglas, *South Wind* (New York, 1931), 87–88.

13. Ibid., 325.

14. John Pemble, *The Mediterranean Passion: Victorians and Edwardians in the South* (Oxford, 1987), 88.

15. Lawrence, *Etruscan Places,* 112.

16. Clive James, "D. H. Lawrence in Transit," in Stephen Spender, ed., *D. H. Lawrence: Novelist, Poet, Prophet* (New York, 1973), 159–169, at p. 160.

17. Rebecca West, *Ending in Earnest: A Literary Log, 1931,* excerpted in *Rebecca West: A Celebration* (New York, 1977), 388, 392–93.

18. In this regard, see Peter Green, *The Expanding Eye: A First Journey to the Mediterranean* (New York, 1957).

19. D. H. Lawrence, *Twilight in Italy* (New York, 1916), 299–300.

20. Ibid., 173.

21. Ibid., 78.

22. Ibid., 176–77.

23. D. H. Lawrence, *The Lost Girl* (London, 1920), 343.

24. Lawrence, *Twilight in Italy,* 176–77.

25. Norman Douglas, *Old Calabria* (London, 1938), 63–64.

26. D. H. Lawrence, *Aaron's Rod* (New York, 1922), 52, noted in the introduction to Norman Douglas, *D. H. Lawrence and Maurice Magnus* (Florence [?], 1924), 14.

27. Lawrence, *Twilight in Italy,* 172.

28. D. H. Lawrence, *Sea and Sardinia* (New York, 1930), 11.

29. Ibid., 58.

30. Ibid., 207–8.

31. Douglas, *Old Calabria,* 147.

32. Norman Douglas, *Footnote on Capri* (New York, 1952), 39–40.

33. Lawrence, *Sea and Sardinia,* 15.

34. Ibid., 23.

35. Compton Mackenzie, *The West Wind of Love* (New York, 1940), 298.

36. Jeffrey Meyers, *D. H. Lawrence: A Biography* (New York, 1990), 350.

37. Michael Grant, *The Etruscans* (New York, 1980), 62.

38. Ibid., 62.

39. Ibid., 64.

40. Ibid., 64.

41. Ibid., 65.

42. James, "D. H. Lawrence in Transit," 160.

43. Lawrence, *Etruscan Places,* 20.

44. B. T. Tracy, *D. H. Lawrence and the Literature of Travel* (Ann Arbor, Mich., 1983), 92–93.

45. Lawrence, *Etruscan Places,* 11, 12, with cuts.

46. Lawrence, *Sea and Sardinia,* 161.

47. Lawrence, *Twilight in Italy,* 199.

48. Douglas, *Old Calabria,* 208.

49. See Jeffrey Meyers, "D. H. Lawrence and Homosexuality," in Spender, ed., *D. H. Lawrence: Novelist, Poet, Prophet,* 135–46, at p. 136; and Meyers, *D. H. Lawrence: A Biography,* 215.

50. Lawrence, *Etruscan Places,* 23.

51. Ibid., 96.

52. Ibid., 28.

53. Ibid., 70.

54. Ibid., 88–89.

55. Ibid., 106.

Macedonia Redux

Eugene N. Borza

A nation is a group of people united by a common error about their ancestry and a common dislike of their neighbors.

ROBERT R. KING, *Minorities under Communism*

An essay on modern political culture in a volume devoted to reciprocity in life and art in the ancient world may require a word or two of explanation. The theme of what follows is the modern rebirth of ancient Macedonia as a symbol of nationalism in a part of the Balkans that has been a killing ground in recent times. Many contemporary observers have attempted to reinvent the ancient history of the region in order to fit the necessities of their own lives and the vagaries of modern Balkan politics. It is a distorted reflection of the past, which, in its warped form, serves a purpose useful beyond the romantic antiquarianism of the classroom, the tourist path, and the museum. Midst the great body of Peter Green's scholarship on literature, art, and the history of antiquity, one must not lose sight of the fact that he is one of our most perceptive observers of modern Greece, having lived among Greeks for several years, and having understood them better, perhaps, than they might have wished. Green's essays in publications such as the *New York Review,* the *New Republic,* and the *Times Literary Supplement* are a rich source of insight for anyone who not only wishes to know something about contemporary Greece, but also requires some understanding of the issue of continuity and discontinuity between the past and present.[1] I hope that he will accept this essay in the spirit he has expressed in his own work on like subjects.

In the spring of 1993 I taught an undergraduate senior seminar to History majors, the topic of which was "Ethnic Minorities and the Rise of National States in the Modern Balkans." We examined the status of minorities following the founding of Serbia (1815), Greece (1832), Bulgaria (1878), Albania (1913), and Yugoslavia (1918). Not long into the semester I asked my American students to identify their own ethnic backgrounds. One young

woman said proudly that she was "Macedonian." Grist for my mill. I asked her what that meant: was she Greek or Slav? She answered that she was Macedonian, and certainly not Greek, although she pointed out that she had spent most of her school life pretending that she was Greek, for, whenever her teachers asked about her ethnic background and she answered "Macedonian," they responded, "Oh, you must be Greek." Now, as an honors student and a senior at a major university, she had stopped pretending she was Greek, and took my seminar in part to help her learn something about her Slavic Macedonian background.

Her family lived near a decaying central Pennsylvania mill town called, appropriately, Steelton. About halfway through the semester, the student told me that she had visited her church cemetery in Steelton, and that she had seen a number of gravestones on which the deceased had been identified as having been born in "Macedonia." I asked what the dates of burial were, and she said "Oh, the 1950s." "Not good enough," I responded, "Next time you visit, look for earlier dates," knowing that by the 1950s it would not be unusual for birthplaces to be given as "Macedonia" in light of the federal status of Macedonia as a Yugoslav Republic. About two weeks later my student informed me that she had seen gravestones of the 1930s with the Macedonian identification. I jumped at the chance. "I'm going to pay you a visit in Steelton," I told her. "Find some old-timer in your church, and let's go looking for gravestones."

Steelton is located along the Susquehanna River, just south of Harrisburg. The deteriorated mills, now largely deserted, stretch along the river, separated from a dilapidated old working-class community by a highway. Affluence has lured many people into the suburbs of Harrisburg a few miles away, and the houses and people who remain have clearly seen better times. The town climbs a bluff from the river. The higher parts are marked by greenery, better kept and larger homes, and bits of parkland. On the summit of one of the highest bluffs is an open, grassy area of several acres, the site of the Baldwin cemetery. Within lie the remains of immigrants who escaped the violence and poverty of Balkan life generations ago to seek economic well-being in the mills of Steelton.

The old woman who accompanied us knew the history of the cemetery and the churches whose members were buried there. One of the first things that struck me was that, by and large, the deceased who were identified as Serbs, Bulgarians, or Macedonians were buried in separate parts of the cemetery. In death, they sought the separation that sometimes eluded them in life. The old Macedonian woman had little but contempt for the Serbs, many of whom she had known, but she sometimes appeared confused by the distinctions between Macedonians and Bulgarians. For until the establishment of the Macedonian Autocephalous Orthodox Church in 1967,[2] the Macedonians belonged to either the Bulgarian Orthodox Church or to

the "Macedonian-Bulgarian" Orthodox Church described on a few grave-
stones. Indeed, the Macedonian community in Steelton had apparently
experienced internal division over whether their priests should most legiti-
mately have been trained in Macedonia or in Bulgaria.

We picked our way past hundreds of gravestones, stopping to take pho-
tographs[3] and looking for earlier dates. Some stones were engraved in Latin
letters, most in Cyrillic. A few decrepit headstones had been replaced with
new ones, but most were original, and I mused that my old teachers of epig-
raphy would have been pleased that many of the techniques used to exam-
ine ancient inscribed stones were useful in this twentieth-century American
cemetery.

Nearly all the deceased had been born in the southwestern Macedonian
town of Prilep, about forty miles northeast of the Greek frontier above Flo-
rina. Several stones appeared with death dates in the 1920s, and a few in
the 'teens. We halted at the edge of the cemetery, where the hillside had
begun to collapse into a valley. I was told that the earliest gravestones had
fallen away down the slope, and that the presence of snakes and ticks made
the descent perilous. I was satisfied, for at my feet was an intact gravestone
with the name of the deceased who had been born in "Prilep, Macedonia"
in 1892, and who had died in Steelton in 1915. I was stunned. Here was
clear evidence of a man who died in a central Pennsylvania mill town only
two years after the Second Balkan War, and was identified at his burial as a
Macedonian.[4]

A subsequent trip to the cemetery in 1995 confirmed and enlarged the
data base. I now have 30 gravestones in my photo file, the most interesting
one of which was discovered in my 1995 visit. It is a simple, weather-worn
headstone with the name of the deceased followed by (in English) "Mace-
done [sic] died Sep. 20, 1906 At Steelton Pa."[5] Thus, six years before the
First Balkan War in which the region of Macedonia was detached from the
Ottoman Empire by Serb, Greek, and Bulgarian armies, the reality of Mace-
donia/Macedonian already existed among Macedonian immigrants in cen-
tral Pennsylvania.

All of which is confirmed by reference to the 1920 United States census
report from Steelton.[6] The census-taker collected data from about 250 per-
sons who lived along Main Street in Steelton. Of the total 76 claimed to have
been born in "Macedonia," and to have "Macedonian" as their mother
tongue.[7] All 76 listed their parents as having been born in "Macedonia,"
with "Macedonian" as their mother tongue. Thus 228 persons were identi-
fied by a U.S. census taker in 1920 on a single street in Steelton as having a
Macedonian connection.

In the second century B.C. the Romans ended the independence of the five-
century-old kingdom of the Macedonians. During that period the Macedo-

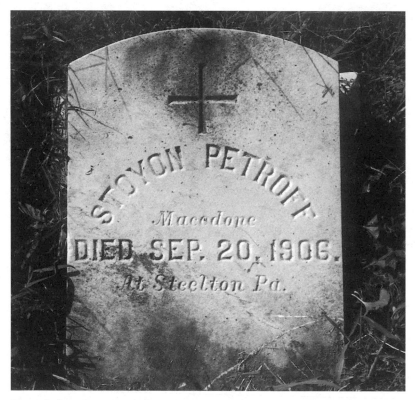

Figure 16.1. Gravestone, Baldwin Cemetery, Steelton, Pennsylvania. Photograph by Eugene N. Borza.

nians had emerged from the Balkan backwater to a prominence unanticipated and much heralded. Under the leadership of Philip II, the Macedonians conquered and organized the Greek city-states as a prelude to Alexander the Great's conquest of the Persian Empire. Macedon continued to produce talented kings during the Hellenistic era, sufficient to threaten the new Roman order in the East, and perhaps even Italy itself.

The Macedonian kingdom was absorbed into the Roman Empire, never to recover its independence. During medieval and modern times, Macedonia was known as a Balkan region inhabited by ethnic Greeks, Albanians, Vlachs, Serbs, Bulgarians, Jews, and Turks. With the collapse of Ottoman rule in Europe in the early twentieth century, Greeks, Bulgarians, and Serbs fought for control of Macedonia, and when the final treaty arrangements were made in the 1920s, the Macedonian region had been absorbed into three modern states: Greece, Bulgaria, and Yugoslavia. Despite population exchanges, ethnic minorities were preserved in all states, for example, Slavs

and Turks in Greek Macedonia and Thrace, Albanians, Bulgarians, and Greeks in Yugoslav Macedonia (officially part of Serbia), Greeks in Albania, and Greeks and Turks in southwestern Bulgaria (Pirin Macedonia). Thus, recent claims based on ethnic conformity and solidarity notwithstanding, the region of Macedonia has, until well into the twentieth century, housed Europe's greatest multiethnic residue, giving its name to the mixed salad, "macédoine."

Peaceful ethnic pluralism has not been a common feature of Balkan life, save under authoritarian regimes such as the Ottoman and Hapsburg Empires and Yugoslavia under Tito. Attempts to establish ethnic purity in the region have varied from simple legal and religious restrictions against cultural expression to outright violence, as in the case of the Bosnian "ethnic cleansing" campaign of the 1990s. In modern Greece the purification device is "Hellenization," the absorption of non-Hellenes into the general Hellenic culture. In the forefront of the Hellenization movement has been the Orthodox Church, centered in the Greek partriarchate at Constantinople.[8] Its centuries-old effort to Hellenize the non-Hellenic Orthodox population of the Balkans was in keeping with the long-standing tradition of the Greek Church as the repository and protector of ancient Hellenism and Hellenic Christianity. Its success in this regard can be measured by the custom of the Turks, in their census reports, of identifying all Orthodox, without respect to ethnicity, as Greek, that is, adherents of the Church centered in Constantinople. With the growth of Serbian and Bulgarian nationalism, the Patriarchy unsuccessfully opposed the establishment of autonomous Serbian and Bulgarian churches in the nineteenth century, as it has the Macedonian church in the twentieth.

The emergence of a Macedonian nationality is an offshoot of the joint Macedonian and Bulgarian struggle against Hellenization. With the establishment of an independent Bulgarian state and church in the 1870s, however, the conflict took a new turn. Until this time the distinction between "Macedonian" and "Bulgarian" hardly existed beyond the dialect differences between standard "eastern" Bulgarian and that spoken in the region of Macedonia,[9] and, while there had been disputes over which dialect should be the literary language, the arguments were subordinated to the greater struggle against Hellenization. By 1875, however, the first tracts appeared favoring a Macedonian nationality and language separate from standard Bulgarian,[10] and the conflict had been transformed from an anti-Hellenization movement into a Bulgarian-Macedonian confrontation.

The region of Macedonia was freed from Turkish rule by the Balkan Wars (1912–13), and it was partitioned among Serbia (the Kingdom of the Serbs, Croats, and Slovenes in 1918, then Yugoslavia after 1929), Bulgaria, and Greece. Both Macedonian nationalism and a literary language continued to

develop, despite the hostility of the three states that now laid claim to the region.[11] Serbs and Bulgarians continued to regard Macedonian as a dialect, not a real language, although, as Thomas Magner once pointed out, the decision about when a dialect becomes a language is sometimes a political, not a linguistic, act.[12] The Greeks, under provisions of the Treaty of Sèvres (1920), were obligated to permit education and cultural outlets in native tongues for the minorities under Greek administration. Accordingly, a Macedonian grammar was produced in Athens in 1925,[13] but never used because of an anti-Slav political climate in Greece in the late 1920s and 1930s, and Greek governments have prohibited the public and private use of Macedonian ever since.[14]

The development of a Macedonian ethnicity continued apace as an internal phenomenon. During World War II, the German forces occupying Yugoslavia exploited latent nationalist feelings, most infamously in organizing the fascist Ustashi group in Croatia. Less well known, however, is the German recognition of Macedonian nationalism. When the Allies persuaded Bulgaria to abandon the Axis in the autumn of 1944, the Germans were forced to reorganize the occupation of Macedonia—which hitherto had been under Bulgarian control—and to assume direct occupation themselves. German administration of Macedonia was short-lived, but the fact that Bulgarian postage stamps used in the area were overprinted "Macedonia" in *Macedonian* suggests that the Germans were consistent in their policy of encouraging local ethnicity in Macedonia, as they had in several other places in Europe.

Thus it is clear that Tito did not invent either a Macedonian ethnicity or a Macedonian language—as has been alleged—when he created a Macedonian Republic as a part of the postwar Yugoslav federal state. He rather provided legitimacy and support for a movement that had been under way since at least the late nineteenth century.[15] Whatever the merits and flaws of Tito's Yugoslavia, it was an experiment in ethnic diversity, based on his recognition that the best hope for a unified South Slav state against traditional antagonists was to recognize and encourage ethnic development within the Yugoslav federal system. Tito's imprimatur on a Macedonian state was an attempt to counter traditional Bulgarian influence in the region of Macedonia. From the Yugoslav federal point of view, one of the best safeguards against the Bulgarians, who were traditional enemies of the Serbs, was to give recognition to the Macedonians as a separate south Slavic ethnicity. (As of this writing, the Bulgarians, like the Greeks, still do not recognize the Macedonians as a distinct nationality.) Tito's policy was the culmination of a process that had been under way for the better part of a century; he provided legitimacy for Macedonia and accelerated a natural passage of nation-building already well under way.

Which modern state has the most legitimate claim to the territory of the

ancient Macedonian kingdom? All and none. If the claim is purely geo-
graphical, Greece, Bulgaria, and the Republic of Macedonia have equal
claims on the land of the ancient Macedonians now lying within the bound-
aries of these respective national states. That is, the regions south of Skopje
in the Republic of Macedonia, around Thessaloniki in Greece, and around
Blavgoegrad in southwestern Bulgaria are equally situated within the land
of ancient Macedonia, and the residents of all three areas can claim legiti-
macy based on present occupancy.

If the claim is based on ethnicity, it is an issue of a different order. Modern
Slavs, both Bulgarians and Macedonians, cannot establish a link with antiq-
uity, as the Slavs entered the Balkans centuries after the demise of the ancient
Macedonian kingdom. Only the most radical Slavic factions—mostly émi-
grés in the United States, Canada, and Australia—even attempt to establish
a connection to antiquity.[16] For contemporary Greeks, however, it is a differ-
ent matter, as it is an article of faith among most of them that the ancient
Macedonians were Greek, and that no one but modern Greeks may claim
rights to the name and culture of the ancient Macedonians.[17] No matter that
genetic purity in the Balkans is a fantasy, or that there is no such thing as a
cultural continuity in the Macedonian region from antiquity to the present.
Politics in the Balkans transcends historical and biological truths.

The propaganda campaign in Greece has been forceful. And one need
not look to Greek governments as the source of the propaganda; the
feelings are widespread and deeply felt. There are sufficient private politi-
cal, cultural, and academic societies to formulate and maintain anti-
Macedonian sentiments.[18] In 1992, my students and I boarded an Olympic
airplane in Santorini for the flight to Athens. Pasted to the exterior of the
fuselage next to the rear door through which we entered was a printed
Olympic Aviation pilots' union sticker that read "MACEDONIA IS GREEK.
Always was, Always will be. STUDY HISTORY!" in *English*. During the short flight
to Athens, the cabin attendants passed out copies of the sticker to the pas-
sengers, most of whom were foreign tourists. The phrases "Macedonia. 4000
years [*sic*] of Greek history" and "Macedonia is Greek" became a feature of
ordinary Greek life, forming postmarks on letters processed in the mail sys-
tem, and even adorning the paper table mats distributed by an Athenian
wine company to Greek restaurants in the United States. Telephone cards
now widely used throughout Greece bear the inscription "Macedonia is one
and only and it is Greek," in Greek *and English,* despite the fact that for most
of the 2,600 years since the genesis of the ancient Macedonian kingdom eth-
nic Greeks have been a minority of the population. The overwhelming Hel-
lenic impact on Greek Macedonia is largely the result of the settlements and
population exchanges of the early 1920s. Even Thessaloniki, with its rich
Byzantine architectural heritage, counted far fewer Greeks than either
Sephardic Jews or Turks until after the Balkan Wars of 1912–13.

Rumor was rife in Athens that the paper currency of the Republic of Macedonia featured the White Tower of Thessaloniki, a monument that, although probably Turkish in origin, had come to symbolize the city since its incorporation into the Greek state in 1912. In fact, no monument that has at any time been within the boundaries of the Greek state appears on any Macedonian currency. The currency designs consist mainly of medieval churches, fortifications, and quaint village scenes.[19] And until recently, many persons in Athens believed the false rumor that the airport in Skopje had been named after Alexander the Great.

Nowhere is the battle fought more fiercely than among Greek and Macedonian émigré communities in Australia, Canada, and the United States.[20] Some of the energy in this conflict results from the passion of post–World War II immigrants from Macedonia who introduced a more intense anti-Bulgarian nationalism than had existed among the older generations of émigrés, some of whom still had some pro-Bulgarian feelings dating from the early twentieth century. Some of the conflict was generated by Greek immigrants reacting against the writings and demonstrations of the Macedonians, often exacerbated by the residue of hatreds generated by the Greek Civil War. And certainly the fervency and frequency of clashes among émigrés can be explained by the simple fact that they were freer to express their political views in their newly adopted Western democracies than they had been in their Balkan homelands. Such is the concentration of feeling among the émigrés that it is difficult to know whether they are being driven by governments in Athens and Skopje or are the driving force themselves. Among Greek and Macedonian émigrés, much of the hostility is directed toward one another, but there is another, more subtle, campaign designed to influence public opinion in the English-speaking world.

Among the opening rounds fired in the struggle for public opinion was an exhibition of antiquities that included recently excavated materials from the ancient Macedonian royal burials at Vergina in northern Greece. Opening in Washington in 1980, the exhibition and its offshoots toured a number of U.S., Canadian, and Australian cities during the next two years, under the title "The Search for Alexander." While undeniably a lavish display of rich and beautiful objects as well as a tribute to the skills of Greek archaeologists whose efforts produced the materials, the exhibition—for which the Greek government amended its own antiquities law in order to permit these items from the national heritage to travel abroad—was widely seen as a device to link modern Greece with ancient Macedonia.[21] The Macedonian community responded by establishing a chair in (Slavic) Macedonian Studies at the University of Melbourne, much to the outrage of the active Greek community in Australia.

In response, the Australian Institute of Macedonian Studies sponsored the First International Congress on Macedonian Studies, designed to "trace

the Greek origins of the people who inhabited Macedonia from earliest antiquity through to modern times."[22] It became clear to all concerned that many aspects of the Congress would become politicized, as the large Macedonian community in Melbourne was determined to disrupt the proceedings, which they believed were part of a "world-wide campaign organized by the Greek government" to deny the legitimacy and identity of the Macedonian people. For Melbourne is a hotbed of ill feeling between the Greek and Macedonian communities. There were shouting matches and occasional minor bloodshed in the streets.

In an effort to repair the damage done from a politicized 1988 conference, the Institute sponsored a second international congress in 1991, with its theme strictly confined to ancient Macedonia. Unlike the first congress, which was dominated by Greek speakers with a clear political agenda, the second was coordinated with faculty from the University of Melbourne, and a number of foreign scholars—including this author—were invited to participate. In general, the quality of papers, most of which were on "safe" subjects, was high. But Balkan political passions, always lying just beneath the surface, erupted as it became clear that both Greek and Macedonian émigrés and some scholars from Greece were unable to separate the past from the present. Analyses of the ancient Macedonians, however soundly based on impartial scholarship, that did not seem to support modern political views, were attacked, and at one point the Greek delegation from Thessaloniki refused to continue their participation in the scholarly sessions until a certain Western scholar apologized for having presented conclusions that appeared to them to be politically incorrect.

In 1989 (during which year, incidentally, a new exhibition of ancient Macedonian antiquities toured three Australian cities), the Pan-Macedonian Association, an umbrella organization of local Hellenic Macedonian cultural societies in the United States and Canada, produced a five-day symposium co-sponsored by Columbia University, "Macedonia: History, Culture, Art," a program of public lectures and seminars for high-school and college teachers on ancient, medieval, and modern Macedonia. Despite efforts by the Greek and American participants to avoid the most sensitive political issues, parts of the symposium were disrupted by Macedonian demonstrators from Toronto who had been denied an opportunity to present their point of view. In 1988, the Smithsonian Institution in cooperation with the Embassy of Yugoslavia presented a two-day symposium in Washington on the heritage and culture of the Socialist Republic of Macedonia. In 1990, the Smithsonian Associates presented a lecture series on the glories of Greece, with an emphasis on the Greek heritage in Macedonia.

Macedonian and Greek disputants, both private and government-sponsored, have thus courted the international scholarly community to provide a dignified venue for the continuing struggle. It appears to lend to the

conflict the legitimacy of the Academy: Columbia University, the University of Melbourne, the National Gallery of Art, the Smithsonian Institution. But each of these events was marked by behavior that could not be controlled, as extremists from one side or the other disrupted proceedings or— worse—the papers and discussion presented by representatives of the scholarly community failed to provide the analysis of the past so eagerly sought by the contending factions. Scholars neutral in the conflict and whose conclusions are based upon the rules of evidence are looked upon with scorn: Greeks and Macedonians do not want neutrality, they want support, and, failing to get it from those who possess legitimate scholarly credentials, they feel betrayed and become hostile.[23]

Many Greeks today on both official and popular levels are disappointed and bitter that the publicity given over to the Macedonian Question within Greece, much of it designed to influence foreign opinion, has had little effect. By 1994, most governments had recognized the new Macedonian state. Newspapers, geographers, cartographers, international postal authorities, and even beauty pageants throughout the world, like individual foreign governments, accepted the state as "Macedonia," although, even at the present writing, Greece continues to refer to it as FYROM (The Former Yugoslav Republic of Macedonia). That is, the Greeks have not been successful in their efforts to persuade the rest of the world of their position.[24] One Greek critic of the situation (see n. 25 below) has written with reference to German journalists visiting Greece: "They might have lent a more sympathetic ear to Greece's apprehensions and taken them more seriously had they not been greeted at every turn by the vast, shoddy industry that has been made out of the sacred names and symbols of Macedonia and the kings of the Macedonian dynasty purely for domestic consumption; had they not been peremptorily commanded by signs and leaflets at airports and stations to study Greek history, and dragged round museums and archaeological sites to be shown things they regarded as self-evident—with precisely the opposite effect from that which was intended."

Thus, whatever other reasons may account for the Greek failure, the style with which the Greek position was presented may have been a contributing factor. It was a negligence also to pay heed to the warning made in the 1920s by one of the greatest statesman in Greek history, when Eleftherios Venizelos warned that Europeans would not be moved by arguments about "Greek rights." The appropriate term is "Greek interests," a framework for persuasion that, if presented effectively, might help sway world opinion to the Greek side on matters of international concern.[25] In fact, sentimental Greek rights, not Greek interests, have dominated the Greek position in the present dispute. There is a strong Greek "interests" case to be made for stability, the recognition of existing frontiers, protection against external pandering to irredentist notions among ethnic minorities within Greece, and

economic cooperation in this part of the Balkans. But the Greeks have attempted mainly to appeal to "rights" based on the distant past, and in the doing so, have made claims about that past that have dubious scholarly foundations (although see n. 32).

This is a tale of two Balkan nation-states. One has a long, distinguished history based in part upon the fame of an ancient society and the heritage of Byzantine Christianity. Modern Greeks point with pride to the power and glory of their past. But there may be something else at work in the Greek mentality. Until the early nineteenth century, Greeks of the Diaspora had been prominent throughout Europe in diplomacy, commerce, and cultural affairs. The courts and counting houses employed or were managed by Greeks whose skills in these matters were legendary in Europe for centuries, and who had a telling influence on European life out of proportion to their small numbers. With the outbreak of the Greek War of Independence and the consequent establishment of the modern Hellenic state in the 1820s and 1830s, many of these talented Greeks joined the effort to build the new nation. But in so doing, Greek influence abroad waned.[26] In time, the Greeks, who had once been prominent in antiquity, in Byzantine times, and in modern Europe found that they were now relegated to obscurity, dependent upon major European states to provide financial resources and military security against the Turks, struggling to maintain a cohesive government in a remote tip of the Balkans, and engaged in an internal conflict between an imported authoritarian monarchy and the liberal notion that the inventors of democracy should have progressive constitutional government. Thus emerged one of the enduring characteristics of modern Greek life: a desperate attempt to regain a past glory, rooted in the cultural accomplishments of antiquity and the religious and political might of Byzantium. An identification with the ancient Macedonians is part of that attempt.

On the other hand, the Macedonians are a newly emergent people in search of a past to help legitimize their precarious present as they attempt to establish their singular identity in a Slavic world dominated historically by Serbs and Bulgarians. One need understand only a single geopolitical fact: As one measures conflicting Serb and Bulgarian claims over the past nine centuries, they intersect in Macedonia. Macedonia is where the historical Serb thrust to the south and the historical Bulgarian thrust to the west meet. This is not to say that present Serb and Bulgarian ambitions will follow their historical antecedents. But this is the Balkans, where the past has precedence over the present and the future.

The twentieth-century development of a Macedonian ethnicity, and its recent evolution into independent statehood following the collapse of the Yugoslav state in 1991, has followed a rocky road. In order to survive the vicissitudes of Balkan history and politics, the Macedonians, who have had no history, need one. They reside in a territory once part of a famous

ancient kingdom, which has borne the Macedonian name as a region ever since and was called "Macedonia" for nearly half a century as part of Yugoslavia. And they speak a language now recognized by most linguists outside Bulgaria, Serbia, and Greece as a south Slavic language separate from Slovenian, Serbo-Croatian, and Bulgarian. Their own so-called Macedonian ethnicity had evolved for more than a century, and thus it seemed natural and appropriate for them to call the new nation "Macedonia" and to attempt to provide some cultural references to bolster ethnic survival. One of these cultural references was the 16-pointed sunburst that was a symbol of the ancient Macedonians, as known from recent archaeological discoveries at the old Macedonian center of Aegae, near the Greek village of Vergina.[27] The yellow sunburst became the centerpiece of the new red Macedonian national flag, and was featured on a postage stamp. It was perhaps no coincidence that in the spring of 1992, only a few months after the declaration of Macedonian independence, the Greek government released a 100-drachma coin that bore the same symbol.[28] The sunburst appears on the arm patches of the uniforms of crowd-control police in Athens. It replaces the letter o in the logo of the Greek television network "Makedonia." It is the symbol of the Bank of Macedonia Thrace. It adorns some military vehicles on the streets of Athens, and is prominently displayed at the gates of an army camp at Litochoro below Mount Olympus. The Greek Parliament made the sunburst an official symbol of the Greek state, and the Great Sunburst War commenced, both sides claiming rights to the sunburst, with Greeks adamantly demanding that the Macedonians abandon their official use of the symbol. The conflict raged for three years, apparently ending in September 1995 when Macedonia agreed to relinquish the sunburst as a national symbol as part of negotiations designed to resolve a number of outstanding issues.

It is difficult to know whether an independent Macedonian state would have come into existence had Tito not recognized and supported the development of Macedonian ethnicity as part of his ethnically organized Yugoslavia. He did this as a counter to Bulgaria, which for centuries had a historical claim on the area as far west as Lake Ohrid and the present border of Albania. What Greeks seem not to have understood is that a viable small Macedonian state in the region where Bulgarians and Serbs have clashed in the past is perhaps the best security that Greeks could hope for along their northern border. Instead of encouraging the development of such a state, they have done virtually everything short of military action to thwart its continued existence. Common sense would dictate that a Greek-Macedonian alliance would be mutually beneficial. The Vardar-Axios river valley is the ancient historically significant route from the Aegean Sea to the inner Balkans. Close ties would benefit Thessaloniki, the outlet for such trade.

Moreover, Macedonia is poor and economically undeveloped; it had remained the backwater of modern Yugoslavia, as anyone who traveled in the region before the breakup of Yugoslavia knows firsthand. The Greeks possess the Balkans' finest skills in banking, trade, and technology, much needed in Macedonia. Both nations would profit enormously from a sound economic and geopolitical link.[29]

It remains to be seen whether the Greeks will abandon their hostility to a neighboring state bearing the name of a famous ancient kingdom with which the Greeks claim kinship. Or whether the Macedonians will honor their pledge not to harbor irredentist notions or to intervene on behalf of the Macedonian minority in Greece.[30] Or whether the Bulgarians will reassert their historic medieval claims on the region. Or whether the growing Albanian minority in Macedonia will continue to provoke repressive measures on the part of the government in Skopje.[31] It is, all told, a very Balkan problem, in a part of the world where many people prefer a past bent out of shape rather than a reasonable and peaceful vision of the future.[32]

NOTES

1. E.g., see the title essay in Peter Green's *Shadow of the Parthenon* (Berkeley and Los Angeles, 1972).

2. See Hugh Poulton, *Who Are the Macedonians?* (Bloomington and Indianapolis, 1995), 180–82. As of this writing, the Macedonian Orthodox Church has not been recognized by any other Orthodox hierarchy. The role of the church as a component of Macedonian nationhood is an interesting, if unresolved, matter.

3. I have a file of these photos. I gave copies of a few of them to an American colleague in Athens who is interested in Macedonian matters. He reported that he showed them to a Greek friend who denounced them as fakes.

4. There is little doubt in my mind that the toponym should be considered as a statement of the ethnicity of the deceased. This is confirmed by the preferred and common Macedonian "off," and "eff" endings to surnames (as against typically Bulgarian endings for those born in Bulgaria), and by the census reports which distinguish between the Macedonian and Bulgarian languages. Curiously, the gravestones of Serbs do not provide a toponym of origin.

5. Linguistically, it is impossible to determine what is meant by *Macedone,* whether "Macedonian" or "Macedonia." What is clear is that in 1906 (!) the stonecutter attempted to identify the deceased either by the place of his birth or by an ethnic term, however misspelled.

6. For what follows I am indebted to Professor Joseph C. Flay, whose experience in handling the information imbedded in nineteenth- and early twentieth-century U.S. census reports has proved invaluable. Only a portion of the 1920 Steelton census is reviewed here, and I was unable to check the census and gravestones against the records of the local Macedonian Orthodox Church. Although much remains to be done, the evidence gathered thus far points clearly to the conclusions that follow.

7. All those born in Bulgaria listed "Bulgarian" as their mother tongue. "Croatian" was given by those born in "Hungary" (Austria-Hungary, i.e., the Hapsburg Empire), while "Servian" (the old form of "Serbian") was spoken by those born in "Servia" and "Slavonia." Among the other languages given are Slovenian, Russian, Yiddish, Magyar, and Polish.

8. Victor A. Friedman, "The Sociolinguistics of Literary Macedonian," *International Journal of the Sociology of Language* 52 (1985): 31–57. For a detailed case study describing how the non-Hellenic components of a population long resident in the Langadas Basin north of Thessaloniki acquired Hellenic ethnicity in only two generations, see Anastasia Karakasidou, *Fields of Wheat, Hills of Blood: Passages to Nationhood in Greek Macedonia, 1870–1990* (Chicago, 1997). So successful was the program of Hellenization among these villagers that many persons of Slavic and Turkish background came to believe that their newfound Greek ancestry stretched back to antiquity.

9. The confusion of the old woman in the Baldwin cemetery in the 1990s (supra) about her Bulgarian/Macedonian identity is not an isolated case, as is made clear in the *Harvard Encyclopedia of American Ethnic Groups* (Cambridge, Mass., 1980), 690.

10. The conflict is described in Friedman, "Sociolinguistics of Literary Macedonian," 34–35, with relevant bibliography.

11. Some sense of Bulgarian hostility to the notion of a Macedonian nationality separate from Bulgaria can be found at large in a 900-page volume of documents translated into English and produced by the Institute of History of the Bulgarian Academy of Sciences, *Macedonia: Documents and Material* (Sofia, 1978), which is also a powerful anti-Serbian tract. The modern Greek position is laid out most forcefully and persuasively by a sound scholar, Evangelos Kofos, in *The Macedonian Question: The Politics of Mutation* (Thessaloniki, 1987); "National Heritage and National Identity in Nineteenth- and Twentieth-Century Macedonia," *European History Quarterly* 19 (1989): 229–67; and *The Impact of the Macedonian Question on Civil Conflict in Greece (1943–49)* (Athens, 1989). The prize for Greek jingoism must surely go to Nicolaos K. Martis, *The Falsification of Macedonian History* (Athens, 1984), now unfortunately in its fourth edition.

12. Thomas F. Magner, "Language and Nationalism in Yugoslavia," *Canadian Slavic Studies* 1 (1967): 346. Or, as Manning Nash once put it, a language is "a dialect with an army and a navy" (*The Cauldron of Ethnicity in the Modern World* [Chicago, 1989], 6).

13. Friedman, "Sociolinguistics of Literary Macedonian," 49–50, and Poulton, *Who Are the Macedonians?* 88–89.

14. For a frightening report of Macedonian ethnicity-denial in contemporary Greece, written from the perspective of a cultural anthropologist of Hellenic background, see Anastasia Karakasidou, "Politicizing Culture: Negating Ethnic Identity in Greek Macedonia," *Journal of Modern Greek Studies* 11 (1993): 1–28. Karakasidou's article resulted in a storm of protest from Greece. Among the less extreme reactions were those of N. Zahariadis, B. C. Gounaris, and C. G. Hatzidimitriou, published as review essays in *Balkan Studies* 34 (1993): 301–51. To the credit of that Thessaloniki-based journal, the editors gave Karakasidou the opportunity to respond to her critics: "National Ideologies, Histories, and Popular Consciousness: A Response to

Three Critics," *Balkan Studies* 35 (1994): 113–46. In reviewing the debate, the impartial observer will note that the criticisms reveal a lack of understanding of Karakasidou's anthropological methods. One can hardly find a more instructive and revealing firsthand insight into the debate than these *Balkan Studies* essays.

Karakasidou's assessment is confirmed elsewhere. See, e.g., "Country Reports on Human Rights Practices for 1990," a report submitted to the Committee on Foreign Relations, U.S. Senate, and the Committee on Foreign Affairs, House of Representatives, by the Department of State (February 1991), 1172–73, which raised strong protests from the Greek government and Hellenic Macedonian cultural societies in the United States; *Denying Ethnic Identity: The Macedonians of Greece.* Human Rights Watch/Helsinki (1994), and Poulton, *Who Are the Macedonians?* 162–71. And, following the declaration of Macedonian autonomy from the collapsing Yugoslav federation in 1991, Pope John Paul II include a brief statement in Macedonian as part of his traditional multilingual Christmas message. There were serious Greek protests over the pontiff's use of the "nonexistent Macedonian tongue." Certainly the early twentieth-century Macedonian immigrants in Steelton, Pennsylvania, believed that they were speaking a distinct language.

15. Poulton, *Who Are the Macedonians?* 116–21.

16. One such group, centered in Canada, believes that Linear B[!] is the ancient Macedonian language, from which Greek and all Slavic languages have derived, and that the ancient Thracians spoke Macedonian. Some of these beliefs find their way into print, e.g., G. Sotiroff, *Kinks in the Linear B Script* (Regina, Canada, 1969); id., "Homeric Overtones in Contemporary Macedonian Toponomy," *Onomastica* 41 (1971): 5–18; and id., "A Tentative Glossary of Thracian Words," *Revue Canadienne des Slavistes* 8 (1963): 97–110.

17. No amount of reason will shake modern Greek faith in the Hellenic ethnicity of the ancient Macedonians and their kings. It is more than a political preference: many Greeks see it as a necessity, despite the inconclusive ancient evidence on the nationality of the Macedonians. But recent scholarship has begun to provide a response to old Greek arguments. There is an insufficient amount of evidence—the existence of Greek inscriptions in the kingdom of the Macedonians notwithstanding—to know what the native language or dialect was. E.g., several dialects of Greek were used in ancient Macedonia, but what was the *Macedonian* dialect? The evidence of ancient writers suggests that Greek and Macedonian were mutually unintelligible languages in the court of Alexander the Great. Moreover, if contemporary or historical opinion from antiquity means anything, the ancient world from the fourth century B.C. into the early Hellenistic period—roughly the age of Philip and Alexander—believed that the Greeks and Macedonians were different peoples. None of which, incidentally, denies that the Macedonians, at least in their court and gentry, were quite highly hellenized, as recent archaeology has clearly shown. See E. Badian, "Greeks and Macedonians," *Macedonia and Greece in Late Classical and Early Hellenistic Times,* Studies in the History of Art 10, ed. B. Barr-Sharrar and E. N. Borza (Washington, D.C., 1982), 33–51; Eugene N. Borza, *In the Shadow of Olympus: The Emergence of Macedon,* rev. ed. (Princeton, 1992), ch. 4 and pp. 305–6; id., "Athenians, Macedonians, and the Origins of the Macedonian Royal House," in *Studies in Attic Epigraphy, History, and Topography Presented to Eugene Vanderpool, Hesperia* suppl. 19 (1982), 7–13; id., "Ethnicity and Cultural Policy at Alexander's Court," *AncW* 23 (1992):

21–25; and id., "Greeks and Macedonians in the Age of Alexander: The Source Tradition," in *Transitions to Empire: Essays in Greco-Roman History, 360–146 B.C. in Honor of E. Badian*, ed. R. W. Wallace and E. M. Harris (Norman, Okla., 1996), 122–39. The most that one can hope for is that one's views of the ancient Macedonians will not be misinterpreted as taking sides in contemporary Balkan politics.

18. My own experience is that the Macedonian issue sometimes divides even families in Greece, so that, for the sake of domestic tranquility, discussion of the issue is prohibited. The only comparable forbidden topic that I know is the Greek Civil War.

19. The Moslem Albanian minority in Macedonia, which accounts for something over 20 percent of the population, has begun to protest Christian imagery on the official paper money of what purports to be a multicultural, multireligious nation.

20. For what follows, see the overview provided by Poulton, *Who Are the Macedonians?* 120–21, and by the keenest observer of the émigrés, Loring M. Danforth. The latter is an experienced cultural anthropologist working among Greeks and Macedonians, both natives and émigrés. Danforth's papers, including those presented at scholarly meetings and privately circulated, have won wide respect among Balkan experts. His earlier work has been enlarged and superseded by the publication of *The Macedonian Conflict: Ethnic Nationalism in a Transnational World* (Princeton, 1995), in which Danforth explores the character of Macedonian ethnicity both in the Balkans and among overseas émigrés. Some of what appears in this essay owes much to Danforth's work, which is fundamental to an understanding of the several complex issues that mark this subject.

21. In a speech of welcome given at the opening of the exhibition in Thessaloniki in July, 1980, the president of the Greek Republic, Constantine Karamanlis, said, "As for Greece, Alexander has served as no other man has done the dreams of the nation, as a symbol of indissoluble unity and continuity between ancient and modern Hellenism."

22. From the introduction to the volume of papers published from the conference, *Macedonian Hellenism*, ed. A. M. Tamis (Melbourne, 1990). In addition, much of what follows regarding the first two Macedonian Congresses is based on newspaper and eyewitness accounts. I was a participant in several of the Greek-sponsored symposia and conferences discussed in this section, and can testify to the credibility of what is written here. Of special value is the testimony of Danforth, *Macedonian Conflict*, whose fieldwork as an observer of émigré activity underlies his published scholarship.

23. Many of the papers presented at the second Melbourne congress, including one of my own on Alexander the Great, which caused an unfortunate uproar, were never published. A few papers from the working sessions, mainly by Australian scholars, eventually appeared in print; see *Ancient Macedonia: An Australian Symposium. Papers of the Second International Congress of Macedonian Studies. The University of Melbourne, 8–13 July 1991*, edited by Peter J. Connor, in *Mediterranean Archaeology* 7 (1994). Some in the Macedonian émigré community in North America have adopted Ernst Badian, Peter Green, and me as "their" scholarly authorities, believing (without basis) that we possess a pro-Macedonian bias in this conflict. While it is true that we share certain similarities in our views about the *ancient* Macedonians, none of us has, to the best of my knowledge, publicly expressed any political opinions on the modern Macedonian Question. Thus, in a recent telephone conversa-

tion initiated by a fervent Macedonian nationalist from Toronto who saw in me a potential ally, the caller expressed astonishment when I said that I thought his views on the languages of ancient and modern Macedonia were without scholarly merit and bordered on the absurd. He never called back.

24. For insight into one aspect of this failure, see Kyriakos D. Kentrotis, "The Macedonian Question as Presented in the German Press (1990–1994)," *Balkan Studies* 36.2 (1995): 319–26.

25. Ibid., 325.

26. Argued in detail by William H. McNeill, *The Metamorphosis of Greece since World War II* (Chicago, 1978), 51–57.

27. The decorative sunburst symbol, found in Macedonian art and artifacts of the late classical and early Hellenistic eras, has been variously interpreted as a "royal" or "national" sign. While it may be impossible to distinguish between what was "royal" and what was "national" in the ancient Macedonian kingdom, the wide distribution of the symbol of the sunburst suggests a Macedonian tradition that may be associated with the origins of the royal house; see Hdt. 8.137–39 and Eugene N. Borza, "The Macedonian Royal Tombs: Some Cautionary Notes," *Archaeological News* 10 (1981): 81–82.

28. The first issues of these coins bore 1990 mint marks, but had been kept unreleased in storage until the changing political climate required their discharge into general circulation. The obverse of the coin bears a portrait of Alexander the Great. One further point about currency: until recently all Greek banknotes—50, 100, 500, 1,000, and 5,000-drachma notes—were watermarked with the head of the Charioteer of Delphi. The new 200-drachma and 10,000-drachma notes have as their watermark a portrait of Philip II of Macedon.

29. But the full recognition of Macedonia by Greece might raise other problems involving the Serbs; see Symeon A. Giannakos, "The Macedonian Question Reexamined: Implications for Balkan Security," *Mediterranean Quarterly* 3 (Summer 1992): 26–47. This article is a balanced review of the various perspectives—Greek, Macedonian, Bulgarian, and Serbian—on the Macedonian Question in the immediate aftermath of the Yugoslav breakup.

30. One can hardly overemphasize the importance of this Macedonian minority in Greece, located primarily, but not exclusively in the area around Florina. Greece officially denies the existence of ethnic minorities within the country; see Hugh Poulton, *The Balkans: Minorities and States in Conflict* (London, l991), ch. 13, and Karakasidou, "Politicizing Culture" (cit. n. 14, above). In 1990, the president of the Greek Republic, Christos Sartzetakis, proclaimed: "In Greece there are only Greeks, of exclusively Greek descent, with the exception of the small minority which international treaties refer to as Muslim" (*Athena Magazine* [April 1990]: 256). The denial of the very existence of minorities in Greece is consistent with the centuries-old policy of hellenization, but it also denies the serious consequences of minority repression, especially when a neighboring state is dominated by a population of the same ethnicity. Greeks have supported the claims of repressed ethnic Greeks living in Albania since the formation of that state in 1913. Yet they deny the right of the government of Macedonia to support Macedonians living in Greece, and they do so by simply proclaiming that there are no Macedonians in Greece, only Slavic-speaking Greeks. Thus the Greeks actively promote the problem they fear most:

foreign (Macedonian) support of a minority group in their own nation. See Stephanos Stavros, "The Legal Status of Minorities in Greece Today: The Adequacy of Their Protection in the Light of Current Human Rights Perceptions," *Journal of Modern Greek Studies* 13 (1995): 1–32, who argues that the treaty arrangements of the 1920s, ostensibly designed to protect the rights of minorities in Greece, are inadequate today, as Greek courts continue to issue decisions denying equal rights to some minorities.

31. In Macedonia, the main human rights issue relates to equal rights for its several ethnic minorities. Even though Macedonian law embodies the principle of equal rights for minorities, the practical application is uneven, especially with regard to employment and minority language education of ethnic Albanians, who number nearly 22 percent of the population. See *A Threat to "Stability": Human Rights Violations in Macedonia,* Human Rights Watch Report (New York, 1996).

32. Some things may be changing. In early 1996 the Greek government led by Prime Minister Costas Simitis and Foreign Minister Theodoros Pangalos adopted a policy of Balkans reconciliation in part as a response to increased tensions between Greeks and Turks. Pangalos was widely quoted in the Greek press and television as having stated (concerning the Republic of Macedonia), "[W]e spend too much time talking about Alexander the Great rather than addressing ourselves to the future of economic cooperation." There was the expected angry reaction from some quarters. In April 1996, the Serbian government formally recognized Macedonia *as Macedonia.* In Greece, the announcement was widely greeted with outrage and a sense of betrayal by what had been regarded as Greece's closest Balkans ally. Yet, within a few weeks *Kathimerini,* the most prestigious newspaper in Athens, published a 32-page supplement to its Sunday edition that was entirely devoted to an attractive description of the economic, social, and cultural life of Macedonia (although still called "Skopje"). This warming trend is consistent with travelers' reports that border crossings between Greece and Macedonia are routinely made without difficulty.

SELECT BIBLIOGRAPHY OF WORKS
BY PETER M. GREEN

Peter M. Green is the author of many works ranging from short occasional pieces to full length books. The following selective biography makes no attempt to chronicle with any completeness the many book reviews, short poems, and other brief pieces he has produced. Moreover, a few of his longer works have been omitted.

BOOKS

Classical

Essays in Antiquity. London: Murray; New York: World, 1960.

Juvenal: The Sixteen Satires. Translated with introduction and notes. London: Penguin Classics, 1967. Reprinted, 1970, 1972. Revised edition, 1974. Ten reprints, most recently 1992.

Alexander the Great. London: Weidenfeld & Nicolson; New York: Praeger, 1970. German translation, 1974; Italian translation, 1975.

Armada from Athens: The Failure of the Sicilian Expedition, 415–413 B.C. London: Hodder & Stoughton; New York: Doubleday, 1970. Reprint forthcoming from the University of California Press, 1996.

The Year of Salamis, 480–479 B.C. London: Weidenfeld & Nicolson, 1970. Reprint forthcoming from the University of California Press, 1996.

The Shadow of the Parthenon. London: Temple Smith; Berkeley and Los Angeles: University of California Press, 1972.

Ancient Greece: A Concise History. London: Thames & Hudson; New York: Viking, 1973. Paperback edition, 1979. Dutch translation, 1975. Japanese translation, forthcoming.

The Parthenon and Acropolis. London: Hodder; New York: Newsweek Book Division, 1973.

Alexander of Macedon, 356–323 B.C.: A Historical Biography. Hamondsworth: Penguin, 1974. Berkeley: University of California Press, 1991. Polish translation 1978.

Yannis Ritsos, *The Fourth Dimension (I Tetarti Diastasi),* 6ᵗʰ edition. Athens: Kedros, 1976. Translation, introduction, and notes by Peter Green. Princeton: Princeton University Press, 1993.

Ovid: The Erotic Poems. Translated with introduction and notes. New York: Penguin Classics, 1982. Reprinted.

Medium and Message Reconsidered: The Changing Functions of Classical Translation. New Orleans: Tulane University Press, 1987.

Classical Bearings: Interpreting Ancient History and Culture. London and New York: Thames & Hudson, 1989. Paperback forthcoming from the University of California Press, 1998.

Alexander to Actium: The Historical Evolution of the Hellenistic Age. Berkeley & Los Angeles: University of California Press; Centennial Books; London: Thames & Hudson, 1991. Reprinted with revisions and corrections, 1993. French and Greek translations forthcoming.

Hellenistic History and Culture. Edited by Peter Green. Berkeley and Los Angeles: Univerity of California Press, 1993.

Ovid: The Poems of Exile. Translation with introduction, commentary, and glossary by Peter Green. New York: Penguin Classics, 1994.

The Greco-Persian Wars. Berkeley & Los Angeles: University of California Press, 1996.

Apollonius Rhodius: The Argonautika. Translated with introduction, commentary, and glossary by Peter Green. Berkeley and Los Angeles: Univerity of California Press, 1997.

Historical Fiction

Achilles His Armour. London: Murray, 1955; New York: Doubleday, 1967.

The Sword of Pleasure. London: Murray; New York: World, 1957; New York: Penguin, 1960. (Heinemann Award for Literature, 1957.)

The Laughter of Aphrodite: A Novel about Sappho of Lesbos. London: Murray; New York: World, 1965. Reissued by the University of California Press, 1993.

Nonclassical

The Expanding Eye: A First Journey to the Mediterranean. London: Dobson, 1953.

Kenneth Grahame, 1859–1932: A Study of his Life, Work, and Times. London: Murray, 1959.

Sir Thomas Browne. British Council Monograph. London: Longmans, 1959.

John Skelton. British Council Monograph. London: Longmans, 1960.

Habeas Corpus and Other Stories. London: Hamish Hamilton, 1962.

Beyond the Wild Wood: The World of Kenneth Grahame. Exeter: Webb & Bower; New York: Facts on File, 1982–1983.

ARTICLES

"Pique-la-Lune: Antoine de St. Exupéry." *Cambridge Journal* 6 (1952): 40–50.

"Du Côté de chez Waugh." *Review of English Literature* 2 (1961): 89–100.

"The First Sicilian Slave War." *Past and Present* 20 (1961): 10–29.

"Aspects of the Historical Novel." In *Essays by Divers Hands,* 35–60. Royal Society of Literature, Vol. 31 (1962).

"The World of William Golding." In *Essays by Divers Hands,* 35–57. Royal Society of Literature, Vol. 32 (1963).

"The Quest for Sappho" (with original translations of frr. 1, 16, 31, 94, 96 L-P). *Horizon* 8 (1966): 104–111.

"Property and Power in Ancient Athens." *Times Literary Supplement* 3703 (1973): 209–10.

"Alcibiades: A Lion in the State." *International History Magazine* 17 (1974): 8–23.

"The Context of a Conqueror." *Times Literary Supplement* 3754 (1974): 157.

"Caesar and Alexander: *aemulatio, imitatio, comparatio.*" *American Journal of Ancient History* 3 (1978): 1–26.

"*Ars Gratia Cultus:* Ovid as Beautician." *American Journal of Philology* 100 (1979): 381–92.

"The Flight-plan of Daedalus." *Classical News and Views* 23 (1979): 30–35.

"The Innocence of Procris: Ovid *AA.* 3.687–746." *Classical Journal* 75 (1979): 15–24.

"Strepsiades, Socrates, and the Abuses of Intellectualism." *Greek, Roman and Byzantine Studies* 20 (1979): 15–25.

"Tut-Tut-Tut" (A Survey of Contemporary Work in Egyptology). *New York Review of Books* 26, no. 15 (1979): 19–32.

"The Poets' Greece." *New York Review of Books* 27 (1980): 40–44.

"Greece against Itself." *New York Review of Books* 28 (1981): 35–39.

"The Macedonian Connection." *New York Review of Books* 27 (1981): 37–42.

"Wit, Sex, and Topicality: The Problems Confronting a Translator of Ovid's Love Poetry." *Classical News and Views* 25 (1981): 79–96.

"*Carmen et Error:* πρόφασις and αἰτία in the matter of Ovid's exile." *Classical Antiquity* 1 (1982): 202–20.

"Longus, Antiphon, and the Topography of Lesbos." *Journal of Hellenic Studies* 102 (1982): 210–14.

"Ovid in Tomis." *Grand Street* 2 (1982): 116–25.

"The Rentier's Rural Dress." *Times Literary Supplement* 4156 (1982): 1299–301.

"All That Again (Robert Graves)." *Grand Street* 3 (1983): 89–119.

"The Furies of Civil War." *Times Literary Supplement* 4216 (1984): 51–2.

"After the Successors." *Times Literary Supplement* (16 August 1985): 891–3.

"The Last of the Ptolemies." *Grand Street* 4 (1985): 133–68.

"The Politics of Royal Patronage: Early Ptolemaic Alexandria." *Grand Street* 5.1 (1985): 15–63.

"Hellenistic Technology: Eye, Hand, and Animated Tool." *Southern Humanities Review* 20.2 (1986): 101–13.

"The New Urban Culture: Alexandria, Antioch, Pergamon." *Grand Street* 5.3 (1986): 140–52.

"Endymion's Dreams: The Mystery Cults of Hellenism." *Southern Humanities Review* 21 (1987): 1–17.

"The Armchair Epic: Apollonius Rhodius and the Voyage of Argo." *Southern Humanities Review* 22 (1988): 1–15.

"Juvenal Revisited." *Grand Street 9* (1989): 175–96.
"The Cretan." *The New Republic* 203 (1990): 39–43.
"Greek Gifts?" *History Today* 40 (1990): 27–34.
"Rebooking the Flute-Girls: A Fresh Look at the Chronological Evidence for the Fall of Athens and the ὀκάμηνος ἀρχή of the Thirty." *Ancient History Bulletin* 5 (1991): 1–16.
"The Village Classicist." *The New Republic* 204 (1991): 42–50.
"Getting To Be a Star: The Politics of Catasterism." *Fenway Court* 27 (1994/5): 52–71.

RECENT CHAPTERS, SECTIONS, AND SHORT MONOGRAPHS

"The Horatian Creed." In *Times Literary Supplement 10: Essays and Reviews from the Times Literary 1971,* edited by A. Crook, 112–19. London: Oxford University Press, 1972.
"Some Versions of Aeschylus: A Study of Tradition and Method in Translating Classical Poetry." In *Aeschylus: A Collection of Critical Essays,* ed. Marsh H. McCall, Jr., 164–83. Englewood Cliffs, N.J.: Prentice Hall, 1972.
"The Royal Tombs of Vergina: A Historical Analysis." In *Philip II, Alexander the Great and the Macedonian Heritage,* edited by W. L. Adams and E. N. Borza, 129–51. Washington, D.C.: University Press of America, 1982.
"Sex and Classical Literature." In *The Sexual Dimension of Literature,* edited by Alan Bold, 19–48. Towata, N.J.: Barnes & Noble, 1983.
"Works and Days 1–285: Hesiod's Invisible Audience." In *Mnemai: Classical Studies in Memory of Karl K. Hulley,* edited by Harold D. Evjen, 21–39. Chico, CA: Scholars Press, 1984.
"New Approaches to the Hellenistic World." In *Hellenistic History and Culture,* edited by Peter Green, 1–11. Berkeley: University of California Press, 1993.
"Text and Context in the Matter of Xenophon's Exile." In *Ventures into Greek History,* edited by Ian Worthington, 215–27. Oxford: Clarendon Press, 1993.
"Delivering the Go(o)ds: Demetrius Poliorcetes and Hellenistic Divine Kingship," forthcoming in *Kingship and the Organization of Power in Greek Society,* ed. T. Palaima, University of Texas Press.
"Alexander's Alexandria," forthcoming in the J. Paul Getty Museum's symposium volume on *Ancient Alexandria.*
"The Metamorphosis of the Barbarian: Athenian Panhellenism in a Changing world," forthcoming in the *Festschrift* volume honoring E. Badian, ed. R. W. Wallace & E. Harris, University of Oklahoma Press.

TRANSLATIONS

Oldenbourg, Zoë. *Les Brûlés (Destiny of Fire).* New York: Pantheon, 1961.
———. *Le Bûcher de Montségur (Massacre at Montségur).* New York: Pantheon, 1961.
Beauvoir, Simone de. *La Force de l'Age (The Prime of Life).* Cleveland: World, 1962.
Flacelière, R. *La vie quotidienne en Grèce au siècle de Périclès (Daily Life in Greece at the time of Pericles).* New York, Macmillan, 1965.

Le Clézio, J. M. G. *Le Déluge (The Flood)*. New York: Atheneum, 1967.

Breglia, Laura. *L'arte romana nelle monete dell'età imperiale (Roman Imperial Coins)*. London: Thames & Hudson, 1968.

Bianchi Bandinelli, Ranuccio. *Rome: le centre de pouvoir (Rome: The Centre of Power: Roman Art to a.d. 200)*. New York: G. Braziller, 1970.

———. *Rome: La Fin de L'Art Antique (Rome: The Late Empire)*. London: Thames & Hudson, 1970.

Charbonneaux, J., Martin, R., and Villard, F. *Grèce Hellénistique (Hellenistic Art)*. London: Thames & Hudson, 1973.

Archilochus. "A new epode by Archilochus." *Times Literary Supplement* 3810 (1975): 272.

Yannis Ritsos. "Phaedra." *Southern Humanities Review* 20 (1986): 227–47 (with B. Bardsley).

———. "Persephone." *Grand Street* 6 (1987): 143–56 (with B. Bardsley).

———. "Helen." *Grand Street* 8 (1988): 65–85 (with B. Bardsley).

———. "Chronicle." *Southeastern Review* 1.1 (1990): 39–46.

Apollonius of Rhodes. "Jason and Medeia" (*Argonautika*, Bk iii, 744–1407). *Southern Humanities Review* 25 (1991): 217–33.

Apollonius of Rhodes. "The Clashing Rocks" (*Argonautika*, Bk ii, 536–610), *Southern Humanities Review* 26 (1992): 9–10.

CONTRIBUTORS

Ernst Badian is John Moors Cabot Professor of History Emeritus, Harvard University. His publications include *Foreign Clientelae 264–70 B.C.* (Charendon Press, 1958); *Studies in Greek and Roman History* (Blackwell, 1964); *Roman Imperialism in the Late Republic*, 2nd ed. (1st commercial ed.; Blackwell/Cornell Univerisity Press, 1968); *Publicans and Sinners* (Blackwell/Cornell Univeristy Press, 1972; reprinted, with corrections and critical bibliography, Cornell University Press, 1983); *From Plataea to Potidae* (Johns Hopkins University Press, 1993); and *Zöllner und sünder* (Wissenschaftliche Buchgesellschaft, 1997). He was the founder and is the editor of *The American Journal of Ancient History*. He also founded the Association of Ancient Historians and the New England Ancient History Colloquium.

Alan L. Boegehold is professor of classics at Brown University. He has been chair of the Managing Committee of the American School of Classical Studies at Athens (1990–1998) and is now a trustee of the school as well as of the Gennadius Library. Recent publications include *The Lawcourts at Athens* (The Athenian Agora, vol. 28; American School of Classical Studies at Athens, 1995), *Athenian Identity and Civic Ideology* (ed. with Adele Scafuro; Johns Hopkins University Press, 1993), *In Simple Clothes* (a translation of Eleven Poems of Constantine Cavafy; Occasional Works, 1992), and *When a Gesture Was Expected: A Selection of Examples from Archaic and Classical Greek Literature* (Princeton University Press, forthcoming).

Eugene N. Borza, professor emeritus of ancient history at The Pennsylvania State University, is past president of the Association of Ancient Historians. He lectures widely on the history and archaeology of ancient Macedonia and has recently served as Mitchell Distinguished Visiting Professor at Carleton College. Among his numerous publications are *In the Shadow of*

Olympus: The Emergence of Macedon (rev. ed., Princeton University Press, 1992) and *Makedonika: Essays by Eugene N. Borza* (edited by Carol G. Thomas; Association of Ancient Historians, 1995).

Stanley M. Burstein is professor of ancient history at California State University, Los Angeles and past president of the Association of Ancient Historians. He is the author of numerous articles and books on various aspects of Greek history including *The Hellenistic Age from the Battle of Ipsos to the Death of Kleopatra VII* (Cambridge University Press, 1985), *Agatharchides of Cnidus: On the Erythraean Sea* (The Hakluyt Society, 1989), and *Graeco-Africana: Studies in the History of Greek Relations with Egypt and Nubia* (Aristide D. Caratzas, 1994). He is co-author of *Ancient Greece: A Political, Social, and Cultural History* (Oxford University Press, 1999).

Diana Delia is professor of ancient history at Rhode Island College. She is the author of *Alexandrian Citizenship during the Roman Principate* (American Classical Studies, 1991) and articles on the intellectual and social history of Hellenistic and Roman Egypt and on editions of Greek papyri. She is currently preparing a history of ancient Alexandria.

Robert Eisner is professor of classics and humanities at California State University at San Diego. He is the author of *The Road to Daulis: Psychoanalysis, Psychology, and Classical Mythology* (Syracuse University Press, 1987) and *Travelers to an Antique Land: The History and Literature of Travel to Greece* (University of Michigan Press, 1991; paperback, 1994). He writes on travel and reviews frequently for *The Washington Post, The New York Times, The Boston Globe,* and *National Geographic Traveler.* He has just completed an adaptation, as both novel and screenplay, of Robert Louis Stevenson's unfinished romance *The Weir of Hermiston* and is currently working on a novel about the last days of the Grand Tour.

Donald Engels is professor of history at the University of Arkansas at Fayetteville. He is the author of *Alexander the Great and the Logistics of the Macedonian Army* (University of California Press, 1978), *Roman Corinth: An Alternative Model for the Classical City* (University of Chicago Press, 1990), and the forthcoming *Classical Cats: The Rise and Fall of the Sacred Cat* (Routledge, 1999). The topic of the Alexander book was suggested to him by Professor Green.

Frank J. Frost is professor emeritus of history, specializing in Greek history and the history of seafaring, at the University of California, Santa Barbara. He is the author of *Plutarch's Themistocles: A Historical Commentary* (Princeton University Press, 1980), *Greek Society* (fifth edition; Houghton Mifflin, 1997), and many articles on Greek history, archaeology, and the history of

seafaring. He was most recently co-director of excavations at Phalasarna, western Crete.

Karl Galinsky is the Floyd Cailloux Centennial Professor of Classics at the University of Texas at Austin. The revised edition of his most recent book, *Augustan Culture* (Princeton University Press, 1996) was published in paperback in 1998.

Erich S. Gruen is Gladys Rehard Wood Professor of History and Classics at the University of California, Berkeley. He is the author of *The Last Generation of the Roman Republic* (1974), *The Hellenistic World and the Coming of Rome* (1984), and *Heritage and Hellenism: The Reinvention of Jewish Tradition* (1998), all published by the University of California Press.

Frank L. Holt is associate professor of ancient history at the University of Houston. He has published widely in the fields of numismatics, Alexander studies, and Hellenistic history. His books include the third edition of *The Greeks in Bactria and India* (by William Tarn; Ares, 1985), *Alexander the Great and Bactria* (Brill, 1988), and *Thundering Zeus: The Making of Hellenistic Bactria* (forthcoming from the University of California Press).

Richard F. Moorton, Jr., is associate professor of classics at Connecticut College. He has published articles on Aristophanes, Vergil, and Eugene O'Neill. He is the editor of *Eugene O'Neill's Century: Centennial Views on America's Foremost Tragic Dramatist* (Greenwood Press, 1991).

Alan E. Samuel is professor of Greek and Roman history at the University of Toronto. Recent books include *The Promise of the West: The Greek World, Rome, and Judaism* (Routledge, 1988), *The Shifting Sands of History: Interpretations of Ptolemaic History* (Association of Ancient Historians, 1989), *The Greeks in History* (University of Toronto Press, 1992), and *Treasures of Canada* (Samuel-Stevens, 1995, 1998).

Philip O. Spann is associate professor in the Department of Languages and Literature at the University of Utah. He is the author of *Quintus Sertorius and the Legacy of Sulla* (University of Arkansas Press, 1987). Most of his other publications also concern the late Roman Republic and Roman Spain. He has contributed the south-east quadrant of Hispania ("Hispania Carthaginiensis") to the *Atlas of the Greek and Roman World*, which is being published by the American Philological Association under the direction of R. Talbert.

Frances B. Titchener is associate professor of history at Utah State University. She has been for ten years the editor of *Ploutarchos*, the journal of the International Plutarch Society. She has published numerous articles on Plutarch and Thucydides and is finishing a commentary on Plutarch's *Life of Nicias*.

Elizabeth Vandiver is visiting assistant professor of classics at Northwestern University. She is the author of *Heroes in Herodotus: The Interaction of Myth and History* (Peter Lang, 1991) and has published articles on Catullus, Sappho, and Greek tragedy. Her translation of Johannes Cochlaeus's *Commentaria de actis et scriptis Martini Lutheri* is forthcoming, and she is currently preparing a book on the influence of the classical tradition on British poets of the First World War.

INDEX

Compositor: Braun-Brumfield, Inc.
Text: 10 / 12 Baskerville
Display: Baskerville
Printer: Braun-Brumfield, Inc.
Binder: Braun-Brumfield, Inc.